# ANGLO-SAXON ART

## MANCHESTER STUDIES IN THE HISTORY OF ART
GENERAL EDITOR: C. R. DODWELL
### VOLUME THREE

C. R. DODWELL

# Anglo-Saxon Art

## A new perspective

MANCHESTER UNIVERSITY PRESS

Published by
Manchester University Press
Oxford Road, Manchester M13 9PL

*British Library cataloguing in publication data*

Dodwell, C. R.
  Anglo-Saxon art: a new perspective.
  1.  Art, Anglo-Saxon–History
  2.  Art–England–History
  I.  Title
  709′.42        NG763

    ISBN 0-7190-0861-1  (*hardback*)
    ISBN 0-7190-0926-X  (*paperback, not published
                          simultaneously with hardback*)

Typeset by Oxford Verbatim Limited

Printed in Great Britain
at The Alden Press, Oxford

# CONTENTS

# ACKNOWLEDGEMENTS

This book began as a more limited survey of the sources for the period between *c.* 943 and 1066. Both Professor Dorothy Whitelock and Professor Dennis Green kindly commented on the initial typescript and, when I had enlarged the study to cover the whole of the Anglo-Saxon period, I was able to call on the generosity of two other scholars – Dr Peter Hunter Blair and Dr Gale R. Owen. Since that time, parts of the book have been rewritten so that, in more than a conventional sense, I can say that any errors that remain are entirely my own.

Other scholars have answered specific questions: Dr Rupert Bruce-Mitford, Professor Peter Clemoes, Dr Paul Crossley, Dr Peter Dronke, Professor David Greene, Dr Martin Hennig, Professor Kenneth Hyde, Professor Harry Jocelyn, Mr Donald King, Dr Roger Ling, Dr W. J. Rodwell, Professor William Rothwell, Dr Alex Rumble, Dr Donald Scragg, Professor Walter Ullman and Dr Joy Watkin. Where I have incorporated their information in the text, I have made acknowledgements in the notes. I have received much appreciated help from Dr Richard Schofield and Mr Timothy Graham; Mr Piers Tyrrell has helped procure for me copies of some of the more obscure sources; Miss Evelyn Cundy and my wife have commented on the text from the general reader's point of view; the typing of the book by Mrs Majorie Sheldon and Mrs Julia Willcock has called for great meticulousness. The British Academy has generously paid for most of the colour plates. Mr John Banks of the Manchester University Press has given me considerable assistance and, at his suggestion, I have agreed to modernise letters that are specifically Old English in order to reduce the cost of printing and enable the book to be sold more cheaply.

C.R.D.

*The author and publishers extend their grateful*
*thanks to the Trustees of the British Museum, the*
*Master and Fellows of Trinity College, Cambridge, the*
*Winchester Excavations Committee, Merseyside County*
*Museums, Liverpool, and the curators of the many*
*other libraries, museums and galleries who have*
*supplied photographs of material in their possession.*

# BLACK AND WHITE PLATES

# COLOUR PLATES

**A**   Picture of a monastic scribe as part of the ornamentation of initial B in a Psalter made at Canterbury for Bury in the second quarter of the eleventh century (Vatican, Biblioteca Apostolica MS. Reg. lat. 12, fol. 21).

**B**   Christ in Majesty, from an early eleventh century manuscript, probably from Christ Church, Canterbury (Cambridge, Trinity College MS. B 10 4, fol. 16v).

**C**   St Mark from the St Margaret Gospels, 1030–60 (Oxford, Bodleian Library MS. Lat. lit. F. 5, fol. 13v).

**D**   Detail of St Æthelwold in a cathedral, from the Benedictional of St Æthelwold, a manuscript made for him between 971 and 984 (British Library, Add. MS. 49598, fol. 118v).

**E**   Portrayal of King Edgar offering to Christ a charter for the New Minster, Winchester. He stands between two of the foundation's patron saints, the Virgin and St Peter. Made after 966 at Winchester (British Library, Cotton MS. Vespasian A VIII, fol. 2v).

**F**   Details of two of the prophets on a stole orginally made at Winchester between 909 and 916 and found in St Cuthbert's coffin (Durham Cathedral Treasury).

**G**   Crucifix reliquary of walrus ivory, mounted on cedar wood which is sheathed in gold with filigree and cloisonné decoration and enamels. On the back are the Agnus Dei and symbols of the evangelists in repoussé work (Victoria and Albert Museum, 18.5 cm high).

**H**   The Tassilo chalice, 777–88 (Kremsmünster Abbey, Austria, 26.6 cm high).

*The colour plates appear between pages 52 and 53*

# CHAPTER I

# ART SURVIVALS AND
# WRITTEN SOURCES

The Anglo-Saxon arts which attract most attention today would have
had little interest for the Anglo-Saxon writers. This is partly due to
changes of taste but chiefly to accidents of survival. Such is certainly
true of the arts after the seventh century though some earlier ones had
different fortunes. These were the crafts that the Anglo-Saxons
practised before their own conversion to Christianity.

The pagan Germanic tribes, later known as the Anglo-Saxons, who
came to England before the mid fifth century, arrived in small scattered
groups and, confronted by the determined opposition of the British
inhabitants, were only slowly able to take over the country. This they
occupied and divided into numerous small kingdoms. Their later con-
version, which began with St Augustine's mission from Rome in 597,
was also gradual and piecemeal. It could be argued that this was
because many of the indigenous Britons were not only Christian but
prepared to mobilise Christianity against the invaders: at least Bede
tells the story of over twelve hundred British monks who were brought
to pray for an Anglo-Saxon defeat on the edge of one battle-field.[1] But
this was already when the domination of the country by the Germanic
incomers was assured; and the records show that the Anglo-Saxons
were very tolerant towards Christianity. Æthelberht, the first Anglo-
Saxon king whom St Augustine approached and converted, had a wife
who was not only Christian but who was allowed to have her own
Frankish bishop with her.

One reason for the slowness of the conversion was that, when the
Anglo-Saxons accepted Christianity, it was not because of a sudden
flash of illumination, like that of St Paul on his way to Damascus, but
because of hard-headed assessments of spiritual and political
advantages, and the most famous and touching of all Bede's metaphors,
comparing life to the brief flight of a sparrow through a fire-lit hall,
occurs in the context of just such an appraisal. This was when Edwin of
Northumbria was considering his own conversion. He had already
half-promised to become Christian in order to secure a Christian bride,

had seen the new faith attested by his own delivery from assassination, by the birth of a daughter and a victory over the West Saxons, but was still continuing to discuss the issue with his councillors. Decisions thus cautiously made could be quickly reversed if they were later considered disadvantageous. The early successes of the Roman missionaries in Kent proved, therefore, to be ephemeral for they were soon followed by relapses into heathenism, and, even after the so-called Synod of Whitby in 664, the onset of a plague led many to seek refuge in the paganism of their fathers. The fluidity of religious fortunes is indicated by an episode in the life of St Cuthbert who lived between c. 634 and 687. Bede tells of how people jeered at monks who were drifting out to sea on rafts since these were the very men who had robbed them of their old ways of worship and then fumed against Cuthbert when he suggested praying for them. But, when Cuthbert's own prayers were answered and the violent wind changed direction and bore the rafts safely back to shore,[2] they joined together in praising the faith of the Christian saint. For a number of decades there was a fluctuation between the fortunes of paganism and of Christianity, yet there was also a kind of co-existence between them which, for example, allowed a pagan ruler to ally himself with a Christian one. All this is symbolised by the action of King Rædwald in dedicating altars in his temple both to the heathen gods and to the Christian one.[3]

In some form and in some areas, paganism continued for almost a century after the landing of St Augustine. It was not until St Wilfrid's conversion of the South Saxons in Sussex and the Isle of Wight between 681 and 686 that the whole of England could be said to be Christianised and it is an astonishing fact that, no sooner was this completed, than the Anglo-Saxons launched their own missionary enterprise into areas of Germany. This was an undertaking initiated by Willibrord, who reached Frisia with his own body of missionaries in 690. But it was dominated by St Boniface, whose work in converting the Germans and setting up a Church in Germany between 718 and 754 changed the course of German history. Back in England, however, the old heathenism was not entirely dead. Indeed, at the end of the seventh or beginning of the eighth century – probably between the times when first St Willibrord, and then St Boniface, carried the torch of the Christian faith abroad – a whalebone casket (now known as the Franks casket) was being carved in Northumbria with representations appealing to both Christian and pagan sentiments. On it a depiction of the Adoration of the Magi was accompanied by scenes from the old pagan myths (Plates 1a and 1b). Though these carvings have been claimed to illustrate the legend of Wayland the Smith,[4] their exact meanings may, in

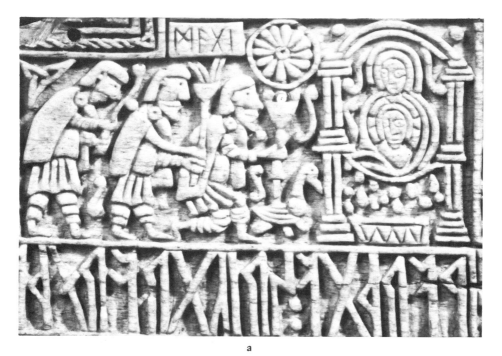

a

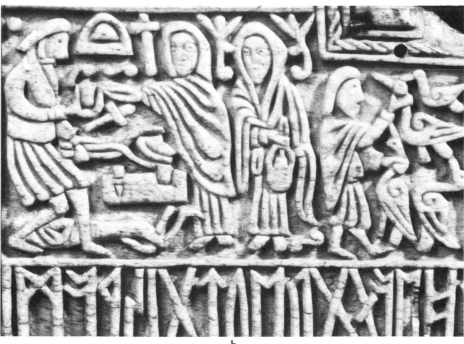

b

**1** Details of scenes from the Franks casket, a whalebone casket of the late seventh or early eighth century in the British Museum: (**a**) the Adoration of the Magi; (**b**) a pagan scene.

fact, now be lost to us.[5] However, it is certain that they relate to religious beliefs held in England before the arrival of Christianity. Paganism was never entirely eradicated from Anglo-Saxon England. Though it might be diverted into comparatively harmless forms, it could still find open expression, as, for example, under the Danish pressures of the tenth and eleventh centuries.[6] Yet, despite all this, it is true to say that, by the end of the seventh century, after a long period of overlap between pagan and Christian traditions, Christian customs had come to prevail. This meant that works of art were no longer interred. It meant also that they were no longer safeguarded.

Although grave-robbing in England is attested as early as the seventh century,[7] the heathen practice of the earlier Anglo-Saxons of burying grave-goods with the dead had tended to conserve some categories of them. These were the objects in precious metal. They could withstand the dampness underground and were left unseen and undisturbed for centuries until in more modern times they could be recovered by the skills and patience of the modern archaeologist. One result of this is that we have a very good idea of certain crafts of the early Anglo-Saxons in this country. As with other Germanic tribes, their arts were primarily of a portable kind and chiefly took the form of personal accoutrements and decoration – necklaces, bracelets, brooches and so on. They are best exemplified by the magnificent finds at Sutton Hoo,[8] which were inter-red *c.* 625. Here the most finely crafted objects are of Anglo-Saxon workmanship – the great gold buckle with its intricate and brilliantly executed animal-interlacing (Plate 2a): the purse-mount with its cloisonné work of surprising delicacy: the gold clasps with their garnets, mosaic glass and filigree and their over-all designs (Plate 2b). They indicate the astonishing level of accomplishment already reached by pagan Anglo-Saxon goldsmiths in the first half of the seventh century. No doubt, if major pieces of the goldsmiths' work of the Christian Anglo-Saxons of the seventh century had come down to us, we should have been equally amazed, for there is no reason to think that the craftsmanship of the pagan and of the Christian goldsmiths varied in quality. Indeed, one of the few small crosses to have survived from the seventh century is attributed to the workshop that produced the Sutton Hoo jewellery.[9] The difference between pagan and Christian gold-smiths' work of the period, we may surmise, was not of artistry but of preservation. The one was safeguarded in the graves of the dead. The other was at hazard in the land of the living.

Where Christianised Anglo-Saxon England is concerned, there have been enormous artistic losses but what has suffered disproportionately has been works in gold and silver. Their other crafts were exposed to

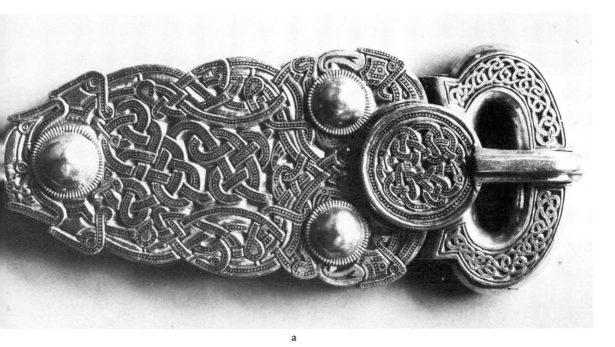

a

b

**2** (**a**) Great gold buckle from Sutton Hoo, *c.* 625 (British Museum, 13.2 cm long). (**b**) One of a pair of curved clasps from Sutton Hoo, *c.* 625 (British Museum, 12.7 cm long).

various perils but none was so vulnerable as these. Indeed, no goldsmith's work that the Anglo-Saxons would themselves have considered significant remains to us today. In other cultures also, works of art in precious materials have been at higher risk than those of a more modest sort – in Egypt and Siberia, the tomb robbers were searching for the gold not the textiles, and, in South America, the Spanish *conquistadores* were looking for the Inca art in gold. There is nothing unique in the fact that today our attention is largely concentrated on Anglo-Saxon arts which have no bullion value simply because of their capacity to survive.

A major danger to some arts was the rebuilding which continued throughout the Middle Ages and which (as we shall see later) was particularly extensive under the Normans. This meant the demolition of Anglo-Saxon architecture but also entailed the destruction of any wall-paintings and sculpture that formed part of the architecture.

Such rebuilding was often a consequence of fire which was a particularly grave menace in the Middle Ages. This is alluded to by an eleventh-century chronicler in his remark that this was a danger that Wilton (the most celebrated of the Anglo-Saxon nunneries) had so far escaped.[10] Fire continued to be a threat to such Anglo-Saxon works of art that remained in churches and other buildings after the Norman Conquest. It was a hazard exacerbated by the earlier practice of building in wood, but even great monasteries and churches of stone continued to remain vulnerable as long as fire could spread to them from buildings with thatched roofs huddled around. There were few who, like Samson of Bury St Edmunds in the twelfth century, not ony saw the danger but took action against it by having adjacent thatched buildings re-roofed in slate.[11] Fires often consumed whole districts including churches and cathedrals and their contents. In only seven years, between 1116 and 1123, the Anglo-Saxon Chronicle recorded catastrophic fires at three important centres – Peterborough,[12] Gloucester[13] and Lincoln[14] – and two of these fires destroyed not only most of the towns concerned but also parts of the monasteries together with works of art in them. In the eleventh and twelfth centuries, Canterbury cathedral suffered three disastrous fires. In the first:

It happened that the city of Canterbury was set on fire by the carelessness of some, and that the fire was borne by the rising flames into the mother church and settled there . . . the voracious fire destroyed practically all that was most precious, whether in gold and silver or in various art-objects of other kinds or in sacred and secular manuscripts.[15]

Since this fire took place in 1067 we may assume that all these objects

were Anglo-Saxon. In the second fire: 'The house of God . . . was reduced to a despicable heap of ashes, a dreary wilderness exposed to all the affronts of the weather . . . Many art-objects and goods of the church were also reduced to ashes.'[16] Almost the entire monastery at Glastonbury was consumed by fire in 1184, and 'the destruction of treasures made in gold and silver, of hangings, silks, books and other art-objects of the church, would move to tears even those who only heard of it from afar.'[17]

Anglo-Saxon works of art in precious metals might be melted down in such flames but others might find the same end in fires which were less fortuitous. For the greatest and the most persistent hazard to the precious art of the Anglo-Saxons came from a conscious decision to retrieve its gold and silver content. This was frequently seen as an answer to financial needs.

Sometimes such needs might be pious ones. Faced with a famine in the tenth century, St Æthelwold declared 'with a sigh of his inmost heart that he could not endure the continued existence of dumb metal whilst man, who was created in the image of God and redeemed by the precious blood of Christ, died of starvation and want', and he broke up the precious vessels of his church in order to buy food for those in distress.[18] His action (which had its secular precedent)[19] was emulated by Leofric at St Albans a little later.[20] When, in the twelfth century, famine meant that an 'endless throng of the poor of the region flocked to the abbey' of Abingdon, the abbot melted down an Anglo-Saxon reliquary to provide relief[21] and, in the same period, the monks of St Albans,[22] Canterbury,[23] Evesham[24] and Ely[25] all sold off treasures to pay for food for themselves and others.

More often, the needs were less edifying. Church treasures were occasionally sold off before the Conquest simply to meet the Danegeld exacted, and (according to the eleventh-century chronicler Hemming) the monastery of Worcester was forced to break up gold and silver altar-frontals, chalices, Crucifixes and precious bindings for this purpose.[26]

If such objects in gold and silver were at risk from their owners, they were even more so from brigands of every description. Some were themselves Christians, though there is something very extreme in the fact that Æthelred, the king of the Mercians, who had been a benefactor of monasteries and churches and who was himself to become a monk and abbot, allowed his army to loot from churches and monasteries in 676.[27] But others, under less dramatic circumstances, were tempted by the treasures of churches. When, in his Sermon to the English of 1014 written under his pen-name of 'Wolf', Wulfstan, the great archbishop of

York and statesman, castigated his readers for the fact that 'we have
entirely despoiled God's churches within and without, the houses of
God . . . are stripped inside of all that is seemly,'[28] he was referring not to
the pressures to pay Danegeld but to the rapacity of some Anglo-Saxon
magnates. His comments find support in remarks made in the chronicle
of Evesham,[29] and we know that the excesses of the ealdorman, Ælfric,
at Glastonbury were such that he had to be threatened with papal
excommunication.[30]

All this, however, remained somewhat exceptional. In terms of wide-
scale pillage, the real threats came from abroad. Of these, the attacks of
the Vikings were the most wide ranging, the most continuous, the most
ruthless and the most devastating. When they began, Alcuin expressed
his horror at the plundering of St Cuthbert's monastery at Lindisfarne
in 793: 'never has a terror, such as this, appeared in Britain before . . .
The church of St Cuthbert is spattered with the blood of the priests of
God and despoiled of all its ornaments . . .'[31] But this was only the
prelude. In the following year the Danes sacked Bede's church at
Jarrow, and, in 795, they despoiled Columba's monastery on Iona.
Monasteries, which had been sited near the coast in order to be
removed from the distractions of the world, suddenly found themselves
in the front line of destruction. Their art treasures offered a rich and
easy booty for which the pagan Vikings returned again and again. All
this culminated in 865 in the actual invasion of England by the great
Danish army, whose successes were such that the Danes were later able
to destroy three of the four major Anglo-Saxon kingdoms and dominate
the north-east of the country. The stand of Wessex against them under
King Alfred (871–900) is famous in history, but the devastation of
art-objects continued and is referred to by King Alfred himself in a
celebrated and elegiac passage: 'I remembered how, before it was all
ravaged and burnt, I had seen how the churches throughout all
England stood filled with treasures and books . . .'[32] In the subsequent
period the Anglo-Saxons began to claw back the territory they had lost
to the Danes and to weld England into a single nation but, as long as
warfare continued, so did the destruction of art.

In effect, the Vikings extinguished monasticism in England; and
monasteries, along with the cathedrals, had always been the major
centres of religious art-treasures. Even after the revival of monasticism,
which was prompted by King Edmund's narrow escape from death when
hunting on the cliffs of Cheddar about 943, the Viking plundering
continued. In 980 there was a resumption of Danish raids on the earlier
pattern, which continued almost every year for thirty years. Between
1009 and 1012, no fewer than fifteen counties were ravaged and

plundered, and, as late as 1070, according to the Anglo-Saxon Chronicle, the Danes despoiled Peterborough of 'so many treasures in money and vestments and books that no man can reckon it up to another.'[33] A few years later, in 1075, they attacked York Minster and made off with much booty.[34]

These terrors so scarred the nation's memory that, during disastrous periods of anarchy later, like Stephen's reign in the twelfth century, they still served as an ultimate yardstick by which to measure contemporary sufferings. Individual religious houses never forgot their private losses and private tragedies, and the St Albans chronicle, for example, could later recall how,

when the madness of the Danes raged more fiercely in England and everything lay exposed to their looting and burning and there was none to resist them, they had the effrontery to make a savage attack on the church of the Blessed Alban and to despoil the whole treasure of the church of its vessels and vestments.[35]

If vestments are here mentioned, it is because they had gold in them. And, if manuscripts are referred to, it is because they had gold covers which could be melted down. Indeed, once stripped of these covers, the manuscripts were worthless to the pagan marauders and there is one known instance of them selling back to the Anglo-Saxons a looted manuscript, which, we may assume, had been denuded of its precious binding. The manuscript, produced at Canterbury in the mid ninth century and now in the Stockholm Royal Library (MS. A.135), had superb polychrome calligraphy as well as richly coloured decoration and evangelist portraits (Plates 19 and 37). But these were of no interest to the Scandinavian land-pirates. They therefore sold the book to an Anglo-Saxon ealdorman, named Alfred, for 'pure gold', and he restored it to Canterbury. A lengthy ninth-century entry at the top and bottom of folio 11 of the Codex Aureus, or Golden Manuscript, as it is called, gives the details:

In the name of our Lord Jesus Christ, I, Ealdorman Alfred and Wærburch my wife obtained these Books of the Gospels from the heathen army with our pure money, that was, with pure gold, and this we did for the benefit of our souls, and because we did not wish these holy Books to remain longer in heathen possession. And now they wish to give them to Christ Church [Canterbury] to the praise and glory and honour of God, and in gratitude for His Passion, and for the use of the religious community which daily raises praise to God in Christ Church; on condition that they shall be read every month for Alfred and for Wærburch and for Ealhthryth, for the eternal remedy of their souls, as long as God has foreseen that the Christian faith shall continue at that place.[36]

This destruction by the Vikings caused the greatest havoc that Anglo-Saxon art experienced before the Norman Conquest, but – as we shall see in our final chapter – the Normans themselves also caused losses on a scale that was quite catastrophic.

There were also lesser predators. In the west, when King Gruffydd of Wales and his troop forced an entry into Hereford in 1063, 'they returned home, enriched by considerable spoils'.[37] In the north, the Scots, in the course of sacking religious houses, turned their attention to objects in precious metals, as their plundering of Hexham illustrates.[38] In the east, the Anglo-Saxon Chronicle records that in 1102 'there came thieves, some from Auvergne, some from France and some from Flanders, and broke into the monastery of Peterborough and took in it much of value in gold and silver crosses and chalices and candlesticks'.[39] Some of these precious objects (as we learn later) were certainly Anglo-Saxon.[40]

The remark by a fifteenth-century chronicler at Canterbury about the hazards to early Christian vessels in precious materials, given to the Anglo-Saxons, applies equally to the gold and silver art-works of their own craftsmen. Writing then from the cloistered tranquillity of Canterbury, Thomas of Elmham observed that

I cannot note, without a sigh, that I am utterly at a loss as to what I should now write about the gold and silver vessels which, as Bede and other historians relate, were gathered together by the blessed Gregory and transmitted by him through Augustine to this monastery of St Augustine at Canterbury. For some say that, at the time when the unholy Danes ravaged the land, everything was hidden away in secret places which are not yet revealed. Others say that, in the time of Richard I, the gifts mentioned were removed from the monastery for the Duke of Austria [Leopold V] to ransom the king from imprisonment. Yet another opinion is that, when abbot Æthelsige fled to Denmark . . . in the year 1071 for fear of William the Conqueror, and William confiscated the monastery and all that belonged to it and appointed a certain monk called Scotland as abbot, valuables of this kind, with many others, were stored away in secret places which are not known to posterity.[41]

Even so the worst was yet to be. Thomas of Elmham might give a gentle sigh at the thought of the loss of a few treasures brought to England at the time of its conversion in the sixth century, but he was spared the foreknowledge of the devastation of English art treasures by the Reformation of the sixteenth. Virtually all monastic mediæval works of art in precious metals that had survived the fires, famines and financial crises, the invasions, warfare and anarchy, of the Middle Ages were then to be seized and melted down, and these would, of course, have included any Anglo-Saxon works that yet remained. Records were kept of some of

these depredations and we are told, for example, of the stripping of the most important shrine at Canterbury – the one for St Thomas which was, of course, made long after the Anglo-Saxon period – 'the spoils of which shrine in gold and precious stones filled two chests' so great that 'six or seven strong men could do no more than convey one of them out of the church'.[42]

Little was then said of monastic possessions in humble materials, such as manuscripts. Indeed, their very valuelessness ensured their ultimate survival. Some, it is true, were put to the most disreputable uses. 'They reserved of their library books some to serve their jakes [privies], some to scour their candlesticks, and some to rub their boots: some they sold to the grocers and soap-sellers, and some they sent overseas to the bookbinders . . .'[43] But large numbers were simply ignored and left undisturbed to await an age which appreciated them better. Amongst them were Anglo-Saxon manuscripts with pictures which are now highly regarded. Earlier on, as we have seen, the Codex Aureus of Stockholm had owed its survival to its lack of intrinsic value and so, too, had the personal library of St Boniface. After his martyrdom at the hands of the Frisians,

. . . the heathenish mob seized with exultation upon the spoils of their victory . . . they stole the chests in which the books and relics were preserved and, thinking that they had acquired a hoard of gold and silver, carried them off, still locked, to their ships . . . [There they] found to their dismay that they held manuscripts instead of silver plate. Disappointed in their hope of gold and silver, they littered the fields with the books they found, throwing some of them into reedy marshes . . .[44]

But the financial worthlessness of the books proved their ultimate salvation, and 'the manuscripts were discovered a long time afterwards . . . and they were returned by those who found them to the monastery in which they are used with great advantage to the salvation of souls even at the present day'.[45]

The lack of bullion content in manuscript-painting, and also in stone-carving, means that we are reasonably well informed about these crafts of the Anglo-Saxons. However broken the sequence may be, no one would suggest that surviving vellum-paintings, ranging from those of the Lindisfarne Gospels of c. 700 (Plate 7) to those of the Trinity Gospels of the eleventh (Plate B), do anything but justice to their talents as painters. In the same way, their qualities as carvers are well represented by monuments ranging, in stone, from the seventh- or eighth-century cross at Ruthwell (Plates 26, 28a, 28b) to the eleventh-century Harrowing of Hell at Bristol, and, in ivory, from the eighth-century Virgin with apostles at Munich (Plate 16) to the late-tenth-century reliquary cross

in the Victoria and Albert Museum (Plate G) and beyond. Yet their talents in goldsmith's work are little represented. Here we have to make do with a scattering of small objects – finger-rings,[46] disc-brooches,[47] coin-brooches,[48] strap-ends,[49] sword-pommels (Plates 51a, 51b),[50] a bronze-gilt reliquary cover (though of disputed pedigree),[51] one or two very small jewelled crosses, and so on. Admiration is not stinted but it is admiration for little objects, like the St Cuthbert's cross, the Kingston Brooch (Plate 3) and the Minster Lovell and Alfred jewels (Plate 4), all of which are less than eight centimetres in their greatest dimension. Indeed, it is precisely their diminutive size that has led to their survival; the first was too small to be seen even by someone making an official search,[52] and the second and third were probably dropped unnoticed by their owners. They give a totally inadequate picture of the splendours and grandeur of the goldsmiths' work of the Anglo-Saxons after their conversion. This ill-fortune of Anglo-Saxon works in precious metals is all too well known to the specialist, but it needs stressing here since it was exactly this work that the Anglo-Saxons cared about most. The gold-embroidery, which they also greatly admired, has suffered even more, and only five small examples remain from the Christian period (Plate F).[53] Nor are the losses of Anglo-Saxon art confined entirely to workmanship in gold and in gold thread (though, in view of the Anglo-Saxons' own preferences, they are the most significant), for changes of architectural taste and religious belief have led to the destruction of virtually all the Anglo-Saxon wall-paintings.

If the survival pattern of the various crafts of the Anglo-Saxons has distorted our knowledge of their arts, it has also falsified our understanding of their visual tastes. It can, of course, be rightly asserted that the only true guide to the tastes of a period is its actual art, and no one will doubt that a few minutes with the Parthenon frieze will tell us more about the spirit of Greek art than all the pages of Herodotus and Pliny. But, if categories of art have not survived, or survived only inadequately, then the only recourse left to us is literary descriptions and comment. Moreover, even if survivals of art had been more evenly distributed, we would still have to go to the written sources to learn something of the position of the artist in society, of the community's attitude to him and, not least, of the relationship of the secular artist to the monastic one. The latter subject, in a general mediæval sense, once provided an impassioned arena of controversy between historians, like Coulton and Swartwout, and others like Texier, Springer and Gasquet. Since then, the pre-Gothic artist has attracted little study, and a critical appraisal of the Anglo-Saxon artist can only be of value in this wider context.

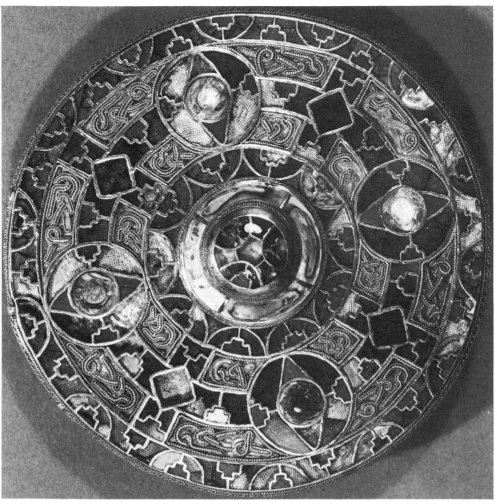

**3** The Kingston brooch, first half of seventh century (Walker Art Gallery, Liverpool, 8.2 cm diameter).

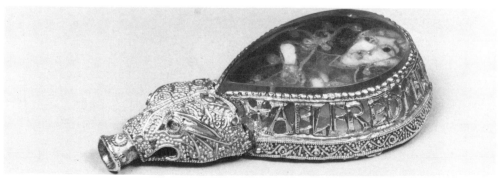

**4** The Alfred jewel, 871–99 (Ashmolean Museum, Oxford, 7.4 cm long).

The intention of this study is not, then, to write a history of Anglo-Saxon art. It is to supplement such a history – to seek an understanding of Anglo-Saxon taste: to search out information about Anglo-Saxon artists: to see if the distortions given to Anglo-Saxon art by a given pattern of survivals can be corrected by an examination of the comments made about Anglo-Saxon art whilst it was still in balance and still a normal part of mediæval society. Such an investigation will necessitate an examination of all written sources and these will include not simply those of the Anglo-Saxons themselves but also later writings derived from Anglo-Saxons. They must further encompass comments made after the Norman Conquest by authors who could still claim an intimate knowledge of their still-surviving art. All this needs, of course, to be done critically for there are many problems involved.

One of these is the fragmentary nature of the written evidence itself. The Anglo-Saxon age, as we have seen, was one of great turbulence. If we put together the years during its six-hundred-year span which were free from internal strife or external attacks, they would not add up to more than a century. And the warfare and sackings which caused the loss of works of art led also to the destruction of many monastic libraries which were the chief repositories of manuscripts and documents. (The library at York which raised nostalgic memories in Alcuin when he was making his contribution to the Carolingian Renaissance on the Continent was considered one of the foremost of the Western world.) The havoc was general but, even so, some parts of England were devastated more than others, and the losses in East Anglia and the east midlands were such that almost nothing is known of the history of these areas.[54]

There were other factors also that led to the disappearance of written sources, and the very way in which the Anglo-Saxons tried to get important legal documents copied into church Gospel-books indicates the insecurity that they themselves felt about the permanence of such records. There must have been many lawsuits which concluded like the one held in Herefordshire in the reign of Cnut: 'Then Thurkil rode to St Æthelberht's minster [i.e. Hereford cathedral] with the consent and cognisance of the whole assembly, and had it recorded in a Gospel-Book.'[55] By and large, the written word owed its preservation to the goodwill of monasteries, and this meant that secular poetry which harked back to traditional and pagan themes had few chances of survival. So had those entirely secular Anglo-Saxon wills which did not record legacies to monasteries or churches. Then, again, the Norman Conquest led to the neglect and loss of some categories of writings for, as Old English was superseded by Latin in its written form, and evolved into Middle English in its spoken form, so it ceased more and more to be

understood, and books and documents in the native tongue of the Anglo-Saxons came to be little regarded unless they were legally important or artistically attractive.

In the initial recording of information, there had been a random element which means that our intelligence about the Anglo-Saxon period would have been unbalanced anyway. So we know more about the kingdom of Northumbria during its period of power than of the kingdoms of Wessex and of Mercia during theirs. This was because Northumbria produced, in Bede, a historian of genius, whose works were so much disseminated, even on the Continent, that there was never a great likelihood of all copies being destroyed, whilst Wessex and Mercia bred no such great historian – or at least no one whose work was so frequently reproduced that it could escape destruction by the sheer number of copies. In the same way, because it was York and not Canterbury that produced, in Alcuin, a scholar keen enough to set down in verse an account of his own church, we know more about early presentations to York cathedral than we do about early gifts to Canterbury.

Our sources are always fitful and there are times when, like guttering candles, they seem to throw more shadows than light. Anglo-Saxon writings survive incompletely, as do the Anglo-Saxon arts themselves. But, what chiefly matters from the point of view of our enquiry is that the two are not incomplete in matching areas. The factors of financial need, or greed, which discriminated against Anglo-Saxon art in precious metals did not affect the written sources. In like manner, some of the factors which led to the suppression or loss of certain categories of written sources did not come to bear on the art. What all this means is that, although surviving information can in no way span the chasm left by the destruction of art, it can at least reduce its breadth.

Once this has been said, it must be added that no surviving writings take anything but a marginal interest in art. There were no historians of art in the Middle Ages, like Pliny the Elder in the classical period, or Vasari and others during the Italian Renaissance. Over the whole of the mediæval epoch, the closest that we get to a study of the arts for their own sake is the twelfth-century work of the German Theophilus,[56] and even his interest was technical – to provide a manual of instruction for the practising craftsman. No written material which relates to the Anglo-Saxon period has a primary or even significant interest in art. Our sources consist of chronicles, saints' lives, poetry, legal documents, theological tracts and collected letters and – as we would expect, and as we should also find in the political histories, saints' lives, verse, legal papers, religious tracts and miscellaneous correspondence of today –

they contain few references to art and these are usually made *en passant*. One chronicler, writing of his monastery, might possibly refer to the treasures it most prized and even let slip the name of an artist. Another, out to extol a king, might include a comment on the works of art he had given in order to enrich the detail. Yet another, this time concerned to catalogue the scandalous conduct of someone highly born or simply to register the miseries of his generation, might perhaps season his account with a description of the splendid works of art that had been plundered or destroyed. The writers of saints' lives might occasionally record that the saint concerned had once owned, or given, or even produced a work of art. A poet might occasionally notice a precious object. A will might specify a hanging or piece of plate that was being bequeathed. A moralist might draw attention to an object of extravagance as an example of the luxury of contemporary society. Writers of letters might indicate the nature of a gift that had been sent or received. These references are always unpredictable. Nevertheless, if all the sources are thoroughly searched, it is possible to find scattered amongst them fragments of evidence – a description here, a comment there, a particular form of emphasis elsewhere – which, when assembled, should tell us something about the arts of the Anglo-Saxons before the disbalance brought about by their destruction.

Tracking them down calls for a lengthy and prolonged search which is, in a sense, a form of literary excavation. Instead of trying to uncover works of art in the ground, we can endeavour to discover descriptions of them in the sources. As far as Latin chronicles and saints' lives after 900 are concerned, this search has already been assiduously pioneered by Dr Lehmann-Brockhaus[57] and his three-volume compendium of quotations is exceptionally thorough, though this very comprehensiveness means that the extracts are of varying authority and, if many come from reliable chronicles, others are from late, uncertain, and even highly suspect, sources. Every dubious source will, of course, be excluded here, but in all citations from authentic Latin chronicles after 900 it will be convenient to include cross-references to Dr Lehmann-Brockhaus's now standard work except on those exceptional occasions when such is not possible. This is when a different edition of the text is used – for example, Stubbs's edition of the *De inventione Sanctae Crucis* is here considered more reliable than that of Giles, and Professor Blake's admirable edition of the *Liber Eliensis* has superseded that of Stewart – or when source material – like the *Vita Ædwardi* and *Vita Sancti Wlsini* – has been edited since Dr Lehmann-Brockhaus's own publication, or on the rare occasions when Dr Lehmann-Brockhaus has overlooked a passage – as in Wulfstan's *Narratio de Sancto Swithuno*. When the Latin sources have

been scrutinized, a thorough search has still to be made of all the other sources which include poetry, moral treatises, charters, legal documents, and Old English writings after 900, and writings of every complexion before that date.

In the course of this search, one must expect to be confronted with all the frustrations and difficulties of the more orthodox archaeologist. Instead of digging for weeks in the earth and coming up only rarely with a small find, one must be prepared to search equally long in the records and only exceptionally retrieve a relevant reference. Like the worker in the laboratory, one must learn to reconstruct from incomplete discoveries for by their nature these literary forms of evidence are fragmentary and, though they will of course be presented as such, a sympathetic reader might yet call to mind a line from the Chorus of one of Shakespeare's histories:[58] 'Piece out our imperfections with your thoughts.'

An important part of the source material consists of histories and chronicles and these include two of Anglo-Saxon authorship which are amongst the most famous in the historiography of the country – Bede's *Ecclesiastical History of the English People* and the *Anglo-Saxon Chronicle*. The vast majority, however, are of post-Conquest date and they will need to be treated with caution. References retrieved from them will have to be carefully screened for authenticity. Some from spurious sources, like the *Historia Croylandensis* by the pseudo-Ingulf, will be proscribed (even though the artistic references may not all be fabricated). Others from late sources, which only elaborate on original and more authentic testimony, will usually be ignored.

In a proper attempt to be critical, the investigator should not, however, be uncritically dismissive. Anglo-Saxon works of art survived the Conquest, and there is no reason to doubt descriptions of them – say in the twelfth century – simply because the writer was not an Anglo-Saxon. Even when references to art occur in accounts that are otherwise tendentious, it should not simply be assumed that 'political' partisanship distorted comments about art. Writers at Waltham were particularly prejudiced against the Normans who plundered their collegiate house and it might therefore be thought that their accounts of the treasures that the Normans removed might be unbalanced. But – as one of their own number pointed out – some of the objects still existed at the time when they were described.[59] In other words, the information could be assessed for what it was worth by the writer's own contemporaries. Even when the relevant Anglo-Saxon works of art no longer survived, post-Conquest statements about them might still have their own validity. We know that some Anglo-Norman writers made use of Anglo-Saxon

sources. William of Malmesbury, for example, drew on earlier and authentic material: his comments on King Athelstan were taken from a tenth-century poem,[60] and his biography of Wulfstan closely followed the Old English life of that saint by Coleman[61] who was the saint's chaplain for fifteen years. The Abingdon[62] and Waltham[63] chroniclers refer explicitly to Anglo-Saxon documents as authority for their own information, and it has been shown that the Evesham[64] and Ely[65] chroniclers were drawing too on earlier sources, the former incorporating a contemporary life of Abbot Æthelwig. (Forgers of privileges and charters, of course, also claimed to be citing from ancient archives, but this was in pursuit of material advantage whereas in the inventorying of works of art there was none to be gained.) Let it be added that it is generally accepted that the important post-Conquest accounts of Anglo-Saxon saints by the Fleming Goscelin were based on Anglo-Saxon sources which, though refurbished in style, were maintained in content.[66]

Even where written evidence was not available, reliable eyewitness accounts could be transmitted, as the story of Eadmer at Bari, which will be recounted later,[67] shows. A historian of the stature of Bede depended not only on written sources but on 'the testimony of faithful men',[68] and some later writers modelled themselves on him in this respect,[69] as he himself had followed earlier writers.[70] Though this form of evidence had dangers where the enhancement of material or spiritual power was concerned, it could be serviceable in more innocuous areas, and it has been remarked[71] that it only needed two well-placed, observant and honourable men to reach old age in two succeeding generations for accurate verbal information to span more than a century. So, Dunstan, who, when a boy, had heard of the death of King Edmund in 870 from the murdered king's now elderly sword-bearer, recounted it in his own old age between 985 and 987, and it was set down as an account 'faithfully following a faithful informant'. Again, Henry of Huntingdon, who died in 1155, transmitted an eye-witness account of the Massacre of St Brice's day in 1002, which he, as a boy, had heard from some very old persons.[72] How reliable on occasions such verbal traditions could be is indicated by the fact that the oath made by the monks at Peterborough in the twelfth century, declaring their house to have been given the exceptional privilege of a mint in the tenth century, has been vindicated by numismatic discoveries in the twentieth.[73]

Every remark about Anglo-Saxon art after the Anglo-Saxon period must be assessed on its own merits but there can be no doubt that some post-Conquest statements preserve authentic material. Not, of course, that this is the end of the matter. The fact that a statement is authentic

does not also mean that it is accurate. Indeed, few comments on Anglo-Saxon art are impersonal. They reflect the prejudices of the author, and these we must try to understand if we are to arrive at any objectivity ourselves. Moreover, such an understanding will serve a more positive purpose by giving us new insights into the attitudes of the Anglo-Saxons to the visual arts.

The three most powerful of the Anglo-Saxon prejudices were present in all mediæval countries though sometimes they reached a particular form of intensity in England. The first was the partiality for the costly and the precious. It was objects in gold or silver that brightened the eyes of the writers and moistened their pens whilst works of art in humbler materials (such as stone and wood) left them unmoved unless they had special associations to call them to attention. Carvings and paintings would not have been produced in such numbers if they had not been considered desirable, but it remains a fact that they were mostly ignored by the chroniclers and poets. Whether this was because the writers were uninterested in stone-work and pictures, or because they thought these forms of art inappropriate to their literary contexts, or because they simply took them for granted, we do not know. What is certain is that the writers focused their attention primarily on the more sumptuous arts. This fact will become readily apparent in later chapters so that it need not detain us in this, except to observe that this special interest in precious metals on the part of our sources offers a very real compensation for the exactly opposite emphasis on humble materials in the art that has survived. It is only unfortunate that the writers' enthusiasm for precious works of art in gold and silver found expression in transports of generalised pleasure rather than in detailed descriptions which would have been more helpful to us.

Another Anglo-Saxon prejudice was a partisanship for relics. This form of piety was, of course, prevalent throughout the Middle Ages and is still a devout feature of the Roman Catholic religion. However, even within the mediæval period itself, the special interest of the Anglo-Saxons was acknowledged, and Eadmer, who was born in England a few years before Hastings, was later to say of the Anglo-Saxon period that, 'in those days, the English were accustomed to consider the relics of saints more important than anything else in the world'.[74] They were indeed the church's or monastery's supreme possessions. Aware of the threats from Danish incursions, Dunstan at Malmesbury removed the relics of St Aldhelm from their costly shrine since it was these (not the shrine) that he was anxious to save,[75] and one Anglo-Saxon abbot later refused an emperor's offer of 'estates, vineyards, gold and silver' for the tiniest relic from the body of St Augustine.[76]

Relics were not only the remains of saints but also objects closely connected with them. They could, therefore, include artistic works, and we owe many descriptions of art-objects to the fact that they were associated with saints. Such associations could, however, lead to confusions. The writer's interest in such works of art was as relics, but he found it necessary to eulogise their attractiveness simply because he felt that everything to do with saints had to be acclaimed. In these venerable contexts, there tends, then, to be a blurring of distinctions – an assumption that spiritual grace in the saint postulates physical attractiveness in objects associated with him. In consequence, there is a suspension of the critical aesthetic faculties which means that the information given by writers like Eddius and Goscelin is marred by over-effusiveness. It is no accident that they were both writers of lives of saints, for this was a form of literature which lent itself especially to such fulsomeness: indeed, with more than usual frankness, a very early Anglo-Saxon writer of a saint's life had asked his readers; 'not to feel distaste if we praise the great man somewhat exuberantly'.[77] Where descriptions of art are concerned, it is chastening to read the extravagant praise that the twelfth-century writer, Reginald of Durham, lavished on the wooden coffin in which St Cuthbert was buried,[78] and compare it with the unsophisticated style of the surviving original. Nevertheless, a knowledge of this particular prejudice should enable us to go some way towards correcting it. Its bias lies in the emotive terminology which we can ignore. When, for example, we have repudiated the ecstatic description of Reginald of Durham, we are still left with the unassailable and important fact that the coffin in which St Cuthbert was buried was decorated with carvings, and it is on factual information like this that we must build.

The third Anglo-Saxon prejudice was the most pervasive and needs to be examined at length. It derived from the fact that the authors of chronicles and lives of saints were mostly monks. In historic fact, Anglo-Saxon monks rubbed shoulders with lay people to a greater degree than is sometimes supposed. Some monasteries with important relics – like Bury St Edmunds, Evesham and Malmesbury – attracted hosts of secular pilgrims from France and Ireland as well as from different parts of England. Many monasteries offered the services of a guest house, and the lay guests normally ate with the monks. A number ruled over vast estates which necessarily led to close associations with lay tenants and workmen. The rulers of monasteries were normally drawn from the country's ruling class, and continued to see themselves as part of the leadership of the country – participating in its supreme Council, the Witan, advising and accompanying the king, advancing

his interests in embassies abroad, and even joining him in battle.[79] Ealdred, who was, first, a monk at Winchester, next, abbot of Tavistock, then bishop of Worcester and, finally, archbishop of York, fought against the Welsh in 1049, journeyed to Rome 'on the king's business', led a legation to Germany in 1054, visited the Holy Land, and was again in Rome in 1061 with Earls Tostig and Gyrth and the countess of Northumbria.[80] Few, of course, had Ealdred's opportunities, but few had quite his share of royal confidence, and he at least represents the attitudes of mind to the public service of those in command of abbeys. These were the men who were the major patrons of monastic art and, in some instances, they were patrons of cathedral art too, for a peculiarity of England, in European terms, was that the abbots of some of its cathedral monasteries (Canterbury, Winchester, Worcester, Sherborne, and Lindisfarne before its destruction by the Vikings) were also the bishops of the local dioceses.

However this may have been in the life of the monastery, its writers still tended to evaluate the world from the point of view of the cloister. The actions of kings and princes may, it is true, have come within their historical compass, but their writings usually show an indifference to the values of the lay society outside. Their avowed vocation to reject the secular world seems to have coloured what the Benedictine chroniclers wrote, and certainly led to a continuing inference that secular art was negligible and somehow different from the art of the church. The viewpoint is particularly persuasive since it is never stated but continually implied. Indeed, it is the almost unconscious nature of this assumption that makes it so convincing. None the less, it is quite misleading. In Anglo-Saxon society there was for example, a continuing interchange of artistic work between lay and monastic society – an interchange given special piquancy when we read of one queen making artistic gifts to the house at Ely[81] and another taking works of art from the house at Abingdon.[82]

That monastic works of craft passed into secular hands is quite certain. Some were sold, for sales of objects made in monastic workshops were explicitly permitted by the Rule of St Benedict which advised monks always to sell their objects at a price lower than that charged by secular persons so that the sin of avarice[83] might be avoided. The Rule was of course known to the monks not only in its Latin original but in the translation into Old English made by St Æthelwold. Early in the eleventh century, in the context of monks earning a livelihood, Archbishop Wulfstan mentions the practice of crafts in Anglo-Saxon monasteries.[84] Later, in the twelfth century, Theophilus makes it clear that the sale of books, and even of incorrigibly secular objects, like horns

for huntsmen, ornamented saddles, gold and silver horse-trappings, rings and bracelets, was readily accepted in a German monastery.[85] There must have been some such selling of small objects in the Anglo-Saxon period. It is specifically referred to in the will of the Ætheling Athelstan of about 1015, which speaks of a drinking horn that he had bought from the Old Minster, Winchester.[86] It is also indicated by bronze strap-ends of the late Saxon period discovered in excavations at Winchester.[87] For, though they were obviously meant for secular use, their stylistic relationship to the illumination of local monastic manuscripts suggests that they were made in a Benedictine workshop. The small commercial transactions of monasteries would of course pass unnoticed, and this for obvious reasons. They would never attract the interest of the monastic chronicler nor feature in the types of secular document that have come down to us. The most important of these are the wills, and (despite Athelstan's obliging reference) the normal preoccupation of a man drawing up his last testament is with the destination, not the origins, of his possessions.

Other monastic works of art were transferred to secular hands by gift, but this was unlikely to be mentioned except in the special context of saints' lives, or miracles. The story of two beautifully illuminated Peterborough manuscripts[88] falls into both categories. They were presented by their monastic artist to King Cnut and his wife, Queen Emma, who sent these manuscripts to Cologne. In Germany, they were later given to the Confessor's ambassador, Ealdred, bishop of Worcester, who brought them back to England and gave them to St Wulfstan at Worcester. The saint had known and admired the manuscripts when he was a boy at Peterborough, and had been distressed when they had been sent away to Court, but, since it was then prophesised in a vision that they would be restored to him, he now saw their return as a miracle, and as such it was recorded. We know something of another Anglo-Saxon manuscript which found its way not to Germany but to Normandy, and of the hands through which it passed.[89] It was a large illustrated Anglo-Saxon psalter (presumably made in a monastery) which was acquired by Emma when she was wife of King Æthelred II, and given by the same Emma to her brother Robert, archbishop of Rouen. The latter's son removed it from his father's room and presented it to his wife, Hadwisa, who gave it, through her son, to the house of Saint Évroul. The story was recorded only because the monastic work of art concerned unexpectedly returned into monastic possession.

The artistic traffic the other way – from secular into Benedictine ownership – was vastly more important. In the course of their histories, most monasteries received works of art from lay benefactors. Some of

these gifts had originally served the needs of private chapels in secular houses, as we know from the fact that they were accompanied by shrines, or priest's vestments, or vessels for the Mass. Such were the silver Crucifixes, the gold and silver shrine and the Gospel-books, embellished with silver and precious stones, which came to Rochester from the manor house of the Countess Goda at Lambeth,[90] and the reliquary, the chalice and the priest's vestments which were given to Ramsey by the noblewoman Thurgunda.[91] Others had probably been objects of personal devotion – like the attractive Crucifix which Leofgifu presented to Ramsey,[92] or the gold Crucifix in the possession of the Ætheling Athelstan,[93] or the 'little gold Crucifix' left by Wulfgyth to Canterbury in 1046.[94] Yet others were specially commissioned for monasteries and churches by lay patrons who made use of lay artists. In some instances, this can be demonstrated[95] and, in others, it can be reasonably assumed. When, for example, a monastery like that of Coventry, or a college of canons like that at Waltham, was founded and equipped with artistic treasures by lay people of wealth, then there is a presumption that much of the original art had been made by lay workmen. Suffice it to say that many of the finest art treasures of the monastic churches reflected not only the generosity but also the craftsmanship of the secular world.

In this context of religious and secular art, it is significant to see what little distinction the Anglo-Saxons themselves made between the two in their legacies. To Winchester King Eadred left not only gold Crucifixes but also gold-hilted swords.[96] Alongside the gold Crucifixes and a set of Mass-vestments that Wulfwaru bequeathed to Bath Abbey, was an arm-ring worth (or made of) sixty mancuses of gold and a bowl of two and a half pounds.[97] To Ramsey Abbey one rich lady, called Scheld-wara, gave a gold chalice and a gold brooch,[98] and another, named Alfwaru, presented a chasuble and alb, together with a saddle with all its equipment for riding, a cushioned seat of rich materials, two silver bowls and two hangings.[99] Such secular objects, presented to religious houses, were of course intended for ecclesiastical use. Necklaces and bracelets were specifically given to embellish Crucifixes[100] and holy effigies,[101] and, at St Albans, Leofric especially reserved secular cameos and gems for a shrine.[102]

It is clear from all this that, however obscured it may be by the chronicled accounts, there was an easy mingling of the arts of the secular and monastic worlds in Anglo-Saxon society. In each area, they tended to serve different purposes, but – as will be seen in the next chapter – they expressed the same visual tastes.

# CHAPTER II

# ANGLO-SAXON TASTE

The greatest of the Anglo-Saxon missionaries was St Boniface, to be known later as the Apostle of Germany. In 738 he wrote an open letter asking all Anglo-Saxons to pray that God 'may convert the hearts of the pagan Saxons to the faith . . . Have pity on them because their repeated cry is: "We are of one and the same blood and bone".'[1] The blood relationship between the Saxons in England and the Saxons on the Continent was never forgotten. There was a relationship of taste, too, and this emerges in another of Boniface's letters. In this he asked Abbess Eadburg to send him a copy of the Epistles of St Peter, inscribed in letters of gold, so that 'a reverence and love of the Holy Scriptures may be impressed on the heathens to whom I preach'.[2] It seems that the gold calligraphy which so much appealed to the Christian Saxons also attracted the pagan Saxons – a fact which is not surprising since, just as the Germanic tribes who had poured over Europe after the breakdown of the Roman empire had shared similar tastes, so did their descendants when they had settled in various parts of the West and were developing in their different directions. The tastes of the Anglo-Saxons were never markedly different from tastes on the European mainland. Amongst all the descendants of the northern tribes that the Romans had called barbarian, there was great admiration for artistic workmanship in gold.

Lucian had expressed the view that this interest in gold was a basic element of barbarian taste.[3] The barbarians, he thought, were concerned to amaze by costliness rather than to attract by comeliness: to astonish rather than to charm. Certainly, in the Anglo-Saxon culture, as in others, the costliness of gold was part of its attraction. The minstrel who in *Widsith*, one of the oldest of all Anglo-Saxon poems, received an arm-ring from one patron and a splendid jewel from another was interested in their value as well as their radiance, and he was quite forthright in his statement that the ring, given him by Eormanric, contained six hundred shillings' worth of pure gold.[4] This poem refers back to the pagan and Continental period but, in Christian times, jewellery and gold gifts were as unhesitatingly evaluated. We therefore

learn that, in the eleventh century, a reliquary, given to the abbey of
Ramsey by Thurgunda, had twelve marks of gold in it,[5] that a necklace,
donated to the foundation at Coventry by Godiva, was valued at one
hundred silver marks,[6] and that an altar, left to the house of
Glastonbury by Brihtwold, was worth twenty (gold) marks.[7] Important
gifts might even have inscriptions to proclaim and quantify the liberality
of the donor – like a reliquary at Abingdon which carried the message:
'King Cnut and Queen Ælfgifu commanded the fashioning of this
reliquary from two hundred and thirty gold coins, refined by fire, and
two pounds of silver . . .'[8] Such costings informed viewers of the
open-handedness of the givers (generosity always remained one of the
most admired of the Germanic virtues). But they also remind us today
of the fact that in any unsettled society art treasures never lose their
connotation of accessible wealth. This clearly emerges in the seventh
century, in Bede's statement that the king of Northumbria, Oswiu, gave
King Penda 'an incalculable and incredible store of royal treasures and
gifts as the price of peace'[9] – and it is just as evident in the tenth, when
the will of Wynflæd unceremoniously declares that Eadwold can either
enlarge his arm-ring with the gold from a gold-adorned wooden cup she
is leaving or receive sixteen mancuses of red gold instead.[10] Chroniclers
disarmingly indicated that the value of objects added to their allure,
and Goscelin, for example, said that the gold embroidery at Wilton
delighted by its richness.[11] Preciousness for the Anglo-Saxons was
associated with attractiveness. In their world, what was costly was the
more easily admired.

Yet, though the Anglo-Saxons and other Germanic peoples were
fascinated by work in gold, classical poets, including those as great as
Homer and Virgil, had been no less attracted. In the *Aeneid*, ceilings are
gold-panelled;[12] tables are laid out with gold and silver plate;[13] the
helmets and armour are of gold;[14] the weapons are set with precious
metals;[15] the soldiers glitter with gold,[16] or gleam with jewels,[17] or shine
with the splendour of their gold and purple.[18] The taste of Aeneas for
garments stiff with gold-embroidered purple[19] would have elicited an
understanding response amongst the Anglo-Saxons,[20] who would have
found in Ovid's account of cloaks of purple bordered with gold[21] an
exact description of their own.[22] It was not the predilection of the
Anglo-Saxons for precious metals that separated them from the classi-
cal poets. What divided them was the fact that – for reasons partly of
culture and partly of climate – the classical writers had been much more
conscious of the beneficence of nature than were the Anglo-Saxons.
This means that, whereas the appreciation of gold and sumptuous
colours in classical times was presented in the context of the wide-

ranging palette of nature herself, and viewed, as it were, in the fresh air, the same relish in the Anglo-Saxons lacks this open setting, and seems therefore that much more enclosed and that much more intense.

The Latin writings of earlier Anglo-Saxon scholars like Alcuin, who had studied the classics, certainly make salutations to Nature, and greet the spring, or regret the absence of the nightingale after the Roman fashion. There is evidence also of more spontaneous and less academic responses, such as Bede's pleasure in a star-lit sky and the beautifully observed portrayal of the swan in the Exeter riddle-poems. Saints, like St Cuthbert, are represented as having a rapport with the birds of God's creation, and, in the person of the East Anglian hermit, St Guthlac (674–715), this reaches a point of empathy which seems almost to anticipate St Francis himself:[23] '. . . even the birds of the untamed wilderness and the wandering fishes of the muddy marshes would come flying or swimming swiftly to his call as if to a shepherd; and they were even accustomed to take from his hand such food as the nature of each demanded'. It is true that such episodes in saints' lives were recounted to make a theological point – namely that God's creatures will accept the dominion of a man who recognises the dominion of God – but this does not detract from the feelings described.

All this, nevertheless, is somewhat exceptional and it does not extend to landscape. Here there is nothing in Anglo-Saxon literature that can match the pleasure expressed by classical poets like Virgil and Ovid. The real gift of the Anglo-Saxon writer was, rather, to express its menace and foreboding. Even the author who, in the last quotation, could write sympathetically of God's creatures can find nothing pleasant to say of God's countryside. He fastens, instead, on its dreary aspect and describes the countryside which stretched from near Cambridge to the North Sea as: 'a more dismal fen . . . now consisting of marshes, now of bogs, sometimes of black waters overhung by fog, sometimes studded with wooded islands and transversed by the windings of tortuous streams'.[24] In the earlier period, the poet of *Beowulf* depicts the countryside with its treacherous fen-paths, its wolf-fells, and its wind-swept moors in terms of haunting bleakness. Later on, the poet of *The Seafarer* describes the utter friendlessness of the ocean. And, whether or not this was seen as a theological image of exile,[25] it still comes from the heart, and its account of the stark, implacable moods of the Northern seas will induce a tremor of instant recognition in those who have had long experience of the North Sea and Atlantic Ocean in winter.

The Romans of antiquity had expressed their delights in the countryside not only in their poetry but in their landscape paintings. These were described by Pliny and can still be savoured in the murals of

Livia's villa, and glimpsed in surviving late mosaics of North Africa and Sicily, like those of Cherchell and Piazza Armerina. All this, however, was lost on the Anglo-Saxon artists who, instead, translated the pulsating beauty of flowers and of trees into their own different aesthetic of lively abstract ornament. Feeling none of the Mediterranean assurance in the benignity of Nature, they interpreted it in terms in which they could feel more secure. Especially they related it to gold and jewelled adornments. There is an illustration in one Anglo-Saxon manuscript of the temptation of Christ as described by St Matthew (IV. 8–10), in which He is taken up to a high mountain and shown all the kingdoms and glories of the world. These glories are not represented in terms of the pleasures of nature – by broad acres and entrancing landscapes, or even by lively coursers or seductive women – but simply by gold objects; by gold torques, gold vessels, a gold arm-ring, a gold and bejewelled sword and a gold head-dress (Plate 5). For this artist, the splendours of the world – or at least of those that offered temptation – were comprised in the arts of the goldsmith.

A similar relationship can be seen in literature. In one riddle poem, Nature declares: 'I am more beautiful than ornaments of gold,'[26] and, in poetry, it is to just the artificial workmanship of the goldsmith and jeweller that Nature herself is assimilated. The heavens, therefore, are resplendent 'with starry gems';[27] the sun, 'bright as gold' in one poem,[28] is frequently described as a 'gladsome jewel' in others;[29] the eyes are 'the jewels of the head';[30] the hair of a monarch is not simply 'flaxen' but 'beautifully mingled with gold threads';[31] the forest tree of the Cross becomes an object of shining adornment, decked out with gold and jewels;[32] even a bird of the heavens is seen in goldsmith's terms of the sheen of gems and the radiance of colour: 'the beak glistens like glass or a gem . . . its eye's faculty is strong, and in aspect it is like a precious stone, a sparkling gem, when it has been set in a gold vessel by a smith's skill'.[33] It is true that the bird is not an ordinary one but the legendary phoenix, which is also not to be taken too literally since it is an allegory of Christ. Despite all this, for the poet it clearly epitomises Anglo-Saxon ideas of beauty: it is admired by all mankind for its beauty and form,[34] and – in a significant juxtaposition of adjectives – it is 'beautiful and winsome and gloriously adorned'.[35]

The Anglo-Saxon poets and writers were so hypnotised by the crafts of the jewellers and goldsmiths that they turned naturally to them for their similes and metaphors. A frosty surface could, therefore, be 'as clear as glass and very like gems';[36] one great Anglo-Saxon king could be likened to 'a splendid gem' which 'illuminated our darkness';[37] and the glory of another compared to streams of gold;[38] the righteous were

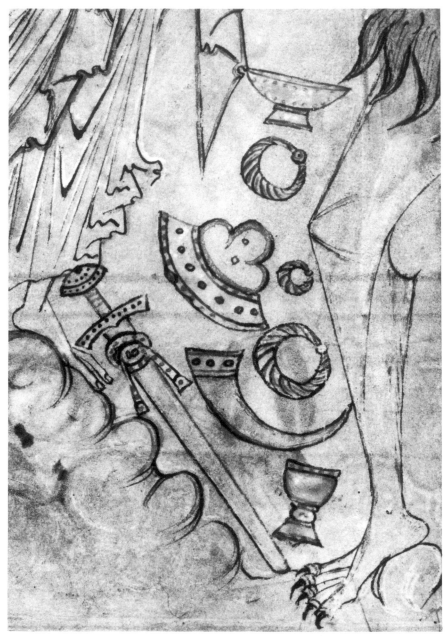

**5** Details of the temptations offered Christ by the Devil, from a coloured drawing in a mid-eleventh century manuscript (British Library, Cotton MS. Tiberius C VI, fol. 10v).

those 'separated from their sins, like beaten gold';[39] Christ's blood was compared to 'the red gem';[40] and even the Word of God was said to be of jewelled gold.[41]

Among the poetry of the Anglo-Saxon period that has survived is an elegy on a deserted town, often identified with Bath – a town which we ourselves tend to associate with the Romans. Naturally enough, the poet's associations could not then be with the dignity and decorum of the classical inheritance. Rather, he visualises the town in terms he knows best, as having once been a flourishing Anglo-Saxon community. And it is interesting to see how, as in his mind's eye he recreates its former halcyon days, it is with visual impressions of the radiance of precious stones and metals that he associates its period of prosperity: '... where once a man glad of heart and bright with gold, splendidly arrayed, proud and flushed with wine, shone in his armour, looked upon treasure, upon silver, upon intricate gems, upon wealth, upon possessions, upon the precious stone, and upon this bright city with its wide dominion'.[42] The literature of the Anglo-Saxons is shot through with similar feelings for the lustrous and the precious.

We should not too easily assume that the visual tastes of the poet were also those of the lay observer – the aesthetic feelings expressed by Virgil were very different from those of Pliny. However, in the Anglo-Saxon period, the tastes of the poet were exactly those of society at large. If the secular elegist of the deserted city speaks of its gold and jewelled radiance, and the writers of religious poetry envisage heavenly cities as being rich with gold and treasure,[43] the chronicled accounts of actual courts and actual monasteries are just as refulgent. When St Margaret, the daughter of an Anglo-Saxon prince and the grand-daughter of an Anglo-Saxon king, became queen of Scotland, her biographer, who knew her well, praised the fact that she 'increased the appointments of the King's court' so that 'the whole building was resplendent with gold and silver. The vessels in which the food and drink were served to the king and the foremost men of the realm were of gold and silver ...'[44] (It is true that she had spent her early life in Hungary but she had been in England from about the age of twelve and the point of the quotation is that it was written by an Anglo-Saxon.) Again in the narration of Cnut's generosity to Winchester, the English source says 'that the amount of precious metal fills visitors with awe, and the splendour of the gems dazzles the eyes of the beholders'.[45]

These are general parallels. But we shall find just as close a relationship in particulars and there are marked congruities between the heroic poetry of the earlier period and the actualities of Anglo-Saxon society. If, for example, the legendary Beowulf had a banner worked in

gold,[46] the historic King Oswald in the seventh century had a gold-enriched banner,[47] and King Harold, in the eleventh, had one on which the figure of a warrior was 'interwoven lavishly and skilfully with gold and jewels'.[48] If, in *Beowulf*, there are references to a gold-plated hall,[49] we are told that, in the eleventh century, the domed architectural canopy that surrounded the high altar at Waltham was gold-plated and had columns, bases and arches also embellished with gold,[50] and a tenth-century portrayal of another canopy in a cathedral (Plate D) shows parts of the capitals and bases in gold. If, in that epic poem, the eaves of the same hall were said to be adorned with gold,[51] we know that, if life had been his companion, as a contemporary delicately put it, King Eadred in the tenth century would have adorned the east porch of the church at Winchester with gilded tiles.[52] If the same poem mentions a golden figured tapestry,[53] we know that even sails in the eleventh century could be embroidered with historic scenes in gold.[54] If, in *Beowulf*, the *Finnsburgh Fragment* and *The Battle of Maldon*, we read of armour and of weapons decked with gold, there are references in the historic sources, which are not only similar but much more frequent. For example, a ship given by Godwine to King Harthacnut had eighty picked soldiers on board each of whom had a partly gilded helmet, a sword with a gilded hilt, a battle-axe rimmed with gold and silver, and a shield with gilded boss and studs.[55] In descriptions of the radiant trappings of society there was no difference between Anglo-Saxon poetry and those pedestrian sources for Anglo-Saxon history – the annals, the legal wills and the chronicles. What we discover, in fact, is that the poets were not dreaming up gilded visions but delineating the tastes of the world around. It was a world which both in the religious and secular spheres savoured resplendence.

Moralists greatly disapproved of this Germanic taste in the secular world although the same taste inspired their own ideas of the life to come. Here, justification was found in the New Testament, which spoke of a new Jerusalem that would be of pure gold, having walls of jasper, gates of pearl, and foundations of all manner of precious stone.[56] Anglo-Saxon Christian poetry took up this theme of the shining, bejewelled city where the blessed wore crowns, wonderfully fashioned with precious stones.[57] Most writers of the Anglo-Saxon period were monks and the acceptability of these tastes for them depended on whether they related to the secular world below or to the celestial world above. This is indicated by the lives of two saints. The first, St Etheldreda, was an Anglo-Saxon abbess of the seventh century, who considered that the jewellery she had worn in secular society as King Egfrid's queen had led God to afflict her with a punishment which she now gladly embraced.

It is said that, when she was afflicted with the said tumour and with pain in her jaw and neck, she was very pleased with this kind of malady and used to say: 'I know for certain that I deserve to bear this wearisome weight on my neck for I remember wearing the idle weight of jewels when I was young. And I believe that God in His goodness wishes me to endure this pain in the neck so that I may be absolved from the guilt of that idle levity as long as a red and inflamed tumour stands out on my neck instead of gold and pearls.'[58]

The account is from Bede. It was later put into Old English rhythmical prose by Ælfric who, in his life of another saint, St Agnes, quotes the reasons she gave for spurning a husband and his proffered jewels on earth – she expected better things in heaven. God, she said,

has offered me better adornments, and has granted me for a pledge the ring of His faith, and has adorned me with unimaginable honour. He has encircled my right hand and also my neck with precious stones and with shining gems. . . . He has decked me with a robe of woven gold, and has adorned me with exceedingly rich jewels: He has also shown me His incomparable treasures which He has promised me if I follow Him.[59]

St Agnes was not an Anglo-Saxon but a Roman. Nevertheless, the Anglo-Saxons would have shared her sentiments, for their own religious dreams and visions were inspired by the same kind of resplendence. In less tangible form, it surrounded the figure of St Bartholomew which St Guthlac saw in his fenland dwelling: 'in boundless splendour of heavenly light . . . with outpoured radiance and . . . girt with golden brilliance from the heavenly dwellings of glorious Olympus'.[60] Æthelwulf speaks of an Anglo-Saxon woman in heaven with her 'whole body covered with gold-embroidered robes'.[61] He also describes an ideal church in which an altar flamed with gold, vessels gleamed with gold or glistened with precious stones, and a cross was lustrous with ruddy gold and dark-hued gems.[62] It might, of course, be argued that all this was metaphorical but, in terms of their gold and jewels, some of the actual churches of Anglo-Saxon England were very similar to this visionary one.[63] And this with all propriety, for here the precious objects were dedicated to God and not to man.

Anglo-Saxon visions were partly inspired by the New Testament, but the splendours within their own churches were justified more by the Old. Indeed, for Bede, the most influential of the Anglo-Saxon theologians, the Old Testament vindicated all church art.[64]

Anglo-Saxon ecclesiastics (like their Frankish counterparts)[65] were imbued with Old Testament concepts. This is everywhere apparent. The episcopal epitaph to St Cuthbert which Bede put into verse concludes with a richness of Old Testament citations.[66] Eddius's account of

St Wilfrid is dotted with Old Testament allusions[67] and his description of the saint's first encounter with the pagan South Saxons in 666[68] is especially saturated with Old Testament references. The heathen priest is compared first to Balaam, and then to Goliath, for, like him, he is struck down by a stone from the sling of another David. The pagan host is defeated by a much smaller force as were the Midianites by Gideon, and the Amalekites by Joshua. Their number of 120 even happens to be 'equal to the years of age of Moses'. During the battle, St Wilfred and his priests lift up their hands in supplication to the Lord of Hosts, as did Moses, Hur and Aaron in Biblical times. Again, the religious service of consecration of King Edgar in 973 (influenced though the Coronation Order may have been by Frankish and German examplars) is shot through with Old Testament reminiscences:

. . . multiply thy blessings upon thy servant N., whom in lowly devotion we do elect to the kingdom of the Angles or of the Saxons, and ever cover him with thy powerful hand, that he, being strengthened with the faith of Abraham, endued with the mildness of Moses, armed with the fortitude of Joshua, exalted with the humility of David, beautified with the wisdom of Solomon . . . may nourish and teach, defend and instruct the church of the whole realm . . .[69]

In art (Plates 12, 13, 33, 35, 36)[70] as in literature,[71] churchmen were clearly prepared to see the Israelites as themselves. In the matter of vestments, their preoccupation with the Old Testament was reflected in the fact that they sometimes hung the lower hem of the priest's cope with small bells[72] in imitation of Israelite practice;[73] and, in questions of music, they went so far as to revive the old Israelite instrument of devotion – the timbrel.[74] Moreover, if – as some scholars believe – the *æstel* that King Alfred sent to all the bishoprics of his kingdom to accompany copies of his translation of St Gregory's *Pastoral Care* was a costly pointer, then we have here yet another instance of Israelite inspiration, for silver pointers were traditionally used by the Jews in the reading of the *Torah*, and are still used in synagogues to this day.[75] (The Minster Lovell jewel and the famous Alfred jewel (Plate 4) were probably originally the precious handles of such pointers.[76]) These forms of Old Testament identification legitimised and encouraged the natural instincts of the Anglo-Saxons for resplendence. At Abingdon, the chronicler explained that it was because St Æthelwold was 'mindful of the saying of the Old Testament prophet: "O Lord, I have loved the beauty of Thy House" ' that he 'enriched his house . . . with the most precious adornments'.[77] At Ely, a similar reference to the prophet's desire for the beauty and glory of God's house heralded a description of the spectacular works of art in gold that the Abbot Brihtnoth set up

there.[78] The Anglo-Saxons were particularly entranced by the exotic descriptions of the tabernacle of Moses and the temple of Solomon – the latter with its golden altar, golden lamps, golden censers, golden candlesticks, and even its cedarwood fabric overlaid with gold[79] – and they were determined to make their own Christian churches equally splendid and equally glorious. 'As Moses built an early tabernacle made with hands, of different and varied colours according to the pattern shown by God', said Eddius in his description of the founding of Ripon towards the end of the seventh century, 'so the blessed Wilfrid wonderfully adorned the bridal chamber of the true Bridegroom and Bride with gold and silver and varied textiles.'[80]

In an account of the late-tenth-century oratory at Wilton associated with St Edith, the attempt to identify an Anglo-Saxon church with the Israelite temple becomes even more explicit. It is true that the inflated rhetoric and over-close correspondences with the Old Testament raise one's suspicions about the actual realities of what was being described. It is also true that the writer, Goscelin, was Anglo-Saxon not by birth but by sympathies and by adoption. However, the account reflects the attitudes of mind in the England of the eleventh century when this verse-narrative was set down. The church, it is claimed, had been built to vie with the temple of Solomon.[81] Like that temple, it had been constructed of cedar and firwood,[82] decorated with palm trees and cherubim,[83] fitted with winding stairs[84] and polished stones,[85] and made resplendent with contents of gold.[86] The priests there were seen as 'the ministers of the tabernacle of the Lord': those 'that went before the Ark of the Covenant'.[87] A nun was likened to Miriam, the sister of Aaron. Her embroidery was conceived in overtly Old Testament terms,[88] and we are told that, as the rational made for the priests of the temple had been 'of violet and purple and twice dyed scarlet' inter-woven with gold,[89] so the vestments she embroidered were 'of purple and reddish purple and twice dyed scarlet interwoven with gold';[90] like the rational, also, they were set with 'crystolite, topaz, onyx and beryl and other kinds of precious stones'.[91] So long as they were dedicated to religious purposes, the Old Testament justified all the Anglo-Saxon tastes for splendour.

The Anglo-Saxon pleasure in gold did not simply spring from a knowledge of its costliness. In *Beowulf* there is a description of a gold banner whose brightness illuminated the dragon's den,[92] and this radiance – the light-effects of gold – was an important part of its attraction. Æthelwulf remarks on how the changing light gave vibrancy to gold vessels[93] and, in the dark interiors of northern buildings, unlit as yet by a general and generous use of windows, we can understand how

the warm glow of gold would give a delicate tremulousness to the surface of art treasures as they caught and reflected at various angles the northern light or the gleam of wax lamps or candles. In the dim interiors of the Russian orthodox churches of more modern times there is a similar insistence on the reflective surfaces of precious metals. The fleeting modulations of light that intrigued the Anglo-Saxons can be relished today by turning the leaf of an Anglo-Saxon manuscript, illuminated with gold, when the gold will catch the light at various angles and give evanescent effects of brightness and shadow. Variable brightnesses fascinated the Anglo-Saxons. This is admirably expressed in a description of a peacock written by St Aldhelm at the end of the seventh or beginning of the eighth century in which he concentrates on the iridescences of its colours: 'the peacock, the beauty of whose feathers now grows golden with a saffron hue, now blushes red with a purple sheen, now shines with a bluish depth of colour or glows with the tawny glint of gold'.[94]

These sensibilities were lost to later periods of history which more and more limited their perceptions of colour to its hue – so that we now speak of the one in terms of the other and talk of blues, greens, reds, and so on. But overlaying, and even overriding, these distinctions of the spectrum for the Anglo-Saxon were other modulations of brightness and shade. This is indicated in some of their colour-words which, primarily, express nuances of brightness – most particularly the words *brun*, *fealu* and *wann*, which suggest, in turn, the degree of brightness of metal in sunshine, of shining material under the same circumstances, and the subdued brightness of something seen on a dull day.[95] The Anglo-Saxon interest in the gleam of surfaces emerges in differing written sources. In *Beowulf* a sword is poetically described as a battle light (*beadoleoma*, l. 1523). In his eighth-century life of a saint, Eddius refers to walls in terms not of their colour but of their polished stone.[96] What intrigues Æthelwulf about a lily in his verse-chronicle of the ninth century is the way it glows.[97] Although in her will of the tenth century Æthelgifu speaks of the colours of her garments, the one she seems to prize most is her 'brightest'.[98] Again, in the poem on the phoenix, the accent is on the gleam of surfaces: '. . . About its neck, like the round of the sun is the brightest of rings, woven of feathers. Of rare beauty is the belly beneath, wonderfully fair, bright and gleaming . . .'[99]

The interest in varying degrees of brightness is seen in Anglo-Saxon manuscript paintings, like those of the Benedictional of St Æthelwold, the New Minster charter, the Trinity Gospels, the Bury Psalter, and the St Margaret Gospels (Plates D, E, B, A, C). Here it is chiefly expressed by gold, but it is also registered by differing tones of the same

colour. These latter break up the structure of figure and foliage in tonal resonances, and the backgrounds are enlivened by surges of colour, fringed white like surf on the waves. Perhaps, indeed, it is in the sea and the mesmeric fascination it still has for us today that we can recapture some of the Anglo-Saxon interest in colour. Though the sea can change almost imperceptibly from blues to bruise-coloured greys and greens, its real visual attraction lies in the fact that each colour can vary within its own range in terms of 'depth' and 'brightness'. The merest ruffling of the surface produces an exciting mobility of brightness of the same hue which gives a new animation and interest to the whole. This vibrancy the Anglo-Saxons managed to achieve even in their coloured outline drawings, and the almost shimmering quality of some of their coloured drawings reminds us of Æthelwulf's interest in the tremulous flames of the hanging torches at night which he likened to gleaming stars.[100]

Some Anglo-Saxon colour-words derived from the names of animal hides.[101] This implies undertones of the animals' sheen, and the hides themselves were used decoratively in the Anglo-Saxon period to provide a surface gloss. At Wilton, horse-hides adorned the inside of the porch,[102] and the bear-skins given by Leofric to Exeter cathedral[103] were presumably intended to provide textural interest to walls or altars or tombs. Anglo-Saxons were always attracted to surfaces which reflected the play of light. They imported glistening and costly silks — particularly (as we shall see in a later chapter)[104] those most subtle in registering the variable effects of colour-brightnesses. They made use of ivory with its mellow lustre;[105] of jet which Bede (in an expression borrowed by Goscelin)[106] called the black jewel;[107] of semi-precious stones which they fashioned into religious objects, like chalices[108] and pastoral staffs.[109] Marble was so much esteemed that it was imported from abroad. Because of a supposed miracle when the beast carrying it collapsed under the weight, we learn that Aldhelm was transporting a slab of marble from Rome in the early years of the eighth century.[110] Because of the survival of a letter from Charlemagne to Offa, we know that 'black stones' – presumably blocks of black marble – were being sent, about 796, from the Frankish kingdom to Mercia.[111] This black marble was no doubt similar to the Tournai marble, later used in Romanesque carvings. It was also used by Anglo-Saxon sculptors. At least, the statement that the Waltham crucifix of the early eleventh century was of black flint, impenetrable to nails,[112] suggests that it was made of black marble.

In view of their interest in reflective surfaces, it is understandable that the Anglo-Saxons should be intrigued by precious stones. We are told that a gem set under the Christ-figure of the Waltham Crucifix

gave out 'a radiance in the darkness of night when the lights have been put out and provides a dim light which enables those standing round to see'.[113] At Evesham, three precious stones in one of the Anglo-Saxon shrines were so luminous that they lit up a great part of the church at night.[114] The cross bequeathed by St Margaret to Durham was praised because it was 'marvellously agleam with large and polished pearls'.[115] These pearls feature much in the written records – not least because there was a tradition of their use in embroidery, as we shall see in a later chapter.[116] Some were quite specifically referred to as English pearls,[117] and it is probable that most were indigenous since, as Bede has pointed out, the native shores yielded excellent specimens. They were not simply white but of other colours, such as red, purple, violet and green.[118]

These colours are similar to those used by Anglo-Saxon manuscript-painters, who also added blues and browns to their palettes and mingled them all in varying and subtle combinations for their body paintings. The colours of textiles were more restricted. They, of course, derived not from pigments but from dyes, and the ones that were most favoured were usually rich and sumptuous.

The most popular dye was probably purple. Our knowledge of the taste for it is confused by the existence of a material (which will be discussed in a later chapter)[119] which was called *purpura* but which was not necessarily purple at all. This in no way affects the Anglo-Saxon partiality for the colour, which they may well have brought with them from the Continent since, in his *Germania* which was written at the end of the first century A.D., Tacitus already speaks of the dress of Germanic women being enhanced with purple.[120] The colour continued to enjoy esteem throughout the Anglo-Saxon, and indeed mediæval, period. The church made use of purple vestments,[121] and, in secular society, purple added richness to the attire of both men and women. In a letter believed to have been written about 675, St Aldhelm indirectly indicates this in his advice to Wihtfrid to avoid garments dyed with purple.[122] Again, when, in his Life of St Cuthbert, written about 721, Bede refers to the fact that the monks of the saint's own monastery still continued to follow his example by not wearing garments 'of a costly colour'[123] he must have been referring to purple which, being imported, was expensive, and which had apparently found its way into religious communities from the world outside. In a letter of 747 to the archbishop of Canterbury, Boniface later attacked 'youths in purple garments' who were actually in monasteries, and more specifically speaks of 'their wide embroidered purple stripes' – their 'ornaments as they call them'[124] – which are mentioned earlier by Aldhelm himself.[125] In a letter of 793

claiming that the Viking attack on Lindisfarne was due to the self-indulgence of the Anglo-Saxons, Alcuin refers to the empurpled rich amongst them,[126] and, if we are to believe Goscelin,[127] this taste for purple was not denied a royal nun in the tenth century. In this and the next century, there are references to the purple garments of men [128] and, later on, Osbert of Clare was to draw attention to the feminine interest in purple during the Confessor's reign. Osbert was an unreliable, not to say unscrupulous, writer where the interests of his own house of Westminster were concerned, but his account of pre-Conquest fashions could have advantaged no one and he describes the ladies of the Anglo-Saxon nobility as daughters of Tyre who were customarily arrayed in purple, dipped in the precious blood of the *murex*.[129] This *murex* was the Mediterranean purple-fish, from which the celebrated Tyrian purple, referred to by the classical poets,[130] derived. Hence Osbert's allusion to Tyre, though Tyrian purple cloth continued to be imported to the West even after the Mohammedan conquests.[131] There is a good deal of artifice in Osbert's prose, but this was not simply a literary conceit of the twelfth century, for Osbert had access to a source written by one contemporary,[132] and his statement can be cross-checked for reliability with another.[133]

Another popular colour was red. This had the double advantage of being both indigenous and practical, for, according to Bede, a scarlet dye was produced from the shell-fish of England which 'can never be faded either by the heat of the sun or by the onset of rain': indeed, 'the older it is the more lovely it becomes'.[134] As a liturgical colour, red naturally appeared on a number of Anglo-Saxon vestments.[135] It was also used in secular society. In the seventh century Aldhelm spoke of both sexes wearing scarlet,[136] and the tenth-century poet quoted by William of Malmesbury alluded to the scarlet cloak worn by King Athelstan.[137] Together with the king's jewelled belt and his Saxon sword in its gold scabbard, it must have produced an effect of great splendour. The Anglo-Saxon interest in red colours extended to other areas. This was recognised in later ages which took special note of the Anglo-Saxon proclivity for reddish tones – its bronze unusually red:[138] its ivory 'overspread with a reddish colour':[139] its imported silk of a purple enriched with a red in a way unknown to the twelfth century:[140] and even a much prized classical cameo 'of a reddish colour',[141] too.

To give interest to their works of art, the Anglo-Saxons relied partly on light-reflective materials and partly on colour. But they also depended a good deal on surface decoration. This, indeed, was so much taken for granted that it is hardly ever alluded to. For them, it was the undecorated that was exceptional. So, when Ælfgifu left one cup to the

king together with 'two armlets, each of a hundred and twenty man-
cuses', and another to the queen together with 'a necklace of a hundred
and twenty mancuses',[142] she made no reference to any workmanship
on the drinking vessels. Yet it is evident enough from both the context of
the gifts and the rank of the recipients that these cups were particularly
rich, and must certainly have been decorated. When the Anglo-Saxons
do use the term *ornamented*, it is usually to indicate the application of
gold or silver ornamentation to a baser material. Bishop Theodred's
remark in his will of 942–51 about an unornamented (*ungenerad*)
chasuble[143] was to identify it as one without gold embroidery and, in her
will of 980–90, Æthelgifu speaks of a blue tunic which is unornamented
(*unrenod*) at the bottom[144] to indicate that it is without a gold border.
The reference to the two 'large ornamented Gospel-books' left by
Leofric to his cathedral[145] was to show that their bindings were en-
hanced with gold or silver. The ornamented (*geronede*) drinking horns
that occur in the gifts made to Peterborough by Bishop Æthelwold in
963,[146] in the wills of secular ladies like Ælfgifu[147] and Wulfgyth[148] and
in a later Durham inventory[149] were those which had gold mounts or
other precious adornments. Such vessels are described in detail by a
foreign observer, William of Poitiers, who speaks of Anglo-Saxon drink-
ing horns ornamented at each end with precious metal,[150] and the metal
mouth-pieces on a pair of drinking horns found in the seventh-century
barrow at Taplow (Plate 6)[151] indicate how far back into the pagan past
the tradition of such drinking vessels goes.

   Whether stated or not, every attempt was made to fill or cover empty
surfaces. Fabrics adorned bare walls (Plates 33 and 34), floors, and
furniture; and wall-hangings, carpets, seat-covers and other coverings
recur in wills and inventories of gifts.[152] Such textiles could be adjusted
to both taste and purse and could even be supplemented or replaced by
the greenery of nature. When Goscelin came to England about 1058
and adopted local customs, he decked out the walls and seats of his poor
lodgings with fabrics but the floor he covered with brightly coloured
grass and rushes.[153] Again, in describing the earlier home of Godric
near Ramsey, he says that 'both ceilings and floors were green with
foliage'.[154] The plain surfaces of artistic objects and furnishings were
also invigorated and given interest by embellishment and decoration.
In the military sphere, weapons were enhanced with inlaid work and
with precious metal (Plate 51a, 51b).[155] In domestic life, chests were
'well decorated',[156] wooden cups 'ornamented with dots',[157] and even a
distaff might have varied carving.[158] In the sphere of personal adorn-
ment, jewellery was given a more interesting texture by filigree or
engraved work.[159]

**6** Mouthpiece of drinking horn excavated from the seventh-century grave of a Teutonic chieftain at Taplow (British Museum).

Some of the decoration must have been vivacious and sophisticated. The Lindisfarne Gospels have survived to show the amazing subtlety of the finest Anglo-Saxon illumination at the very end of the seventh century (Plate 7), but there are comments on these animated patterns in other areas. In *Beowulf* the swords are described as having 'woven' patterns,[160] which, as one commentator aptly remarks, suggest 'curving lights which catch the light, like designs on silks and brocades'.[161] In *Elene* their vibrancy is enhanced by the fact that the blade itself is quivering and trembling and flashing with changing hues.[162] The reference to the variety of figured patterns which Dunstan supplied for a stole[163] suggests an interest in complex decoration in embroidery. A more general regard for artistic dexterity and adroitness is implied by

**7** Decorative page from the Lindisfarne Gospels, late seventh century, probably before 698 (British Library, Cotton MS. Nero D IV, fol. 26v).

the praise given to 'the miracles of ingenuity' in the church of Wilton[164] and by the censure accorded to the 'ingenious skill' of domestic adornments by a moralist.[165] Calligraphy itself was seen by one Anglo-Saxon in terms of decorative intricacy – as an art of graceful elaboration.[166]

There was ingenuity also in the making of solid, three-dimensional objects. An ivory incense-container that came into the possession of the Conqueror was shaped like a small ship,[167] and even in the Gothic period an Anglo-Saxon shrine was described as being elaborate.[168] On the whole, however, literary accounts show little interest in the carving of solids or the disposal of spaces to produce effects of elegance and balance. Some of the surviving Anglo-Saxon ivories are quite superb in quality (Plates 16, 17, 52, 53, 55 and G) and the monumentality of the stone sculptures of Ruthwell and Bewcastle (Plates 26, 27, 28a and 28b) is remarkable for its early period. Yet such objects are hardly ever mentioned. This is primarily due to the fact that their materials were lacking in costliness, but there was also, perhaps, another factor: namely that writers did not often think in three-dimensional terms. Poets and chroniclers tend to mirror a world rather like that of a sumptuous manuscript painting: one with splendour of gold, richness of colour, vigour of line and subtlety of decoration, but with little indication of depth.

Even buildings were not often viewed in their own aesthetic terms of spatial harmony. Chroniclers relished instead those architectural complexities which – like the interweaving of Anglo-Saxon paintings – can tease the eye, as the Anglo-Saxon riddle can the mind. So, in his account of the rebuilding of the Old Minster and cathedral at Winchester between 965 and 995, Wulfstan the Cantor draws especial attention to the elaboration of the colonnaded alleys and the adjacent chapels in which – as in a well-constructed maze – the visitor will be bewildered by the intricacy. 'Whoever walks in these courts cannot tell the way he came in nor the way he is to get out. Open doors are to be seen on every hand but no path is a certain one.'[169] His interest in the crypts is very similar. They conceal the secrets of the involved directions of the various passages in a way made more mysterious by the fact that they are now in darkness and now illuminated by the sun.[170] The much earlier description of Wilfrid's foundation at Hexham (672–8) by Eddius (another cantor) expresses the same feelings but in a less developed way, and he emphasises the diversity of the columns, the number of the side aisles and the 'various winding passages with stairs leading up and down and around'.[171] Here we have also a seasoning of Old Testament reminiscences.

The only extant account of the Holy Land to come from the eighth

century was written by an Anglo-Saxon. It is St Willibald's *Hodoeporicon*
or *Itinerary*.[172] It is perhaps unfair to expect artistic appraisals from St
Willibald since he went as a pilgrim, but it is a little surprising to find
that, although he spoke of over twenty churches that he visited, he gave
impressions of the architectural appearances of only one – a church in
Bethlehem which he simply said was shaped like a cross. He com-
mented on its great beauty,[173] but leaves us uncertain whether this
derived from the proportions achieved, the material used, the decora-
tion applied, or the furnishings inside. There is certainly no comment
on its architectural balance. Nor does such an interest emerge in the
later, very lengthy, description of a tenth-century tower at Winchester
where, in fact, attention is chiefly focused on the sculptural
decoration.[174]

Anglo-Saxon writers were little interested in form or proportions.
They speak often of the attractiveness, or quality, of the workmanship,
but when they do so it is the surface embellishment that they usually
have in mind. In a letter sent to Lull in 764, Cuthbert refers to the
'subtle workmanship' of two textiles he is sending on.[175] This can hardly
have pertained to their cut since they had none. It must have related to
the decoration on them. Again, when the poet of *Beowulf* describes
Beowulf's banner as being a 'wonderful piece of craftsmanship'[176] he
can only be referring to the embroidery or other decoration on its
surface. Much later, in 1058, the Anglo-Saxon Chronicle remarks that
the gold chalice that Bishop Aldred presented in Jerusalem was of 'very
wonderful workmanship'.[177] This cannot have defined its shape or its
proportions, which were dictated by tradition, but must have indicated
the decorative work on it. When the Anglo-Saxons referred to
craftsmanship, or beauty, they were usually appraising not the compe-
tence or elegance with which an object was made, or was proportioned,
but the attractiveness with which it was adorned.

On exceptional occasions, in accounts of buildings, attention was
drawn to their size. There seems, for example, to have been a conven-
tion that the magnitude of Roman buildings should attract comment.
In the elegy on a ruined, and perhaps Roman, city, the poet conceived
of the fallen walls as being the 'work of giants',[178] and when, in a more
specifically historic context, a Roman structure was excavated at St
Albans in the eleventh century, we are told that the people 'looked in
wonder at the remains of such mighty buildings'.[179] Size – particularly
height – in their own buildings could also give rise to enthusiasm. The
greatness of Hrothgar's hall in *Beowulf* is insisted on, and the impression
which is especially conveyed is that of height. Eddius was effusive about
the magnitude of Wilfrid's seventh-century church at Hexham – the

depths of the foundations, and the height and length of the walls – and he concluded: 'we have heard of no other house on this side of the Alps built on such a scale'.[180] In the competitive atmosphere between the two minsters at Winchester in the tenth century, the new tower was also lauded by the New Minster spokesman for its 'marvellous height'.[181] Hexham has been excavated, its proportions are known and there is no reason to doubt Eddius's assertion that it was large for its time. This was probably true of the Winchester tower also.

Despite all this, the Anglo-Saxons were not particularly concerned with grandeur. It could be extolled, but it is equally significant that the monastery of Wilton, rebuilt by Queen Edith before the Conquest, was described and even commended as being 'modestly planned'.[182] Writers were normally interested in aspects other than vastness of scale. Descriptions of the new eleventh-century foundations of Waltham and Coventry therefore concentrated attention not on the size of the architecture but on the splendours of the objects and appointments within. William of Malmesbury's remark that the Anglo-Saxons were committed not to the largeness of buildings but to the nature of their contents[183] is a just one. Their main interest was not in the spacious but in the sumptuous. They wished to make their churches, as Eddius, in an apt quotation from the Book of Kings, said: 'all glorious within'.[184] The focus of their taste was resplendence and this, as we shall see in the next chapter, very much shaped their attitudes towards their own artists.

# CHAPTER III

# ARTISTS AND CRAFTSMEN IN ANGLO-SAXON ENGLAND

The interest of the Anglo-Saxons in resplendence means that much of our information about their artists is weighted in favour of those who worked in gold. Two secular poems in Old English illustrate this well.[1] One presents an extended account of the gifts, and the other of the fortunes, of man. Both ignore completely the sculptor and painter but give attention to the worker in precious metals – the one who 'is assigned wonderful ability in the goldsmith's art':[2] the one who is 'cunning in gold and gems whensoever a prince of men biddeth him prepare a jewel for his adornment'.[3] The same bias is seen amongst foreign observers who greatly admired the Anglo-Saxon artists who handled gold or gold-thread. For various reasons, this esteem was expressed with special force during the period after the Anglo-Saxons' own eclipse – soon after the Norman Conquest.

At this time, two writers from Northern France showed a considerable interest in England. One was William of Poitiers, who was born in Normandy. The other was Goscelin, who came from the Flemish area further east. No two persons could have taken more diametrically opposed attitudes towards the same country. For William the English were a nation ostentatious in appearance, perfidious in character and barbaric in behaviour – a nation, in short, for which he had little stomach. So sympathetic, on the other hand, did Goscelin feel towards the English that – after crossing the Channel some eight years before the Conquest – he became English by adoption, travelling from monastery to monastery, affectionately writing up the lives of the English saints, and earning from the English themselves their respect and friendship. Yet though their emotional responses were totally different, these two writers did have one view-point in common: it was a warm admiration for the skills of those Anglo-Saxon artists who worked in precious metals. 'The men of England', wrote William, 'are outstandingly skilful in all the arts'.[4] He speaks of all the arts, but it was clearly those of the goldsmith that he had in mind, for it was on the Anglo-Saxon works of art in precious metals that he lavished his

praise. In rising waves of approbation he says that no one could believe how beautiful they were:[5] that they would delight the gaze of those already acquainted with the noblest of treasures, including those who had voyaged to Arabia:[6] and that the precious objects from Anglo-Saxon England deserved to be honoured to the end of time.[7] Turning his attention to the craftswomen of England, William writes that they 'are very skilled with the needle and in weaving with gold'.[8] This was the aspect of English art that the other writer, Goscelin, emphasised most, though he made his own fulsome tributes to the goldsmiths. He praised the English women for their skill in gold embroidery, and comments on how they embellished the garments of the princes of the church and of the princes of the realm with gold-work and gems and with English pearls that shone like stars against the gold.[9]

William of Poitiers claimed that Anglo-Saxon works of art in precious metals would be cherished even by the Byzantines,[10] and, however rhetorical this remark may be, it is certainly true that the craftsmanship of the Anglo-Saxon goldsmiths was highly regarded at the one centre of Latin Christendom competent to compare it with Greek workmanship – namely Montecassino. Montecassino, more than any other Western centre, made use of artists from the Christian East, and its esteem for English goldsmiths is explicit in its chronicle[11] and implicit in the patronage of one of its greatest abbots.[12] If the workmanship of Anglo-Saxon goldsmiths was prized in Italy, it was valued as well in Ottonian Germany, for St Bernward, who was himself a craftsman, took an interest in Anglo-Saxon metalwork, as his biographer, Thangmar, tells us.[13] Anglo-Saxon workmanship in precious metals was also much admired in France, where, paradoxically, its reputation was enhanced by the Norman Conquest since this led to so many examples of it being sent to the Continent.[14] This was the reason why William of Poitiers gave his attention to Anglo-Saxon goldsmiths' work which was still drawing admiration at the end of the eleventh century and early in the twelfth.

When the crusaders captured Antioch in 1098, their chronicler thought it high praise for the engraved work in precious metals there (which the representatives of Latin Christendom were in the process of destroying) to say that it would be admired even by English goldsmiths.[15] This chronicler, Raoul, was a Norman from Caen, as he himself tells us,[16] and it seems to have been pre-Conquest goldsmiths' work that he had in mind, for large quantities of this were sent to Normandy and especially to Caen, by William the Conqueror and his son.[17] Later, when Henry I offered to send a considerable amount of gold and silver to be made into a reliquary for the remains of St Julian

at the cathedral of Le Mans, its bishop, Hildebert, begged him to have the shrine made in England. The reason he gave – and despite the effusiveness of his diplomacy, he was one of the most discerning prelates of his age – was that, in those regions of France, there was nothing to compare with the wonderful craftsmen of England who produced such splendid engraved work in precious metals.[18] Here, again, it was probably an acquaintance with Anglo-Saxon goldsmiths' work that fired this foreign enthusiasm. Anglo-Saxon work in precious metals had been distributed not only to Normandy but through various parts of France by the Conqueror.[19] It is not likely that Maine, which was also ruled by William and which sent troops to support his invasion of England, would have been excluded from this largesse, and Hildebert had been at Le Mans from about the time of the Conquest. Again, the reputation of the English metalworkers in France is indicated by the fact that the Bishop of Coutances sent for one, named Brismet, to repair damage to his cathedral in 1091, and, not least, to restore the gold cock on it. The quality of the renewal of the latter so affected him that, ill as he was, 'he gave orders that he should be lifted up . . . and, sitting up in bed, prayed, giving thanks to God. And, when he had stopped, he said "I feared that, if my death had come first, that cock, or another like it, would never have ascended up there on high" '.[20]

Finally, there is every evidence that Anglo-Saxon goldsmiths were appreciated abroad in the Anglo-Saxon period proper as moneyers to mint money, for they were employed as such in all the three Scandinavian kingdoms in the decades before the Conquest.[21]

Though the Anglo-Saxons had a special interest in what we might call the sumptuous arts – that is in those that were rich and costly – they had a general respect for all crafts. This clearly emerges in their proverbs, one of which says that a man's craft enhances his honour.[22] It is also evident in their poetry, where Christ Himself is seen as the supreme artist, the 'Craftsman and the King'.[23] Their regard for the crafts is indicated in a more oblique way by the fact that one Anglo-Saxon source could insinuate that a monk had used his artistic gifts to seek preferment,[24] and by the less certain fact that another monk's rise to high office may perhaps have been linked to his artistic talents. The name of the latter was Spearhafoc. His gifts as a goldsmith certainly helped to bring him to royal attention, for we know that he worked for the Confessor, and that one of his commissions was associated with the queen.[25] He was raised by the king from being a monk at Bury St Edmunds to the abbacy of Abingdon, and then, in 1050, was nominated to the Bishopric of London – though here the Confessor's ambitions on his behalf were not fulfilled. The name means Sparrowhawk, but

ultimately Spearhafoc showed himself interested in prizes more glittering than the common sparrow. He was provided by the king with a store of gold and choice jewels for the fashioning of a crown, and from this source, the chronicler baldly says, and from the Bishop's revenue, he stuffed his coffers full and, secretly leaving England, was never seen again.[26]

At a later stage of English history a certain condescension towards the manual skills sometimes infected some of the intelligentsia, and there is an element of patronage in the late mediæval remark that Osmund, who became Bishop of Salisbury in 1078, 'did not think it beneath his dignity to write, bind and illuminate books'.[27] We may contrast with this the robust and reiterated advice of the great Anglo-Saxon archbishop, Wulfstan, to the secular clergy that they should acquire a manual skill – not simply for the benefit of their bodies but also for the well-being of their souls.[28] Before the Conquest, there was no feeling that the craftsman was inferior to the intellectual: no patronising of the gifts of the hands by those endowed with gifts of the head. All such talents derived from the same God who

> variously distributeth His gifts:
> to one virtues, to another crafts,
> to another . . .
> a well ordered mind[29]

This recognition of the significance of the crafts led to an acceptance of makers' names on secular objects, and these 'signatures' are to be found today on surviving brooches, rings, rune-stones, a sword pommel and so on.[30] They even at times exhibit a self-regard which other ages would have considered unseemly. This, not least, amongst quite minor pieces where the weight given to the craftsman can equal, and even surpass, that given to the patron. One surviving pocket sundial, for example, has a message asking for tranquillity for the owner but salvation for the maker;[31] a ring from Lancashire in the British Museum has the name of the engraver (Eanred) in as large letters as the name of the owner (Ædred);[32] and a decorated scramasax, or single-edged knife, in the same collection gives even more importance to the maker's name (Biorhtelm) than to that of the owner.[33] On stone-work, the craftsman's 'signature' can become absurdly obtrusive – one simple stone font is dominated by the statement that it was made by Wigberhtus,[34] the craftsman and mason, and on one memorial slab the name of the stone-mason is inscribed in letters as large as those of the memorial inscription itself.[35]

There was none of this affectation within the walls of the monasteries.

Indeed, as we shall see later, quite contrary views prevailed though, even here, the esteem for the arts was such that monastic writers always kept a proper balance between the gifts of the mind and those of the hands and never tried to play off the one against the other. *The Life of St Dunstan*, written by a contemporary, for example, begins by speaking of Dunstan's study of the sacred texts and then simply goes on to say that 'in order to be sufficient in all things' he acquired artistic skills.[36] The description of abbot Mannig of Evesham is impartial about his academic and manual skills: 'This man was most venerable, and was steeped in the holy Scriptures and in many other arts'; which, in this context, prove to be mostly crafts.[37] The account of St Edith – a natural daughter of King Edgar, who fulfilled her religious vocation in the nunnery for ladies of the Anglo-Saxon aristocracy at Wilton – emphasises the nobility of her mind and of her understanding but gives as much weight to her gifts as an artist.[38] Again, though known to us only through later derivative descriptions, contemporary monastic views of Edward the Confessor's queen were equally objective about her literary and artistic skills. They remark that this Edith 'was celebrated and distinguished for verse and prose; and, in the workmanship and depictions of her embroidery, was another Minerva'.[39] The same balance is seen in descriptions of foreign artists. So Benna, the German priest at Wilton in the tenth century, was extolled for his virtue and learning but was just as much praised for his artistic skill.[40]

From all this it is clear that, even though certain categories of artists attracted a special prestige, all had a respected place in their own communities. It is when we try to focus more finely on the identities and work of individual artists that we are surrounded with difficulties.

One major problem is that the most important written sources for individual artists are the chronicles and (as we have already seen) these were chiefly compiled by monks who were little concerned with the art or artists of the outside world. Even the craftsmen of their own Order were normally excluded from their purview and only accidentally brought within it by factors which, initially, had nothing to do with art. A craftswoman, like Edith, might later be canonised and then her work as an artist would be of interest. Another artist, like Spearhafoc, might be the witness of a miracle and his workmanship might then attract attention. Yet another, like Mannig, might reach high office and, as an abbot, come within the terms of reference of a monastic history. All in all, the information that we have about individual Anglo-Saxon artists is either incidental or accidental.

This certainly limits our investigation severely. But there is another problem which confuses it. This is an ambiguity in the Latin. It is one

met with in all mediæval sources and derives from the fact that the patron who commissioned the work of art was often described as the person who 'made' it. In a similar way, we are told later, in India, that it was Sháh Jehán who built the Tâj Mahal. This problem can only be overcome by a careful and critical sifting of the evidence and by a refusal to recognise anyone as an artist unless he is quite explicitly described as having made the work of art 'himself' or 'with his own hands'. Even here, statements that works were made by saints need to be treated with special caution. These claims advanced the merits of the objects concerned as objects of devotion, and such attributions might owe more to pious hope than historic fact. The *Liber Eliensis* said that the patron saint of Ely, St Etheldreda, had been a highly talented embroideress and 'with her own hands' had made for St Cuthbert 'a stole and maniple . . . of gold and precious stones' which, in the twelfth century, was kept at Durham where it was displayed for veneration to the specially favoured.[41] Yet Bede, who is the primary source for both St Cuthbert and St Etheldreda, makes no mention either of St Etheldreda's skills or of such gifts. Nor does the anonymous *Life of St Cuthbert*. The attribution is therefore highly suspect. The same difficulties confront us in our assessments of St Æthelwold as a craftsman. We know that he was a teacher and scholar. But the Abingdon chronicler later claimed too that he 'made' for that house various crafted objects – gold and silver crosses, or Crucifixes, a gold and silver altar retable with figures of the twelve apostles, a gold, or gold-plated, revolving wheel with bells and lamps, also an organ,[42] and two bells made as well 'with his own hands'.[43] In point of fact, all this would have called for skills of the highest order. We know from the treatise of Theophilus on mediæval crafts how wide-ranging was the technical knowledge needed to make an organ with its pipes, wind chest and bellows unit and then to tune it,[44] and how so much danger was involved in handling molten metal during the founding of bells that only those with great experience and the swiftest reactions were employed.[45] If Æthelwold had indeed possessed these skills and made these objects, they would certainly have been mentioned in the biography of him written by his contemporary, Wulfstan the Cantor, or in the related biography by Ælfric. Yet neither refers to them. Ælfric certainly stresses the fact that Æthelwold worked with his hands. At Glastonbury, he happily laboured every day in the monastic gardens cultivating fruit and vegetables for the refectory table,[46] and, at Abingdon, he not only exhorted his monks to join the workmen in their task of rebuilding but set an example himself.[47] There can be no doubt that this leader of the church was unafraid of physical toil. But we must make a clear distinc-

tion, as the Anglo-Saxons themselves did, between the hand prepared for simple labour, as St Benedict enjoined,[48] and what one Anglo-Saxon poet describes as the hand that is 'learned, wise and powerful as befits a craftsman'.[49]

Æthelwold was but one example of the involvement of Anglo-Saxon abbots in manual work. Eosterwine, the co-abbot of Wearmouth from 682 to 686, shared in the toil of the others, and 'Where he came across the brethren working, he was accustomed to join in their labour without delay, either by directing the course of the plough with the handle, or by shaking the winnowing fan with his hand, or in some other such way'.[50] In this passage Bede was concerned to emphasise the fact that, although (like a large number of other Anglo-Saxon abbots) Eosterwine was of noble blood, he was anxious to cultivate the monastic virtue of meekness. In the same spirit, he tells us that, on leaving a high position at the Northumbrian court to become a monk at Lastingham, an East Anglian nobleman named Owine approached the monastery wearing a simple garment and carrying the implements of a labourer.[51] This humility was the ideal to which the whole Benedictine Order was dedicated. St Augustine was originally a monk and when, during his mission to England, he discovered in himself a gift for miracles, he was sharply reminded of the dangers of presumption,[52] a remonstrance which was in perfect accordance with the Benedictine injunction to self-effacement. Such humility was of course not less important for the monastic craftsmen as the Rule of St Benedict makes clear:

> Let such craftsmen as be in the monastery ply their trade in all lowliness of mind if the abbot allow it. But if any be puffed up by his skill in his craft . . . such a one shall be shifted from his handicraft, and not attempt it again until such time as he has learnt a low opinion of himself, and the abbot bids him resume.[53]

Given this attitude, it is understandable that so little is known of the ordinary monk-craftsman. Two only are named in the many monastic chronicles, and these occur in one single narrative which is itself an exceptional and strangely inflated verse-account of a daughter-cell of Lindisfarne, written in the early part of the ninth century by Æthelwulf.[54] He mentions that the monks under abbot Eanmund (704–16) included one, Ultan (in fact an Irishman), who was unsurpassed at calligraphy,[55] and another, Cwicwine, who was responsible for making the table vessels.[56] This reference to a metal-worker (as opposed to a goldsmith) is in the highest degree exceptional even though, as smiths, they were of great importance to a monastery. How great, Bede himself discloses. He tells us that the crafts of one smith were so necessary to the

community that he was tolerated by the brethren despite the fact that he preferred the pleasures of alcohol and of the loose life to those of prayer and worship: 'He was persistently reproved by the brothers and seniors of the house and told to change to a stricter way of life. And, though he refused to listen to them, they yet put up with him for a long time because his physical work was necessary to them: for, in the smith's craft, he was excellent.'[57] Bede did not insert this incident into his *History* in order to advocate indulgence for such craftsmen in a monastery. On the contrary, it was to point a different message, for he goes on to say that the smith was visited on his death-bed by a vision of his own future damnation. The smith himself is not named and, though in this instance it might have been an act of charity, more worthy monks who were craftsmen still went unmentioned.

In the Lindisfarne Gospels[58] (Plate 7) there is a famous entry,[59] which we assume was copied from an original one. It was inserted in the tenth century by Aldred, who has been identified as a provost of Chester-le-Street, to which centre the manuscript had by now been removed. Amongst other things, the entry tells us that the cover was embellished with gems, gold and silver-gilt by Billfrith the anchorite, who was presumably associated with the monastic community of Lindisfarne at the very end of the seventh century when the manuscript was made. Here the reference to Billfrith's craftsmanship does not prejudice his vocation of humility, for the intention of the inscription was not to draw attention to his skill but to invite intercession for his salvation. This is quite explicit in another entry of the Lindisfarne Gospels (folio 89v) which asks God to remember those concerned in the making of the book: 'Thou Living God, be thou mindful of Eadfrith, Æthelwald, Billfrith, and Aldred a sinner: these four have, with God's help, been engaged upon this book'.[60] Spiritual intercession for their future in eternity was the one reward for their work that the best type of monk might hope for in this world, and monastic writers, like Bede,[61] and monastic scribes, like Wigbald[62] and Cutbercht,[63] were certainly willing to ask for the prayers of their readers. From this, it follows that, when such requests for prayers are found in monastic manuscripts, we must presume them to have been made on behalf of monks unless there is evidence to the contrary. We may, therefore, assume that the petition for prayers found in another splendid Gospel-book – the Golden Codex that the Danes sold back to the Anglo-Saxons[64] (Plates 19, 37) – was on behalf of the monks who originally wrote, illuminated and embellished it in the mid eighth century. Given the amount of gold illumination in the manuscript, it is noteworthy that one of the monks concerned is a goldsmith, Wulfhelm, though originally his skills were probably more

prominently displayed on a gold binding that has disappeared. The others named are Ceolhard, Niclas and Ealhhun.

From records made at the New Minster, Winchester, we exception-ally learn the identities of six of its monk-artists of the tenth and eleventh centuries, and discover that three goldsmiths there were called Wulfric, Bryhtelm and Byrnelm, and that three painters were named Ælfnoth, Æthelric and Wulfric. This information derives from anniversaries of their deaths entered into a calendar, written not long before the Conquest, and from lists of tenth- and eleventh-century monks in its *Liber Vitae*.[65] The latter source also refers to a churchwarden, called Alwold, who made a shrine,[66] though it is not clear whether he was a monk or not. What is clear is that, when we have teased out every possible source, we are left with little information about the ordinary monk-craftsman and that is usually confined to their names. Even the inclusion of monastic priors will only add slightly to our store of information. Ælfric, who was prior of Evesham at about the time of the Conquest, made dorsals.[67] And because the name of a tenth-century prior of Ely called Leofwine was later attached to a silver Crucifix there, we can perhaps infer that he was a goldsmith.[68]

If we are seeking knowledge about the monk-craftsmen that goes beyond their simple identities, we shall not find it amongst the ordinary monks. We shall, rather, have to look at those Benedictine artists who achieved distinction in fields other than their own crafts. For it was not as artists, but as abbots, or bishops, or particularly saints, that monks were most likely to commend themselves to the attention of the chroniclers who might then, incidentally, remark on their intellectual or artistic talents. It is only in the context of those who achieved high office or great sanctity that chroniclers give us information that is at all helpful. This might seem to curtail its value but this is not really so. To begin with, although abbots might, and some apparently did, continue with their artistic activities after taking over the administration of a monastery, details given about their artistic accomplishments were probably often retrospective and incorporated their earlier work. Even if this were not true and our intelligence was limited to their later years when they were advanced in office or in sanctity, the information could still be properly applied to the time when they were of more humble status. Dunstan was in turn a monk, an abbot and an archbishop, and he was at the same time a saint. His positions of authority and his qualities of holiness attracted the attention of writers, who then give other information about him, such as the fact that he played the harp and practised crafts. Yet neither his promotion in the church nor his advancement in sanctity could have affected the technique of his harp-

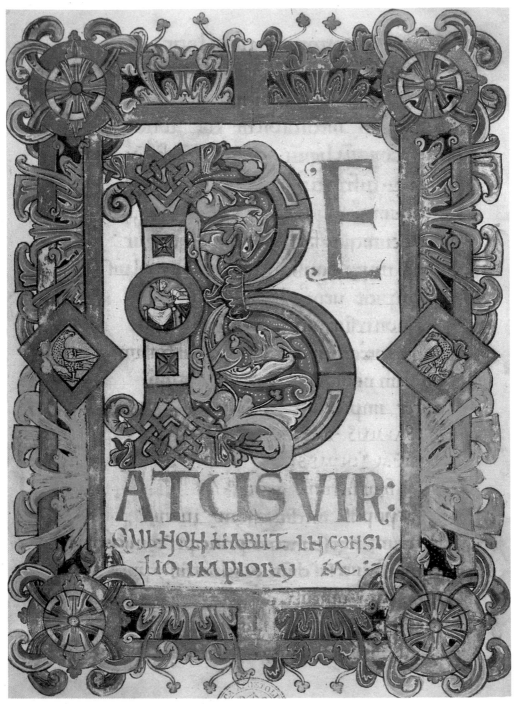

**A**   Picture of a monastic scribe as part of the ornamentation of initial B in a Psalter made at Canterbury for Bury in the second quarter of the eleventh century (Vatican, Biblioteca Apostolica MS. Reg. lat. 12, fol. 21).

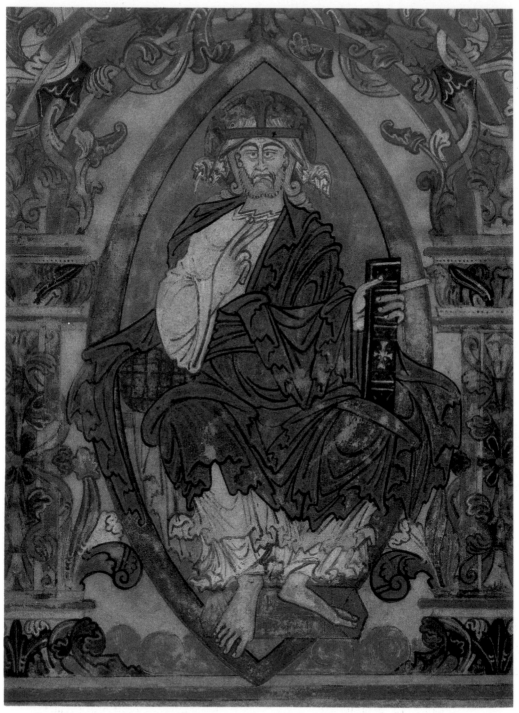

**B**  Christ in Majesty, from an early eleventh century manuscript, probably from
Christ Church, Canterbury (Cambridge, Trinity College MS. B 10 4, fol. 16v).

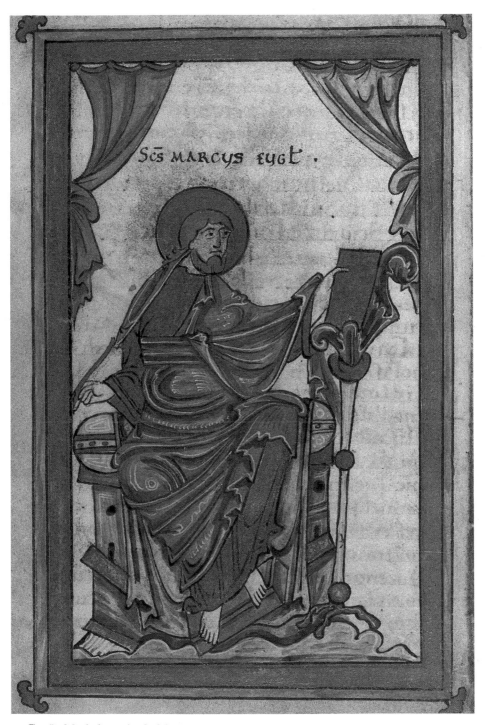

SCS MARCUS EUGT .

C   St Mark from the St Margaret Gospels, 1030–60 (Oxford, Bodleian Library MS. Lat. lit. F. 5, fol. 13v).

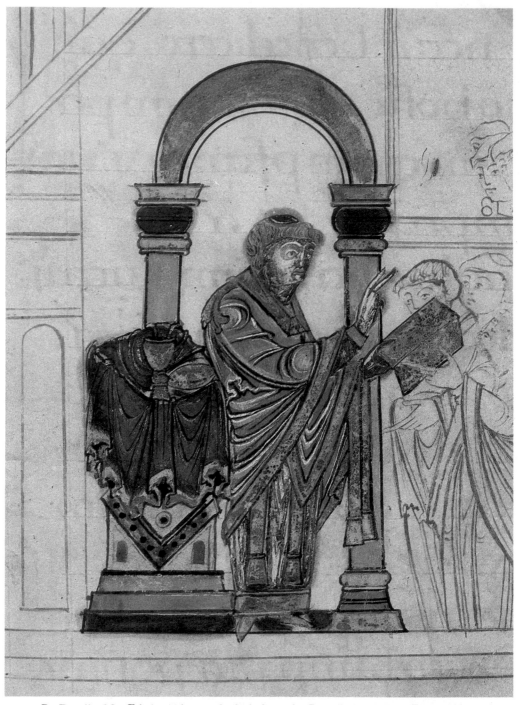

**D** Detail of St Æthelwold in a cathedral, from the Benedictional of St Æthelwold, a manuscript made for him between 971 and 984 (British Library, Add. MS. 49598, fol. 118v).

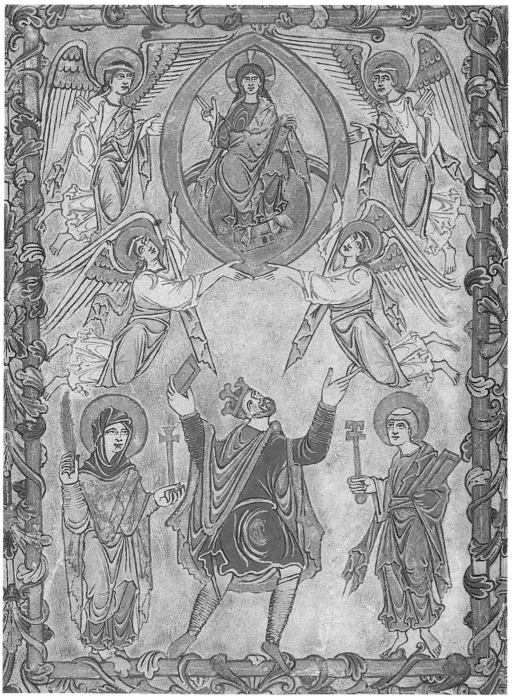

E   Portrayal of King Edgar offering to Christ a charter for the New Minster, Winchester. He stands between two of the foundation's patron saints, the Virgin and St Peter. Made after 966 at Winchester (British Library, Cotton MS. Vespasian A VIII, fol. 2v).

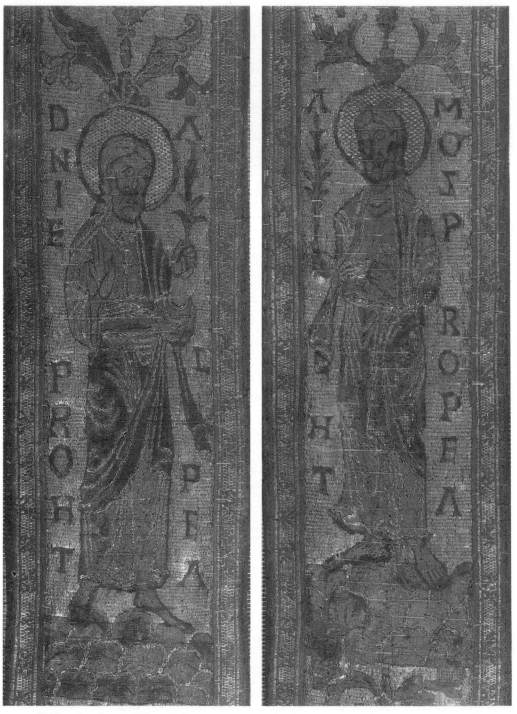

**F** Details of two of the prophets on a stole orginally made at Winchester between 909 and 916 and found in St Cuthbert's coffin (Durham Cathedral Treasury).

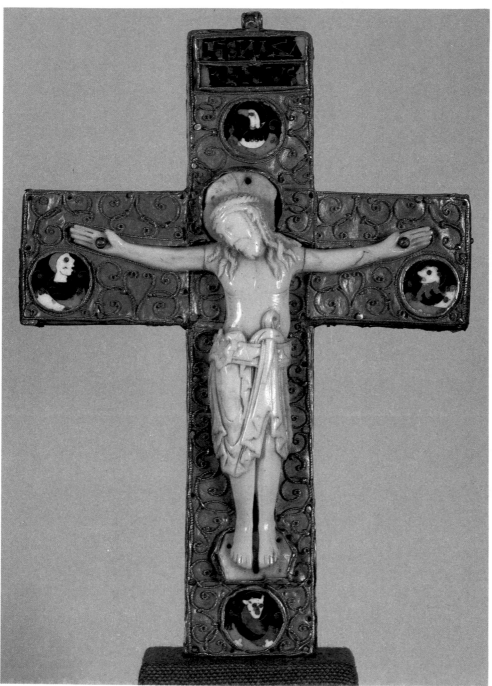

**G** Crucifix reliquary of walrus ivory, mounted on cedar wood which is sheathed in gold with filigree and cloisonné decoration and enamels. On the back are the Agnus Dei and symbols of the evangelists in repoussé work (Victoria and Albert Museum, 18.5 cm high).

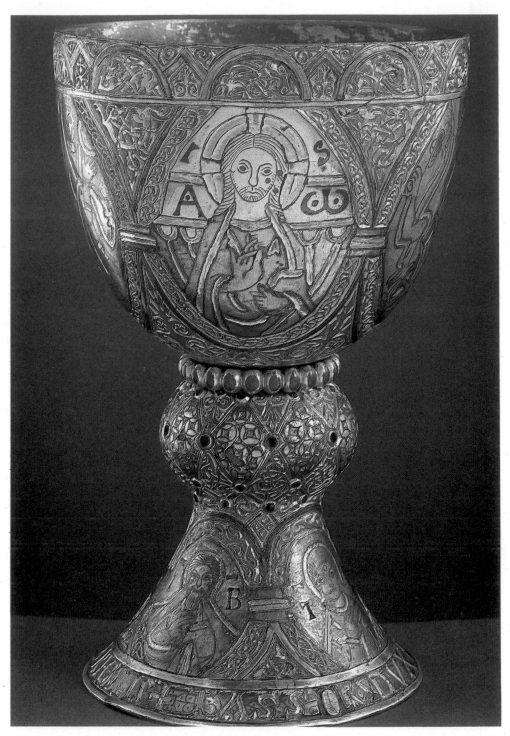

**H** The Tassilo chalice, 777–88 (Kremsmünster Abbey, Austria, 26.6 cm high).

playing nor the methods of his workmanship. They would have been the same had he remained a simple monk. And his methods of making music and of fashioning objects were presumably those of other monks. In the same way, although, in the eighteenth century, Frederick the Great of Prussia owed his celebrity as a flautist not so much to his mastery of the instrument (though this was undoubted) as to his royal position, we could still assume that his musical techniques reflected those of other performers at his court of less elevated status even if all the records had been destroyed. Our sources may focus their very limited interest in artists on those who were dignitaries and saints, but the information they give is still valid for the ordinary craftsmen of the cloister. Nevertheless, generalisations about the Anglo-Saxon monk-artists from such a narrow band of evidence should still be made sparingly.

One conclusion that can be reasonably drawn is that there was a certain versatility amongst the more talented. Of Dunstan himself a contemporary writer said that he diligently cultivated the art of calligraphy as well as skill in painting,[69] and a contemporary drawing of Christ at Oxford (Plate 8) is claimed for his hand by a statement at the top of the page which is unfortunately too late to be of any possible value.[70] Despite this, a picture of a monk in obeisance at the feet of Christ is clearly identified as Dunstan by an accompanying inscription asking Christ's protection for him. There is some controversy as to whether this is an addition but, if it is, it is a contemporary one for the same hand appears in the body of the manuscript. It is reasonable, therefore, to suppose that both the 'portrait' and its inscription are by Dunstan himself. Early posthumous tradition also ascribed to Dunstan an expertise in metalwork. This led the monastic post-Conquest writer Osbern to claim that Dunstan 'could make whatever he liked from gold, silver, bronze and iron',[71] to recount the colourful story of him seizing the devil by his nose with his white-hot tongs,[72] and, in the description of a miracle attributed to the middle years of the eleventh century, to refer to a bell which Dunstan was thought to have made.[73] Osbern's remarks were not only repeated but exaggerated by later chroniclers, but Osbern himself was an uncritical writer and his own assertions are not supported by the contemporary account of Dunstan's life. They should, therefore, be treated with caution. The most we can say is that, within a century of Dunstan's death, traditions affirmed that he was expert in metalwork. However, we are still left with the established facts that he was a musician, a scribe, and a painter.

As well as being an embroideress working in gold thread and precious stones, Dunstan's contemporary, St Edith, was also skilled in music,

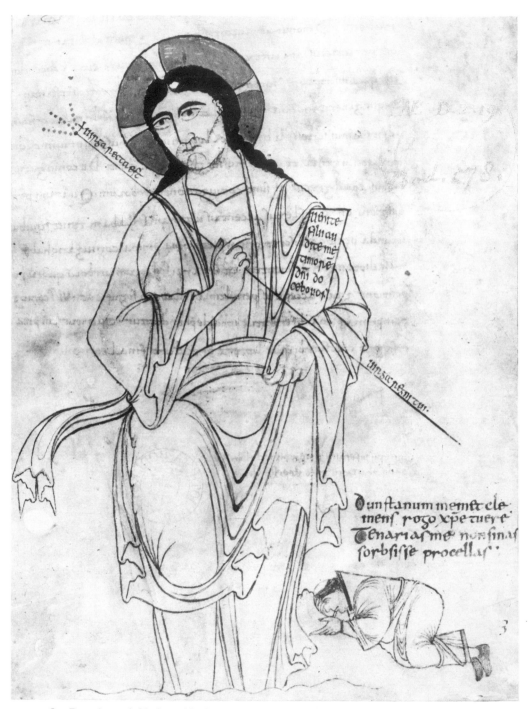

**8** Drawing of Christ with figure of Dunstan, mid tenth century, probably from Glastonbury; top inscription trimmed (Oxford, Bodleian Library, MS. Auct. F. iv, 32, fol. 1).

calligraphy and paintings.[74] We owe this information to Goscelin, who was normally reliable in his facts, if over-effusive in his expression of them. But his statement about the versatility of Spearhafoc has special weight since he knew this artist personally. 'I knew an exceptional artist, Spearhafoc, abbot of Abingdon, who was outstanding in painting, gold-engraving, and goldsmithing.'[75] Spearhafoc's contemporary at Evesham was Mannig, and the Evesham chronicler informs us that Mannig was expert in the arts of calligraphy, painting and goldsmithery.[76] The chronicler gives details of some of his activities as a goldsmith and tells us that 'he copied out a Missal and a great Psalter with his own hands and painted them admirably'.[77] Then, according to information derived by William of Malmesbury from a contemporary biographer of St Wulfstan, the saint's tutor at Peterborough, Earnwig, was both a scribe and a painter. He was probably the same Earnwig who became abbot there in 1055, and we know that his illuminated manuscripts were so highly prized that they passed as diplomatic gifts between England and Germany.[78] He was 'greatly skilled in calligraphy and in making coloured paintings of whatever he wanted',[79] and Malmesbury draws attention to a Sacramentary and a Psalter that Earnwig had copied out and embellished with gold capitals.[80]

In this context of versatility, the two crafts most often associated by writers were those of calligraphy and painting, and we see that Dunstan, Edith, Mannig and Earnwig were all scribes as well as painters. The combination of these two skills would, of course, be especially valuable for the production of beautiful manuscripts in monasteries, and these skills were probably already associated in the earlier period. The source material then is much thinner than for the tenth and eleventh centuries, but a relationship between the two crafts seems earlier to have been taken for granted. The bishops of Lindisfarne were monks living in community, and the inscription in the Lindisfarne Gospels which has already been referred to states that the manuscript was copied out by Eadfrith (Bishop of Lindisfarne, 698–721) and bound by Æthelwald (his successor). It tells us nothing, however, about the artist of the paintings – a surprising omission since they include some of the greatest examples of decorative art left to us by the Middle Ages (Plate 7). In fact, it has been left to scholarly research to show that Eadfrith illuminated the Gospel Book as well as writing it:[81] in other words, the writer of the original inscription made the tacit assumption that the scribe of a manuscript would also be its artist. The same presupposition seems to be implied by the early interchange of the vocabularies of the two crafts: in the second quarter of the eighth century, an expatriate Anglo-Saxon artist signed himself as the person who had 'written' a

picture,[82] and, in the first quarter of the ninth, an Anglo-Saxon chronicler spoke of a calligrapher 'painting' words.[83]

Calligraphy itself must have been a normal pursuit in monasteries and a monastic scribe is represented in the first letter of the first psalm of an eleventh-century Psalter probably made at Canterbury for Bury (Plate A).[84] The psalm opens with a description of the blessed man who will meditate on the law of the Lord, and a monk is shown writing out the words of God for his brethren to meditate on.[85] Within the monasteries there were probably many, like Hwætbert (to become abbot of Monkwearmouth/Jarrow in 716), 'who, from earliest boyhood, had been trained up not only in the observation of the discipline of the Rule but in writing . . .'.[86] A letter addressed by Cuthbert, abbot of Monkwearmouth/Jarrow, to the Archbishop of Mainz in the second half of the eighth century indicates how subject this activity was to the vicissitudes of a northern climate. In it, Cuthbert explained that he had not been able to send on more of the works of Bede, as he would have liked, because the intense cold of the severe winter had held up the work of copying.[87] In their more mature years, even the greatest of the Benedictines continued with their tasks as scribes. Bede normally wrote out his own works,[88] and, amidst all the hardships of the missionary field, St Boniface tried to find time – not always successfully – to copy out texts. In one letter, he writes: 'In regard to copying out the passages of Scripture for which you have asked me, please excuse my remissness, for I have been so much occupied in preaching and travelling about, that I could not find time to complete it. But when I have finished it I will send it to you.'[89]

The letter was addressed to St Eadburg, abbess of Minster in the Isle of Thanet, and there is every reason to suppose that she herself was a calligrapher of distinction. This belief derives not only from St Boniface's acknowledgements of the manuscripts he had 'many times' received from her,[90] but, more particularly, from the fact that, when he wanted a particularly luxurious manuscript to be copied out in gold letters, he approached her personally to make it for him.[91] Boniface's correspondence suggests that the manuscripts he required were chiefly supplied by nuns.[92] It also gives us an idea of the scholarly pursuits of Anglo-Saxon nuns of the period, some of whom were receiving instruction from St Boniface himself either directly or by correspondence.[93] The fact that the sanctity of one of these disciples of Boniface led to her life being written casts yet more light on the academic attainments of the cloistered women of England who were then helping in the missionary work in Germany. The subject of the biography, St Leoba (c. 700–80), emerges as a nun whose studies of the Scriptures, the Church Fathers,

the decrees of the Councils and the whole of ecclesiastical law[94] were such that she was consulted by bishops and princes;[95] her reputation for learning as well as holiness 'spread far and wide and her praise was on everyone's lips'.[96] Aldhelm, earlier, had referred to the high degree of culture attained by the nuns of his day (c. 640–709), and had alluded to their knowledge of history, grammar[97] and scriptural commentaries. Their capacity to comprehend the wordy convolutions of his own Latin style certainly goes some way to confirm his flattering estimate of their academic attainments.

In the treatise on virginity that St Aldhelm sent to the nuns of Barking towards the end of the seventh century, he uses metaphors from weaving or needlework.[98] These, of course, occur in a general sense but there was clearly a tradition of needlework in nunneries from very early times. As in other artistic spheres, this craft was praised when offered to the service of God but criticised when put to personal use, particularly by those who had dedicated themselves to God, and Bede records the displeasure felt towards the nuns of Coldingham before 681 for misapplying their skills: 'Whenever they are at leisure, the virgins, dedicated to God, but despising the respect due to their vocation, devote their attention to weaving fine clothes, either to adorn themselves like brides to the peril of their calling, or to procure the friendship of strange men'.[99] Later, in 745, St Boniface expressed to the Archbishop of Canterbury his concern at the ornamentation of habits in nunneries.[100] This criticism was taken up at the Council of Cloveshoe in 747, which recommended that religious women should give their attention to reading and singing psalms rather than to decorating their habits in varied colours and for empty show.[101] But St Boniface had no wish to discourage needlework when put to its proper use, as he indicates in the warm thanks he sent to the Abbess Eadburg (or Bugga) for the vestments she had sent him,[102] which had presumably been made within her own community.

A detailed account of only one piece of embroidery known to have been made by a nun for church use has come down to us. It was an alb, embellished by St Edith, which 'was embroidered with gold, jewels, pearls and little English pearls at the top . . . Around the hem were golden figures of the apostles standing around the Lord, who was seated in their midst, while she prostrated herself in the role of the suppliant Mary, kissing the feet of the Lord'.[103] Though described by Goscelin because it was by now a relic, there is no reason to suppose that it differed from the embroidery of other nuns. It offers an example of the much praised gold-embroidery of the Anglo-Saxon women and exemplifies the use of pearls and of precious stones to which he alludes

elsewhere.[104] It will be noticed that the artist represents herself as a suppliant at the feet of Christ, rather like Dunstan in the Oxford drawing (Plate 8). Elsewhere it was the patron who was presented in a comparable rôle. The monk at the side of a full-page picture of St Peter in a tenth-century manuscript from the New Minster, Winchester (Plate 9) is probably Ælfwine, who (as we know from a cryptogram in the Calendar) certainly owned the book even before he became abbot, and is here shown presenting it to one of the patron saints of his own monastery. In the next century, the owner of a Gospel-book, Countess Judith, is portrayed at the base of the Crucifixion painted inside (Plate 10). A post-Conquest description more particularly speaks of Richard, abbot of St Albans (1097–1119), having his picture painted at the feet of Christ because he was its donor.[105] St Edith may, of course, have paid for the materials of her alb as well as making it and thus have been its patron as well as its artist, but it was her artistry that Goscelin was anxious to emphasise. In particular, he wished to present her as an accomplished artist in gold thread and jewels: in other words, as the female equivalent of the male goldsmiths, the most highly regarded of Anglo-Saxon craftsmen.

The work of the goldsmith was held in such esteem that monk-goldsmiths continued their craft even when they had become abbots. What is more, they considered themselves free to travel about to different commissions, and we know of two abbots in the eleventh century who made journeys to other monasteries in pursuit of their artistic vocation. Some time before 1047, Spearhafoc, who was himself then abbot of Abingdon, was fashioning figures in metal at St Augustine's, Canterbury.[106] And, in the decades before the Conquest, Mannig, the abbot of Evesham, was invited to make artistic objects 'at Canterbury, in the church of Coventry, and in many other places'.[107] If abbots with the pastoral and administrative care of communities could move from one place to another to practise their crafts, we might suppose that other monastic craftsmen also travelled if they could get the necessary permission. There are even indications that, on occasions, both monastic and secular craftsmen went abroad.

The fact that a number of scribes followed in the wake of St Boniface's missionary successes in Germany is attested both by a statement in Willibald's life of the saint[108] and by surviving manuscripts from the newly founded German houses which were written (and illuminated) by English monks. These latter scribes, who helped to found and colonise new monasteries in Germany, might more properly be described as emigrants than as travellers, but there were Anglo-Saxon miniaturists in France in the tenth and eleventh centuries who seem to

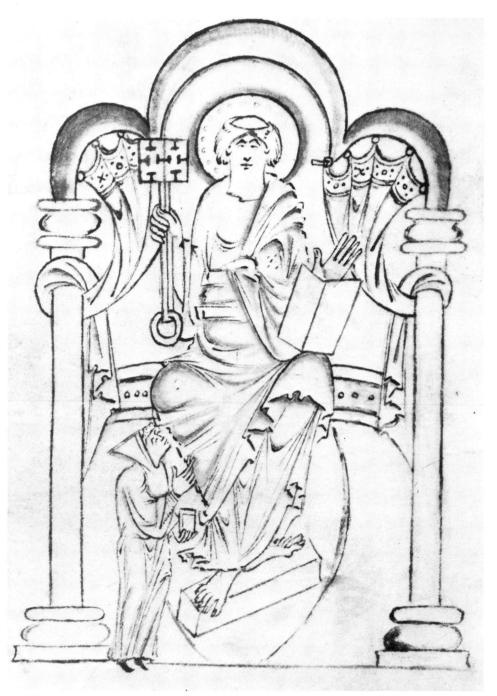

**9** A drawing of St Peter with the donor of the manuscript, the Winchester monk, Ælfwine. Ælfwine became abbot of New Minster between 1032 and 1035 and the manuscript was written *c.* 1023–35 (British Library, Cotton MS. Titus D XXVI, fol. 19v).

**10** Crucifixion with Virgin and St John, and with Judith, countess of Flanders, at the foot of cross, 1051–65 (New York, Pierpont Morgan Library, MS. 709, fol. 105v).

have been on special visits, or breaking journeys between England and Rome. Two were responsible for some particularly fine drawings in manuscripts from Fleury (Plate 11). Two others (one probably from Canterbury) enriched a Psalter and Gospel-book at St Bertin's with drawings and paintings which include a Christ in Majesty of exhilarating quality (Plate 21).[110] Stylistic considerations of one or two drawings in Norman manuscripts suggest that there may possibly have been others in Normandy in the eleventh century.[111]

There was an Englishman helping in the reconstruction of St Bavo's at Ghent about 940,[112] and much earlier, in the last quarter of the eighth century, Anglo-Saxon goldsmith's work had left its impress in Bavaria in the famous Tassilo chalice[113] (Plate H) which will be described in detail in a later chapter.[114] The Anglo-Saxon influences in it may have been due to the fact that the craftsman himself was an Anglo-Saxon who had travelled direct from Northumberland or indirectly from an Anglo-Saxon monastic foundation on the Continent.[115] The Anglo-Saxons certainly had close associations with Bavaria. Indeed, its earliest organisation as a church province had been in the hands of an Anglo-Saxon, St Boniface, who appointed its first bishops and was himself its metropolitan. This was at the invitation of its duke, Odilo, whose son and successor, Tassilo, commissioned the chalice and, since it is inscribed with the names of himself and his wife, Liutpirc, we may assume that it was personally made for him by a goldsmith whom he could command. Since, furthermore, he is named as duke, it must have been made before 788 when he was forced from his dukedom into a monastery. He succeeded his father in 748, which gives us the earliest date for its crafting, though, if it was intended as a gift to the monastery of Kremsmünster where it still remains – a reasonable supposition though not a documented fact – then it was made in, or after, 777 when the house was founded. Three years before the Battle of Hastings, there is more certain evidence of an English goldsmith abroad – this time at Montecassino. It is characteristic of our sources that we learn of this by accident, and indeed because of an accident, for, had the goldsmith not been struck by lightning in 1063, record of this unusual fatality would not have found its way into the Montecassino chronicle[116] and we should not have known of his presence there. At the time, the abbot of this venerable centre of monasticism was Desiderius, one of the greatest patrons of art of the Middle Ages, and, just as he summoned mosaic-craftsmen from Byzantium, it is possible that he brought goldsmiths from England. Certainly (as we shall see in a later chapter)[117] the work of Anglo-Saxon goldsmiths was well known in Italy.

If occasion required, the craftsmen of Western Christendom travel-

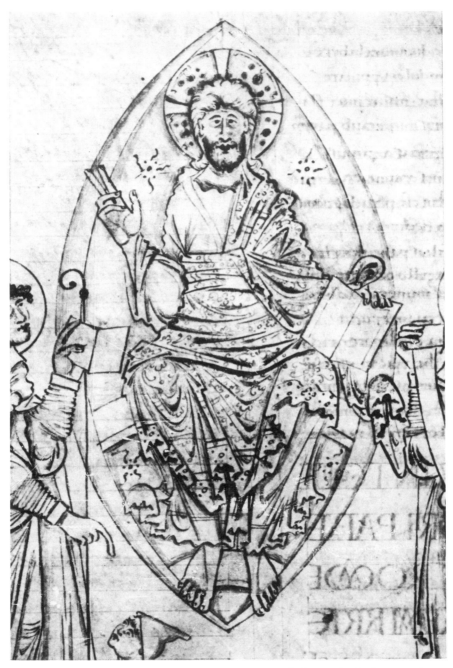

11 Detail of Christ in Majesty, from a drawing made by an Anglo-Saxon artist at
Fleury in the late tenth century (Orléans, Bibliothèque Municipale MS. 175, fol. 149).

led from place to place and from country to country. They included monks like Tuotilo, the ninth-century painter of St Gallen, who was described as 'a much travelled man with extensive knowledge of places and cities':[118] the eleventh-century monk from Tours, Odolric, who made wall-paintings at St Benôit-sur-Loire:[119] and the goldsmith, Odoran, who journeyed from his own monastery at St Pierre-le-Vif to make a shrine at St Savinian.[120] Secular craftsmen also moved from one centre to another. The emperor Henry IV, for example, 'had all the skilled and industrious architects, smiths, masons, and other craftsmen, from his own kingdom and also from other kingdoms' brought to Speier for the enlargement of the cathedral there.[121] And, for the rebuilding of the church at St Chaffre-du-Monastier, Abbot William called upon 'skilled craftsmen from various regions'.[122] This was before the twelfth century when, for his stained-glass windows alone, Suger summoned 'many craftsmen from different regions'.[123]

The Anglo-Saxons also called in workmen from other areas and other countries. In their ancestral lands, mirrored in *Beowulf*, their forebears had sent throughout the whole known world to find artificers to furbish Hrothgar's mighty hall,[124] and, when, in a very different context, Benedict Biscop founded the monastery of Monkwearmouth in 674 and decided to build the church 'in the Roman style he had always loved',[125] he brought men experienced in this type of work from Gaul. 'Crossing the sea, Benedict sought from the abbot Torhthelm (long joined to him in friendship) builders, by whose superintendence and labour he might build a church of stone. When he had obtained them, he brought them from Gaul to Britain.'[126] On this occasion, Frankish builders travelled to England but, when in the next generation (*c.* 710), Nechtan, king of the Picts, wished to build a church 'after the Roman manner', it was Anglo-Saxon workmen who travelled to Scotland.[127]

Another form of expertise that Biscop transferred across the Channel was that of glass-making for he persuaded some Franks experienced in this craft to travel to Monkwearmouth in the north of England 'to lattice the windows of the church and of its chapels and upper storeys'.[128] However, the claim made by Bede that they taught glazing to the English who were unacquainted with the skill[129] needs some comment. Bede here is referring to events in, and following, 675 yet, according to a contemporary, St Wilfrid had already been able to get York Minster reglazed between 669 and 671,[130] and the original foundation (completed before 642)[131] must itself have had glass for Eddius cites, as an example of its disgraceful condition, the fact that birds could now fly through the window openings and foul the interior.[132] Further south, in about 690, Aldhelm was to remark on the windows in the church of

Princess Bugga of Wessex,[133] and, back in Northumbria in the early years of the ninth century, Æthelwulf was inspired by these very lines to give a similar description of the soft light diffused from the sun through the windows of his cell of Lindisfarne,[134] which had been founded between 704 and 716. A twelfth-century monastic artist in Germany was later to comment on those who sought in other lands what they could have found at home,[135] and it may be that Biscop's addiction to foreign travel had led him to bring from abroad what, with more patience, he might have located in England. When, in this context, we consider the skills of the Anglo-Saxons in metalwork and needlework and the fact that, in 664, the kings of Northumberland and Kent could send 'no small number' of gold and silver vessels to Rome,[136] we must also take leave to query Bede's assertion that the reason why Biscop had to procure vessels and vestments abroad was because he could not obtain them in his own country.[137] However this may be, the skill of glass-making that he had brought to Monkwearmouth/Jarrow from the Frankish kingdom had been lost there in less than a century for one of his successors, Cuthbert, was writing to Lull, the archbishop of Mainz, in 764, to ask if he could find makers of glass vessels for him either in his own or another diocese.[138] A quantity of plain and coloured window-glass has, in fact, been excavated from the site of Monkwearmouth/Jarrow,[139] though all that can be said of its date is that it was clearly made before the Viking destructions there of c. 867.

Biscop sought for musicians abroad as well as for craftsmen, and he personally conducted from Rome an instructor in music, the arch-cantor John, who taught the monks at Monkwearmouth the chant as sung in St Peter's.[140] Amongst these musical experts, as amongst the workmen and craftsmen, there were some who were prepared to travel. Eddius not only journeyed from Kent to teach the chant to the churches of Northumbria[141] but, when his master, St Wilfrid, was displaced from York, moved with him again.[142] At the request of Wilfrid's former chaplain, Acca, another singer, Maban, came from Kent to Hexham[143] and, after Rochester had been destroyed by Æthelred, king of Mercia, in 676, the bishop of that see, Putta, became a peripatetic music teacher.[144]

Although the artistic and musical enterprises of Biscop are better documented than those of any other Anglo-Saxon, he was not, of course, the only one to seek special skills abroad. In a letter of 764 Abbot Cuthbert is seen enquiring in Germany for a harpist to come to Northumbria to play a harp which already existed in his monastery,[145] and according to Asser, King Alfred had large numbers of craftsmen (apparently building operatives) 'whom he had gathered from all

nations' permanently around him.[146] At a much later period there is some evidence of Germans travelling to England.

These included merchants who, as subjects of the emperor, were given special privileges in England where they were allowed to winter.[147] Some specialised in the export of Anglo-Saxon works of art, and William of Poitiers remarks on those who were especially knowledgeable in this field and 'who travel to distant lands in their ships and carry the works of the skilled hands' of the Anglo-Saxons.[148] As far as German craftsmen in England are concerned, we know of one at Wilton in the time of St Edith. He was a priest from Trier, called Benna, and he decorated the church there with wall-paintings just before 984.[149] There is also evidence from their names of moneyers from Germany (and other parts of the Continent) in pre-Conquest England.[150] The 'German style' of the pulpit and arches of gold, silver and bronze that Ealdred, archbishop of York, erected over the pulpit of Beverley not long before Hastings[151] perhaps reflected the influence of his year's sojourn in Cologne as the king's ambassador in 1054–5 rather than the presence at Beverley of German craftsmen. However, the Confessor's own partiality towards Germans is indicated by the German element amongst his clergy[152] and by the German names borne by important royal servants under him, such as Henry the treasurer and Theodoric the royal cook. One of his goldsmiths had the German name of Theodoric.[153]

It was the English goldsmith, Mannig, abbot of Evesham, who was however the greatest master craftsman of the Confessor's reign. Such at least was the opinion of the Evesham chronicler,[154] who was not perhaps the most unbiased of sources, though Mannig's reputation certainly extended from Coventry to Canterbury.[155] He died early in 1066 before his country was struck by the disaster of Hastings though for a long time he had borne an affliction of his own. This was paralysis which he endured for most of the last seven years of his life.[156] During this illness, he had been unable to practise his craft though, as the chronicle of his house says, he had made a large number of works of art in his prime. Of these, his greatest masterpiece was probably the gold, silver and gemmed shrine, which had originally been intended for the relics of St Odulph, but which turned out to be so admirable that it was used for the relics of St Ecgwine, the patron saint of the abbey instead.[157]

Mannig was in overall charge of the shrine and the master craftsman responsible to him was a certain Godric.[158] Unhappily for Godric, but fortunately for ourselves, he suffered an accident. 'As this kind of task requires, he [Godric] was intent on the work, again and again casting

and hammering and engraving with a chisel. One day, as he was sitting as usual and with his chisel very carefully fitting together little figures, he suddenly by accident injured his left hand with the tool which he was holding . . .'[159] The injury was severe, piercing through the centre of the hand. It was healed with exceptional speed (immediately, it is said elsewhere) and, because this was accounted a miracle, we are vouch-safed this and other information about Godric. We learn, for example, that he was the father of a son who was to become Prior of Evesham,[160] and we are told that he himself took the cowl at Evesham some twenty years later during the time of Abbot Walter.[161]

These points may seem trivial but their significance is not entirely marginal. They indicate that, at the time of the event, Godric was a secular. And so, too, were his skilled craftsmen, the *artificiosi*. These could not have been monk-craftsmen since they are described as being 'very many',[162] and the whole of the Evesham community in 1058 (which was about the time that the shrine was made)[163] consisted of only twelve monks.[164] Apart from all this, the account makes it clear that the work-force under Mannig had arrived as an established group, or team, with Godric at its head.[165] This means that the actual craftsmanship of the Evesham masterpiece was in the hands of lay professionals. Given this insight, it is significant to learn that Mannig also had secular goldsmiths with him when he was working at Coventry. At least, the account given by Ordericus implies that the goldsmiths were secular for they were free to respond to the summons of a lay woman. 'The devout Countess Godiva', he says, 'bestowed all her treasures on this church, and, sending for goldsmiths, piously dis-tributed amongst them all the gold and silver she possessed to be made into [book-covers for] sacred Gospel-books, Crucifixes, statues of the saints and other wonderful art-objects for the church.'[166]

All this raises the question of whether, at this stage of his career, Mannig was not acting as an overseer: the equivalent in goldsmith's work of a present-day architect: someone who gave a general super-vision and provided initial designs rather than someone who involved himself in the day-to-day workmanship. Indeed, it was perhaps just his responsibility as a superintendent and designer that the chronicler was trying to convey by his description of Mannig as a great *master* of the visual arts for, if we can take the analogy of mints, it was the task of the master – for example the one at Pavia – to supervise and maintain standards amongst the actual moneyers.[167] And, in this context of providing designs, we might consider the contract made by the chapter of Nivelles in 1272[168] even though it is very much out of historic context. This stipulated that two secular goldsmiths, Nicholas of Douai and

Jacques of Nivelles (together with other workmen), should make a shrine 'according to the sketches of Master Jacques, goldsmith and monk of Anchin'.

It is at least certain that, under Mannig, lay craftsmen were fashioning art treasures for a monastery, and so they were also for two other Benedictine communities. The first was at Winchester, where we know that the metalworkers who made the reliquary for the translation of St Swithun in 971 were lay goldsmiths. The language of Wulfstan, a monk at Winchester at the time, is quite unambiguous: 'King Edgar . . . ordered goldsmiths to gather together, all of them skilled, to make a worthy sanctuary [i.e. reliquary] in honour of the father'.[169] They did not work in the monastic workshop, which they would have done had they been monks, but were, says Wulfstan, gathered together by the king at his own residence 'commonly called the great villa'[170] (which was possibly King's Sombourne).[171] There the reliquary was made and, at the actual translation, the people of Winchester walked barefoot three miles out of the city to meet it.[172] The second Benedictine community was at Wilton, where the three goldsmiths employed by King Cnut to make a shrine for the relics of St Edith must have been lay-professionals since, when found guilty of adulterating the precious metals, they suffered a secular punishment for their dishonesty and were blinded and turned out as beggars on the street.[173] These goldsmiths at Evesham, Coventry, Winchester and Wilton were all working in teams and this leads one to ask whether Anglo-Saxon goldsmiths did not normally join together in this way on major commissions, and whether the one who met an untimely death at Montecassino did not himself belong to a group of Anglo-Saxon goldsmiths there.

Given the indifference of monastic writers to the lay world, we can never know the full extent to which monasteries were indebted to secular craftsmen for their own works of art. But, apart from those working on special commissions, other craftsmen were attached to monasteries on a more permanent basis. This was especially true in the tenth and eleventh centuries when – in contrast to monastic establishments of the very early period[174] and except for Christ Church, Canterbury[175] – the numbers of monks tended to be small and their estates large. Between 965 and 1066, the monks at the two important monasteries of the Old and New Minsters at Winchester averaged about forty and fifty; there were only twenty-six at St Benet's of Holme in 1020, and, at the time of Hastings, Evesham and Worcester had only about a dozen monks each.[176] Yet, by this time, many of the monasteries were great landowners with the need for numerous dependants to maintain their buildings, services and estates, and the Domesday

inquest reveals, for example, that Bury had seventy-five servants or workpeople.[177] If, in about 1042, the monastery and church of Cluny had so many secular goldsmiths and glaziers that they had a special workshop for them (as we know from the *Ordo Farfensis*), then we might assume that the more important English monasteries also had need of specialised secular craftsmen. Of these, there are only fleeting glimpses in the English records. Here, we discover that a mid tenth-century scribe held land at Worcester on condition that he copied books for the monastery there[178] (apparently not all monastic manuscripts were made by monastic scribes). Here also we find references to secular metalworkers. One was Leofwine the goldsmith who, according to Domesday Book, held land of the abbot of Abingdon,[179] perhaps in exchange for his own services. Another was a certain 'truthful' smith at Winchester, who was visited by St Swithun in a vision about 968.[180] He was attached to the Old Minster in some capacity and could hardly have been a monk since he was free to travel to Winchcombe. Yet another was a secular goldsmith at the nunnery of Barking in the second half of the tenth century who was brought to attention because he unhappily demonstrated the prescience of its saintly abbess. When reproved for his extravagant ways by St Wulfhild, he had the temerity to answer the abbess back and this earned him a prognostication about his fate which, coming from less holy lips, might have been set down to irascibility. But, since the goldsmith met with the unhappy death predicted for him, the comment was attributed to her gift of prophecy.[181]

It is the nature of our sources that these stray references to lay craftsmen attached to monasteries or nunneries are highly exceptional. And there is no comment at all on whether a powerful house, such as Canterbury or Bury, made use of the expertise which existed on its own doorstep in the form of a mint run by secular and highly skilled goldsmiths, though it would be remarkable if they did not.

If a monastery was to be founded or enlarged, a secular workforce would of course be recruited, though details are rarely given unless, as with the building at Monkwearmouth, the chronicler was exceptional, or the circumstances unusual. At Ramsey, towards the end of the tenth century, those engaged in building operations were supervised by the prior, Eadnoth.[182] At Abingdon, under Æthelwold, a few years earlier, there were both skilled and unskilled workmen engaged in the rebuilding.[183] The account tells us that the monks themselves joined the labour force – apparently with more goodwill than good fortune, for one of them, named Goda, fell from the top of the roof where he had been working with the masons.[184] Surprisingly enough he suffered no injury –

unlike Æthelwold himself who had half his ribs crushed in an accident[185] which probably happened on the same site. A similar accident occurred during the building of the church at Hexham between 672 and 678:

Now while the masons were constructing the highest part of the walls of this building, a certain young man among the servants of God slipped from a pinacle of enormous height, fell to the ground and was dashed upon a stone pavement. His arms and legs were broken, all his limbs were out of joint and he lay breathing his last . . .[185]

The youth's name was Bothelm, and he is introduced into the narrative because his recovery was ascribed to the prayers of St Wilfrid. The writer, Eddius, was interested not in the man but in the miracle.

All this information is scattered and fragmentary. But, when we take into account the almost complete indifference of monastic chroniclers to lay craftsmen and the entirely incidental nature of these references, then even this evidence offers quite significant testimony to the degree to which secular craftsmen were involved with monasteries – whether in the production of works of art or in the maintenance and construction of monastic buildings. This close association may explain the easy relationship between the monk and lay craftsmen implied in Ælfric's *Colloquy*, which reflects the real world, despite the fact that it is a contrived school-room exercise. All this should never, however, lead us to underestimate the importance to Anglo-Saxon art of monasticism. As we have seen, abbots and abbesses, inspired by the psalms, were only too ready to emulate David in their anxiety to bring beauty to the House of God and, whether the executants were monks or laymen, there can be no doubt that this monastic delight in beauty provided a great stimulus to Anglo-Saxon art and Anglo-Saxon artists.

Monastic craftsmen who became heads of monasteries were still willing to continue their artistic work – at least in a supervisory sense – and this was true of some monastic bishops also. The enthusiastic biographer of that early ecclesiastic prince, St Wilfrid, even claimed that he was personally responsible for the design of the church of his monastery of Hexham in the seventh century.[187] In the world outside, persons of the very highest rank were prepared to take an interest in the crafts. King Alfred was one of the most hard-pressed of all Anglo-Saxon kings but, according to Asser, he 'did not cease . . . to instruct . . . all his craftsmen and . . . to erect buildings' surpassing those of his predecessors.[188] Later – as both Wulfstan and Ælfric testify[189] – King Eadred made a special journey to Abingdon expressly 'to plan the structure of the buildings for himself. With his own hand he measured all the foundations of the monastery exactly where he had decided to raise the

walls.'[190] A reliable source claims that the Confessor's queen, Edith, used to encourage the workmen in the rebuilding of the nunnery at Wilton,[191] which was dedicated in 1065. It was a religious centre with which she had a special connection since she had been educated there, and a picture made only two or three decades earlier (purportedly to illustrate God witnessing the construction of Babel) shows the building methods of the Anglo-Saxons of the time (Plate 12). Edith was not, however, content simply to supervise others for she had a particular skill of her own. This was embroidery.

Like her namesake, King Edgar's daughter, Queen Edith was an expert embroideress. Osbert of Clare spoke with approval of her distinction at this craft,[192] and a second and more reliable chronicler[193] who, like Osbert, could make use of a contemporary source perhaps commissioned by Queen Edith,[194] added that the garments in which the Confessor was clothed at great feasts were 'interwoven with gold which the queen had most sumptuously embellished'.[195] These secular skills only interested chroniclers when they were associated with royal persons, or saints or monasteries. Even so, there are clear indications that some ladies of the aristocracy were involved with the highly specialised craft of gold embroidery. The *Liber Eliensis*, for example, records that, in the reign of Cnut, a noblewoman called Æthelswith was making gold embroidery for the monastery of Ely.[196] A few decades earlier, according to a contemporary, a noblewoman, named Æthelwynn, called Dunstan 'to her with a friendly request that he himself should design for her a stole for the divine service with various figured patterns, which she could afterwards embellish and diversify with gold and precious stones'.[197] Whether any of these noble ladies was fulfilling the ideal of 'a Christian young lady' of one of George Eliot's novels[198] some hundreds of years later and personally nurturing 'the care of her soul over her embroidery in her own boudoir' is uncertain. We are specifically told that they had women to help them in their craft. These women were clearly servants, perhaps even slaves,[199] and, given the ambiguity of the Latin for 'making' a work of art, we must ask ourselves whether the noble ladies were themselves making gold-embroidery or simply establishing the designs and supervising others, as we have suggested Mannig did when he 'made' his greater shrines. The same applies to the work of Queen Edith also. The answer may vary from person to person.

That some parents were particularly anxious for their daughters to acquire the highly esteemed craft of gold-embroidery is indicated by an entry in Domesday Book. This reveals that a Buckinghamshire sheriff prized the accomplishment so much above the finer points of his office

Hanc turrē. nembroth gigas construxit. Qui p̄ confusione lingua
rū migrauit ide ad psal. eosq̄; igne̅ colere docuit.

**12** God witnessing the building of Babel; Canterbury (St Augustine's), second quar-
ter of eleventh century (British Library, Cotton MS. Claudius B IV, fol. 19).

suggestion of literature is borne out by the evidence of history, and we know, for example, that in 949 King Edgar gave land in the Isle of Wight and in Wiltshire to one of his goldsmiths – 'to a man of mine called Ælfsige because of his diligent and devoted service to me in gold and silver work'.[258] In other ranks of society, a thegn, like Æfhelm Polga in Cambridgeshire, could reward his goldsmith with a gift of land,[259] and the land which the goldsmith, Leofric, held of Godwin in Huntingdonshire in the tenth century[260] was presumably in exchange for his professional services. It is in Domesday Book that we can see to the full the wealth that could be attained by the most favoured goldsmiths. One is recorded as owning land in three counties – Surrey, Berkshire and Oxfordshire[261] – and a second as holding, or administering, land in another three counties – Cambridgeshire, Essex and Suffolk.[262]

Without aspiring to such affluence as this, other craftsmen could still achieve some fortune, particularly if they could attract the right kind of patronage. A painter called Wulfnoth had fifty-five acres of land to dispose of in Northamptonshire between 963 and 992.[263] A scribe of King Æthelred's owned three estates in Oxfordshire.[264] Teinfrith, a 'church-wright' of the Confessor, was in possession of an estate in Middlesex with judicial and financial rights and exemptions.[265] An embroideress named Leofgyth held an estate at Knook, which supported four villages, four smallholders and a serf.[266] But this was after the Conquest, and in 1066 it had belonged to her husband.

Written twenty years after the Conquest, during which time England had seen one of the most abrupt social changes in its history, the great census of William I must be taken cautiously as evidence for the past, except where tenures of the Anglo-Saxon period are specifically mentioned. In some ways it shows a deviation from the past, especially in the new use of Norman masons[267] and in the increasing patronage of German goldsmiths,[268] though the partiality for Germans was a trend already to be seen under the Confessor,[269] and moneyers with Germanic names who had immigrated from the Continent were already well known in the reign of King Edgar.[270] There was, however, some continuity. In Wiltshire the Anglo-Saxon embroideress, Leofgyth, whom we have mentioned, continued to make gold embroidery for the Norman king and queen as she had for the Anglo-Saxon ones.[271] One goldsmith, who had earlier served the Confessor and held land from him at Kennington, was greatly enriched by the Conqueror.[272] In Berkshire a goldsmith, who had held Shotterbrook of Queen Edith, had a goldsmith son, named Alward, who also held it of King William.[273] Known in the twelfth century as Shotterbrook Goldsmith,[274] this estate

traditionally provided for the upkeep of the royal goldsmithies. We can read, then, into this entry not only some continuity with the Anglo-Saxon past but also the existence already of a hereditary tenure amongst goldsmiths that becomes more fully documented later.

We meet goldsmiths in Old English poetry and also in Domesday Book, which further records their female equivalent, the expert in gold embroidery. It is curious, then, to discover that neither in poetry nor in this great survey do we encounter the stone-carver or the painter. Domesday Book refers to stone-masons,[275] carpenters,[276] smiths in large numbers,[277] and even a so-called 'engineer',[276] but not to these craftsmen. Again, although the reconstructed Winchester survey of c. 1056–9 mentions a goldsmith,[279] a blacksmith,[280] a swordmaker,[281] and even a turner[282] (who presumably fashioned furniture and fitments for buildings), it has nothing to say of sculptors or of painters. It is true that these Winchester surveys are restricted, since they are limited to royal properties. But the absence of painters from the Anglo-Saxon one is thrown into relief by the fact that no fewer than five are referred to in the survey of 1148.[283]

The Anglo-Saxons were little concerned with niceties of definition, or differentiation, within the crafts, and we earlier find them using the Latin term *architecti*, which we would normally translate as *architects*,[284] to indicate those supervising work on a building, the stone-masons who actually worked on it, and the master-craftsmen in stone-work who presumably embellished it.[285] We might, then, explain the absence of the stone-carver from the surveys of Anglo-Saxon holdings by the assumption that this specialised craft was subsumed under the general trade of stone-masonry. This suggestion is given some support from the fact that the maker of a simply decorated surviving font describes himself as a stone-mason and a craftsman.[286] The absence of painters cannot however be explained in this way. There was no other obvious craft to embrace them. And the answer to this problem has to be more speculative.

On the Continent, wall-painters travelled over large distances from one commission to another. In the eleventh century Otto III summoned a wall-painter from Italy to Aachen,[287] who then travelled on to Flanders.[288] During the same period, another Italian wall-painter was working in France.[289] As it happens, Benna, the only wall-painter of an Anglo-Saxon church actually known to us by name, had also come from afar: he was from Germany, though he had been brought to Wilton to act as chaplain[290] to the daughter of a king and not primarily as an artist. His sojourn for England may, indeed, owe something to the fact that he came from Trier,[291] for the archbishop there, Egbert, had

English affiliations,[292] being the son of an English mother. All the same, this travelling of wall-painters raises the question of whether they went unrecorded in the English surveys because they were peripatetic. The hypothesis has some attractions but the evidence from the Continent suggests that the painters who travelled such distances were probably only a few at the peak of their profession.

A more promising line of enquiry lies in the fact that Anglo-Saxon wall-paintings had associations with gold. We have only three descriptions of Anglo-Saxon wall-paintings and two had gold in them.[293] Furthermore, we know that goldsmiths could be painters: at least, the only two goldsmiths of whom we have extended accounts, Spearhafoc and Mannig, are also described as painters:[294] painters of manuscripts, it is true, but, to judge from the tiny fragment of a wall-painting that survives from Winchester,[295] wall-paintings could be similar in style, and even in scale, to manuscript-paintings. Surviving mural-paintings on the Continent, like the ninth-century ones from the crypt of St Maximin at Trier,[296] indicate the same close association between wall-paintings and manuscript-paintings. Possibly, then, pre-Conquest painters are not mentioned in the Domesday and Winchester surveys because the paintings were made by goldsmiths.

Except for the generality of this suggestion, there is nothing untoward about it since we know that, occasionally, individual metalworkers on the Continent during the Anglo-Saxon period (such as Bernward of Hildesheim)[297] were also painters, and that, later, two of the greatest goldsmiths of twelfth-century England – Anketil of St Albans[298] and Hugo of Bury[299] – painted manuscripts. The linear emphasis both of gold-engraving and of Anglo-Saxon drawings and paintings must have meant, in fact, that the artistic skills of the goldsmith-engraver and the painter were very similar. This is clear from the figures on a surviving Anglo-Saxon silver-gilt portable altar, which are so close to contemporary paintings and drawings that, on this evidence alone, we can suppose the goldsmith to have been also a manuscript-illustrator, and, by extension, perhaps a wall-painter, too. If we compare one of the engraved figures – that of St John – with the detail of a figure of St Paul in a Canterbury drawing also of the early eleventh century (Plates 14 and 15), we shall see the same sketchy quality of line in each and the same drapery style characterised by a fluttering hem near the ankles, a deep zig-zag hem-line over the knees and a loop of tucked-in material at the waist. This style is particularly familiar in Anglo-Saxon drawings and paintings,[300] and is found again and again.

If goldsmiths were also painters, then there would be some parallel between wall-painting in Anglo-Saxon England and print-making in

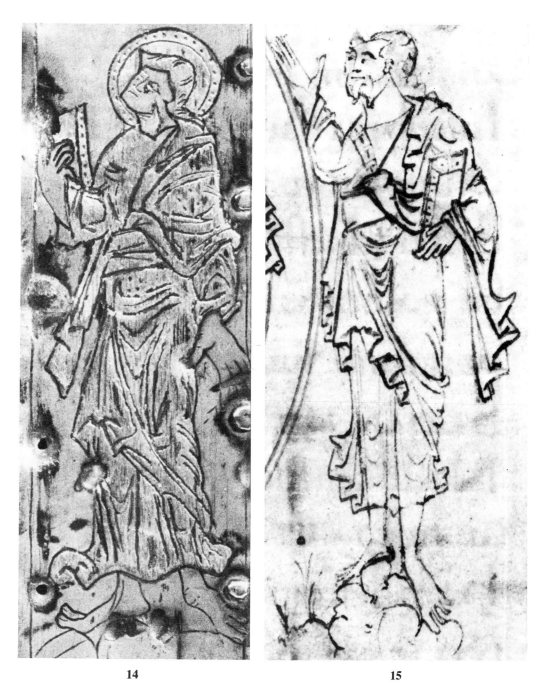

**14**    Detail of engraving of St John from a small portable altar of the first half of the eleventh century in the Cluny Museum, Paris.

**15**    Detail of St Paul from a Canterbury drawing of the first half of the eleventh century (Florence, Biblioteca Medicea Laurenziana MS. Plut. XVII. 20, fol. 1).

Northern Europe in the fifteenth century for, between 1430 and 1470, engraved prints were also mostly produced by the goldsmiths. And, if Wulfnoth, the single secular painter known to us by name, was also a goldsmith, then this would account for his wealth. In all this there is an encouraging element since, if goldsmiths did turn their hands to painting, then we can get some idea of the engravings on the lost shrines, reliquaries, altars, vessels and so on, from the manuscript-paintings and drawings that survive. Indeed, the dynamic lion of the Echternach Gospels (Plate 18) has itself all the appearance of a vigorous brooch, and many of the gilded illuminations (Plates A, B, C, D, E) have obvious associations with goldsmith's work.

In Anglo-Saxon society, talented artists working in the right materials for the right patrons could clearly earn handsome rewards. There is even a passing – if equivocal – reference to their ability to achieve some fame. This is in the unhappy context of the story of the three secular goldsmiths who were commissioned by Cnut to make a shrine for St Edith but who adulterated the precious metal and were savagely punished. The comment of the later chronicler on this episode is that 'They were first famed for their skill and then notorious for their crime'.[301] There is too much interest in balance and rhythm and sheer rhetoric in Goscelin's description for much weight to be given to any particular word or words in it, but it does suggest that Anglo-Saxon secular artists could enjoy some celebrity. It is true that this seems to be the only reference to the fame of the artist-craftsman in secular society. However, if the monastic artist could achieve a wide enough esteem within the network of the Benedictine community to be asked to travel from one part of the country to another, and, if a monastic work of art could apparently still be known by the name of its maker a century and a half after it was fashioned,[302] then, within his own framework of society, a secular artist could probably achieve some renown. The fact that Ætheling Athelstan names the maker of his silver-hilted sword and gold belt and armlet[303] certainly indicates that there were local reputations to be won. Artists in the Middle Ages signed their works for more than one reason but the 'signatures' on Anglo-Saxon coins come into this context of artistic reputations. There were something like seventy mints functioning in England during most of the late Anglo-Saxon period,[304] and, without entering into the highly specialised field of numismatics, we can at least take note of the fact that many of these mints employed highly accomplished goldsmiths. Little is known of them apart from their 'signatures' and their surviving work.

Little indeed is known of any Anglo-Saxon artist as an individual, and none emerges as a fully rounded artistic personality despite the

most thorough combing of our sources. Their identities and personal achievements are mostly veiled from us by a fog of anonymity. We are lucky if we can catch fleeting glimpses of the work of a Mannig or a Spearhafoc in the monastic sphere, which is much more than we can discern in the more important secular area. Any conclusions about them must, then, be couched in the most cautious of terms. We can claim a certain versatility for some artists which might allow an illuminator to be a calligrapher, and a goldsmith to be a painter. We can see that some artists travelled to different parts of the country, and even abroad, on various commissions. We can deduce that important monastic art treasures were made by secular goldsmiths, and we can suggest that these latter often worked in teams. We get a hint of the fact that craftsmen's workshops were already being assembled in streets. We can get small insights into the importance to secular craftsmen of attachments to wealthy households. We can show that some categories of craftsmen were admired abroad, that most received a proper degree of respect at home, and that their prestige was graduated in terms of the costliness of the material used. This probably meant that the finest artists gravitated towards the crafts in precious metals where the social esteem was higher and the rewards greater. This was the area also favoured by the literary sources for, as we have already seen in general terms and the next chapters will display in more detail, the works of art that interested writers most were those in gold and silver. It is, however, the arts which attracted writers least that we shall discuss first.

# CHAPTER IV

# PAINTING AND CARVING

When St Augustine approached the pagan king Æthelberht in 597 to make his first conversion amongst the Anglo-Saxons, he was accompanied by a picture of Christ the Saviour.[1] Figure painting came with Christianity to England.

Not that such painting had been unknown in England before. Along with mosaics, it had featured in the adornment of villas during the Roman occupation and had even presented Christian themes. The earlier infiltration of Christianity under the Romans had left its own artistic record: for example, fragments ascribed to the fourth century and pieced together from the Lullingstone Villa in Kent represent Christian symbolism and Christians at prayer.[2] What was new was the fact that St Augustine's mission had been inspired by a pope especially anxious to use art as a means of instructing the ignorant and the pagan: 'For what writing is to the reader [Gregory the Great had written to one bishop] painting is to the uneducated, for the perceptive can 'read' a painting even if they do not understand letters. Therefore painting is especially suitable for pagans [*gentibus*] instead of reading matter.'[3] Gregory the Great's ideas would have been well known in the monastic circles at Rome from whence St Augustine and his companions were drawn, and they would no doubt have been reiterated to Augustine once he had been selected to head the papal enterprise – he was certainly plied with advice from Rome when he was in the mission field in England. We may assume that these early missionaries were well aware of Pope Gregory's firmly held views on the importance of painting in explaining Christianity to the uninitiated.

The exact details of the first artistic programmes are, however, unknown. The earliest extant descriptions of Christian paintings occur only eighty or ninety years after St Augustine's mission. They are Bede's accounts of pictures which Benedict Biscop introduced into his joint monastery of Wearmouth/Jarrow between 675 and 686.[4] These took the form of panel-paintings[5] which Biscop brought back from his journeys to the Eternal City.

Using boarding which extended from one wall to another, Biscop set up some of these panel-paintings across the central vault of the church of Monkwearmouth – perhaps across the arched entrance to the sanctuary. These represented the Madonna, together with portrayals of the twelve apostles.[6] Other panels with depictions of the Gospel story he placed on the south wall, and yet others with illustrations of the visions in St John's Apocalypse on the north. Later, he hung pictures presenting incidents from the life of Christ all round the church, high up. The result must have looked something like a picture-gallery, though – in accordance with the principles of Gregory the Great – Biscop's own interest was not to delight the eye but to enlighten the soul, and it is significant that, in his description of them, Bede (who had been a pupil of Biscop) refers to the precepts of Pope Gregory. He remarks that these pictures would benefit the unlettered by reminding them, on the one hand, of the grace of God and, on the other, of the perils of the Last Judgment.[7] Here in fact, in visual form, was an extensive statement of the beliefs, hopes and fears that the church wished to instil in the Christian.

A more sophisticated message was presented by panel-paintings which Biscop displayed in the church of his other monastery at Jarrow. He

arranged them most methodically to show the correspondence of the Old Testament and the New. For example, he juxtaposed the painting of Isaac carrying the wood on which he was to be sacrificed with one, just above, of Christ bearing the Cross on which he also was to suffer. He also matched up the serpent raised by Moses in the desert with the Son of Man raised up on the cross.[8]

Such visual concordances of the two Testaments were not new. They had begun in theological terms as attempts to reconcile the Old and New Testaments, and this had led to incidents of the former being interpreted as parallels, or analogies, of the latter. Even in the New Testament itself, St Paul had said that, as well as their literal meaning, the events of the Old Testament had a symbolic application to later times,[9] and St Peter had specifically seen the saving of souls by Noah's Ark in the Old Testament as an analogy of baptism in the New.[10] These theological relationships were developed to a high degree by the early Fathers who brought much poetic inspiration to their interpretations and, from a very early time, they were also represented in art. For example, verses left by Prudentius[11] in the fourth or fifth centuries and by Rusticus Helpidius[12] in the sixth already describe pictures in which themes of the two Testaments are figuratively, or mystically,

associated. The many parallels include one between the Israelites crossing the Red Sea and Christ walking on the water: another between the Israelites being fed in the desert and the feeding of the five thousand: and another between Joseph being sold by his brothers and Christ being sold by Judas. The most obvious parallel of all was that between the sacrifice of Isaac and Christ's sacrifice on the Cross. It was present in the pictures described by Rusticus Helpidius, and also in the paintings Benedict Biscop brought back from Rome. It has even survived into the contemporary art of today for, in his *Message Biblique*, Chagall has associated the sacrifice of Isaac with Christ carrying His Cross.

What exactly the panel paintings in Biscop's churches looked like we do not know. Since the church of Monkwearmouth is known to have been eighteen and a half feet (5.6 m) across,[13] it has been estimated that the panel-paintings of the Madonna and apostles, set on the boarding that spanned it, were each not more than seventeen inches (43 cm)[14] wide. This assumes that they were placed side by side in a single row[15] whereas, in view of the extraordinary height of the nave (some thirty feet: over 9 m), they may have been set in rows above each other.[16] The small 'framed' pictures which feature on a page of the St Augustine Gospels are placed above each other in this way[17] and may themselves have been derived from panel-paintings in Italy. Alternatively, the figure of the Virgin may have dominated the central area as she does, for example, in an eighth-century ivory carving (Plate 16), or as St Luke does on another page of the same St Augustine Gospels.[18]

The actual depictions on the panels of the Apocalypse at Monkwearmouth have attracted speculation. This has been prompted by the belief that the illustrations of two Carolingian manuscripts of the Apocalypse (Paris, Bibliothèque Nationale, nouv. acq. lat. 1132 and Valenciennes, Bibliothèque Municipale MS. 99)[19] derive from Italian models of roughly the same period as Biscop's pictures,[20] and that one of them (the Valenciennes manuscript) betrays signs of an English intermediary in its decoration.[21] There was, however, already a strain of English influence on the Continent[22] when this latter manuscript was made, and whether the Anglo-Saxon features were absorbed locally or brought from England is unknown. Even if they had come immediately from across the Channel, it would still need to be shown that the Valenciennes illustrations were derived from Biscop's pictures and not from another illustrated manuscript of the Apocalypse which had been brought – as were so many other manuscripts – from the Mediterranean to England, before they could be seriously related to the panel-paintings at Monkwearmouth.

We have no real knowledge of how these seventh-century Roman

16  Ivory carving of the Virgin, flanked by candlesticks, between apostles and symbols of the evangelists, second half of the eighth century (Munich, Bayerisches Nationalmuseum).

panel-paintings appeared, though it can be demonstrated how two of
their themes were treated on panels of the next century by the Anglo-
Saxons. These, however, are ivory panels, and are no doubt quite
different, and they are only known to us because they have survived.
The first ivory panel is of the Virgin with the twelve apostles, though
here the symbols of the evangelists are included as well (Plate 16). The
second is of the Last Judgment – the earliest developed representation
of it known to us in the surviving art of the West (Plate 17).[23] Trumpeters
sound the last trump. Corpses – their souls represented in the tradi-
tional form of birds – rise from their coffins. The enthroned Christ
invites the blessed to the Kingdom. The saved are received by an angel
below, and the damned huddle before the mouth of hell.

   The primary source of our knowledge of the panel-paintings at
Monkwearmouth and Jarrow is Bede's history of the abbots there, but
it has been discerningly pointed out[24] that Bede also mentions them in
two sources which are much less well known. One is his homily on
Benedict Biscop. In this, Bede remarks that the great abbot had
brought these paintings to decorate the church, to instruct the
spectators and further to enlighten those who could not read, for, by
gazing on the pictures, the unlettered could learn of the works of our
Lord and Saviour.[25] The other source is Bede's commentary on the
Temple of Solomon, written shortly before 731. In this, specific refer-
ence is made to the theme of Moses raising the brazen serpent in the
desert and its New Testament analogue of the Son of Man being raised
on the Cross. But, here, Bede's focus of attention is not the ways in
which the Old Testament could anticipate the New, but the ways in
which the Old Testament could justify the New in art – a subject of
critical importance for all the visual arts of the Middle Ages.

   From time to time in this long period, uncertainties were felt about
the propriety of any representational art. Feelings in the Western
church never reached the extremes in the Eastern one where
iconoclasm, or the destruction of Biblical figures in art, became at times
a policy that was not only advocated but firmly enforced. Nevertheless,
an uneasiness about the subject percolated into the West and it is just
this feeling of disquiet (probably recently communicated from the
East)[26] that Bede was trying to assuage. The anxieties, as he himself
recognised, originated in God's commandment prohibiting the making
of a likeness of anything on earth or in heaven (Exodus XX. 4). These
were fears generated by the Old Testament, and Bede set about confuting
them by reference to the Old Testament itself. In particular, he showed
that Moses and Solomon had both approved the representation of
living things: Moses, on the instructions of God Himself, had had

**17** Ivory carving of the Last Judgment, late eighth or possibly early ninth century
(London, Victoria and Albert Museum).

cherubim portrayed on the mercy seat of the ark, and a serpent of metal made in the desert. (Exodus XXV. 12–20; Number XXI. 89): Solomon, in his temple, had set up various representations including those of palm-trees, cherubim, oxen and lions (3 Kings, A.V. 1 Kings, VI. 29 and VII. 24–5, 29, 35–6):

Now, if it were permissible to lift up a brazen serpent on a piece of wood so that the Israelites who beheld it might live, why should it not be allowable to recall to the memory of the faithful by a painting that exaltation of our Lord Saviour on the Cross through which He conquered death, and also His other miracles and healings through which He wonderfully triumphed over the same author of death . . .?

. . . If it was permissible to make twelve brazen oxen . . . what is to forbid the painting of the twelve apostles who went to teach all peoples . . . and thus, as it were, to place a living writing before the eyes of all?

And again, if it was not contrary to that same law to make sculptured images . . . why should it be considered contrary to the law to sculpt or to paint on panels the stories of the saints and martyrs of Christ . . .?[27]

God, argued Bede, had not prohibited representational art in general but images for pagan worship in particular, and, in following up this point, he turned also to the New Testament. Here, he pointed out that, when Christ was shown tribute money impressed with the name and image of Caesar, His only reaction had been to say: 'Render unto Caesar the things which are Caesar's: and unto God the things which are God's' (Matthew XXII. 21). In other words, He took no exception to the likeness of Caesar before Him, and made no remark about it being contrary to the Divine Law and a source of idolatry. This He would have done, had He conceived it to be a source of error.[28]

The anxieties that Bede was trying to contain were very real ones. They were strengthened, of course, by the fact that the forms of paganism most publicised by the Church itself were those based on figural representations or idols – be they of Jupiter and Venus on the one hand, or of Wodan and Thor on the other (the names of the deities in the two forms of paganism tended in any case to become interchangeable). In his writings, Bede gave various reasons for considering representational art both permissible and desirable and these can be brought together and summarised under five headings. First, such art provided a visual message of Christianity which could reach out to those who could not read. Secondly, it offered constant reminders of Christ's sacrifice and Christ's powers to the Christian. Thirdly, it contributed decoration to the churches. Fourthly, it helped give in-

struction to the faithful. And, fifthly, it had been approved by God's servants, Moses and Solomon, in the Old Testament, and condoned by His only begotten Son in the New. The first of these arguments derives, of course, from Gregory the Great but – until contrary evidence is forthcoming – we must suppose that the others came from Bede himself. And this may have been of significance for the future.

In the latter part of the eighth century under pressures from Eastern Christendom, the whole question of representational art in the West reached such a point of crisis that Charlemagne was driven to issue a treatise in its defence – the *Libri Carolini*.[29] The length of this document is itself an indication of the anxieties of the period and so, too, is the density and subtlety of its arguments where 'political' feelings are very much involved with artistic ones. Now, the erudite author of this tract[30] knew one or two of Bede's works[31] and, like him, allows that the actions of Moses and Solomon validated figural art[32] and, like him, refers to the episode of the tribute money,[33] though placing a somewhat different interpretation on it. More importantly, the two primary arguments he uses are those earlier adduced by Bede: namely that figural paintings are to be supported because they offer a perpetual reminder of Christ and His saints, and because they provide decoration for the churches – 'in memoriam rerum gestarum et ob ornamentum ecclesiarum'.[34] In this labyrinth of theological discussion, it is difficult to define exactly the extent of Bede's influences but they certainly seem to be here, however suffused they may be. In other words, Bede's writings had some part to play in justifying the whole future of representational art in the West.

No stress needs to be given to Bede's importance in reporting paintings of the early period of Christianity in England for it has always been recognised that his account of artistic themes within an Anglo-Saxon church is the earliest and the most comprehensive. It is only unfortunate that in this he was not imitated by the writers who followed. They refer to one or two separate subjects – for example, portrayals of saints (especially patron saints): incidents from the Gospels and the Apocalypse: the Crucifixion, which was always vitally important (though, in fact, it is implied rather than actually described by Bede). But these never again appear in the context of such an overall programme as Bede's. And when artistic subjects are mentioned, it is normally only because they are represented in precious materials. Writers of the future were to take little notice of paintings. Bede himself, we may observe, was little interested in Biscop's paintings as works of art – he has nothing to say about their style, their size or their colours. He did not turn his attention to them because he was a connoisseur of art, but because he was, in a sense, a 'missionary' who saw them as drawing

men to God, a historian who saw them as a link between Monkwear-mouth/Jarrow and Rome, a theologian who was interested in their Scriptural themes. Later chroniclers were as little interested in the beauties of paintings as was Bede but they lacked his 'missionary' zeal and – unlike him – they were not historians in any deep sense, nor theologians in any detailed one.

That wall-paintings existed in the Anglo-Saxon period is certain. A partial wall-painting of angels supporting a mandorla at Nether Wallop in Hampshire is claimed as Anglo-Saxon,[35] and it has been persuasively suggested that Cynewulf's poem on the Ascension was partly inspired by a church-painting on this theme.[36] In this area of art, excavations have been disappointing, though a significant fragment has been unearthed at Winchester which may have originally decorated a monastic stone dormitory, perhaps commissioned by King Alfred himself. It shows the partial remains of three figures, one of which retains almost a complete head, and was certainly made before 903 since the stone on which it was painted was re-used in the foundations of the New Minster which was consecrated in that year.[37] In the written sources, however, references to wall-paintings are rare.

It could be argued that this meagreness of information reflected their infrequency of use, and that the Anglo-Saxon partiality for wall-hangings meant that wall-paintings and panel-paintings had little part to play in their churches. There is probably some truth in such a surmise, but a more demonstrable factor is the prejudice in favour of the most costly arts evinced by writers not only in England but on the Continent. For them, paintings were too inexpensive, too ordinary, to evoke comment. A similar attitude is apparent in the field of pottery, which, as we know from archaeological finds, was produced in vast amounts, but which goes almost unmentioned in the written accounts of the period. When, in fact, Anglo-Saxon wall-paintings are referred to by writers, it is usually because their humble status has been redeemed by some affinity with a saint, or by some especially precious pigment.

If twelfth-century writers were sufficiently interested in the seventh-century church at Hexham to remark that it was originally embellished with paintings and carvings,[38] this was because it had been founded by a saint, St Wilfrid, who was even said to have designed it.[39] Again, if more detailed and better authenticated descriptions exist of paintings made at Wilton just before 984, this was because they were devised by a saint – St Edith.[40] They portrayed Christ's Passion and the church's patron saint, St Denis, and had the added attraction of costly ingredients, such as gold and azure. A reliable eleventh-century description of these wall paintings exists,[41] but the most detailed account is in a

fifteenth-century poem[42] which draws on earlier sources now lost to us:[43]

> The passione of god was welle peyndud there
> And the sepulcre of gode was peyntede there also
> And the ymage of seynt Denys w^t other y-fere
> W^t golde and asere and mony other coloures mo.[44]

The reason why paintings made at Beverley at about the time of the Conquest attracted comment was also, no doubt, because of the gold incorporated in them. We are informed that Ealdred (archbishop of York, 1060–9) 'covered all the upper part of the church from the choir to the tower . . . with painter's work which is called ceiling-painting, which is intermingled with gold in various ways and in a wonderful fashion.'[45] The information here is slight, but it does suggest that – like the most costly manuscript paintings – some of the wall-paintings of the Anglo-Saxons gleamed and glittered with gold. There may also have been the same allurement of gold in the contemporary murals of a church near Abingdon. It is true that the brief description of them makes no mention of precious metals but neither do the early and brief accounts of the paintings at Wilton, and we only know of the gold used there because of information preserved in a late mediæval poem. However, all that we are actually told about the pictures near Abingdon is that, in the years before 1066, a wealthy priest, named Blacheman, built a church and cloisters at Andresey which 'were adorned everywhere, inside and out, with paintings and carvings delightful to see'.[46]

The fact that Anglo-Saxon wall-paintings at Glastonbury, which were neither associated with saints nor enriched with gold, were described in the twelfth century is due to the fact that the writer, William of Malmesbury, was one of those very rare chroniclers in the Middle Ages to share Bede's sense of the historically significant. He took a special interest in the antiquity of the venerable abbey of Glastonbury. Age, he remarked, had drawn the mist of oblivion over the identity, actions, and memory of its earliest abbots who were buried there, but the names of three of them – Worgret, Lademund and Bregored – were displayed in a picture.[47] Apparently this was not simply a painted inscription for he said of an abbot of the ninth or tenth centuries, called Stiward: 'Paintings testify that his habits did not conflict with his name, for, each time he appears in them, he is shown with a scourge or a birch'.[48] There were, then, commemorative paintings of Anglo-Saxon abbots at Glastonbury, possibly – though this is not stated – to mark their tombs. There must also have been Anglo-Saxon depictions of the greatest of the abbots of Glastonbury, St

Dunstan, when he was archbishop of Canterbury for, not long after the Conquest, Osbern observed on the resemblance between a priest of the locality and St Dunstan as he was known from representations.[49] Since we must presume that the fire that gutted the cathedral in 1067 destroyed any of its murals, it is not probable that these likenesses took the form of wall-paintings. Perhaps they appeared in manuscript-paintings.[50] As we have seen, a surviving Anglo-Saxon manuscript does have a small drawing of St Dunstan in obeisance before the Almighty (Plate 8), though it is too small to offer a likeness.

Unlike the wall-paintings of the Anglo-Saxons, their manuscript paintings and drawings have survived, and survived not only in large numbers but in admirable condition.

The manuscript has, of course, always been an essential element of Christianity for it was in a manuscript – the Book of the Gospels – that the divine word of God was revealed. In Christian art, Christ Himself is portrayed with a book, and it was by books that Christianity was spread. When St Augustine had begun his work of conversion, he was sent 'many books' by Gregory the Great.[51] When in their turn, the Anglo-Saxons initiated their own missionary activities in Germany, their leader, St Boniface, was never without his own small library.[52] Later, it was by bringing Anglo-Saxon scribes to the Continent to build up the libraries of monasteries there that he consolidated his work of evangelisation.

As the assassins of St Boniface, the Viking plunderers of Canterbury and the administrators of the Protestant reform movement in England all discovered, the recoverable value of the materials used in manuscripts is insignificant. But this does not mean that they were inexpensive in the first place. The special attention that writers gave to the three Pandects, or Bibles, made for Ceolfrith at Wearmouth/Jarrow between 680 and 716[53] may seem unusual until we learn that the skins of some 1,550 calves were needed for their vellum leaves.[54] This, it is true, was highly exceptional since the manuscripts were of such considerable size. But more ordinary manuscripts required calf-skins which might otherwise have been sold, or used for foot-wear or garments. These skins, furthermore, had to be unblemished. There is record of a twelfth-century English monastic artist at Bury sending especially to Ireland in order to obtain skins of the quality necessary for his vellum-paintings,[55] and the Anglo-Saxons would have been faced with the same problem of selectivity. Added to this were the costs of dressing the skins, of the ink and binding, and of the pigments and gilding if illustrations or gold-work were envisaged. For a copy of a book on travel, or geography, King Aldfrith of Northumbria (685–704) gave land that would have kept

eight families for life.[56] It was described as being of wonderful work-manship, which means that it was a *de luxe* manuscript, probably with gold work on it and in it, but the purchase price still recognises the fact that the making of a manuscript was expensive. So, too, does the action of King Alfred in sending to all his dioceses, together with translations of Gregory the Great's manual for clerics, entitled *Pastoral Care*, a precious pointer[57] which had the equivalent value of fifty oxen. If this was the adjunct, we may suppose the book itself to have been costly.

Under these circumstances, we can understand why the building up of libraries in religious centres was seen as an act of material, as well as spiritual, patronage. This was particularly true when it was known that the manuscripts concerned had had to be purchased. Bede, therefore, eulogised Biscop for 'the most noble and extensive library which he had brought from Rome',[58] and explained the care that was to be taken to see that it should be preserved into the future. Acca's work of collecting 'a very complete and excellent library' at Hexham in the early eighth century was also praised,[59] and it was associated with the acquisition of other church objects, such as sacred vessels. Later, Alcuin extolled the glories of the library at York[60] that had been founded by Egbert.

Once the heroic period of building up monasteries and cathedrals and their libraries was over, however, writers showed less interest in ordinary manuscripts. Occasionally, mention is made of a single book – like the splendid Bible which Archbishop Oswald (archbishop of York, 972–92) gave to Ramsey[61] – or of a collection of books – like that given by St Æthelwold to Peterborough after its restoration in 963[62] – but references now are very infrequent. Occasionally, they occur in the private wills of the tenth and eleventh centuries, from which we learn that, between *c.* 942 and 951, Bishop Theodred left the mass-book 'which Gosebriht bequeathed me' to another Theodred,[63] and that, between 997 and 1012, Bishop Ælfwold bequeathed some of his books to Crediton and two to Ordwulf.[64] These allusions are not always flattering for, in her will of *c.* 950, Wynflæd 'makes a gift to Æthelflæd of everything which is unbequeathed, books and such small things'.[65] In fact, the interest of later writers was primarily engaged by *de luxe* manuscripts, written or illuminated in gold.

In a spiritual sense, books disseminated the word of God and His saints but they were also an instrument of art. A number of them had paintings or drawings which were used to embellish, to illustrate, or to explain the text, or even perhaps to offer a pictorial narrative to those who could not properly construe it, and this form of artistic activity was originally encouraged by the example of the first Italian missionaries from Rome. Such, at least, is suggested by the fact that a surviving

sixth-century illustrated Italian Gospel-book, now at Cambridge,[66] is ascribed to this mission[67] and, perhaps, belonged to St Augustine himself. It originally contained no fewer than seventy-two scenes, of which twenty-four remain. No doubt the close ties between Rome and the church in England meant that other Italian manuscripts with pictures came later. Biscop obtained books in Rome on three separate visits and, from the one in 678–9/80, he returned with a 'boundless store of books of every kind'.[68] We do not know whether these included any with illustrations. Nor can we say whether any of the 'numerous volumes' that two pilgrims brought back from Rome before 705[69] contained paintings. We are, however, informed that Bishop Cuthwine of Dunwich (716–31) imported from Rome a manuscript with pictures of almost all the sufferings of St Paul,[70] and an incription transmitted to a later manuscript suggests that he also owned an Italian illustrated copy of Sedulius's *Carmen Paschale*.[71] One of Ceolfrith's great Bibles which has survived (the famous Codex Amiatinus, now MS. Amiatinus 1 of Biblioteca Medicea-Laurenziana of Florence) has illustrations (Plate 24) which were inspired by a Bible which he himself had brought back from Rome in 679–80,[72] and the fact that he was taking the Codex Amiatinus to the pope when he died at Langres in 716 suggests that, very occasionally, English illustrated manuscripts might pass in the opposite direction – to Italy.

Even in this early period of the Anglo-Saxon church, Italy was not the sole foreign source for books though it was always the most important. William of Malmesbury tells the story[73] of how Aldhelm – apparently between 705 and 709 – visited Dover and there discovered that sailors in a ship from Gaul were offering a copy of the Old and New Testaments for sale, together with other objects – presumably all from Gaul. He was full of interest but thought the price too high and suggested a lower one. This annoyed the sailors who scoffed at him and angrily put out to sea, where, however, they were overtaken by a sudden storm. In their panic, they appealed by calls and signs to Aldhelm on the shore and he was able to abate the gale. On their return, they expressed their gratitude by offering the Bible to the saint as a gift but he insisted on paying for it – though at the price he had originally offered. The anecdote – like so many – was only preserved because it centred on a saint's miracle, but it suggests that there was nothing exceptional in books, or other such church treasures, being brought across the Channel from Gaul.

We do not, of course, know whether the manuscript bought by Aldhelm was illuminated but evidence was already emerging in England of the Anglo-Saxons' own great talent in this field and, as early

as the end of the seventh and the beginning of the eighth century, Northumbrian manuscript-painting could rise to the level of the animated intricacy of the Lindisfarne Gospels (Plate 7) and of the ritualised dynamism of the Echternach Gospels (Plate 18). The Anglo-Saxons were superb artists and their manuscript-paintings and drawings represent a great period of that art in England. Other Western countries also produced admirable paintings, but none with the consistency of England and at a time, before the Carolingian Renaissance, when the manuscript art of Francia consisted chiefly of laborious initials, Anglo-Saxon painting was already marked by a great creative vivacity. Their figure painting of the eighth century is of the distinction of the Codex Aureus (Plate 19) and of the Barberini Gospels (Plate 20), and the ninth century is represented by the Cerne Gospels in Cambridge (University Library MS. Ll 1 10). Figure paintings and drawings of the post-reform period of the tenth and eleventh centuries variously express exhilaration (Plate 21), airy spaciousness (Plate 22) and invigorating majesty (Plate B). Ebullience is everywhere and, in the modest form of coloured drawings, adds piquancy to many a manuscript. The lightness of touch is such that it can represent even the Last Judgment as a bright social occasion, with angelic masters of ceremony ushering in the guests on the left (Plate 23a), and St Peter, with his enormous key, receiving them as the welcoming host on the right (Plate 23b).

Nothing of this exciting chapter in the history of English art is mentioned by the chroniclers. Bede records the decision of abbot Ceolfrith of Monkwearmouth/Jarrow to present the Codex Amiatinus at Rome, but makes no reference to the large and important pictures in them, and they are only known to us because of the survival of the manuscript itself (Plate 24). There is the same indifference in the account of a manuscript's miraculous recovery, derived from the ninth century and transmitted by Symeon of Durham, writing early in the twelfth.[74] He recounts how two church dignitaries fled with the shrine of St Cuthbert from the threat of the Danes in 875, and tells of their voyage to Ireland. Unfortunately, in the Solway Firth, they were overtaken by a storm which so tossed the ship about that 'the Gospel Book, adorned with gold and precious stones, fell overboard and sank into the depths of the sea'. In great distress, the ecclesiastics turned back to shore, where they were vouchsafed a vision from St Cuthbert himself. He appeared to one of the bearers of his shrine and ordered a search to be made for the manuscript at low tide. This was done. The ebb was much stronger than usual – presumably because of a spring tide – and the search was successful. In the words of the chronicler, 'they find the Gospel Book,

which still has all its splendour of jewels and gold on the outside and the original beauty of its letters and pages within, as if it had been scarcely touched by the water'. In this latter description, there is a considerable interest in the costly binding of the manuscript but little in its illumination. Yet the manuscript contained some of the greatest masterpieces of decorative art of all time. For this was the celebrated Lindisfarne Gospels (Plate 7).

The anecdote derives from an Anglo-Saxon source, authentic enough to name the bearer of the shrine who received the vision as Hunred (though, in fact, all seven bearers were remembered with special honour far into the future). Its interest for us, however, is not its veracity (which has been doubted) but its indication of Anglo-Saxon forms of emphasis (which is not in dispute). It is on the rich bindings of manuscripts that the Anglo-Saxons focussed their attention, and these costly bindings will be discussed in a later chapter. The paintings within manuscripts on the other hand, like the wall-paintings, tended to go unnoticed unless they had associations with a saint, or the enrichment of costly pigments. They might of course have both, like the Gospel-book belonging to St Margaret, in which touches of gold enriched the pictures of the evangelists, and 'every capital letter gleamed in its entirety with gold'.[75] The description comes from the saint's biographer but, in this instance, we do not need to rely on the written sources, since the actual manuscript (though without its jewelled binding) has survived (Plate C) and is now in the Bodleian Library (MS. Lat. lit. F. 5).

The gold in Anglo-Saxon manuscripts made them appropriately sumptuous for foreign presentations and, as we have seen,[76] Cnut sent two to Cologne. He also despatched to William II of Aquitaine a manuscript of the Lives of the Saints which was written and illustrated in gold. It was to such manuscripts embellished in gold[77] that Anglo-Saxon writers of the later period tended to confine their chief attention. At Glastonbury the prayer book donated by Æthelnoth was recorded because it had gold paintings,[78] and the Book of Collects bequeathed by Bishop Brihtwold was noted because it was 'illuminated in gold'.[79] At Winchester a chronicler drew particular attention to the charter given to the New Minster by King Edgar which still survives and which was 'entirely written in gold letters' (Plate E),[80] and, at Abingdon, a tenth-century writer took special interest in privileges embellished with gold leaf.[81] It was the beauty of a probably golden initial that prompted an interest in literature in one of the most scholarly of the Anglo-Saxon kings,[82] and it was the preciousness of the gold initials that enticed the early attention of one of the wisest of the Anglo-Saxon saints.[83] Both

99

**18**  Symbol of St Mark, late seventh or early eighth century (Bibliothèque Nationale, cod. lat. 9389, fol. 75v).

**19** St John from the Codex Aureus; Canterbury, 730–60 (Stockholm, Royal Library MS. A. 135, fol. 150v).

**20** St Matthew from the Barberini Gospels; second half of eighth century (Rome, Vatican, Biblioteca Apostolica MS. Barberini Lat. 570, fol. 11v).

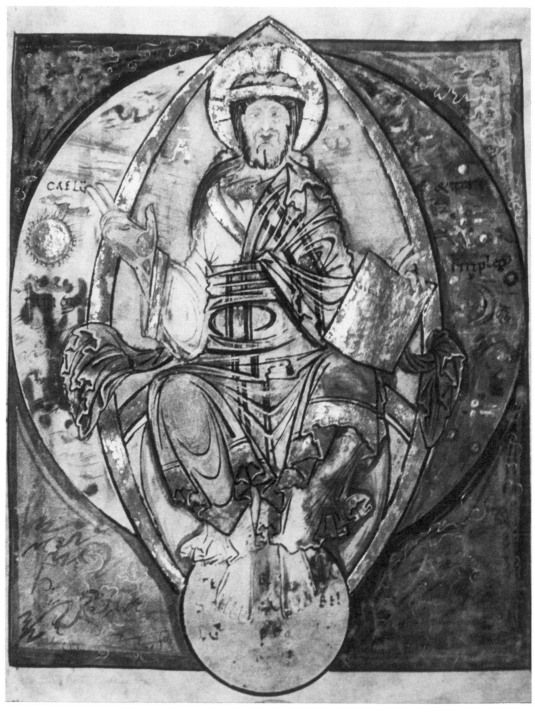

21  A painting of Christ in Majesty made by an Anglo-Saxon at Saint-Bertin between 990 and 1007 (Boulogne-sur-Mer, Bibliothèque Municipale MS. 11, fol. 10).

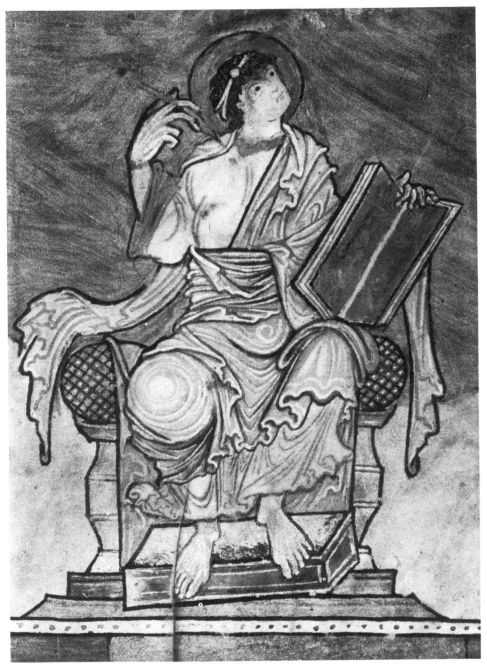

**22** Detail of painting of St Matthew, probably made at Canterbury (Christ Church) at the end of the tenth, or beginning of the eleventh century (York Minster, Chapter Library, MS. Add. 1, fol. 22v).

**23**(**a**) and (**b**)  A drawing of the Last Judgment on two folios of a New Minster (Winchester) manuscript, 1020–30 (British Library, Stowe MS. 944, fols. 6v and 7).

b

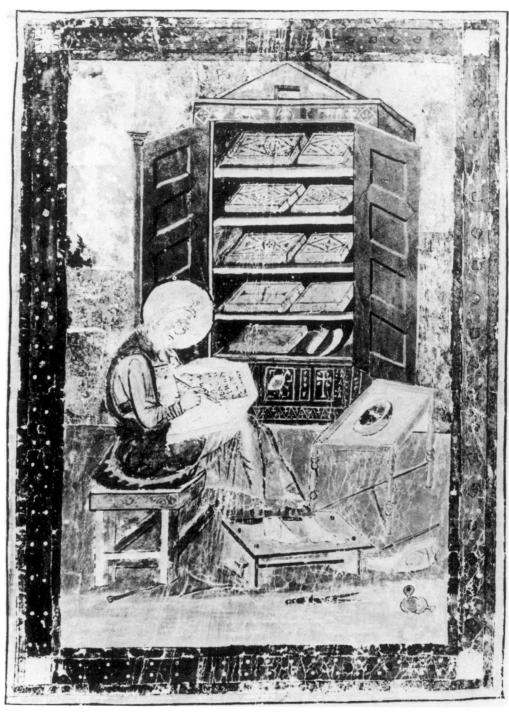

**24**  A picture of Ezra in the Codex Amiatinus, made at Wearmouth/Jarrow 690–716 (Florence, Biblioteca Medicea-Laurenziana, MS. Amiatinus 1, fol. V).

King Alfred and St Wulfstan were boys at the time, but the same taste is evident in the description of a manuscript made for another saint in his maturity, the Benedictional of St Æthelwold (British Library MS. Add. 49598). The paintings of the famous manuscript (Plate D), which was made between 971 and 984, are now considered amongst the masterpieces of Anglo-Saxon art, but the lengthy – not to say garrulous – poem on folios 4v–5 makes no reference to the quality of their style but only to their use of gold and the beauty of their colour: 'St Æthelwold . . . commanded many frames to be made in this book, well adorned and filled with various figures, decorated with many beautiful colours and with gold'. The comment here about gold and handsome colour has only a generalised similarity with the accounts of the murals at Wilton and Beverley, but it is at least enough to reinforce the view that some of the lost wall-paintings reflected the taste for rich colours, set off by areas of gold leaf or gold paint, that we can still see in surviving manuscript-paintings (Plates A, B, C, D, E). In other words, we can visualise the most expensive wall-paintings as having had comparable splendours to this very Benedictional and other comparable manuscripts.

An enigmatic reference in a poem written before 705[84] may indicate the same Anglo-Saxon interest in gold painting. This says that two pilgrims to Rome brought back, as gifts to the church, portrayals of the Mother of Christ with heads that shone golden in the light.[85] The word used, *toracida*, is often interpreted as a bust-picture[86] though this may not always have been punctiliously meant.[87] It is tempting to see them as gilded-glass pictures. The latter were portrayals (often head and shoulder) of figures, especially those from the Bible, and a few (full-length) ones of the Virgin still survive.[88] They were depicted in gold foil, details were etched in, and they were then fused between two layers of (usually circular) glass. In effect, then, the owner had a gilt 'portrait' set in a glass medallion. It is thought that the method was introduced to Italy from Alexandria, and, though they were later made in Cologne, the chief centre for their manufacture seems to have been Rome itself. Large numbers have been found in the Catacombs and the fact that they have also been discovered in the north of France suggests the possibility that some were brought to northern Europe by pilgrims. According to Theophilus, the technique of fusing gold foil to glass was still practised in the twelfth century by Byzantine artists[89] but its application to the making of these particular religious 'portraits' after about A.D. 500 is not substantiated by finds. On the other hand, St Aldhelm who received this very poem implies that secular *toracidae* continued to be made in his day: at least he uses the present tense in his description of the gilding of pictures of noble and royal personages which he, too, refers to as *toracidae*.[90]

If writers are taciturn about ungilded Anglo-Saxon paintings, they are hardly more communicative about their carvings, and for exactly the same reason – both were worked in humble materials.

The admirable quality of the best surviving Anglo-Saxon ivory carvings puts them on a par with the finest of any period. Their excellence has been brought out in a published corpus[91] and is at least indicated here by Plates G, 16, 17, 36, 52 and 53, though the last is much rubbed. Yet, despite their artistic distinction, ivory carvings are hardly ever mentioned in the written sources. In a letter written to the archbishop of Mainz, the archbishop of Canterbury, Breguwine (761–4), refers to a casket made of bone he is sending on, though he does not indicate whether it is carved or not.[92] An ivory incense-container which came into the hands of the Conqueror has already been mentioned[93] and a post-Conquest inventory in the *Liber Eliensis* records one or two Anglo-Saxon book-covers with ivory carvings which will be referred to again.[94] We are told that a reliquary-cross given by King Athelstan to St Cuthbert's tomb had ivory work on it,[95] and that a reliquary donated by King Edgar to Glastonbury had ivory figures.[96] But these two reliquaries incorporated precious metals and had associations with saints and, without these redeeming features, they would not have been chronicled.

The fact that it was associated qualities that normally brought works of art in non-precious materials to attention is demonstrated, indeed almost caricatured, by another form of carving – the cameo. The Anglo-Saxon chronicle described 1005 as 'the year of the great famine throughout England, the most severe in living memory' and it is probably to this year that the later Chronicle of the Abbots of St Albans alludes when it says that, because of famine, Leofric, the abbot of St Albans,

> sold for the sustenance of the poor the treasure which had long been set aside for the rebuilding of the church . . . the building materials, the gold and silver vessels which belonged to the church as well as those from his own table. He kept only some precious gems, for which he could not find buyers, and some noble carved stones which we commonly call 'cameos'. Most of these were set aside for the adornment of the shrine [of St Alban] when it should be built.[97]

The Anglo-Saxons, it is clear from this, found cameos attractive and used them to embellish their most precious works. The Germans did the same, and the celebrated Lothar Cross, made not many years before the famine in England and now in the treasury of Aachen, indicates how admirably a classical cameo could be set off by gold and jewels. Only one of these cameos of Leofric, however, came to special attention later.

This was one which had been, or was to be, presented to King Æthelred, and his name as the donor was engraved on the setting. Post-Conquest sources for St Albans[98] describe this cameo in such detail that the information they give will be sufficient to identify it if it ever re-appears. It was held in its setting by six claws. It was oblong, almost half a foot long, and 'could scarcely be held in one hand'. It had a dark ground and border of a bronze and reddish colour. It was engraved with 'a draped figure, holding in one hand a spear, up which a snake is crawling, and in the other a boy bearing a shield', and in front of the feet of the figure was an eagle spreading its raised wings. As well as these literary descriptions, a drawing was made of it by the thirteenth-century chronicler Matthew Paris, who was a fine book illustrator (Plate 25). His portrayal is so realistic that it has been reproduced in a specialised book on Roman engraved gemstones from British sites, and dated and described as if it were the original.[99] It is attributed to the late fourth or early fifth century and is said to represent a late Roman emperor as Jupiter, holding a sceptre assimilated to the staff of Asclepius, the god of healing.

We may ask why this late classical object attracted such detailed and comprehensive mediæval attention in England. It was clearly considered attractive, otherwise it would not have been reserved for the primary shrine of St Albans both before and after the Conquest. Perhaps the donor himself gave it some slight historic significance since, whatever contemporaries and later historians might think of King Æthelred, he was, as the St Albans chronicler reminds us, the father of Edward the Confessor. All this, however, proves to be irrelevant for we discover that what engendered the interest in the cameo was its miraculous properties. It was considered to have healing properties and to be especially efficacious in relieving women during childbirth, and, for this reason, was never actually used on the shrine. The idea that signet and some other stones had magical or amuletic associations did not, of course, originate with the Middle Ages for it was already there in classicial antiquity. Yet the point of the story of the St Albans cameo is not the inheritance by the mediæval English of some forms of credulity from the past but their decision to describe an artistic object on grounds that were non-artistic.

The indifference of writers to purely aesthetic attractions is demonstrated yet again by their attitudes to Anglo-Saxon stone carvings. The fine quality of these is well demonstrated by surviving examples which attain real nobility in famous sculptures like the Ruthwell Cross (Plates 26, 28a and 28b) and the Bristol Christ. From the conversion period onwards carved stone crosses formed a familiar artistic feature of the

**25**  A drawing by Matthew Paris (d. 1259) of a late antique cameo which was at St Albans before the Conquest (British Library, Cotton MS. Nero D. 1, fol. 146).

Anglo-Saxon scene so that there can be no doubt of their popularity. Despite this, such carvings are rarely mentioned.

The suggestion that the origin of the Anglo-Saxon stone cross and its special cult in Northumbria derived from the action of King Oswald in setting up a wooden cross before his successful battle against the pagan Cadwallon in 633 carries conviction.[100] In a sense, this was a parallel to Constantine's famous vision of a cross before his epoch-making victory of 312 which led to the Christianisation of the Roman empire, and it was in Constantinople that the veneration of the cross was developed with special intensity.[101] This was particularly true after the discovery of the true cross by Constantine's mother, and the later removal of its relics to Sta. Sophia of Byzantium by Heraclius in 628. It is possible that the Byzantine archbishop of Canterbury, Theodore (668–90), brought to England some of the heightened adoration of the cross that was to be found in the Eastern church, though this would more probably have found expression in gold-work rather than in stone, and the fact that the first reference to standing stone crosses in England appears in Theodore's canons may simply be a coincidence. Indeed, his canons merely require such crosses to be set up to mark the altars of churches that have been removed[102] and this was a very minor function of the Anglo-Saxon cross.

In Anglo-Saxon England, stone crosses were often used as outposts for preaching and for prayer, and, in her account of the travels of St Willibald (c. 700–86), Huneberc, a contemporary Anglo-Saxon nun at Heidenheim, indicates something of their frequency and one of their functions. She tells of how Willibald was so seriously ill at the age of three that his parents despaired of his life, and they offered him up before the holy cross of our Lord as a sign that they would dedicate him to the monastic life if he recovered. 'And this they did', she continues: 'not in the church but at the foot of the cross, for on the estates of the nobles and good men of the Saxon race it is a custom to have a cross, which is dedicated to our Lord and held in great reverence, erected on some prominent spot for the convenience of those who wish to pray daily before it'.[103] This setting up of crosses on the estates of the great is confirmed by Felix's remark that the noble parents of St Guthlac (who was born about 674) had a cross outside their home.[104]

Yet these crosses had other locations. In the surprising context of the trial for heresy of Aldebert, a self-proclaimed saint, there is a reference to stone crosses on the Continent in the same century. It occurs in an account, which St Boniface sent to Rome and which was discussed there by a synod convened in 745. 'In the fields or near springs or wherever he [Aldebert] had a mind, he erected crosses and small chapels and

ordered prayers to be recited there. As a result, throngs of people absented themselves from the established churches . . .[105] This positioning of the crosses was apparently normal for it provoked no criticism from the Anglo-Saxon writer. Boniface's charge was simply that the Gaulish heretic Aldebert had dedicated the crosses to himself. But the placing of them near springs may be of significance since sources of water were the focus of some forms of paganism – indeed, the worship of water wells was still being interdicted as a heathen custom as late as the eleventh century in England. Anglo-Saxon society was agricultural and its old gods were rural – associated with oak trees, groves, forest clearings and springs. One question to be asked, therefore, is whether some of the stone crosses which spread through the countryside of England were not set up to displace former centres of heathen worship. This would certainly have been consistent with the overall policy of the Church in England which was to harness pagan customs to Christian purposes. Pope Gregory had, therefore, advised his missionaries in England to adapt the pagan temples to Christian worship:[106] to divert the pagan rituals of sacrificing oxen to the Christian purpose of providing food for saints' feastdays:[107] in a word, to legitimise any pagan habits that were innocuous and to give them a Christian stamp.

These stone crosses were not all intended as centres of outdoor worship. Some defined the boundaries of sanctuary, for there is a twelfth-century comment on the 'three wonderfully carved stone crosses' that King Athelstan erected at Beverley for this purpose.[108] Others marked the stopping places of the cortège of a saint. When St Aldhelm died in 709, his body was taken from Doulting to Malmesbury and was rested at each seven-mile stage of the fifty-mile journey. These halting points were identified by crosses which were still known in the twelfth century as 'bishop-stones'.[109] In principle, if not in architectural elaboration, they must have anticipated the famous Eleanor crosses of the late thirteenth century. At a cell of Lindisfarne, Abbot Sigwine (who succeeded c. 771) was buried by the tall cross which he himself had set up but, more conventionally, stone crosses were erected specifically to stand over the graves of the great.[110] Æthelwald (bishop of Lindisfarne, 721–40) raised a beautiful stone cross to commemorate St Cuthbert before the wanderings of that saint's relics.[111] At the head and foot of the grave of Bishop Acca, who died at Hexham in 740, a 'wonderfully carved' example was set up which was described by Symeon of Durham in the twelfth century[112] and which still survives fragmentarily.[113]

The graves of some dignitaries were also graced by arches and columns. At St Augustine's abbey, Canterbury, these were apparently considered incommodious in the early eleventh century for they were

transferred elsewhere. Goscelin remarks that, at this time, Abbot Ælfmer 'removed arches and columns which had been solemnly erected with Roman elegance over the bodies of the saints' and used some of them to adorn the cloister of the monastery.[114] This custom of commemorating the eminent dead continued, however, and the grave of the last Anglo-Saxon bishop to survive the Conquest, St Wulfstan, was distinguished in the old way by an attractive stone arch, which was supported by what William of Malmesbury calls *pyramids* (*piramides*).[115]

This is a curious word to find in the context of pre-Conquest England, though it is one that occurs often. The Anglo-Saxons liked to identify themselves with the Israelites who were captives in Egypt, but their *pyramids* had nothing to do with the land of the Pharaohs. To begin with, they had tops that were flat and not pointed. This is evident from the description by an Anglo-Saxon monk, Lantfrith, of someone standing on a *pyramid* at Winchester,[116] and from the statement that *pyramids* at Beverley acted as supports for columns[117] (as they obviously did also for the arches at Worcester). Then, the positioning of these *pyramids* rules out the possibility of them having had the enormous bases in relationship to their height of the Egyptian kind. According to Eadmer, the grave of St Dunstan was marked by a large and lofty *pyramid*.[118] But the grave itself was set before the steps which led up to the altar of Christ where Mass was daily celebrated by the monks: in other words, it was a particularly busy spot in the cathedral and, if this memorial had been a pyramid in a conventional sense, it would have obstructed both movement and view. The *pyramids* which William of Malmesbury later described at Glastonbury were in the cemetery outside, and one of them rose to a height of twenty-six feet and another to that of eighteen feet.[119] Since they were only a few feet from the main church,[120] it is even more difficult to conceive of them having had a base to the scale of an Egyptian pyramid. The impression we are given of these Anglo-Saxon *pyramids*, in fact, is that they were tall, slender, and flat at the top.

It so happens that there are two Anglo-Saxon monuments at Penrith today which – like those originally at Glastonbury – are only a few feet away from the church.[121] Like them also, they are quite tall (about fourteen feet high). As the Glastonbury monuments attracted the attention of William of Malmesbury in the twelfth century, so these intrigued Sir Walter Scott in the nineteenth, and he visited them often.[122] They also interested early writers on the Lakeland district, and two joint-authors in the eighteenth century described them as 'pyramidal'.[123] Here, unknowingly but correctly, they were using a term of considerable antiquity for these Penrith monuments are carved shafts, and it is exactly these carved uprights of crosses, or the crosses themselves, that

the Anglo-Saxons meant by *pyramids*. This is clear from the evidence, and is fully confirmed by the Anglo-Saxon use of the word for, in his account of the translation of St Swithun, Lantfrith actually interchanges the words cross (*staurus*) and pyramid (*pyramis*): in one place, he speaks of the stone cross behind the tomb of St Swithun, and later refers to it as 'the aforementioned *pyramid*'.[124] The Anglo-Saxon *pyramid*, then, was simply a cross-shaft or cross, used as a grave memorial.

This aberrant use of the word seems to be peculiar to England and can be explained, perhaps, by the penchant of the Anglo-Saxons for visiting Rome. Here there were two famous classical tombs which actually were pyramids. One was, in reality, the burial place of the Augustan, Caius Cestius,[125] but was believed in the Middle Ages to be the tomb of the great Augustus,[126] under whose rule the Redeemer of the World had been born. The second was thought to mark the last resting place of Romulus,[127] the founder of the Eternal City, and, for good measure, the more gullible pilgrims were informed that it bore witness to a miracle of St Peter who had originally placed a mountain of corn on this spot and had then turned it into a block of stone so that it should be kept out of Nero's hands.[128] The first of these pyramids still survives near the Porta Ostiensis,[129] and both of them were given special attention by a twelfth-century writer on *The Wonders of Rome*. He was called Gregorius and, in M. R. James's view, he was probably English.[130] Gregorius begins by using the word *pyramid* in its correct sense to define the shape of these two famous tombs but then extends the meaning of the term to cover any funerary monument of someone famous. In one place, for example, he speaks of *pyramids* simply as 'the tombs of great men',[131] and elsewhere includes amongst the *pyramids* of Rome the Vatican obelisk,[132] which today stands in front of St Peter's. *Pyramid*, then, for Gregorius was any form of funerary monument. In his treatise, we can actually watch the extension of the meaning of the word, but it is one that must have taken place some time before as a result of the visits to Rome of Anglo-Saxons. In fact, this Anglo-Saxon use of the word continued after the end of the Middle Ages. Sir Thomas Browne was perfectly familiar, of course, with pyramids of the orthodox kind but he could yet, in 1658, speak of human remains in urns as being 'Pyramidally extant'.[133] Again, as we have already seen, two eighteenth-century writers could describe the Anglo-Saxon shafts at Penrith as being 'pyramidal'.

If a *pyramid* for the Anglo-Saxons was simply a funerary monument, and the normal grave-memorial in their own country was a carved cross or cross-shaft, then this is how they would understand the word. We can, therefore, visualise the *pyramids* which William of Malmesbury tells

us marked the last resting place of St Wulfstan as being something like the uprights of crosses which survive at Penrith to this day.

In his treatise *On the Antiquity of the Church at Glastonbury*, which he wrote after staying with the monks there about 1125, William of Malmesbury refers to *pyramids* in the cemetery there. It is unfortunate that this tract has come down to us in only one late copy, into which mediæval editors have interpolated legendary material (such as the burial of Arthur and Guinevere at Glastonbury) which they hoped to make more credible by these means. But these accretions can be recognised and ignored. Malmesbury was one of the finest of twelfth-century historians and the *pyramids* he himself saw were clearly commemorative. One was made for King Centwine,[134] who died in 685. We do not know whether it was raised at his death or later, but its existence would suggest that there were memorial carved crosses in Wessex which shared the antiquity of the earliest surviving ones from Northumbria at Bewcastle and Ruthwell and were perhaps even older. The Bewcastle cross, which can be dated 750–850,[135] is certainly a memorial, though whom it commemorates we do not know. It was once thought to be associated with Alhfrith, son of King Oswiu of Northumbria, who died *c.* 664, but this view is no longer held.[136]

Two of the Glastonbury *pyramids*[137] must have been physically similar to the ones at Bewcastle (Plate 27) and Ruthwell (Plates 26, 28a and 28b). They were, like them, extremely tall, surpassing even the Ruthwell cross (just over seventeen feet) in height, for they are the *pyramids* of twenty-six feet and eighteen feet already mentioned. Like the northern crosses, they were also divided into panels or tiers, the loftier having five tiers, and the shorter four. But, whereas the two surviving crosses have figural sculptures representing scriptural episodes, or imagery, the Wessex ones, or rather the one more fully described, had carvings which portrayed or recorded Anglo-Saxon dignitaries. At the top of the taller cross was a figure in bishop's robes. Below him was another in royal display. The third and fourth panels down simply had names, which were respectively: Wemcrest, Bantomp and Winethegn: and Hate, Wulfred and Eanfled. In the lowest was a figure and the names: Logthor, Weslicas, Bregden, Swelpes, Hwingendes and Bern. The shorter cross was inscribed with the names: Hedde bishop, Bregored and Beoruuard. Haeddi was bishop of Winchester from 778 to ?805, and, as Malmesbury tells us, Bregored and Beoruuard were abbots of Glastonbury. Malmesbury argues that Logthor and Bregden were also historic persons since they had given their names, respectively, to Logtheresbeorh (since renamed Montacute) and to Brentacnolle (since renamed Brentamerse).

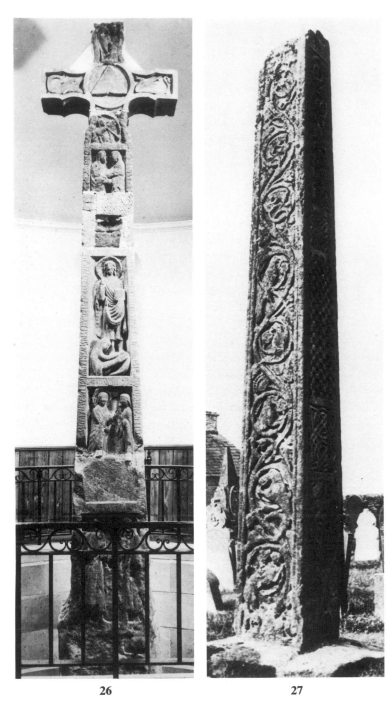

**26**        **27**

**26**    The Ruthwell cross (Dumfriesshire), mid seventh century to mid eighth.

**27**    The Bewcastle cross (Cumbria), mid seventh century to mid eighth.

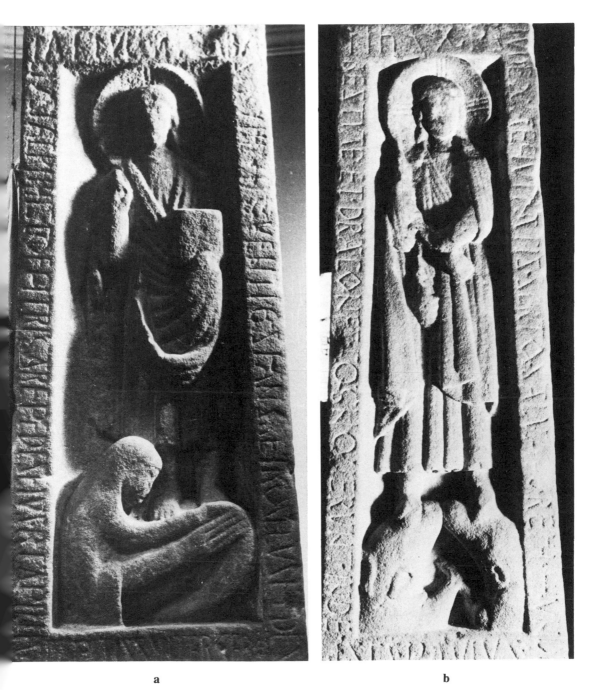

**28** Two details from the Ruthwell cross: (**a**) Christ and Mary Magdalene; and (**b**) Christ treads the beasts underfoot (Psalm 90, A.V. 91, verse 13).

Malmesbury does not mention an inscription to identify the topmost episcopal figure of the taller cross. Perhaps it was too high up, or too weathered. The lettering identifying the regal figure in the next tier down must have been difficult to decipher but he succeeds in recording it. It was *her* (i.e. here) and *sexi et blisyer* (all, according to our source, inscribed in lower case). It is difficult to discover a Wessex monarch with this name. The closest is Sexburga who, according to the Anglo-Saxon Chronicle, ruled Wessex for a year after the death of her husband, King Cenwalh, in 672. However, even in a manuscript text with the regrettable history of this one, it cannot be argued that *sexi et blisyer* is a corrupted form of *sexburga*. In fact, Malmesbury does not say whether the sculpture was of a male or female but merely speaks of a figure exhibiting 'royal pomp' (*regiam pompam*) – perhaps simply holding the symbols of office – and his caution may have been due to the fact that the carving was too worn for him to distinguish details. There was an episcopal figure at the top of this cross, and it is no doubt a coincidence that Sexburga's husband, Cenwalh, set up the first bishop of Winchester, though the priority given here to a bishop over a monarch (of whatever sex) offers yet another problem. If Malmesbury, the historian of Glastonbury, proclaimed himself unable to understand this *pyramid* in the first half of the twelfth century, perhaps we should not expect to be more successful seven and a half centuries on, especially now that the monument itself has disappeared.

There were other Anglo-Saxon crosses, or cross-shafts, at Glastonbury with purely decorative carvings. This we know from their surviving fragments which are exhibited in the museum on the monastery's site. But these would not have been called *pyramids* unless their function had been to commemorate the dead.

As well as these cross-shafts, there were, of course, stone Crucifixes in the Anglo-Saxon period. One which survives at Romsey (Hants.) is life-size (though not in the round) and it seems probable that there were very many others in pre-Conquest England. These go unmentioned in the sources unless they had fortuitous associations with saints or miracles.

Later writers of varying reliability give descriptions of Anglo-Saxon stone Crucifixes which were credited with the gift of speech. These speaking Crucifixes were probably introduced into English historical writing by Osbern, who had been a child of the cloister at Canterbury before the Conquest, but whose reputation as a historian was never high even amongst his own contemporaries. Chroniclers like him seemed to think that King Edgar had a special empathy with miraculous crosses for they claimed that not only at Winchester[138] but also at

Glastonbury[139] his presence had stirred Crucifixes to intercede. In the fifteenth century, Capgrave actually saw at Winchester a Crucifix identified by an attached inscription as the one that had addressed the Anglo-Saxon king.[140] They are a fascinating subject, but of more relevance to the historian of legend than the historian of art, and we would do well to avoid them. The one exception is the most famous of them all: the Waltham Cross, whose Christ-figure had its head inclined over the chest,[141] as in surviving Anglo-Saxon and Ottonian art of the eleventh century.

In its original state, the Waltham Cross was later said to have been a particularly fine carving: 'an incomparably beautiful figure of the Saviour on the cross made from black stone, which, by the wonderful and unheard-of craftsmanship of the sculptor, attained such harmony in the extension of the arms and arrangement of all the parts of the body that you might think it had been fashioned by the hands of the supreme Craftsman Himself'.[142] No doubt it was the miraculous properties of the Crucifixion that called forth this fulsomeness of praise and we must therefore discount it. All the same, in the light of this admiring description, it is surprising to learn that there were those who thought it not quite complete, for Tovi the Proud, the Danish follower of Cnut who became a Somersetshire potentate, provided the stone Crucifix with a great variety of craftsman's work in gems, gold and silver,[143] and fastened his own sword to its side with plates of silver.[144] His devout wife, Glitha, went further and

at her own expense encircled its head with a crown fashioned in wonderful craftsmanship of pure gold, set with most precious stones . . . Round its thigh she also put a remarkable head-band of the purest gold – of the kind worn by the noblest ladies of the time – embellished with a wonderful adornment of precious stones. From the same gold a footstool was made from her necklaces and bracelets . . .[145]

The pair, we are told, 'spent their whole life adorning it continually with gold, silver and precious ornaments'.[146] At Durham, something comparable took place, for there Tostig, the Anglo-Saxon earl of Northumberland, and his wife, Judith, 'ordered a figure of Christ on the cross to be made . . . and also figures of Mary, the holy Mother of God and John the Evangelist and clothed them with gold and silver'.[147] Described as being 'of wonderful craftsmanship',[148] this Durham Crucifix seems from the contexts of the accounts to have been made of stone or wood.

There were, of course, effigies of gold or silver in the Middle Ages, of which the reliquary figure of Ste Foie at Conques is a celebrated

survival. To clothe or hang a stone or wooden figure with precious adornments and a precious garment is, however, something different. The earliest indication of this practice in England is found in the description of the Waltham Cross, and it is ascribed to the period when the reins of power had been taken over by the Danish monarchy and Danish aristocracy who were still very close to Scandinavian paganism.[149] Denmark had been Christianised only a few decades before, and then not whole-heartedly; Cnut's father, Swein Forkbeard, king of Denmark and briefly of England before his death in 1014, had himself remained a heathen until his late and tepid conversion to Christianity. This advent of the Danes introduced into England a revival of the old paganism. And it was a paganism which had recently co-existed with Christianity in Denmark, where there had even been some overt rivalry between the two religions: for, just as the converted Christian might wear the symbol of the Crucifixion around his neck, so the adherent of the old faith might wear the symbol of Thor – the hammer – around his. A mould in which both symbols were cast exists in the National Museum of Copenhagen and shows that silversmiths were prepared to cater for both faiths.[150] Perhaps it is just this form of artistic competitiveness that is exemplified in England by the Waltham Crucifix.

Any efforts we may make to substantiate this suggestion are hampered by the fact that our knowledge about the artistic representations of the pagan deities of the North is threadbare in the extreme. In stamping out paganism, Christians suppressed information about it. Even the very rare references made to paganism whilst it was still a living force – like that, for example, in Adam of Bremen – turns out, on inspection, to be of little help. Our chief information about these Northern gods of the early Middle Ages comes from the poetry and prose of Iceland and especially its sagas which, in historic terms, are not reliable documents. Despite this, we might yet consider that the comments in them on paganism contain sediments of remembered fact, especially since the conversion from paganism in Iceland was an exceptionally peaceful and even 'democratic' one, without the violence and coercion that tarnished Christian conversions elsewhere.

The Saga of St Olaf describes the idol of Thor, the most powerful of these gods, as being 'of great size . . . adorned with gold and silver'.[151] This is supported by the *Flateyjarbók* and the Latin life of St Olaf, both of which say that the idol is a hollow carving enriched with gold and silver.[152] All this would indicate that we have here a large seated effigy of wood or of stone, decorated with ornaments of gold and silver. These ornaments, according to the saga, St Olaf actually tore from the idol and handed to the populace, with instructions that they should give

them to their womenfolk and never hang them on stock or stone again.[153] This suggests the the adornments were of a feminine kind, as were some on the Crucifix at Waltham. The Waltham figure, moreover, had a costly garment, and it has been claimed from a reading of an eleventh-century Irish text that these idols of Thor were provided with precious clothing also.[154] This interpretation by an earlier French scholar is not, in fact, supported by the Irish scholarship of today[155] but, despite this, we are left with a basic relationship between the effigies of Thor and the Christ-figure of the Waltham Crucifix: both were statues of non-precious material, bedecked with gold and ornaments. In one very real sense, then, the two Danes, Tovi and Glitha, were enriching a Christian effigy in the style of a pagan one – an assimilation of inoffensive heathen practices to Christian use of which Gregory the Great would have approved.

Ælfric remarks in his *Colloquy*[156] (perhaps *c.* 987–1002) that the stone Crucifixes of his day were coloured, and there are indications in other sources that Anglo-Saxon carvings were painted. In the ninth century, Æthelwulf wrote of a figure of the Virgin standing to the right of the altar of a cell of Lindisfarne, and his description of it being 'glorious in white robes and with an elegant mingling of differing colours'[157] certainly implies a painted effigy of the Madonna. It may have been placed there between 704 and 716 for it is in this context that it is described. In the Old English poem *Andreas*, which is attributed to the eighth century, there is reference to the bright adornment of carved angels which suggests that they also were painted.[158] They were described in detail because they were miraculously brought to life to testify to Christ's own divinity, and, since in the original Apocryphal text from which the poem derives, they were sphinxes,[159] it is possible that this description was interpolated in the Anglo-Saxon period and influenced by contemporary sculpture. We know from excavations that early architectural sculpture at the churches of Monkwearmouth/ Jarrow was in some instances painted red and black,[160] and paint has been found on stones of the later Anglo-Saxon period from a number of sites – Burnsall, Stonegrave, Kirklevington, Lancaster, Deerhurst, Reculver and Ipswich.[161] A surviving London tombstone of the 1030s (formerly in St Paul's churchyard and finely decorated in the Viking style) provides a good example of the painting of Anglo-Saxon ornamental stone-work, and there is evidence that an Anglo-Saxon font at Wells originally had figures actually painted under the arcades.[162] The real importance of the written sources is their indication that figure sculpture itself might be coloured.

The longest account of stone carvings to survive from the Anglo-

Saxon period is in the *Liber Vitae* of the New Minster at Winchester.[163] It describes the tower which was built there between 980 and 993 and the six sculptures which embellished it. Each presented a different subject: the first was the Virgin Mary with a choir of angels: the second was the Trinity: the third, the Crucifixion: the fourth, a choir of saints: the fifth, more saints with St Michael: and the sixth composition was of the four Evangelists.[164] The meaning of some passages is confused by the waves of inflated rhetoric but one proposed interpretation of an obscure narrative[165] has been that, like the original stone friezes of the church of Breedon-on-the-Hill, these carvings were placed on the outside wall. There, it is suggested, they were set vertically and in such a way that the theme of each carving corresponded to the dedication of an adjacent storey of the tower. The representation of the patron saint of a church was probably quite normal, but an artistic portrayal of six different subjects of dedication on one building is unique in our sources. This, however, is probably not because such carvings were themselves unique but because the source is. The account is quite exceptional in the way that it focuses attention on carvings in stone despite the fact that they are unredeemed by associations with saints or miracles.

Both these forms of witness to divine intervention were there to justify – and even demand – Goscelin's enthusiasm for stone carvings unearthed at Canterbury towards the end of the next century – they were on the tomb of a saint and they escaped damage by a miracle. At the translation of St Augustine in 1091, the carvings on his tomb were miraculously preserved during a fall of masonry and, because of this, Goscelin (writing between 1099 and 1107) says something about them. He especially draws attention to a portrayal of angels with the Deity and his observation that they were 'wonderfully formed'[166] indicates that they were in relief and not engraved.

Further details are not forthcoming about the composition, but the emphasis on the angels calls to mind one which suddenly appeared in the art of Canterbury not long after Goscelin's account of the carvings. It is a painting forming part of the initial of a manuscript of the earlier twelfth century (Plate 29a). In it, two angels support the figure of Christ in a medallion. Some centuries earlier, a very similar composition had been carved on sarcophagi where sculptures in relief had also portrayed winged figures raising aloft a bust within a roundel. There, however, the winged figures had not represented angels but flying Victories, and the bust-figure had been not of Christ but of the man buried within. These sarcophagi, in fact, were classical ones, and a detail from such a one in the Museo delle Terme in Rome is illustrated (Plate 29b). This composition of a bust-figure within a medallion or wreath is a familiar one in

other areas of classical art and is generally known as the *imago clipeata*,[167] or likeness on a shield. Flying figures could be added to it as supporters, as we see not only in these sarcophagi but elsewhere – for example, in the remains of a famous Romano-British pediment at Bath.[168] Pagan though the composition was, it was soon assimilated to their own needs by the early Christians. And this quite simply, for they only needed to make a slight adjustment to the bust-figure (to present it as blessing, for example, or to give it a sceptre) for it to become a portrayal of Christ Himself in a roundel supported by angels. In this Christian guise, it appears on at least one early Christian ivory (Plate 29d), and is familiar in later Christian art, including that of the Carolingians (Plate 29e). The question which all this raises is whether St Augustine was buried in a classical sarcophagus on which a conventional Roman carving of a bust, supported by Victories, was mistaken for the equally conventional Christian representation of Christ, being raised by angels, which derives from it.

Bede tells us that, when St Augustine died (it was some time between 604 and 610, but probably in 604 or 605), he was first buried outside the church of the blessed Apostles, Peter and Paul, which was still being built, and, later, on its completion, was interred in its north chapel.[169] This church and monastery (later more familiarly known as St Augustine's) was the site of the translation of the saint as described by Goscelin, and the translation was made necessary by the destruction of the early church to make way for Norman rebuilding. There had, to be sure, been earlier extensions of the original church by the Anglo-Saxons themselves.[170] Some time between 731 and 760, the north chapel was extended northwards to make room for the burial of further archbishops (though none is recorded). A further extension, apparently westwards, took place in the tenth century, after which the church was rededicated by St Dunstan in 978. Between 1047 and 1059, abbot Wulfric began enlarging the main church eastwards by coupling it to a small eastern chapel of St Mary. But in all these operations St Augustine's tomb had been left undisturbed. The Anglo-Saxon alterations to the fabric did not call for its removal. Had they done so, and had the saint who had brought Christianity to England been translated by the Anglo-Saxons, then this would have been a great and sacred event, not only widely reported but also permanently commemorated by an appropriate entry in the English Benedictine calendars. It is clear, then, that the sarcophagus which Goscelin was describing was the one in which St Augustine was first buried within the church. It is not, it is true, described by Bede as having carvings on it even though he speaks of an inscription.[171] But this itself is of no great moment for Goscelin himself

a

b

c

d

e

only mentions them because they were the subject of a miracle. We know that Anglo-Saxon writers usually ignored stone carvings, and there is no reason why Bede's source of information should have been exceptional in this regard.

Between the first burial of St Augustine and his second interment within the church, there was all the time required for any desirable preparations. These could hardly have included the actual making of a stone sarcophagus with sculptures in relief because the arts of the pagan Anglo-Saxons did not include that of stone carving, and – as far as we know – these skills did not exist then at Canterbury. However, we know from later evidence that if Roman sarcophagi could be found the Anglo-Saxons were prepared to use them for the burial of their dignitaries. When Sebbi, the retired king of the East Saxons, died between 692 and 694, the sarcophagus in which his corpse was laid was clearly not made for the occasion. It was found to be too small for him, and only the chipping of the inside, assisted by a miracle, saved his kinsmen the embarrassment and labour of having to find another.[172] This must have been a Roman sarcophagus. So, too, must have been the one provided for the translation of St Etheldreda at Ely, sixteen years after her death in 680.[173] It was searched for, and found, in the former Roman town of Cambridge, and described as being 'most beautifully made of white marble' with a close-fitting lid. We do not know whether it was plain or decorated. In Bede's vocabulary, the words 'most beautifully made' would have been excessive for a plain one, but he had not personally seen this one. An interesting point in this account is the remark that Etheldreda's sarcophagus was brought to Ely by ship since it means that the sarcophagus of St Augustine also may have been brought across the water.

There were few decorated stone sarcophagi in Roman Britain. Only six, together with a fragment, have so far been discovered, and two of these had probably been imported.[174] One of the imported, and one of

---

**29** (**a**) Bust of Christ in roundel held by two angels, from a Canterbury (Christ Church) manuscript of 1110–40 (Cambridge University Library MS. Dd 1 4, fol. 157). (**b**) Male bust in a wreath, held by two flying Victories, from a Roman sarcophagus (Rome, Museo delle Terme). (**c**) Male bust in a roundel, held by two flying Victories. Engraving of a Gallo-Roman sarcophagus, the remains of which are in the Municipal Museum at Soissons. (**d**) Bust of Christ on a 'shield' supported by two flying angels. Detail from the so-called Barberini diptych of the early sixth century in the Louvre Museum. (**e**) Bust of Christ in a circular frame held by two flying angels. Detail from a Carolingian book-cover of the ninth century in the Victoria and Albert Museum.

the local, sarcophagi have a carving of a bust-figure in a roundel but neither has supporters as well.[175] There were, however, large numbers of carved sarcophagi in Gaul. This is clear from the surviving ones listed in Espérandieu's monumental catalogue of Gallo-Roman sculptures, and they include some winged Victories raising the bust in the roundel.[176] Curiously enough, the figure in one of them makes a gesture which is remarkably like the benediction given later by Christ[177] when the theme was Christianised (Plates 29d and 29e). Unfortunately, only a fragment of this sarcophagus survives today in the museum of Soissons, but the whole was still complete in the early eighteenth century and an engraving from a drawing made then is here reproduced (Plate 29c).[178]

In Merovingian Gaul, such Gallo-Roman sarcophagi were re-used for Christian burials. Indeed, the hunt for them to provide ornate coffins for Christian saints and kings, after the previous denizens had been evicted, became such a scandal that church councils, especially the Council of Mâcon of 550, tried to legislate against the practice.[179] Always, however, without success. Now Æthelberht, the king of Kent who supervised the first translation of St Augustine, was married to a Merovingian princess, so that he would know and perhaps share the Merovingians' concern to find Gallo-Roman sarcophagi for their eminent dead. Furthermore his alliance with the Merovingians would mean that he would have had no difficulty in shipping a sarcophagus from Gaul to Kent for St Augustine's remains. We may suppose that King Æthelberht would have honoured the entombment of St Augustine in every possible way. Indeed he had built a special church for St Augustine's interment[180] and for the burial of the royal line and future archbishops, too. And though, with his usual restraint, Bede describes the entombment as having been carried out 'fittingly' or 'becomingly' (*decenter*),[181] there was clearly much grandeur involved for Goscelin discloses that even the floor on which the coffin was set was of purple tiles.[182] It is suggested here that the obsequies were also dignified by the provision of a carved Gallo-Roman sarcophagus for the dead body.

This is given support by the fact that Goscelin refers to reliefs other than those of the 'Lord' and 'angels',[183] for classical sarcophagi with bust-portrait and supporters also had added imagery. The additional detail on the sarcophagus from the Museo delle Terme (Plate 29b) comprises bound prisoners of war and heads of barbarians, and other carvings on the sarcophagus from Soissons (Plate 29c) include the pagan deities Oceanus and Gaea with two cupids. Although Goscelin indicates that there were accompanying reliefs on St Augustine's sarcophagus, he makes no attempt to describe them. Was this, perhaps,

because they represented pagan figures whose presence, or even identities, puzzled him?

It is true that Goscelin's reference to a Christ in Majesty as the central theme (or, to use his exact words, a Majesty of God, *maiestas Dei*) conjures up for us today not a bust-figure of Christ but the enthroned Majesty made familiar by the great Romanesque sculpture of France and well known throughout the whole of the Middle Ages. Made originally to illustrate a passage of the Apocalypse[184] (which, in fact, has nothing to say about Christ, or God, or Majesty) these imposing seated figures have impressed themselves on our own consciousness as the only Majesties of Christ. However, the 'Majesty' of the Apocalypse was not invariably portrayed in this way, and one version of it which found acceptance in mosaics, wall-paintings and manuscript-paintings,[185] and which could simply replace the full 'Majesty' in other contexts (such as the paintings of the Exultet Rolls)[186] was of a bust of Christ in a roundel. This, raised by angels, as, for example, in Plates 29d and 29e, became an abbreviated representation of the Ascension, and the Ascension itself was associated, and even confused, at times with the Apocalyptic Majesty in art.[187] If, therefore, this was the theme that Goscelin thought he saw, then his words would have been appropriate enough. Yet even this is to confine mediæval ideas of the Divine Majesty in art too severely and to restrict them to our own purely academic categories. Just before the translation of St Augustine which Goscelin was describing, a question arose concerning a reliquary of St Foillan in the Lotharingian church of Fosse, and it was described as having on one face a representation of 'the Majesty of God [*maiestas Dei*] walking upon the asp and basilisk' (Psalm XC. 13: A.V., XCI. 13).[188] This conforms to no present-day view of the Divine Majesty and indicates how unspecific this term *Majesty* could be.

There is much that is hypothetical about the view being propounded, though acceptable alternatives to it are difficult to imagine. One assumption which it makes is that 'Christ' was represented as a bust-figure in a roundel. Another is that Goscelin could be misled into supposing that the subject was Christian. This itself would not have been difficult, for the similarities between the classical and Christian interpretations of the theme are all too obvious. A flying Victory could be mistaken for a flying angel even by an observer interested in sculpture, and Goscelin was not that. Furthermore, his whole upbringing as a monk and his very piety must have made him see the reliefs through a Christianising filter. He knew nothing at all of classical art and had only ever seen this artistic composition presenting a Christian message. He was, moreover, the most prolific of all writers on the saints of Anglo-

Saxon England, and it could not have entered his head that St Augustine, who was venerated for having saved England from paganism, could himself be interred in a pagan coffin.

The Anglo-Saxon paganism that St Augustine came to oppose was, of course, different from the paganism of Roman Britain. However, he had been counselled by Gregory the Great to put paganism to Christian use, and, if the opinion expressed here is correct, then, in death as in life, he was carrying out his master's precepts.

# TEXTILES

Visitors to Rome in the twelfth century said on their return to England that in the church of Hexham they saw again the splendour of Rome.[1] Such a remark would have gratified St Wilfrid, who founded the church, and also his ecclesiastical comtemporaries in England, for this was exactly their aim – to emulate the churches of Rome. Benedict Biscop, therefore, built his church 'in the Roman fashion',[2] and brought paintings,[3] books,[4] and a music-master[5] from Rome, and probably vestments and vessels as well.[6] The fact that he returned with silks[7] must also be set in this context of assimilating influences from Rome.

The churches of Rome certainly made use of fine fabrics. This is abundantly apparent in the inventories of gifts made to them by the popes which are recorded in the *Liber Pontificalis*. Such fabrics were especially used for hangings and a particularly generous eighth-century pontiff, like Hadrian I, is known to have presented as many as sixty-six hangings of gold and purple to St Peter's, seventy-one to St Paul's, forty-three hangings to St Mary's, and other textiles of this quality to ten other churches in Rome.[8] On his visit to Rome in 855, King Alfred's father, King Æthelwulf, conformed to this Roman custom by offering to St Peter's a gold-embroidered purple hanging and two other hangings.[9] In fact, it was a tradition that was already established in the Anglo-Saxon churches at home. So, in the second quarter of the seventh century, King Oswald of Northumbria had presented the churches he had founded with wall-hangings, described – like some of those in Rome – as being of silk interwoven with gold,[10] and, in the middle decades of the eighth century, Archbishop Egbert had given silk hangings to his cathedral at York.[11] The practice continued throughout the Anglo-Saxon period and is particularly well documented in its last centuries. For example, we find King Athelstan offering tapestries and hangings to the church at Chester-le-Street in the first half of the tenth century,[12] and Oswald, archbishop of York, contributing hangings and tapestries to Ramsey in the second half.[13] Such hangings became part of the vast textile wealth of churches and monasteries. Even after the Norman

Conquest, Ely still conserved from her Anglo-Saxon abundance 'richly ornamented coverings, silk draperies and fine and costly hangings, which had no superior in all that area around . . . for the whole set seemed to be covered with gold'.[14] An inventory of them, made about 1081, more particularly records two gold ones, forty-three others, thirty curtains and four tapestries.[15]

Accounts of such hangings in England are appreciative but lacking in detail. They rarely give us an insight into the decoration or motifs of the fabrics. However, we are told that the seven textiles that Sigeric, Archbishop of Canterbury, gave to Glastonbury at the end of the tenth century were adorned with white lions,[16] and, earlier, Alcuin had described the silk hangings at York in the eighth century as being decorated with exotic forms or figures.[17] Whether these were human, mythical, animal or floral we do not know, but similar unspecific remarks could have been made about hangings in Roman churches, for they presented griffins,[18] unicorns,[19] peacocks,[20] lions[21] and eagles[22] in their decoration. These Roman hangings were also embellished with whole scenes, and especially with depictions of Christian themes. This tradition of Christian illustrations on textiles goes back quite a long way for, as early as c. 410, Asterius of Ameseia had complained that even secular garments were adorned with such pictures – Christ with His disciples, His miracles, His Resurrection, and so on.[23] The hangings of the Roman churches had a particularly wide repertory which included scenes of the Annunciation:[24] the Nativity:[25] Christ's Baptism,[26] Miracles,[27] Passion,[28] and Resurrection:[29] Christ with His apostles,[30] and amongst angels:[31] the story of Daniel:[32] the Assumption of the Virgin:[33] Pentecost:[34] the martyrdoms of Peter and Paul[35] and other saints.[36] Only a few fragments of such pictured silks survive from the period before the end of the ninth century when our source, the *Liber Pontificalis*, peters out, but two eighth-century ones, possibly Syrian and now in the Vatican museum, may give us an idea of the kind of hangings that the Anglo-Saxons saw in Rome. One shows the Annunciation and the other the Nativity (Plates 30a and 30b). If the Anglo-Saxons brought back similar textiles and used them for hangings in their own English churches then the potential of these for influencing the embroidery of Christian pictures in England would have been very considerable. Unfortunately there is no clear evidence of this since – with one exception – the Christian hangings in Anglo-Saxon churches are never described by our sources, though this exception (which we shall come to later)[37] does have a theme of the Miracles of Christ which is paralleled in the textiles of Rome. The only two subjects mentioned on Anglo-Saxon vestments also occur on Roman textiles. The first, the

a

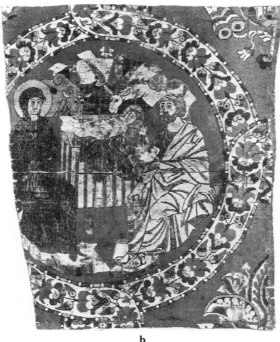

b

**30** Fragments of two eighth century pictured silks showing (**a**) the Annunciation and (**b**) the Nativity: possibly Syrian (Vatican, Museo Sacro).

Nativity,[38] is of course too popular to register a particular relationship, though the second, Christ with the Apostles,[39] is an unusual one in Anglo-Saxon art and – as we can see from the heavily restored apse-mosaic of Sta Pudenziana – was already known in Rome as early as the beginning of the fifth century.

However Roman-inspired may have been the tradition of wall-hangings in Anglo-Saxon churches, there was a similar and independent tradition in secular society. Goscelin, who came to England about 1058 and quickly adapted himself to English customs, tells of how he then transformed a sordid hovel by placing hangings on the wall.[40] In the context of a miracle, he also describes the home near Ramsey of a 'rich and honest man called Godric' of some fifty years before and writes that the walls were 'bright with colourful (or pictured) hangings'[41] (*pictis auleis candescunt*). He may have derived this account from written sources, or verbal traditions amongst the Anglo-Saxons, or simply made a reconstruction from his own English experience, but, whatever its origin, it must have been a true-to-life description of a domestic interior in the eleventh century. The importance of decorative textiles in the home is certainly borne out by the wills of the tenth and eleventh centuries which show that wall-hangings were being bequeathed as highly prized possessions to close relatives, cherished friends or neighbouring monasteries. At Bath, for example, Wulfwaru (who died between 984 and 1016) left to one son 'a hall-tapestry' and to another 'a tapestry for a hall and a tapestry for a chamber'.[42] Æthelgifu bequeathed to Leofsige three wall-hangings,[43] and to St Albans her best one.[44] In the homes of the aristocracy such hangings were large. The assailants who assassinated Earl Uhtred in 1016 could take advantage of the extensiveness of a hanging which stretched right across the hall (perhaps dividing it) to conceal themselves from their victim before making their murderous assault on him.[45] It must have been ample, indeed, to conceal a force of soldiers sufficient to slay not only Uhtred himself but also his entourage of forty men who, according to Symeon of Durham, were cut down too.

As we have observed earlier, we are told remarkably little about the decoration of church hangings. Despite this, in his verse-history, Æthelwulf does let fall a significant comment on the hangings set up in a cell of Lindisfarne, for he remarks that they showed the miracles of Christ.[46] He also refers to the glowing red metal in them. The verb, *rutilare*, he elsewhere[47] uses to convey the glint of gold that the Anglo-Saxons so frequently described as red. We may therefore suppose him to be speaking of hangings with gold embroideries displaying the miracles of Christ. The theme here is an isolated one. It is as though pictures

of Christ in the innocence of childhood, in the agony of the Cross, or in the triumph of the Resurrection, were not to deflect attention from Christ as the wonder-worker – the superhuman Christ performing great and famous deeds. We might perhaps say that Christ was being presented here as the Divine Hero. And, if we agree that an epic is an account of the deeds of a hero or heroes, then we might call these Christian epic tapestries. Now, Æthelwulf was writing between 803 and 821,[48] but he was describing treasures of his cell which had been given at various times, like the chalice donated by Sigbald who had probably died in 771 after being abbot *longo tempore*. We cannot, therefore, say at what time between the earliest possible founding of the cell (704)[49] and the latest possible dating of the poem (821) these tapestries were acquired.

The word *tapestry* is used in this book not in its technical meaning but simply to indicate an embroidered hanging and, in this sense of the word, we can say that this is the only description of any pre-Conquest religious tapestry known to us. Other references may, of course, have been lost but, as we have already seen, writers did not normally describe such works of art. Let it be emphasised then that this Christian epic in needlework was not set in a great cathedral or a famous foundation. It was displayed in the church of a cell of Lindisfarne, so small that it has never been identified. What was in the larger churches we do not know.

We may, however, ask ourselves whether this concentration on the heroic qualities of Christ owed anything to heroic tapestries outside the monastery. Monks, it is true, did not write about secular art, but they could not have been wholly unaware of it since they themselves had been nurtured in lay society. Moreover, the art-patrons of monasteries, the abbots, were powerful lay figures, usually drawn from the nobility, sometimes associated with king and court, and certainly acquainted with aristocratic fashions. Of course, if comparable wall-hangings existed in the secular world, we could only hope to hear of them by the sheerest piece of good fortune. Yet surprisingly enough, we do get slight indications. The first is found in the famous Anglo-Saxon epic poem *Beowulf*.

After the bloody struggle between Beowulf and Grendel, when the hero has torn off the monster's arm and shoulder and sent him to his death, King Hrothgar arranges a feast to celebrate the fact that his land has been freed from the fiendish monster. The guest hall is prepared and the poet tells us that 'Tapestries decorated with gold shone along the walls, many wonderful sights for everyone who gazes at such things'.[50] The subjects of these tapestries we do not know, and, since the poet refers to the Creation, it might even be argued that they presented

Christian themes. However, set as these hangings are in the context of an epic poem concerned with deeds of prowess, and placed as they are on the walls of a guest-hall where an illiterate warrior host was to be entertained, it seems far more probable that they celebrated acts of valour. If this were so, then here was a secular tapestry in gold which paralleled the Christian tapestry in gold described by Æthelwulf. The date of *Beowulf* is a matter of much controversy but there are grounds for placing it in the second half of the eighth century and the poem must have been based on traditions earlier than the written text.

It was certainly a poem that reflected the real world around. Its descriptions of the standard, jewellery, helmets, swords and burial rituals are all in line with excavated material – especially that of Sutton Hoo. In his scholarly and definitive account of this great find, Dr Bruce-Mitford quotes *Beowulf* from time to time almost as a historic source to illuminate the objects excavated,[51] and he especially draws attention to the fact that the funeral of King Scyld, described in the poem, is 'of the same kind and class' as that of the Anglo-Saxon king commemorated at Sutton Hoo.[52] Again, it has been shown that the royal palace which features in *Beowulf* has similarities to a royal residence, reconstructed from excavations at Yeavering in Northumbria[53] and assigned to the sixth century. If, then, gold-embroidered tapestries are mentioned in *Beowulf*, we may presume that it was because they existed at the time of its writing. Indeed, the poet implies that they were not unusual, for he speaks easily of 'everyone who gazes at such things'.

For a more positive reference to a secular tapestry, we have, however, to leap forward to the end of the tenth century – to a much quoted, if misunderstood, passage. In it, the *Liber Eliensis* retrospectively tells us of an epic tapestry received by the monastery of Ely. It presented the deeds of the East Anglian leader, Byrhtnoth, and was given by his widow, in his memory.[54]

Killed fighting the Vikings in 991, Byrhtnoth[55] was clearly one of the great heroes of East Anglia. He attracted the attention not only of the chronicler at Ely, but of the one at Ramsey, and of the writer of the almost contemporary *Vita Oswaldi*.[56] All accounts speak of his courage in battle, and one describes the striking appearance of an earl who had 'swan-white' hair and an immense frame which towered above his comrades in the fray. Yet it is in one of the greatest of all Old English poems, the incomplete *Battle of Maldon*, that he finds his most enduring memorial. Here, he is revealed as an Anglo-Saxon warrior of epic stature who met his death whilst defending his country against its foe. For the purposes of the poem, the battle is presented as a needless one.[57] After navigating a tidal estuary, the Norse raiders had found themselves

trapped on an island (now identified as Northey). From there they could advance towards the Anglo-Saxon forces on the mainland only over a narrow causeway. Their position was militarily untenable, but by appealing to Byrhtnoth's pride (or so the poet says), they were enabled to leave it and to re-group on the mainland, where the odds would be more even, and where, in fact, the Anglo-Saxons were defeated. At a time when England was being mauled and plundered each year by the Vikings, Byrhtnoth's decision can be presented (probably wrongly) as a quixotic one. But it had its own grandeur. And it is with the heroic virtues that the poem is concerned. These it extols with a spare purity which can still haunt the reader: 'Courage can still grow keener, clearer the will, the heart fiercer, as our force faileth'.[58] This is a stirring memorial to Byrhtnoth's final steadfastness in defeat. So, too, it is generally assumed, was the tapestry in his memory that his widow presented to Ely. But this does not seem possible.

The Ely monks removed Byrhtnoth's body (beheaded by the Vikings) from the battle-field and buried it, and we are told that it was then[59] that they received the hanging. But there would have been no time to mobilise the artists (the draughtsman and embroideresses), to prepare the cartoons, and to have the embroideries of Byrhtnoth's final action made in time for the hero's own funeral. And this is what our writer says.[60] He also states that the widow, Ælfflæd, *gave* the hanging. This itself may be of some significance since, when a benefactor specifically commissioned a work of art for the church – as did Cnut's queen the rich covering for the tomb of St Etheldreda – the chronicler rather speaks of it being *made*.[61] Our source, the *Liber Eliensis*, it is true, is a twelfth-century compilation and it might be argued that the details in it are not to be scrutinised too closely. However, parts of it are certainly derived from Anglo-Saxon documents,[62] and they include this area of the chronicle. The chapters before and after the one recording Ælfflæd's gifts are based on Anglo-Saxon archives now lost to us,[63] and this one is thought to derive from a contemporary document expanded from local knowledge.[64]

The difficulty before us can, in fact, be disposed of by a single assumption. It is that the hanging was not actually made for Ely: that it was already in existence in Byrhtnoth's own home, and was simply transferred to the church on his death. In this there would be nothing unusual. We know that lay owners bequeathed hangings from their own homes to monastic churches and, about this very time, curtains or hangings from the homes of Wulfwaru[65] and Æthelgifu[66] were being given to the monastic churches of Bath and St Albans. The fact that the tapestry was accompanied to Ely by a piece of secular jewellery –

namely a gold torque[67] – gives some support to the suggestion for the gift
of hangings to Bath abbey by the secular lady Wulfwaru was also
accompanied by a piece of secular jewellery – a gold armlet. Byrhtnoth
was described by the Ely chronicler as a warrior who was 'unremitting
in his battles against the enemies of the country',[68] and, if this proposal
is correct, then the *gesta*, the deeds, of Byrhtnoth which the embroidery
commemorated were his earlier victories against the Vikings. It is clear
from *Beowulf* that songs were composed and sung in honour of heroes
whilst they were still alive, and there is no reason why such visual
tributes should not have been made then, too. Indeed, in the Bayeux
Tapestry, we have surviving witness to the fact that epics in needlework
were made during the lifetime of those being commemorated.

Byrhtnoth had died fighting the pagan Vikings. During this period,
there was considerable apprehension about paganism in England, and
the reference to the Byrhtnoth tapestry in a monastic narrative of Ely is
probably due to the fact that it was seen as the relic of a Christian,
martyred in his battles against the infidel. This is never explicitly
stated. However, the chronicler's reference to the hero as the *venerable*
Byrhtnoth[69] indicates that he was seen as no ordinary secular soldier.
He was also, as it happens, well known as a staunch supporter of
monasticism and a particularly generous benefactor to Ely. The full
title of the very lengthy chapter about him reads: 'Concerning the
venerable duke Byrhtnoth, who gave to St Etheldreda: Spaldwick,
Trumpington, Rettenden, Hesberen, Seham, Fulbourn, Teversham,
Impington, Pampisford, Croxton, Fimbrough, Triplow, Hardwick and
Somersham with their appurtenances'.[70]

The information about the Byrhtnoth tapestry derives, then, from a
quite exceptional conjunction of circumstances. But this does not, of
course, mean that the tapestry itself was exceptional. Other examples in
their own proper context of secular society would go unrecorded, if for
no other reason than that they were out of sight of the monastic
chronicler. No one would suggest that the one or two heroic poems, or
parts of poems, that survive betoken more than a tiny fragment of the
heroic poetry that actually existed in the Anglo-Saxon period. In like
manner, it is probable that the comment in *Beowulf* and the more secure
reference in the *Liber Eliensis* represent but rare insights into a continu-
ing tradition of heroic hangings in England.

Some oblique support for this view can be found in a particularly
reliable source for the middle decades of the eleventh century – the *Life
of St Edward*, which was perhaps commissioned by the Confessor's own
queen. Here we learn that the Confessor had a ship whose sails were
embroidered in gold with illustrations of the great sea-battles of the

Anglo-Saxon kings. The description is given in an inserted poem, which is incomplete in the copy which has come down to us, and the relevant lines might be very freely translated:

> Noble *purpura* decks the hanging sail,
> Displaying, in its various detail,
> The sea-battles enraged
> Our royal kings waged.
> When, from the mast, the yard-arm upward swings,
> Aglow with gold, the sail extends its wings.[71]

These scenes of naval actions clearly belong to the same genre of epic embroideries as those we have earlier described, and indicate that, on ceremonial occasions, the pageantry of stirring deeds was known to the Anglo-Saxons afloat, as to those ashore.

A fragmentary piece of Anglo-Saxon sculpture, excavated at Winchester[72] (Plate 31), may have a bearing on this theme of the epic

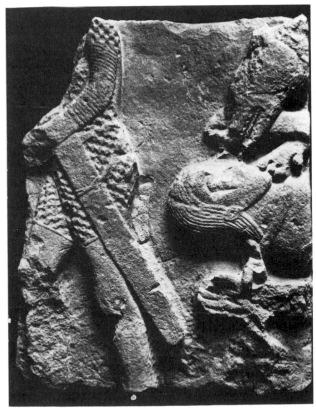

**31** Fragment of Anglo-Saxon sculpture from Winchester, said to represent a detail from the life of Sigmund (Winchester cathedral).

deeds of Anglo-Saxon kings. It was apparently rejected as rubble by the Normans who completely rebuilt the Anglo-Saxon cathedral, and is thought by the scholar who excavated it to have originally been part of two scenes from an extensive stone frieze, four and a half feet high and perhaps some eighty feet long. This, he thinks, presented episodes from the history of the Wessex kings. These kings were traditionally buried at Winchester and they traced their descent back to the hero, Sigmund, who is identified as one of the two figures on the carving. He is the recumbent figure, being licked around the mouth by a wolf, and we are told that this illustrates an episode in the saga of his life when, with legs shackled, he and his nine brothers had been left defenceless in a forest. Each night a fierce she-wolf emerged from the forest to devour one of them until only Sigmund was left. At this point, Sigmund's sister sent help in the form of someone who could smear honey over Sigmund's face and inside his mouth. When, that night, the she-wolf made another of her predatory visits, she so much enjoyed the taste of the honey on Sigmund's face that she tried to get at the honey inside his mouth. Thereupon, the hero snapped his teeth tightly on her tongue. The she-wolf leaped back breaking the shackles on Sigmund's legs, but he maintained his hold and tore out her tongue by the root, so causing her death. In this same interpretation of the sculpture, it is suggested that the standing figure turning away from Sigmund belonged to a separate scene in which the action took a direction away from this one. Adjacent scenes in the Bayeux Tapestry, we are reminded, occasionally point in different directions and we are, indeed, asked to consider the influence of this frieze on the later tapestry. In fact, if such a frieze existed (and much of this is conjectural), and it actually predates the Bayeux Tapestry (on stylistic grounds its dating by archaeologists to the late tenth or early eleventh century is too early), then we should see it not as anticipating the Bayeux Tapestry but as being influenced by a long tradition of epic tapestries of which the Bayeux Tapestry is a late and only survivor.

The evidence for such a tradition is, of course, spasmodic. But it could not be otherwise, given the fragmentary nature of the sources and the indifference of most of them to secular art. The references are rare but, if we consider for a moment how uninterested writers were in describing such works of art and how completely most writers had turned their backs on the art of lay society, then even these references appear as lucky glimpses into a tradition of epic embroideries which take us back to the days of *Beowulf*.

Confirmation of this very tradition is offered by the Bayeux Tapestry itself, for no one with an intimate knowledge of the arts of the Normans

could conceive of them initiating such an epic in needlework. (Apart from stylistic questions,[73] there is no evidence that within their own duchy the Normans had any particular interest in embroidery, or their women any special skills in it, and it was certainly to Anglo-Saxon embroideresses that they turned after the Conquest.[74]) If, however, the Normans found epic tapestries in the homes of the Anglo-Saxon aristocracy that they commandeered after the Conquest, then this would have inspired them with the idea of commemorating in a similar fashion their own, Norman, achievements. Made originally for a secular hall[75] and embroidered in England by Anglo-Saxon craftswomen, the Bayeux Tapestry (Plate 32) has all the special importance of the lone survivor. It also has compelling interest as a social document and as a historic account of recent events. Further to this, it seems unique in its visual attempt to marry the requirements of a chronicle to the conventions of a literary genre, namely the *chanson de geste*,[76] and it is not a coincidence that the patron of the Bayeux Tapestry, Odo of Bayeux, is increasingly considered to be the patron of the first written edition, as it were, of the greatest and earliest of these *chansons de geste*, the *Song of Roland*.[77]

Despite all this, the Bayeux Tapestry would have been considered quite ordinary by the Anglo-Saxons, for it lacks the preciousness of gold thread which was one of their own hallmarks of excellence. In a lengthy poem, sent to the Conqueror's daughter Adela, Baudri de Bourgueil gives an imagined account of another 'tapestry' of the Conquest, which was supposed to be seen in her great and splendid bedroom.[78] However literary this account may be (and it belongs to a long tradition of word-painting), it yet strikes a true note of what would have attracted acclaim from the English themselves in its reference to the interweaving of silk and gold thread, enriched yet further with embellishments of precious stones. Indeed, some of his remarks – such as the comment that the hanging excelled in workmanship and in costliness, and surpassed the rays of Phoebus – might have been made by an Anglo-Saxon writer anxious to praise. It was, of course, the very absence of such precious materials with their fatal attraction for the needy and the covetous that made the survival of the Bayeux Tapestry possible. But, though this famous embroidery would not have been highly prized by the Anglo-Saxons themselves, it yet remains a supreme irony that this, the only surviving example of their long tradition of heroic hangings, should show them at the absolute nadir of their fortunes.

In the wealthier homes textiles were used as wall-hangings, but they served many other functions as well – from covering chairs and cushions to curtaining off beds. Goscelin speaks of "couches covered with rugs" in the earlier home of a man of wealth,[79] and even refers to tapestries on

**32** Detail from Bayeux Tapestry (Musée de la Reine Mathilde, Bayeux).

the seats of his own humble dwelling.[80] The wills of wealthy ladies of the tenth and eleventh centuries mention seat-covers,[81] dorsals,[82] table-covers[83] and bed-curtains.[84] The manuscript-paintings of the same period show hangings dividing rooms (Plate 33), curtaining off walls (Plate 34) and beds (Plate 35), and materials covering tables (Plate 34), pillows (Plate 35) and cushions. The colours, especially of the cushions, are often cheerful and gay, and it is clear that one function of these fabrics was to brighten up the inside of houses.

Fabrics also brought colour into churches, where their functions were occasionally similar to those in the home – for example, covering cushions (Plates 19, 20 and 22) and furniture. More often, their purposes were more specifically ecclesiastical, such as enhancing the altars (Plates 36 and D) and curtaining off the ciborium, or canopy, round the high altar, as the representation of a miracle of St Lawrence in a noble ivory carving of the early eleventh century demonstrates (Plate 36).

This custom of enriching altars with choice fabrics derived from Rome. Inventories there document gifts of fine altar-covers from an early date and, in the eighth century, we find Pope Hadrian decking out six altars with costly fabrics, including silks interwoven with gold.[85] Similar sumptuous altar-covers were to be found in England and, already in the later part of the seventh century and early part of the eighth, we learn of the altar of a church in Wessex being adorned with gold textiles 'which shone with twisted thread',[86] of the altar of the church of Ripon in Northumbria being bedecked by St Wilfrid with silk interwoven with gold,[87] and of the altar of his other church at Hexham being embellished by his successor, Acca, with rich stuffs.[88] The tradition continued throughout the Anglo-Saxon period, and is reflected in various benefactions. To take but a few examples, in the tenth century St Æthelwold gave two gilded altar-cloths to Peterborough,[89] and King Athelstan three altar-cloths to Chester-le-Street,[90] and in the eleventh century, Leofric bequeathed five costly altar-cloths to Exeter.[91] Earlier, Queen Emma had presented to Ely an altar-cloth of blood-red edged with gold,[92] which must have been similar to the gold-bordered altar-cloth that appears in a tenth-century picture of St Æthelwold at Winchester (Plate D), even though the latter is of a different colour. She also donated a large green altar-frontal, adorned with bands of gold, for display at the appropriate festivals.[93]

Costly fabrics were put to other uses in churches – for example, as covers of tombs to enrich them. The Danes who attacked the church of Ely in the ninth century found on the tomb of the patron saint a sumptuous textile which they tore away.[94] Over the sepulchre of King

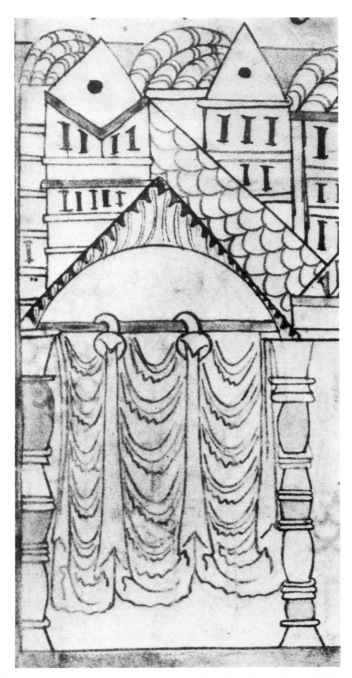

**33** A drawing of a curtain used as a room-divider in a Canterbury (St Augustine's) manuscript of the second quarter of the eleventh century (British Library, Cotton MS. Claudius B IV, fol. 32). The illustration is of Lot's home in Sodom.

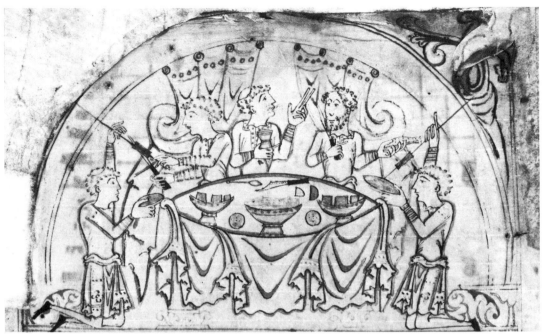

**34** Drawing of a feast from a manuscript probably made at Winchester, mid-eleventh century (British Library, MS. Cotton Tiberius C VI, fol. 5v).

**35** The Anglo-Saxon use of bed-curtains demonstrated in a drawing of the sleeping Sarah (left) and of Abraham and Hagar (right). Canterbury (St Augustine's), second quarter of eleventh century (British Library, Cotton MS. Claudius B IV, fol. 27v).

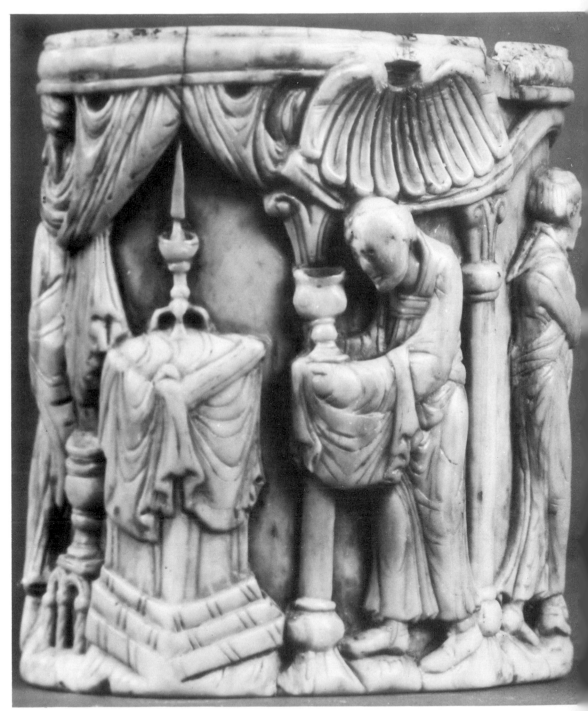

**36** The Anglo-Saxon curtaining of the ciborium as seen in an ivory carving of one of St Lawrence's miracles. Early eleventh century (Victoria and Albert Museum).

Edmund at Glastonbury, Cnut himself placed a rich fabric, woven with peacocks of various colours,[95] and Bishop Brihtwold later gave to the same house ten tomb-coverings, including one of gold cloth.[96] Cnut's queen presented coverings of silk, set with gold and gems, for the tombs of saints at Ely, and, for the tomb of the major saint, one especially sumptuous silk which was bordered with gold and 'decorated in wonderful workmanship with gold and gems which gave a chequered effect'.[97] These decorative embellishments, we may presume, were Anglo-Saxon, but the silks themselves were imported.

Like their contemporaries in the rest of Christendom, the Anglo-Saxons held imported silks in great esteem. Indeed, when they could afford it, not only did they seek to clothe their bishops and abbots in silk, but their churches — walls, tombs, and altars — as well. They also incorporated silk into the more costly secular fashions and, as early as *c.* 686, Aldhelm had commented on the vogue for silk sleeves by both men and women.[98] Silks were, of course, always luxury items. In Ælfric's *Colloquy* they appear in the same context as gold and precious stones,[99] and some indication of their costliness in Bede's day is given by his remark that two silks were exchanged for an estate of three hides.[100] The hide varied in Anglo-Saxon times from forty to one hundred and twenty arable acres, but, as its name (*terra unius familiae*) suggests, each hide represented land sufficient to support a family.[101] In other words, each silk would have kept one and a half families for life.

Silk was always held in high regard but there was another fabric prized even above it. It was called *purpura* and this is something of an enigma.

*Purpura* was clearly associated by the Anglo-Saxons with the distinctive and the costly. A cloak of King Edgar was characterised as being of 'distinguished' *purpura*,[102] and, because a cope given by St Æthelwold was of *purpura*, it was thought appropriate that it should be edged with gold.[103] It was not only the Anglo-Saxons who sought out this material, for there are references to it in post-Conquest England, in the mediæval chronicles of France, Germany and Italy, and in mediæval poetry ranging from *chansons de geste*, like that of *Guillaume d'Orange*, to romances, like that of *Perceval*. It had an éclat throughout the mediæval West. However, in view of the particular interest it had for the Anglo-Saxons, some positive attempt should be made to determine its identity here.

Though also used to mean a purple garment, *purpura*, of course, normally denotes purple as a colour. This is a colour traditionally associated with the panoply of church and empire, and one which, in the Byzantine empire, under the Macedonians, achieved so real a

symbol of power that it became a capital offence for a private citizen to sell purple cloth of any description.[104] Through much of recorded history, purple has generated reverberations of grandeur which are still found today in our use of the phrase 'a purple passage' to indicate the rather full-blown splendours of a literary style. In the hands of poets, *purple* has taken on varying shades of meaning, which have even necessitated recondite explanations. Virgil, for example, has written of the purple spring:[105] Horace of purple swans:[106] Shakespeare of purple blood:[107] and Spenser (in a metaphorical sense) of purple hair.[108] Let it be said from the outset, however, that the *purpura* of the Anglo-Saxons was far removed from this poetic world of sensations and sensibilities. It appears in the most pedestrian of sources such as straightforward inventories. It was a technical term, simply intended to define a certain type of fabric. The problem is to discover what this fabric was.

One of its curious characteristics was that it did not have to be purple. Ely owned a tunicle of red *purpura*;[109] Peterborough had a chasuble of white *purpura* and a cope of green *purpura*;[110] and, soon after the Conquest, we read of Rochester acquiring vestments of black and red *purpura*.[111] Here, the fact that the colour of the material was other than purple is explicitly stated, but elsewhere it is simply assumed. For example, Eddius speaks of St Wilfrid emulating Moses in the seventh century by the 'various distinct colours' in his church at Ripon, and then goes on to refer to them as varied *purpurae*.[112] The implication is that the *purpurae* at Ripon included colours that were both separate and diverse.[113] In fact, even in classical antiquity, the words *purpura* or *purpureus* were not confined to the colour we today call *purple*. Vitruvius, for example, saw *purpura* as a dye, extracted from sea-shells, that could yield blacks, leaden blues, violets and reds.[114] And though, it is true, he was using these colours to qualify *purple*, this still left him with a wide range of tones. Other classical writers used *purpureus* in a very broad sense: to indicate the brown tones of a flower, the redness of the lips, or of a blush: various shades of violet: and every hue in between.[115] But of far more importance for our purposes, is the fact that *purpureus* has already come to indicate brightness – the sun and its refulgence:[116] the light of day:[117] the full spectrum of the rainbow:[118] the glint of sunshine on a lightly rippled sea:[119] and the shining whiteness of snow.[120] In brief, before the Middle Ages had begun, the Latin word for purple was losing its colour content and coming to indicate the glow, or gleam, of light.[121]

Such a glistening quality must have been an obvious characteristic of the fabric called *purpura*. This at least would explain why, in his *Life of St Martin*, Ælfric (following his Latin source) speaks of a garment shining like *purpura*.[122] Since the less exotic materials of the Middle Ages, such

as wool and linen, had no lustre, it would follow that *purpura* was probably some kind of silk. An alternative suggestion is that it was a fur or pelt, but, in fact, a commentary on Isidore, a biography of a tenth-century saint,[123] and a thirteenth-century inventory from London[124] do all equate *purpura* with silk. This, however, does more to deepen the mystery than to clear it. For, if *purpura* was a silk, how were the Anglo-Saxons able to distinguish it from other silks? Eddius clearly differentiated between the silk and the *purpura* on the altar at Hexham in the seventh century,[125] and three centuries later the merchant of Ælfric's *Colloquy* spoke of *purpura* and silk as two distinct materials.[126] In the latter text, the word *purpuram* is glossed *pællas* but this does not help the investigation since *pæll* (a costly garment or covering) is itself lacking in definition.

It is not until we go forward into the thirteenth century that we discover another clue that helps unravel the answer. This is in a London inventory, where we unexpectedly find *purpura* compared to a thick and variegated textile of another kind.[127] This clearly indicates that *purpura* was both thick and of more than one colour. Its robustness, at least, can be confirmed from some of the purposes to which it was put in the Anglo-Saxon period, for it was then used as a banner,[128] a cloak[129] and a sail.[130]

The hints and indications of our sources suggest then that *purpura* had the following qualities: it was distinguished by a gleaming quality: it was a silk but clearly distinguishable from other silks: it was of more than one colour, and it was also thick in texture. These, in fact, are the characteristics of a fabric still in use today: namely, shot-silk taffeta. Its gleaming quality is one of its chief attractions: it is a silk, but immediately distinguishable from other silks: it is of more than one colour – there is one on the top surface and a different colour under-neath, and the shimmering variegations of the two colours, as the light catches now the one and now the other, are the essence of its appeal. Furthermore, this material needs to be thick in order to be effective in its task of keeping the textile slightly stiff and spread-out so that it can catch the light. We know that shot-silk taffeta was used by the Anglo-Saxons for there is an accurate description of it in a narrative, whose only deficiency is its failure to put a name to the fabric and actually call it *purpura*. This occurs in a report of the translation of St Cuthbert at Durham in 1104. It was set down by Reginald of Durham, who, though writing between 1165 and 1172, was drawing on the transmitted con-temporary witness of those who had assisted at the reburial of the saint and 'who handled the incorruptible body of St. Cuthbert, who ex-amined it by sight and contemplated it, lifted it in their arms and held it

in the grasp of their hands . . .'[131] It is Reginald's account of St Cuthbert's dalmatic that concerns us here, and this must certainly have been placed in the coffin-reliquary in Anglo-Saxon times, perhaps when the body was first transferred in 698, for it was then clad in a new garment.[132]

The colour of the dalmatic, said Reginald, was a reddish-purple unknown to his generation,[133] but this was 'shot' with another colour, yellow, which produced ever-changing patterns of variegated colour:

And for more grace and beauty its appearance was frequently changed and variegated by strands of another colour mingled with it – a yellow colour which is believed and judged to be that of the lime. This pleasing variation appears in all its beauty in the purple cloth and produces ever new and diverse patterns by the intermingling of patches of different colours.[134]

This is an exact description of shot-silk taffeta as it catches the light. As the fabric changes its angle to the light, so the underneath colour 'displays' through the interstices of the upper weave and produces a constantly changing, shimmering effect of colour and pattern. Since this fabric depends on light to induce its particular attractions, the fact that the dalmatic was also examined in the shade demonstrates the acute interest of the observers. In these conditions, it was also accurately described in terms of shot-silk as we know it today. When it is away from the light, the underneath colour, seen through the tiny interstices of the upper colour, *does* appear like a scattering of coloured dots, just as Reginald says, and this scattering is neatly characterised by his word 'sprinkled' (*respersa*): 'This infusion of a yellow colour is discerned to be inherent in the cloth, sprinkled dropwise over the whole, and by its strength and brilliance the reddish-purple tint is made to give out a more powerful and brighter light'.[135] Like taffeta, the material of this dalmatic also was thick so that 'when touched by the fingers . . . it gives out a sort of crackling sound because of the firmness of the elegant workmanship and the ample strength of the weaving'.[136]

If the *purpura* of the Anglo-Saxons was this shot-silk taffeta, then the name was a very apposite one, for, as we have seen, *purpureus* in the Roman world had already come to indicate the glowing, gleaming effects of light. It had been used in classical times to describe the glitter of the sea rippled by a light breeze, and sunshine on the ruffled surface of the Mediterranean can produce a scurrying of pin-pointed lights very like shot-silk as it catches the light. This mobility of light and colour, these ever-changing iridescences, must have had a compelling fascination for a race which was always interested in colour-brightnesses and their fluctuations. So, like the dalmatic of St Cuthbert, we must now

allow for the fact that other Anglo-Saxon vestments, together with some secular garments like the cloak of King Edgar,[137] and those church hangings[138] and altar-[139] and tomb-coverings[140] which were described as being of *purpura* were of shot-silk taffeta. We have to visualise a society in which there was much shimmering of colours in the centres of wealth.

Despite the fact that *purpura* had two colours, only the main one is usually mentioned. These, for vestments, are appropriately liturgical ones: red, black, white, green,[141] though, in fact, *purpura* could be of any colour. As in the field of horticulture the rose originally gave its name to a particular colour but today can be of almost any hue – yellow, mauve, red, white, etc. – so, in the world of textiles, *purpura* was first the name of a purple colour, or cloth, and then came, by the mediæval period, to represent shot-silk of any colour. This does not mean that there are no rose-coloured roses today. Nor does it mean that there were no purple-coloured *purpurae* in the Middle Ages. On the contrary, given the predilection of the Anglo-Saxons for purple as a colour, we can feel sure that there was much of it. There is certainly evidence that there was purple among the *purpura* hangings at Ripon,[142] as there was purple in the dalmatic of St Cuthbert, which we have suggested was of *purpura* also.

These shot-silk taffetas, together with other silks, came from abroad, and, even if the merchant of Ælfric's *Colloquy* had not spoken of importing them both, this would be obvious enough. Its Latin term, *purpura*, suggests that the shot-silk taffeta came through Italy and we know that there were English traders entering that peninsula through Pavia for, in a well-known letter written to Offa, King of Mercia, in 796, Charlemagne complained of some of them who mingled with the pilgrims in order to avoid the tolls.[143] Anglo-Saxon merchants, travelling to Italy, also came to unfavourable attention later, as economic historians have pointed out. Regulations of the royal court at Pavia, drawn up early in the eleventh century but referring to tenth-century conditions,[144] spoke of the brawls that the Anglo-Saxons instigated when their trading baggage was searched by customs officials, and the document[145] described a resultant accommodation which allowed the tax on individual Anglo-Saxons to be compounded by a triennial payment from England's royal treasury. This source may reflect on the irascibility of Anglo-Saxon traders but it also demonstrates their importance in Italian commerce for, though similar arrangements were made for Italo-Byzantine towns like Venice, no other non-Italian town or state was so privileged. A further indication of the fact that Anglo-Saxons were trading in Italy (and this time Rome is specifically mentioned) is provided by Cnut's proclamation of 1027 from the Eternal City, in which he proudly states

that he has successfully negotiated with the emperor and the king of Burgundy that 'my subjects, both merchants and others travelling in the cause of devotion, should come and go, to and from Rome in assured peace, under just regulations, free from all the hindrances caused by barriers and tolls'.[146] This trade with Italy will explain a major route by which *purpura* came to England but it does not mean that the shot-silk was made in Latin Italy, for this was a major transit area for silks coming from Byzantium and (even after the Mohammedan conquests in the Mediterranean) from other parts of the Levant.

Of course, parts of Italy itself still remained part of the Byzantine empire until the Norman occupation in the eleventh century and these included the southern area and towns as important as Naples, Amalfi, Salerno and Bari. It is true that these Italo-Byzantine areas would normally only be traversed by Anglo-Saxons on the way to the Holy Land, but the many who went to Rome would find the Eternal City itself pervaded with Byzantine influences. Several of her early popes were themselves Greek or Eastern. When St Wilfrid presented his petition to the pope in 704, he found that the synod needed to discuss his submission in Greek, and, in the eighth century, a primary theological source like the *Dialogues of St Gregory* had to be translated by the papacy into Greek since there were so many monks in the Greek monasteries of Rome who could not understand Latin. Rome was infused with the culture of Byzantium and this found particular expression in Rome's own partiality for Byzantine silks and fabrics.

This is clearly seen in the accounts in the *Liber Pontificalis* of papal gifts of textiles (including vestments) to the churches of Rome. Though some of the silks are referred to as Alexandrian, others are characterised as Byzantine,[149] and, even without these specific references, we should know that a number were Byzantine since their ornamentation is described in terms that are Greek, or Greek-derived. These textiles from Byzantium and the Levant were to be seen in the monasteries of Rome where Anglo-Saxon monks would stay. They could also be viewed in the churches that Anglo-Saxon pilgrims would visit. This latter is of special importance since it was the custom for pilgrims to tour the Roman churches and their shrines: we are told, for example, that in 680 St Wilfrid 'spent several days going round the shrines of the saints to pray',[150] and that in 990 Archbishop Sigeric could find time to see well over twenty churches in a sojourn of only two or three days in Rome.[151] Displays of Byzantine and other silks would then be familiar to almost all Anglo-Saxon visitors to Rome. Those who wished to build a second Rome in England could also buy such silks in the Eternal City.

These purchases did not, of course, interest the chroniclers, so we

hear of them only exceptionally and in relationship to other things. It is only because of Bede's special interest in the founder of his own abbey, his abbot and mentor, Benedict Biscop, that he tells us that from his sixth visit to Rome in about 684 Biscop brought back two silks with fine decoration.[152] It is only because Eddius had a particular hero-worship for St Wilfrid and wished to record every example of his munificence that he informs us that when the saint was in Rome in 704 he bought purple and silk fabrics for his churches.[153] It is only because of William of Malmesbury's interest in the relics of a celebrated saint of his own monastery that we learn[154] that St Aldhelm had worn (and presumably acquired) in Rome in the late seventh century a silk chasuble with a design of peacocks.[155] Again, in the French context, it is only because Odo of Cluny was anxious to record an example of the complete integrity of the French saint Gerald of Aurillac that he reports a conversation between the saint and merchants in luxury fabrics. The passage has become a celebrated one.[156] On his way back from a pilgrimage to Rome, St Gerald (c. 855–909) stopped near Pavia. Here Venetian merchants and others circulated amongst the encamped company offering their wares of stuffs and spices 'as was their custom'. They approached St Gerald but he pointed out that he had already bought fabrics in Rome, and showed them the most precious one. When he disclosed its price, the traders congratulated him on having paid less for it in Rome than he would have been charged in Constantinople, from whence it had obviously come. The reaction of Gerald was one of complete dismay to learn that he had underpaid the traders in Rome and he made arrangements for pilgrims, travelling south, to re-imburse them for what he now conceived to be their loss. The mediæval point of this anecdote was the honesty of the saint. Its interest today lies in the fact that Byzantine silks could be bought in Rome.

Pavia sold Byzantine silks also: a fact confirmed by the sardonic remark of the Monk of Saint Gall, who used the purple and peacock-embroidered secular, silk garments bought in Pavia to exemplify the effete luxury of courtiers.[157] (They may not have been Charlemagne's courtiers, as he declares, but historians agree that he was reflecting the social life of his own time[158] and he was writing between 883 and 887.) Pavia, the capital of Lombardy, held international markets to which came merchants from Salerno, Amalfi, Gaeta[159] and especially Venice. Here could be bought silks not only from Byzantium but from other parts of the Levant.[160]

The Anglo-Saxons had associations with Pavia, and an incidental remark by Asser indicates the numbers who knew the city in the ninth century.[161] But Pavia's chief importance was as a staging post on the

journey from northern Europe to Rome. Most Anglo-Saxon pilgrims journeying to Rome would break their journey there and some, like St Gerald, would make purchases from merchants offering their wares. This is clearly documented in the will of Bishop Theodred, which refers to two chasubles he had bought in Pavia: 'And I grant to Theodred my white chasuble which I bought in Pavia and all that belongs to it . . . And I grant to Odgar the yellow chasuble which I bought in Pavia and what belongs to it . . .'[162] Theodred was consecrated bishop of London some time between 909 and 916, and he drew up this will between 942 and 951, so that the most we can say is that he probably bought these vestments in the first half of the tenth century. The information about Theodred's purchases has chanced to come down to us only because the Bury St Edmunds sacrist wished to preserve a copy of a will which bequeathed land to the earlier church of Bury, and it is not probable that he was the sole Anglo-Saxon to buy vestments at Pavia. As is usual in such documents, there is no description of the decoration of the vestments. However, it was for the sale of its Byzantine fabrics that Pavia was chieflly celebrated commercially.

It is relevant, then, in this context to observe that the only Anglo-Saxon vestments to survive in England (which also happen to belong to the first half of the tenth century) were themselves influenced by Byzantine vestments. Found in St Cuthbert's tomb in the early nineteenth century, they are quite minor pieces – a girdle, a stole and a maniple – which will be more fully discussed in the next chapter.[163] Here, however, it may be said that both the decorative and figural styles of the stole (Plate F) and maniple derive from Byzantium,[164] and it has been persuasively argued from such features as the arrangement of standing figures identified by inscriptions loosely set beside them, and the setting of inscriptions in ornamental fields at the ends, that the craftswomen had knowledge of Byzantine stoles made before the tenth century.[165]

The significance of Pavia was that it was on the road to Rome, and the importance of Rome itself to the Anglo-Saxons needs no underlining. Here, by the end of the eighth century, there was a permanent Anglo-Saxon settlement which the Italians called the *schola Saxonum* but which the settlers themselves referred to as their own 'borough'. It consisted of those who (like one or two early Anglo-Saxon kings) wished to end their days near the shrines of Rome, and probably included some traders. It is, however, not the residents but the visitors to Rome who matter most in our present context. Of these, our sources name only saints, and dignitaries of church and state, and even these but infrequently. Even so, it is noteworthy that, from these distinguished visitors, a saint like

Aldhelm,[166] a king like Cnut[167] and an archbishop like Sigeric,[168] were able to present textiles in England which were apparently Byzantine since their decoration (peacocks and lions) can be paralleled in Byzantine silks which have survived to this day.

In fact, multitudes of the more ordinary Anglo-Saxons travelled to the Eternal City. Some went on official business, some for privileges, some for instruction, some to seek a cure for their afflictions, some as a penance. But the vast majority went as pilgrims to pray. Commenting on the pilgrimage to Rome of Ine, king of the West Saxons, in about 725, Bede already says that 'Many of the English, nobles and commoners, layfolk and clergy, men and women, eagerly followed this custom'.[169] Such were the numbers of Anglo-Saxon women who visited Rome and so unhappy their consequent plight that, twenty-two years later, St Boniface was reduced to asking the archbishop of Canterbury to forbid their frequent journeys, for many found themselves financially stranded and, having set out on a journey of virtue, found that they could support themselves only by a life of sin – in the brothels of the territories leading to Rome. In the midst of his work of converting the Germans, St Boniface had the sad task of warning the archbishop that 'A great part of them perish and few keep their virtue. There are many towns in Lombardy and Gaul where there is not a courtesan or harlot but is of English stock'.[170] Despite such problems, the popularity of the Roman pilgrimage – the 'south-fare', as it was called – continued unabated through the Anglo-Saxon period and we even find the later guild statutes for Exeter making special provision for their members to go.[171]

For safety's sake Anglo-Saxon pilgrims travelled in large groups. When Anglo-Saxon kings visited Rome (as a number did) then it is understandable that – in the words of a Roman observer recording King Æthelwulf's visit in the ninth century – they should be accompanied by 'a great concourse'.[172] But it is surprising to learn that when, in 716, Abbot Ceofrith died on his way to Rome, he had no fewer than eighty of his countrymen with him.[173] The vast numbers of the uncanonised, the untitled and the unbeneficed who came from England would never catch the eye of the chronicler and the writer of saints' lives. Yet they would certainly include some who were affluent enough to buy silks in Pavia or Rome. This is revealed by an early poem, written before 705, which has happened to survive. It was sent to St Aldhelm by a certain Æthelwald, and was composed on the theme of a pilgrimage to Rome. It recounts how two pilgrims (of an original three) returned with rich gifts for the church in England, and these included splendid silk fabrics of various kinds which – to paraphrase the poem with its reminiscence of Ovid – gleamed, like beds of red roses and ivory lilies in a garden, as well

as displaying other colours such as gold, green and yellow.[174]

If Anglo-Saxons travelled to Rome, there were some who undertook the yet more hazardous pilgrimage to the Holy Land. Indeed, in the eighth century, a Saracen commented on the many Anglo-Saxons who made their way there.[175]

In Jerusalem itself, according to retrospective information in a *chanson de geste*, there were fairs where the pilgrim might buy silks.[176] Such markets had prevailed from an early period and, in an account transmitted by Adamnan, Arculf gives a description of the great fair of about 680 when, in September, 'a high concourse of people from various nations everywhere is wont to come together in Jerusalem to do business by mutual buying and selling'.[177] More importantly, one of the major routes to Jerusalem led through the heart of the East Christian empire. Indeed, the writer from England who recorded the Saracen's remark had himself travelled outwards via the centre of Byzantium. It was in Byzantium, of course, that some of the finest silks were made, and its markets – particularly those of Constantinople – offered the greatest variety of silks in the world. Some of the most sumptuous silks might not be allowed out of the country, as the Ottonian legate, Liutprand was to discover. But even the strictest rules could be relaxed or circumvented. And it is interesting to discover that amongst the fabrics on open sale were the 'stripes and trimmings of purple' (to quote one imperial edict)[178] which the Anglo-Saxons emulated, for St Boniface had criticised the fact that they were worn even by monks.[179] These must have had a general influence on Anglo-Saxon fashions, for the Carolingian Paul the Deacon refers to the wide stripes woven in different colours that the Anglo-Saxons wore on their garments.[180]

As usual, the chroniclers only record pilgrimages to the Holy Land by the great of the land, and the most we learn from the Anglo-Saxon Chronicle, for example, is that Bishop Ealdred was in Jerusalem in 1058, and that earlier, in 1052, Earl Harold's elder brother Swein had died in Constantinople on his return from thence. We are told nothing about the pilgrimages of ordinary folk, although the discovery of Byzantine seals and coins at Winchester may provide archaeological documentation of the fact that pilgrims returned with Byzantine objects in the late Saxon or early Norman period.[181] About the transmission of artistic objects the written sources are silent unless they happen to feature in an account of divine intervention. It is only because a Canterbury monk named Æthelwine was involved in a miracle that we learn that, when returning from a pilgrimage to the Holy Land in the years before the Conquest,[182] he bought in Constantinople 'a very valuable and beautiful covering' for the tomb of St Dunstan in his own

English cathedral.[183] Earlier purchases, not sanctified by miracles or the associations of saints, would go unrecorded. But we should not assume there were none. In other words, some Byzantine textiles may have come to England direct from the Christian Empire of the East. They would chiefly be brought by pilgrimage routes but the links between England and Byzantium were not only those forged by the pilgrim.

Writing to Queen Bertha at the very onset of the Roman mission to England, Gregory the Great averred that she was known by her deeds to the emperor of Constantinople,[184] and it has been suggested that the appointment, soon after the mid-seventh century, of two Byzantine ecclesiastics to important offices in the Anglo-Saxon church implied a pre-existing rapport between the Anglo-Saxons and the citizens of Eastern Christendom.[185] This was certainly feared by the Merovingians, for Ebroin, their mayor of the palace, held back one of them, Hadrian, on his way to England, fearing that he headed a mission from the emperor of Byzantium to the kings of England.[186] Hadrian was abbot of St Augustine's, Canterbury, from 671 to 709,[187] and his companion, Theodore, was archbishop of Canterbury between 688 and 690. Possibly, they had Byzantine objects with them. They certainly introduced a form of Byzantine culture for we learn that Hadrian's successor, Albinus, "had no small knowledge of the Greek language"[188] and that Tobias, who was Bishop of Rochester from 693 to 706 and lived on to 726, was as familiar with Greek as with his own tongue.[189] Other ecclesiastics from Byzantium visited England later. There was a Greek monk at the New Minster, Winchester, in the tenth century,[190] and another at Malmesbury in the eleventh,[191] and – if the *Liber Eliensis* is to be believed – a Greek bishop visited England in the reign of King Edgar.[192]

Direct trade between England and Byzantium is uncertain, but the fact that the life of a patriarch of Alexandria, who died in 616, speaks of trade with England,[193] that the Sutton Hoo finds of the seventh century have yielded up a Byzantine dish, and that a Byzantine gold coin known as the *nomisma* is referred to in Anglo-Saxon sources of the seventh[194] and tenth centuries[195] may indicate that there was some commerce of a desultory kind with the Eastern Empire.

It is more probable, however, that trade in the Baltic rather than the Aegean gave Anglo-Saxons a limited access to silks from Byzantium and the Levant, for, if there were middlemen for luxury fabrics in the south, there were others in the north. These were the Scandinavians in Russia. They traded their furs for Byzantine and Arab silks, and transported them to Baltic ports[196] and, until the ninth century, the Baltic trade was dominated by the Frisians, who had particularly close

ties with England including their own colony at York. There are also
references to Anglo-Saxon sailors themselves being in the Baltic in the
ninth[197] and in the mid-eleventh[198] century and, furthermore, in his
edition of Orosius, King Alfred gives accounts of two traders voyaging
from his realm into Scandinavian and Baltic waters. One was Ohthere
and the other Wulfstan, and the latter must certainly have been English.
All this combines with the hoards of Anglo-Saxon coins found in the
Baltic countries and in Russia[199] to suggest the possibility of some silks
reaching England by this more circuitous route.

Apart from the important markets of Italy and the less certain centres
in Byzantium and on the Baltic, silks from the Levant were transmitted
to England by one of the hospitable features of the period: the exchange
of gifts. By then, of course, they had already found their way into the
Latin West.

Some presents – like St Boniface's modest offering of a rug[200] – might
express only kindness and civility, but others represented strong instru-
ments of policy. When St Wilfrid (a generous giver himself) bequeathed
wealth to Ripon and Hexham, it was to enable their abbots to obtain the
friendship of kings and bishops – in other words, to permit them to
bestow gifts in the hope of attracting privileges and favours.[201] The
making of gifts was quite common. In *Beowulf* emphasis is given to the
costliness of those made to the hero, but in the chronicles we normally
only hear about them incidentally. So, the fact that an Anglo-Saxon
ambassador, abroad in the eleventh century, might be proffered many
gifts which included precious manuscripts, only comes to light because
of the unravelling of a miracle.[202] It is unusual for full accounts of such
diplomatic exchanges to be given, though William of Malmesbury,
quoting from a lost tenth-century poem, discloses that a mission from
Duke Hugo of the Franks asking for the hand of the sister of King
Athelstan 'offered gifts of a liberality that would have satisfied the
covetousness of the most avaricious', and that these included a carved
vessel of onyx, 'scented spices such as had never before been seen in
England, choice jewels, especially emeralds . . . a crown of great value
for its gold but even more for its jewels'.[203]

Eastern silks featured highly in the presentations of the period: a
proffer of friendship: a delicate persuader. King Alfred even gave a
costly silk to the Welsh chronicler Asser in order to induce him to stay in
England.[204] In the early seventh century, pope Boniface V sent King
Edwin a Byzantine garment, or cover, and a tunic with a gold
ornament.[205] In the eighth century, Charlemagne presented King Offa
with two silks.[206] To the episcopal sees in Mercia and Northumbria he
also despatched gifts of dalmatics and silks.[207] In the same century,

Lull, the Anglo-Saxon bishop of Mainz, received textiles of delicate workmanship from Wearmouth,[208] and himself gave a fine silk to the archbishop of York.[209] In the ninth century, Alcuin sent a costly fabric to the Archbishop of Canterbury[210] and, though they are not described, the presentations made to King Alfred by the patriarch of Jerusalem[211] may have included Byzantine textiles, or objects, since Jerusalem came within the cultural orbit of Byzantium. In the tenth century, according to a late account which nevertheless has an authentic ring, King Edgar gave decorated silks to King Kenneth of Scotland.[212] In the eleventh, King Cnut was proud of the fact that the presents given him by the Emperor Conrad II in Rome included 'very precious textiles and garments'.[213]

Objects other than silks came to England from the Eastern Empire by routes that were mostly indirect, and these included manuscripts. Indeed, the taste for gold calligraphy on purple leaves, already evident in Byzantine surviving manuscripts of the sixth century like the Vienna Genesis and the Rossano and Sinope Gospels, arrived early in England. Eddius tells us that, in the seventh century, St Wilfrid had a Gospel-book 'written out in letters of purest gold on purpled parchment and illuminated'.[214] Whether Wilfrid had been inspired by Byzantine manuscripts which may have been in the possession of the Byzantine archbishop of Canterbury, Theodore, we do not know. His own Gospel-book is described in the context of the building and dedication of Ripon between 671 and 678, and – despite a stormy interlude later – Wilfrid and Theodore were then on friendly terms. He may, however, have discovered these Byzantine fashions in Italy, and a single purple page, written in imitation gold, in the Codex Amiatinus from Monkwearmouth/Jarrow must certainly have been inspired by an Italian manuscript.

Byzantine influences on Anglo-Saxon manuscripts are more strongly reflected in the Gospel-book which was looted by the Vikings from the Anglo-Saxons and then sold back to them (Plates 19 and 37), and which has been earlier referred to.[215] Written in the mid-eighth century, it has alternate leaves of purple on which the calligraphy is set out in gold, silver or white. The ornamental effect is further enhanced by emblematic patterns inserted in a varying colour. This technique was refined in Byzantium by Porfyrius, who had hoped to impress Constantine the Great in this way.[216] A copy of this book (brought perhaps from Italy) is known to have been in England before 758,[217] but only an amazing piece of good fortune has enabled this particular Anglo-Saxon version of it to survive. Though in the future found only in single or double leaves in the manuscripts that remain to us, this Byzantine taste for gold and purple in manuscripts continued in England. It was reinforced, no

**37**  Purple leaf (fol. 16) from the Canterbury Codex Aureus (see **19**).

doubt, by Carolingian art which, in its turn, was influenced by the purple manuscripts of Byzantium. It appears in a Canterbury manu-script of the very late eighth century (British Library, Royal MS. 1 E VI), where each Gospel is introduced by purple pages with a display script in gold or silver, and where the evangelist pictures (to judge by what remains of them) were also on purple pages with their own touches of gold. The same taste is more partially expressed in a bound and lengthy charter, made for the New Minster, Winchester, after 966 (British Library, MS. Cotton Vespasian A VIII), and proudly referred to by a local chronicler. The opening pages are written in gold, though not on purple. However, the frontispiece picture of the donor, King Edgar, offering up the charter to Christ (Plate E), is on a purple leaf and includes some gold.

These influences from Byzantium were mostly indirect. Yet there may have been more direct ones on metalwork in the sense that we know that Greek metal objects were brought to England. In the tenth century, Chester-le-Street received from King Athelstan a paten 'of Greek workmanship':[218] in the eleventh, the New Minster at Winchester possessed a Greek shrine:[219] and in the same century Waltham owned three large silver and gilt ewers 'of Greek workmanship'.[220] Athelstan's ownership of a Greek paten may be explained by his close Continental associations and the consequent interchanges of gifts. But the New Minster and Waltham had, in Cnut and Harold, patrons who had made the Roman pilgrimage and, since we know that reliquaries could be bought at Pavia, it may be that Byzantine metalwork could be purchased there as well.

Despite this, England's interest in Byzantine art – like that of other Western countries – was primarily in its silks, and the fact that William the Conqueror was able to re-export so many of them to the Continent as a form of war-booty[221] indicates the large numbers in England before the Conquest. Silks were used to honour the eminent and, not least, the eminent dead. Even a saint as ascetic as Guthlac permitted a fine linen cloth to be reserved for his winding sheet[222] and the obsequies of other saints and of secular dignitaries were often dignified with silks. They were used as outer wrappings or shrouds for the corpse, or as underlays or overlays for it. Silks served the same purposes on the Continent and it is no accident that most Byzantine silks in Continental museums come from mediæval tombs.

A Canterbury illustration of the second quarter of the eleventh century shows the shrouding of the dead (Plate 38). Here, the dead person is an Old Testament patriarch but, in mediæval thought, the patriarch was the equivalent of a saint, and this particular artist tended

**38** The shrouding of a patriarch (Joseph) in an unfinished Canterbury picture of the second half of the eleventh century (British Library, Cotton MS. Claudius B IV, fol. 72v).

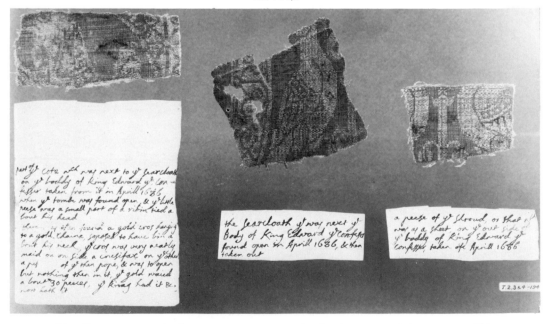

**39** Three scraps of silk taken from Edward the Confessor's tomb in 1685 or 1686 (Victoria and Albert Museum Textile Department T2, T3, T4, 1944).

**40** Detail from the Bayeux Tapestry of Edward the Confessor's pall (Musée de la Reine Mathilde, Bayeux).

**41** Detail from the Bayeux Tapestry of the shrouding of Edward the Confessor's corpse (Musée de la Reine Mathilde, Bayeux).

to express the past in contemporary terms: in other words, he was showing how he would expect a saint of his own day to be shrouded. The picture was not completed and the space around it has been pirated by a twelfth-century scribe but there is sufficient detail to see that the shroud was made of a decorated textile, which may have been Byzantine since a similar patterning is found on surviving Byzantine silks though there the 'frames' are usually lozenge-shaped and not square as here. This painting was made during the quarter century when Edward the Confessor was crowned king and there can be little doubt that when this monarch died in 1066 a silk or silks were buried with him. His obsequies are shown in the Bayeux Tapestry where the representation of his pall being borne publicly to Westminster Abbey (Plate 40) throws significant light on the use of decorative textiles in such Anglo-Saxon cortèges. The earlier preparation of the body for burial is also portrayed and, though the Canterbury artist who made the underdrawings for the tapestry could hardly have been an eye-witness of this intimate scene, it is of interest to see that he assumes that a decorative underlay was used for the body (Plate 41). There is, indeed, other evidence to indicate that costly materials accompanied the king into his coffin.

When in 1685 workmen were involved in some task connected with the coronation of James II, they accidentally made a hole in the Confessor's tomb with a piece of their scaffolding and this enabled observers to see 'the shroud wherein the body was wrapped'[223] which was described by one contemporary as being a 'Gold-colour'd flower'd silk'.[224] The hole was enlarged by the curious and, as we shall see later,[225] a cross and chain were removed from the tomb and no doubt other mementoes as well. Indeed, one contemporary, who held a prebend at Westminster, was actually able to illustrate his description of the shroud with a small sample of it.[226] Three scraps of silk in the collection of the Victoria and Albert Museum (Plate 39) are said to have been taken from the tomb at this time and, since the accompanying labels making this assertion are in a nearly contemporary hand (even though they wrongly give the date as 1686 instead of 1685), this claim must be taken seriously. We must assume that the fragments came from a silk, or silks, wrapped round the body of the Confessor. Whether this shroud was the original one used in Anglo-Saxon days is, however, an open question. The fragments are stylistically related to silks found in the tomb of Clement II (Plate 42) who was buried at Bamberg cathedral in 1047[227] so that they are appropriate in date. And, since they are of a golden hue and the Confessor was seen to be wrapped in golden material[228] when, after his canonisation, he was first translated in 1163, they are appropriate in

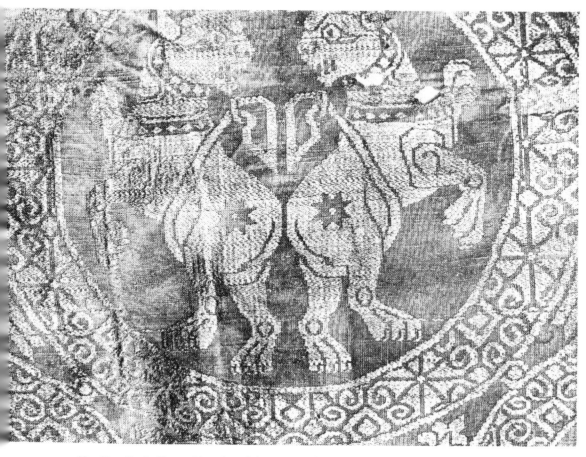

**42** Detail of silk stocking found in tomb of Pope Clement II, d. 1047 (Bamberg, Domschatz).

colour. Furthermore, a fourteenth-century monk of Westminster, Richard of Cirencester, who was well versed in its archives, asserts that everything found in the old tomb was then transferred to the new, except for a gold ring.[229] (It is true that a fifteenth-century tradition, recorded by Flete, claims that three cloths were then removed and made into three embroidered copes,[230] but Richard's account is to be preferred.) There was a second translation in 1269 of which no extended account is known, though those that exist[231] make no reference to the removal of any textiles.

The fragments in the Victoria and Albert Museum might therefore have come from the original dressing of Edward the Confessor's corpse but there are two impediments to such a supposition. The first is the statement made by Richard of Cirencester that, at the first translation, the body was wrapped in a precious silk before being placed in its new tomb. This may have been taken from the old tomb but it may equally have been a fresh silk swathed over the original covering, and the fragments may therefore be from a silk provided in the twelfth century. The second is an assertion by Osbert of Clare that there was an earlier opening of the tomb when the body was inspected in 1102[232] – and Osbert was a monk and prior at Westminster during the periods when he was not actually banished from the abbey.

Osbert, however, is known as a chronicler who was prepared to falsify evidence in the causes he espoused, and the canonisation of the Confessor was one dear to his heart. He forged charters for this purpose and he may have fabricated this account, too. Certainly his claim that a miracle at the tomb inspired the Conqueror to make a splendid gold and silver shrine over the tomb[233] is an absurd one – the miracle is implausible, the historic context impossible,[234] and the absence of any precious workmanship, a few years after the supposed event, is made all too evident by the fact that the whereabouts of the tomb was then unknown even to the Westminster monks themselves.[235] The fact that Osbert's account, issued in 1136, cites, as sole witnesses, a bishop (Gundulf of Rochester) and an abbot (Gilbert Crispin of Westminster) who were long since dead does not add to one's confidence in it, and, though the inspection of a corpse to establish that it was free from decay was a normal preliminary to canonisation, it is difficult to understand why this should have taken place in 1102 when there was no thought of making Edward a saint. Osbert himself gives no hint that anything was removed from the tomb though such a palpable relic would have gone far to establish the veracity of his account. It is all the more remarkable then to learn that when, in 1160, Abbot Laurence of Westminster was petitioning papal legates in France for the canonisation of the Confessor,

he produced as evidence of the king's sanctity a chasuble of costly material (*palli casulam*) which had preserved its pristine condition and was said to have been removed from round the corpse in 1102.[236] The same fabric, though now it is no longer a chasuble but simply a length of costly material (*pallium*) which had encompassed the sacred body, is also mentioned by Ailred of Rievaulx in his life of the saint written two years later.[237] The integrity of Ailred is not, of course, to be questioned, though the respect that is properly extended to this venerable abbot cannot also be attached to his sources. The events of 1102, which were already sixty years away, had taken place before he himself was born, and his own account derives primarily from Osbert of Clare's written testimony, supplemented by statements made to papal legates by Laurence, who only became prior in 1158, and who must himself have been relying on verbal statements, probably emanating from the same Osbert.

The financial benefits to the abbey of Westminster of having a royal saint, its competitiveness with St Paul's over the relics of saints, the atmosphere of political and ecclesiastical intrigue in which the negotiations for canonisation were conducted, the certainty that Westminster monks, other than Osbert, were practising forgery in the decades leading up to the canonisation,[238] the known deceptions of Osbert himself, his failure to remark on the removal of a shroud at the alleged inspection of 1102 and the convenient appearance of such a relic almost sixty years later when evidence for sanctity was being anxiously sought, all these factors caution wariness, not to say scepticism, about the alleged events of 1102. But, even if they are accepted uncritically, there would still be evidence for believing that the Confessor's original shroud was of rich fabric and, therefore, probably of silk, for the 'official' Westminster account, which is willing to believe that the shroud was removed in 1102, also says that it was replaced by another equally costly:[239] in other words, the first one itself was of expensive material. As it is, the probabilities are that the scraps of silk in the Victoria and Albert Museum come either from the very shroud in which the Confessor was buried or from a fabric wrapped round the body at its first translation in 1163.

Silks continued to be offered as a form of homage to the venerable and the saintly long after their deaths. The use of silks as tomb-coverings has already been described but they were also placed inside the tombs themselves. For which of these two purposes Lull, the Anglo-Saxon archbishop of Mainz intended the silk he sent 'for the relics of Bede'[240] in 764 (Bede had been buried in 735) we do not know. But we do know that, in 944, King Edmund had two covers or garments 'of Greek

workmanship' laid over the body of St Cuthbert who had died in 687.[241] When the coffin was opened in 1104, an 'underlay made of splendid silken stuff which had been spread beneath him' was also discovered which 'gleamed as brightly as if it had been freshly woven'.[242] When the tomb was again examined in 1827, after all the ravages of the Reformation, it was still found to contain a Byzantine silk[243] – in fragments, it is true, but capable of being reconstructed as a line-drawing (Plate 43). The fact that the silk is ascribed to the seventh century seems a happy coincidence since this was the period when St Cuthbert lived and died, but the vicissitudes of the coffin make it uncertain whether the silk was actually placed there in Anglo-Saxon times. When the body was translated to a new shrine in 1104, three of the fabrics removed from the coffin were replaced by others which included two silks[244] and we do not know whether this was a replacement. It may still, of course, have been one which had been in England before the Conquest but the most we can claim for the Byzantine silk which is now at Durham is that it had reached there by 1104.

Ironically, its chief motif was a representation of a pagan deity – Gaea, or Ge, the Greek goddess of the earth. The same figure, in later classical art, came also to personify the seasons and it is no doubt from such more innocuous representations that our own actually derives. She appears here as a half-length woman holding fruit – the centre of a composition, in repeat medallions, which also features a pond with ducks and fish below and an abundance of fruit and flowers around. For the observer today, the theme has fascinating associations with both classical and Coptic art, but neither of the two twelfth-century writers who left detailed accounts of St Cuthbert's coffin so much as mentions it. This is characteristic of our sources. However interesting the scenes on silks imported in the Anglo-Saxon period may have been, they would usually have been ignored by the writers who, at the most, would have offered a trite term of eulogy about their admirable craftsmanship. For all we know, the two silks that Bede himself describes as being of 'incomparable workmanship'[245] had just as much pictorial detail as this Byzantine one that survives.

The fabrics that are described on extremely rare occasions are those that had been worn by saints or had been in close touch with their bodies and which, therefore, had special spiritual potency as relics. These included the outer shroud of St Cuthbert's corpse – a cloth of considerable size (about sixteen feet by six feet) which was found wrapped round the saint's body. It was unlikely to have been imported since it was of linen, but it does perhaps show how native embroidery could be influenced by fabrics from abroad, for the heraldic pairing of

**43**  Reconstruction by J. F. Flanagan of a seventh century Byzantine silk found in St Cuthbert's coffin in the nineteenth century (Durham cathedral treasury).

in the tenth.[28] There is some indication that the Anglo-Saxons were actually exporting fur robes at this period for their commercial settlement with Pavia included the stipulation that they should provide two large fur coats to the master of the treasury every three years[29] and such arrangements seemed to relate to the goods actually being imported into Pavia: for example, the Venetians had to provide the master with a fine silk.[30] It has been claimed that the Anglo-Saxons were trading furs with the Frisians very much earlier,[31] which is a plausible suggestion though not one supported by any actual evidence. When the Anglo-Saxon Princess Margaret parted from her brother Edgar and his entourage in Scotland in the eleventh century, 'the great gifts and many treasures' she gave them included not only gold and silver vessels but 'robes of marten skin and of grey fur and ermine'.[32] Domesday Book speaks of marten skins being imported into Chester before the Conquest, and of the King's reeve being given the first refusal of them.[33] They were clearly to be used for making, or trimming, over-garments. (In Wales, the king had been entitled to all marten, beaver and stoat killed, so that his garments could be adorned with their furs.)[34] Though such skins and furs were probably considered attractive in themselves, the primary reason for wearing them was, of course, their warmth. No doubt their quality would also reflect the wealth of the wearer, and we can understand why the Anglo-Saxon St Wulfstan was chaffed for wearing lamb's wool instead of sable or fox-fur,[35] though this was after the Conquest. Before it, in the reign of the Confessor, a Dane who was dressed 'in a sheep-skin garment reaching down to his feet' was clearly considered by Herman of Bury, writing a little later, to have been handsomely attired, but perhaps Herman had in mind the fact that the Dane also 'wore bracelets on each arm in the Danish manner, and had a gilded axe hanging from his shoulder'.[36]

On the whole, in Anglo-Saxon society, wealth and rank were indicated not by the style or fashion of dress but by its quality and by the costliness of its adornments. A combination of the two could lead to garments of some opulence, and it is significant that the richest attire was associated by the Anglo-Saxons themselves with gold and silver. Early in the eighth century, St Boniface spoke of 'all the treasures of this world' in terms of 'gold, silver, precious stones . . . and costly garments';[37] and, in a Herefordshire lawsuit held in Cnut's reign, the defendant conjoined her gold with her wardrobe and formally granted to her kinswoman 'my land and my gold, my clothing and my raiment and all that I possess'.[38]

The richness of Anglo-Saxon attire is most uncompromisingly seen in the head-bands of women of wealth. Germanic women on the Conti-

nent were wearing tight head-bands in the latter part of the second century, and evidence for gold-brocaded head-bands has been found in Kentish graves of the sixth.[39] By the time that the wills of private persons become available to us in the tenth and eleventh centuries, we find that the head-band has become a form of portable wealth. There was so much gold in them that their owners could simply arrange for them to be cut up and distributed as a form of gold bullion. So, Æthelgifu gave instructions that hers should be shared out between five relatives (both male and female!),[40] Wulfwaru decided to have one apportioned between four servants,[41] and Ælfswith directed that hers should be divided between two monasteries.[42] An unfinished Canterbury painting of the second quarter of the eleventh century shows these head-dresses as simple bands, painted yellow to represent gold (Plate 46), but they could be far more elaborate. In a contemporary picture of Cnut's queen, Emma, she is seen wearing a head-band which passes round her forehead, where it seems to be studded with precious stones, and then descends far down behind her back (Plate 47). Since, in the late seventh or early eighth century, Aldhelm had remarked on women who had had long ribbons sewn to their head-dresses and hanging to the ground,[43] it would seem that this was a costly variant on much older fashions. Another head-band, also studded with precious stones, and now of exceptional length, appears in a late tenth-century monastic illustration of Prudentius's *Psychomachia,* or *Contest of the Soul,* which describes the battle between the Virtues and Vices (Plate 48). Here, it is flauntingly displayed by Pompa, the personification of ostentation, and marginal comments on the text speak of 'the wanton delight in . . . ostentatious apparel'.

The garments of both women and men were ornamented with gold-work and, sometimes, with jewels. They must have been costly even by the contemporary standards of the Continent for the Normans who first saw them were clearly taken aback by their opulence and thought that they rendered worthless anything they had seen before.[44] Of course, the Norman chronicler had good reason to draw attention to the gold on the Anglo-Saxon garments which William paraded in Normandy, since it underlined the richness of his own Conquest. But it was an extravagance that had been deplored before that event by the Anglo-Saxon homilists who thought that the wearers should rather be meditating on death and the Judgment. 'Where shall then be his vain garments? Where shall then be the ornaments and the expensive attire with which he previously decked his body? Where previously you saw a garment interwoven with gold, you now see a portion of dust and the relict of worms.'[45]

**46** Unfinished painting of the daughters of Reuel, wearing Anglo-Saxon head-dresses (same manuscript as **12**, fol. 76v).

**47** A drawing, made between 1020 and 30, of Cnut and his queen, Emma, presenting a gold cross to the New Minster, Winchester (British Library, Stowe MS. 944, fol. 6).

**48** A portrayal of Pompa and her head-dress from a manuscript of the late tenth century (British Library Add. MS. 24199, fol. 21v).

If, in the tradition of St Aldhelm, St Boniface and Alcuin, later Anglo-Saxon moralists mention this rich attire in order to condemn the luxury of the age, the English chroniclers only speak of them in the contexts of miracles or of saints, or because they have passed into monastic hands and can now be adapted to religious purposes. It is because of his interest in King Edgar's daughter as a saint that a writer explains how Edith's vocation was tested by showing her, on the one hand, religious objects and, on the other, secular fineries such as jewelled robes and cloaks interwoven with gold.[46] There is no reason to think that, because a princess, like Edith, was later canonised, her attire and tastes were different from those of her predecessors or successors, and the same is true of a king, like Edward the Confessor. We may, therefore, take note of the fact that the Confessor could boast a number of gold-embellished robes[47] and a rich variety of embroidered ones.[48] Those who attended his court were arrayed in costly attire, edged with gold,[49] and this style is portrayed in an earlier picture of King Edgar, almost a century before (Plate E). It occurs as the frontispiece to a Winchester charter, and not only indicates that the fashion for gold-bordered hems on cloaks was a traditional one, but shows (as do other pictures) that the gold embroidery on Anglo-Saxon garments had its own dignity. There is nothing garish here. In this picture the gold work extends not only to the hem of the cloak, but to the cuffs of the tunic, and to the shoes as well. From the records, we learn that a royal cap might be of gold cloth[50] and that the fastenings of an aristocrat's cloak might be enriched with gold and precious stones.[51]

Nor did one have to be at court to follow these fashions for gold adornments. The account, given in the context of a miracle, of an eleventh-century family party, stresses the resplendence of the gold and purple worn by the guests,[52] and this taste for rich attire must have gone back quite far. From the earlier centuries, we learn that, around the year 678, St Wilfrid provoked criticism of himself because so many of his household staff were dressed in apparel that others described as 'royal'.[53] When during the eighth century Anglo-Saxon men were imprisoned in Syria, they were favoured with visits from the local people, who had come not to sympathise with the hardness of their plight but to admire the beauty of their clothes.[54]

Some of the secular garments of the Anglo-Saxons were lavish enough to be offered to churches and to be put to liturgical or decorative use. A cloak that King Edgar gave to Ely, so laden with gold embroidery that it looked like chain mail, was made into a chasuble.[55] The one he presented to Glastonbury was splendid enough to be used as an altar-cover.[56] The Conqueror's queen, Matilda, who used Anglo-Saxon

embroideresses,[57] was able to bequeath one of her cloaks 'made of gold' to the church of the Holy Trinity at Caen to be used as a cope.[58] The Conqueror left one of his cloaks, 'wonderfully adorned with gold and precious stones' and almost certainly Anglo-Saxon, to Battle Abbey[59] no doubt also to be converted into a vestment.

The nature of our sources is such that they give far less attention to the splendour of secular attire than to that of vestments. But this does not mean that the lay garments were necessarily less sumptuous. Goscelin, indeed, associates the two and speaks in the same breath of embroideresses making ceremonial garments both for the princes of the state and for those of the church.[60]

Like the cloaks of the wealthy in secular society, some of the vestments used in church had gold borders. This was true not only of the two copes that Cnut's queen gave to Canterbury[61] but of one of the several copes that St Æthelwold gave to Ely,[62] and of a chasuble that the countess Godiva gave to St Paul's.[63] There is a contemporary picture of St Æthelwold at Winchester wearing such a chasuble with a gold border (Plate D), which may be compared in this regard with the cloak worn by King Edgar (Plate E). The Anglo-Saxon dalmatic found with the body of St Cuthbert when it was translated in 1104 also had a gold border, and the neck and sleeves had a broad gold edging as well:

A golden border like an orfray encircles and completely surrounds the outermost edges of this dalmatic, and, because of the abundance of gold which is introduced into the woven fabric, it is not easily bent back, and then it makes a crackling sound . . . This border extends in width to the measure of a man's palm, and its workmanship is seen to have been very painstaking and skilful. There was a similar border at the extreme ends of both sleeves. . . . Round the neck, however, where there is an opening of the head, there is seen to be a gold border, broader than the former one, and it is even more comparable in workmanship and value. This covers the greater part of both shoulders both behind and in front because in either direction it is broader by the width of nearly a palm and a half.[64]

As we learn both from individual descriptions and from inventoried accounts, gold and even pearls and gems were to be found on the more splendid of the Anglo-Saxon vestments. The tenth-century chasuble of St Oswald preserved at Beverley was described as being of purple and glittering in its ancient beauty with gold and gems;[65] a chasuble of the best *purpura*, given by Leofric to Peterborough, was adorned with gold and jewels;[66] and one presented to Abingdon by Bishop Siweard of Rochester was of dazzling white, embellished with gold.[67] From Bishop Brihtwold Glastonbury received as many as ten copes enhanced with gold and precious stones;[68] and Waltham was enriched by Earl Harold

with a wealth of vestments – copes, chasubles, dalmatics, etc. – adorned with gold and pearls.[69] Despite the calamitous losses that Ely suffered at the Conquest, it could still number, a few years after it, a large number of vestments embroidered with gold – no fewer, in fact, than twenty-two chasubles, four copes, three dalmatics and tunicles, fifty-one albs, forty-seven amices, and fifteen stoles and maniples.[70] By this time, the tunicle of reddish *purpura*, encircled with gold embroidery from the shoulders downwards, which had been given by Lustwine and his wife Leofwaru,[71] seems to have disappeared: no doubt lost at the Conquest, as was certainly one of the most prized possessions of the abbey – 'a chasuble of such inestimable workmanship [i.e. gold embroidery] and worth, that none in the kingdom is considered richer or more valuable'. It had been given by the last Anglo-Saxon archbishop of Canterbury and was removed by the first Norman king.[72]

As the Ely entry indicates, one of the reasons why such vestments were prized was their immense worth. At a time when the Anglo-Saxon Chronicle thought it important to mention that a particularly splendid gold chalice, presented by an Anglo-Saxon bishop in Jerusalem, had five marks of gold in it,[73] we learn that twenty-six marks of gold went into the embroidery of a single important chasuble at Waltham.[74] What the cost of the gold embroidery and other embellishments on vestments meant in terms of purchasing power is revealed by entries made in the Treasurer's Accounts at Canterbury towards the end of the fourteenth century. These record that one cope and two chasubles, made just after the Conquest and almost certainly of Anglo-Saxon workmanship, were discarded between 1371 and 1373, having no doubt been worn out after three hundred years' use. They were incinerated in order to recover the gold, and this, with the other embellishments, brought in £116 6s 8d for the cope and £138 12s 0d for the two chasubles.[75] In the same period, when a labourer was earning 3d a day,[76] Boxley Abbey was negotiating a five-year contract for the building of new cloisters, complete with all mouldings and carvings, and also the provision of some new windows and doors in the monastic church. The cost of this – £120[77] – was not much more than that of the ornamentation of the cope alone. Given this insight into the expense of the goldwork on a single cope, we can understand why monks placed the richer vestments on a par with gold, silver and land, so that the Peterborough version of the Anglo-Saxon chronicle could say of Abbot Leofric, who died in 1066, that he 'gave more goods to the monastery of Burch in gold and silver, vestments and land, than any man before or since'. We can also comprehend why at least one Norman abbot, soon after the Conquest, stripped the gold embroidery from Anglo-Saxon vestments.[78] And, if the embroidery on

secular garments was equally precious, we can see why such lay attire was described as being 'encrusted' with gold by the Norman chronicler,[79] and bracketed with gold and silver by the Anglo-Saxons themselves.[80] We can further perceive why, in some of the monastic inventories, the more splendid vestments were given precedence over more conventional treasures in gold. For example, although the gifts made to Glastonbury by Brihtwold in 1045 included many costly objects in gold and silver, the list is headed by the vestments he presented.[81] We can also grasp the reason for a choice that the Dowager Queen Edith made.

When, after the English defeat at Hastings, the Confessor's widow decided that she should insure against the times by appropriating one or two art treasures from Abingdon, she demanded to see their most precious objects. Hoping to deflect her resolve, the monks began by offering less than their finest, but she was not to be deterred and sent the proferred objects back. Finally she emerged with what the monks and she herself clearly regarded as some of the greatest treasures of the house. These – apart from a preciously bound Gospel-book – were vestments: one was a chasuble 'covered entirely with marvellous gold embroidery', and others were a very fine choir cope and white stole, 'each bordered with excellent work in gold and jewels'.[82]

In happier days, when her husband had been alive, Queen Edith had sent an Anglo-Saxon vestment to the French monastery of Saint-Riquier.[83] It was to heal a rift with the abbot, Gervin, who was often a visitor to the Anglo-Saxon court. Though preciously embellished, it was a minor element of the liturgical apparel – an amice (a kind of ornate neck-covering) – yet Guido, bishop of Amiens, prized it so highly both for its 'extraordinary beauty' and its 'preciousness' that an authenticated account tells us that he gave two churches in exchange.[84] Such Anglo-Saxon vestments were particularly splendid and particularly English, and it seems possible that they had for centuries been used as gifts to foreign prelates and foreign powers; for example, amongst the presentations made by King Æthelwulf to Rome in the mid ninth century were silk albs enhanced with gold embroidery.[85] Even after the Conquest, Anglo-Saxon vestments continued to be sent abroad as gifts of special distinction. Saint Évroul was given by the Conqueror's queen, Queen Matilda, a precious chasuble and cope.[86] Cluny received from her a chasuble so stiff with gold that it could hardly be bent,[87] and, from her husband, a cope practically covered with gold, gems, pearls and amber.[88] Whether such vestments had been confiscated from English monasteries, as was the gold-embroidered chasuble that the Conqueror removed from Ely to his treasury at Winchester,[89]

or whether they had been acquired, like other precious objects, with the royal treasury of the Anglo-Saxon kings, or whether they had been commissioned, we do not know.

It is understandable that the Anglo-Saxons should take some pleasure in the accomplishments of their women, and it was a pride which bridged the Conquest as a refreshing anecdote by Eadmer illustrates.[90] At Christ Church, Canterbury (which he had joined as a boy about the period of Hastings), Eadmer had learned of a precious cope, richly embellished with gold, which had earlier been given by archbishop Æthelnoth of Canterbury to an archbishop of Benevento from whom Queen Emma had bought an important relic – the arm of St Bartholomew. Though some sixty or seventy years had by now elapsed since the time of the original gift, he was startled at the Council of Bari in 1098 to recognise this very cope on the shoulders of the incumbent archbishop. Even in this great and august assembly there was apparently no difficulty in the identification, since it was 'more precious than the attire of any one else present' and, 'outshining all others', clearly 'surpassed the rest': '. . . easily recognising it from what I had once heard I was overjoyed. I pointed out the cope to father Anselm and told him the story recounted to me when I was a boy'. After the Council, Eadmer approached the Italian archbishop and engaged him in friendly conversation. Feigning ignorance of the subject, he broached the topic of the cope and was delighted to be told that this was indeed the very work of Anglo-Saxon embroidery.

The embellishment of Anglo-Saxon vestments took various forms. Often there was a patterning of gold and precious stones. The stole being made by Æthelwynn, for example, in the reign of Athelstan had a variety of elaborate patterns which she was to make resplendent with gold and jewels.[91] The red chasuble presented to Ely by Leofsige in the first half of the eleventh century was covered at the back with gold embroidery and was decorated at the front 'with a sort of chequering of gold and gems'.[92] At Canterbury, vestments, given just after the Conquest but almost certainly of Anglo-Saxon workmanship, had stars and crescents and great circles, all in gold.[93] At Ely,[94] and elsewhere, there is mention of the vestment's 'flower'. This was a gold acanthus leaf. A glimpse of it can be caught on the back of a chasuble worn by St Æthelwold in a contemporary picture of him (Plate D), and it appears more schematically on the front of one worn by St Jerome in an illustration of the Tiberius Psalter, where the 'flower' spreads from the jewelled collar over the shoulders and on each side of the chest (Plate 49). Its full weight is best conveyed by a picture from the canon tables of the Trinity Gospels. Here the 'flowers' over the shoulders and on each

184

**49** The 'flower' on a chasuble in a drawing from a mid-eleventh century manuscript, damaged by fire (British Library, Cotton MS. Tiberius C VI, fol. 71v).

**50** The 'flower' on a chasuble from an early eleventh century manuscript, probably from Christ Church, Canterbury (Cambridge, Trinity College MS. B 10 4, fol. 12).

side of the chest might almost be described as decorative appendages to the gold 'harness' of the vestment (Plate 50). Other forms of botanical life, no doubt highly conventionalised, are mentioned elsewhere. A chasuble, donated by Countess Godiva, had a tree embroidered in gold.[95] Late vestments at Canterbury (post-Conquest but probably still Anglo-Saxon) had flowers, plants, branches and pine-cones in gold.[96] On the same vestments, there were gold beasts in circles, and heads in circles of gold.[97] The dalmatic found with St Cuthbert's body in 1104 had finely embroidered representations of small animals as well as flowers.[98] Glastonbury possessed copes adorned with white birds,[99] and with lions,[100] which latter motif also decorated some of its other textiles.[101]

Some vestments might display actual scenes. For example, a tenth-century alb at Wilton (which is referred to only because it was made by a saint) was embroidered in gold with a picture of Christ among the apostles.[102] A gold-embroidered chasuble at Waltham in the eleventh century (which is mentioned only because of its loss to the Normans) was described as the 'Dominus dixit ad me'.[103] This is a quotation from the psalms (II, 7), and must refer to a relevant illustration on the vestment, for other mediæval vestments are also known by the pictures represented on them.[104] The relevant verse reads: 'The Lord hath said unto me, Thou art my Son; this day have I begotten thee.' And, since this opens the first Mass for Christmas Day, there can be little doubt that the subject depicted on it in gold was the Nativity of Christ. Such references to the depiction of human or divine figures on vestments are rare, but the occasions for them were scanty and, when we remember that Aldhelm (albeit in a general sense) refers to embroidered figures in the seventh century,[105] and that *Beowulf* mentions gold-embroidered tapestries probably in the eighth, we may suppose that these were but chance allusions to a great and long tradition of the embroidery of scenes and figures, often in gold.

One example of Anglo-Saxon gold-embroidery for a vestment (probably of the mid ninth century) is to be found in the Collegiate church of Maaseyck in Belgium[106] where it has been preserved by a pious but erroneous association with two local saints. The decoration is of animals, interlacing, and monograms on coloured silks and there is some evidence that it originally had the added embellishment of seed pearls that writers describe as characteristic of Anglo-Saxon embroidery. Unfortunately, it is in a sadly decayed state and in England itself, from the wealth of pre-Conquest textiles only three very small and almost miraculous survivals remain.

At the time of the Reformation, when all the shrines of the saints in

the kingdom were despoiled of their precious stones and metals, that of
St Cuthbert at Durham suffered the common fate. The outer shrine of
'fine and costly marble all limned and gilted with gold', and 'estimated
to be one of the most sumptuous monuments in all England, so great
were the offerings and jewels that were bestowed upon it',[107] was broken
up. So, too, was the inner shrine 'decked with gold and precious
stones'.[108] The wooden coffin inside was opened and, beneath its sump-
tuous coverings, the saint's body was revealed 'with all his vestments
upon him . . . and his metwand of gold lying beside him'.[109] All this was
removed to recover its gold. But, by some happy accident of indifference
which saw them as mere trifles amidst all this wealth, the smallest and
most minor pieces of the vestments – the embroidered maniple, the
embroidered girdle, and the embroidered stole – were disdained,
though the latter was maliciously cut into pieces of which seven frag-
ments remain. They had been made in Winchester between 909 and
916. Both stole and maniple had originally been embroidered along
their whole length with standing figures, interspersed with ornamental
foliage (Plate F), and concluding with half figures at the ends. The
girdle simply has the ornamental foliage. The figures are identified by
inscription. Those on the stole originally represented the sixteen major
and minor prophets,[110] of whom thirteen remain in various states of
completion, and there are busts of St Thomas and of St James on the
end pieces. The figures on the maniple are of Popes Sixtus II and
Gregory the Great with their deacons Laurence and Peter, and the end
pieces show busts of John the Baptist and John the Evangelist. Each of
the two vestments has a central motif which relates to the adjacent
figures: in the stole, the Lamb of God is placed between two of the
prophets who prophesied the Lamb: in the maniple, the Hand of God,
which here symbolises God's intervention in the sacraments, is set
between figures of those who had particular associations with the
Roman Mass.

Inconsequential as these items may have seemed to the bureaucratic
plunderers of Durham, their very survival has advanced them to a
place of the utmost significance, for they are all we now have from which
to envisage the richness of figural work on Anglo-Saxon vestments
throughout the country. They reveal how the Anglo-Saxon needle-
woman could achieve an effect of almost solid gold in the background by
a thick packing of the gold thread. They indicate how she could give an
impression of gold-enamelling to the various poised figures, portrayed
in blues and browns and brownish-reds, with their own areas of over-
laid gold. With such vestments in front of us, despised as the merest
trivia by the agents of Henry VIII, we can try to visualise what the

major vestments must have been like, and we shall understand why the Blickling Homilies could equate gold with precious raiment[111] and why a chronicler like that at Peterborough could speak of a vestment which 'flashed like gold in the House of the Lord'.[112] The latter statement must have been more literal than metaphorical for these highly specialised embroideresses were as talented in their use of gold as the goldsmiths whose work will be examined in the next chapter.

# CHAPTER VII

# JEWELLERY, SILVER
# AND GOLD

As far back as we can trace, jewellery had been worn by the Anglo-Saxons. It is the one art form, other than pottery, which survives – however haphazardly – from both the pagan and the Christian periods.

As we have seen in an earlier chapter, pagan burial customs conserved many fine examples from the first Anglo-Saxon centuries. No comparably outstanding pieces remain from the Christian times though jewellery was continuously in fashion. In the seventh century St Aldhelm referred to women (presumably Christian) adorning their fingers with jewelled rings, their arms with bracelets, and their necks with 'little moons',[1] and, later on, jewellery was so much taken for granted that the laws of Æthelred of about 1008 found it necessary to enjoin people attending church during days of national fasting to come 'without gold or ornaments'.[2] The extensive fashion for jewellery in the tenth and eleventh centuries was such that it aroused the indignation of the moralists. They envisaged the life to come in remarkably bejewelled terms, but preferred these pleasures not to be anticipated: 'Though we clothe ourselves with the reddest gold and with the whitest silver and are outwardly all hung round with the fairest jewels, still man must await the eternal end.'[3]

Numerous references to jewellery occur in the Anglo-Saxon wills of the tenth and eleventh centuries. Various brooches and bracelets are mentioned, as well as rings, coronets and necklaces, some of high price. At a time when a mancus could buy an ox, Ælfgifu had a necklace which was valued at one hundred and twenty mancuses,[4] and Ælfswith had one worth eighty and another worth forty.[5] The Anglo-Saxon taste for jewellery is also glancingly alluded to in monastic accounts, since these costly adornments were sometimes offered to Benedictine communities by ladies of wealth. For example, in the tenth or eleventh centuries Ælfflæd gave Ely a gold torque;[6] Scheldwara presented Ramsey with 'a gold brooch embellished with precious stones';[7] Glitha donated some of her necklaces and bracelets for the adornment of the foot-rest of the Crucifix at Waltham;[8] and for the effigy of the Virgin at Coventry

Godiva bequeathed a necklace of precious gems which was valued by the chronicler at one hundred silver marks[9] (i.e. fifty pounds of silver). As we have seen,[10] these same ladies of wealth also wore gold head-dresses which were in one sense an item of attire and in another a jewelled accessory.

A poetic aphorism associates jewellery with women,[11] but other poems indicate that men delighted in it as well.[12] They wore rings (some set with gems)[13] and cloak-brooches, but their chief form of personal adornment was the gold arm-ring.

Already in *Beowulf* we meet the gold-resplendent warrior rejoicing in his arm-rings.[14] In the eleventh century the eighty soldiers on board the ship that Godwine gave to Harthacnut each wore two,[15] and a chronicler of the twelfth century claims that, just before the Conquest, Anglo-Saxon men were actually laden with this form of decoration.[16] The arm-rings that feature in surviving wills were costly and heavy − Ælfflæd and Æthelmær each left four, worth three hundred and two hundred mancuses respectively,[17] and the two arm-rings left by Ælfflæd weighed two pounds.[18] Those that have survived are by no means as massive, though they do indicate the quality that could be attained. Such is the arm-ring from Wendover in the British Museum, which is enriched with filigree work and elegantly twisted into a gold rope, itself bent into a circle. A similar twisted arm-ring is depicted in an Anglo-Saxon manuscript of the mid eleventh century (Plate 5) and, no doubt, this simple but effective way of giving a new interest of design and texture to a simple band of gold had an unbroken line of descent from the 'skilfully twisted' arm-rings of *Beowulf*,[19] and beyond. Most arm-rings were probably decorated in some form or another, for the Anglo-Saxons were not inclined to leave plain what they could have ornamented, nor, in his will of 1015, is it likely that the Ætheling Athelstan would have named the maker of the arm-ring he was leaving to Winchester[20] if it had been a simple band of gold.

There is an implication in *Beowulf* that costly adornments, such as these rings, had personal associations − to keep someone in memory[21] − and just possibly, there were still undertones of this in the late Anglo-Saxon period, for the most important arm-rings tended to be bequeathed, along with other personal heirlooms, to the donor's lord as part of the heriot which originally, at any rate, had been a highly personal transaction between follower and lord. Ultimately, however, the man's arm-ring, like the woman's gold head-band, was a decorative form of portable wealth, and − according to the famous poem *The Battle of Maldon* (line 31) − it was in the form of the Anglo-Saxons' arm-rings that the Vikings at that battle demanded their tribute.

An Anglo-Saxon maxim declared that 'Gold has its fitting place on a man's sword',[22] and, amongst the wealthy, swords were so frequently embellished with precious metals that an Old English riddle poem simply assumed that they would be decorated with gold.[23] An Anglo-Saxon compilation on status even had to make it clear that the possession of a gold-plated sword did not of itself entitle a man to call himself a ceorl or freeman.[24] Anglo-Saxon wills of the tenth and eleventh centuries speak laconically of arms embellished with precious metal: Wulfsige left a spear inlaid with gold:[25] Ælfheah owned a short sword whose scabbard contained eighty mancuses of gold:[26] one of the swords bequeathed by Brihtric and Ælfswith was valued at eighty mancuses:[27] Ælfgar had a sword worth one hundred and twenty mancuses of gold, and its sheath carried four pounds of silver.[28] Nothing as costly as this remains though a rare survival from the ninth century – a silver sword handle in the British Museum (Plates 51a and 51b) – reveals that, in the enhancement of such arms, the Anglo-Saxons could find their usual delight in intricate decoration. Riding accessories, such as spurs,[29] were also of precious metals, and even trumpets might be silverplated[30] or 'handsomely worked in ivory and adorned with gold'.[31]

Gold embellishments were to be found at sea as well as on land, for gold work on ships was not uncommon in northern Europe. The Confessor's contemporary, the Welsh King Gruffydd had a ship whose prow and stern-post were skilfully worked in solid gold. They were removed, together with the Welsh King's own head, by the subjects who rose against him in 1063.[32] The Confessor himself owned a ship (presented to him by Earl Godwine) which had a golden lion on the stern and a golden winged dragon at the prow.[33] Other Anglo-Saxon kings – for example, Athelstan[34] and Harthacnut[35] – had splendid ships with gold or gilded beaks, and the descriptions of Cnut's ships indicate the magnificence which some of these vessels of the North could attain. His great 'dragon-ship', according to the *Heimskringla*, had a gilded prow,[36] and the scald, Thorarin Loftunga, described another of his ships as '. . . glittering all with gold And splendour there not to be told'.[37] Some may nurse doubts about the historical validity of such later Icelandic literature, but they can have no such reservations about the prose account of the battle fleet he brought to England, for it was written between 1040 and 1042, only a few years after Cnut's own death.

So great was the ornamentation of the ships that the eyes of the beholders were dazzled, and to those looking from afar they seemed of flame rather than of wood. For, if at any time the sun cast the splendour of its rays among them, the flashing of arms shone in one place, in another the flame of suspended shields. Gold shone on the prows, silver also flashed on the variously shaped ships. So

a

b

**51**  (**a** and **b**) Front and back views of a ninth century silver sword-handle, from Fetter Lane, London (British Museum).

great, in fact, was the magnificence of the fleet, that the ships alone would have
terrified the enemy, before the warriors whom they carried joined battle at all.
For who could look upon the lions of the foe, terrible with the brightness of
gold, who upon the men of metal, menacing with golden face, who upon the
dragons burning with pure gold, who upon the bulls on the ships threatening
death, their horns, shining with gold, without feeling fear . . .?[38]

Perhaps we should bear this kind of rich goldsmithery in mind when we
read that Bishop Ælfwold of Crediton (who died early in the eleventh
century) was leaving a sixty-four-oared ship, which 'he would like to
prepare completely in a style fit for his lord if God would allow him'.[39]

In the wealthier churches, there was some parallel to these golden
prows in the golden weather-cocks which (like most of the prows) were
not of solid gold but gilded. One such gold weather-cock at Winchester
is illustrated in the Benedictional of St Æthelwold (folio 118v) and is
also described in a local poem. Another pre-Conquest one at Westminster
is seen being lifted into place in the Bayeux Tapestry.

The splendour seen on the weapons and in the ships of the mighty
must have found expression in their homes. This did not attract the
attention of chroniclers, but there are occasional indications of the
domestic sumptuousness.

The drinking vessels of the rich, for example, were often of precious
metals. One, in the possession of King Æthelberht in the mid eighth
century, was of silver, lined with gold and weighed three and a half
pounds.[40] A bowl offered to St Æthelwold in the tenth century was of
silver and weighed forty solidi.[41] Three horns given by King Athelstan
to Chester-le-Street were fashioned in gold and silver,[42] and those left to
Ramsey by Archbishop Oswald were 'adorned with a chequered variety
of gold and silver work'.[43] The drinking horn used by King Cnut was
said to have been of gold,[44] and though the source for the statement
would normally be considered too late and unreliable to be
countenanced, it has the support of Anglo-Saxon manuscript-paintings
where there are illustrations of gold horns.[45]

This use of costly vessels was not confined to the courts of kings and
ecclesiastical princes. 'Alas, the bright cup,'[46] sighed the poet of *The
Wanderer* as he reflected on the lost pleasures of the hall, and many halls
in the country must have rejoiced in them, for silver vessels feature in a
number of bequests of private persons. Æthelgyth gave two silver cups[47]
and Alfwaru two silver bowls[48] to Ramsey; Æthelgifu[49] and Wynflæd[50]
mention silver cups in their wills; and Wulfwaru speaks of 'two cups of
four pounds' and 'two cups of good value' in hers.[51] Vernacular riddle
poems simply assume that the drinking beakers and drinking horns of
the rich will be embellished with jewels or precious metals, for they

describe the first as having 'ornaments bright, red and shining',[52] and the second as being covered 'with gold and silver with twisted wires'.[53]

A picture of an eleventh-century feasting scene (Plate 34) suggests that gold ornamentation was not unusual, but we have no detailed descriptions of domestic plate other than observations that they could boast fine workmanship. Comments here are enthusiastic but stereotyped. A cup which Abbot Eadfrith received at St Albans just before the mid tenth century is characteristically described as being 'wonderful as much for its craftsmanship as for its material',[54] and this remark (or variations on it) is applied to Anglo-Saxon art with the frequency of a cliché. In fact, the phrase was borrowed from Ovid[55] and, though it may disclose a literary interest in the classical past at various removes, it offers little help in our attempts to visualise Anglo-Saxon art. In Ovid's *Metamorphoses* the phrase was used to introduce descriptive details, but in our written sources it is used as a substitute for them. And, if the English are unforthcoming about particular forms of decoration, the Normans are speechless, which is just as unhelpful. All that their chronicler could say after the Conquest was that they 'admired the vessels of silver and gold [from England], the description of whose number and beauty would strain credulity'.[56]

The same Ovid-derived cliché is applied to all Anglo-Saxon works in precious metals, whether secular or religious. Remarks generally are appreciative but unspecific. And if, on rare occasions, discriminating phrases occur in wills (Professor Whitelock translates Wynflæd's *agrafenan beah* as her 'engraved brooch', and her *gewiredan preon* as her 'filigree brooch')[57] this is only to identify certain objects for practical purposes.

The preciousness of Anglo-Saxon domestic plate expressed a taste for costliness in the homes of the wealthy, and this must have been manifested in other areas, though much of it has to be inferred. If kings like Athelstan[58] and Cnut[59] gave silver candlesticks (sometimes decorated with gold) to churches, we might suppose that they had something similar in their own palaces. If the Countess Goda's private chapel at Lambeth, in the eleventh century, could boast silver-gilt stools and gilded candelabra,[60] it seems probable that the appointments of her main manor-house had a comparable splendour. If a Waltham account can speak of its 'stools fashioned from a large amount of gold',[61] we might conceive that its wealthy patron, Earl Harold, also had opulent furnishings. (It is true that the source is not a reliable one, but it does have some support from Anglo-Saxon illustrations which show gold chairs, together with other ornate domestic furniture.)[62]

Though normally disregarded by the monastic chroniclers, the taste of the Anglo-Saxons for domestic splendour is attested by the fact that it

was pilloried by their enemies and castigated by their friends. Speaking of the costly domestic objects in England (which took on a new virtue when removed to Normandy),[63] the Norman chronicler, William of Poitiers, made it a point of disparagement against the English that 'treasures, great in their number, their kind and their workmanship, had been amassed, destined either to be kept for the empty pleasure of avarice or to be used shamefully in English luxury'.[64] Earlier moralists among the Anglo-Saxons themselves had condemned the same supposed shortcomings. In the context of such luxuries as precious gems and gold and silver, one Anglo-Saxon homilist, for example, had commented sadly on the 'adorning of their houses'.[65] Another claimed that 'the mighty and the greatest command couches to be made for them of marble and of gold ornaments, and order their bed to be covered with silver coverings and to be hung about outside with the more precious purple . . .'.[66] Again, a third (in a related tract) had referred to marble couches extravagantly decorated with gold, silver and purple.[67] There is, one must admit, as much purple in these passages as in the couches they describe, and we are given additional pause when we learn that these descriptions owe something to the writings of the seventh-century theologian and encyclopædist Isidore of Seville.[68]

Moralising attacks like these on contemporary society must, of course, always be taken critically. Exaggeration, after all, is one of the occupational hazards of the homilist and unthinking traditionalism another, and, if the writer is merely purveying a well-worn moral theme, then he may be battling with ghosts long dead. Against this, it must be said that a sermon would lose its point if it did not have some congruence with contemporary society, and an old literary coinage may yet offer valid currency for a later age. In the latter context, it is relevant to note that, though Anglo-Saxon writers draw on Isidore, they omit those parts of his homily that have no relevance to their own society, and focus their attention on those, such as lavish and precious embroideries, that do. In fact, their comments on couches, decorated with sumptuous coverings and hangings, gain support from three sources: first, from Anglo-Saxon illustrations which show adornments of beds conforming, in general terms at least, to this description,[69] secondly, from wills which make it clear that bed-hangings were highly prized,[70] and thirdly, from descriptions of the gold hangings (albeit not for beds) in monasteries.[71] It is, furthermore, difficult to understand why the Anglo-Saxon poet of *Judith* should amplify the Biblical story[72] with a description of a curtain of gold that surrounds the couch of Holofernes[73] unless it reflected sumptuous textiles of his own experience.[74] If, finally, the moralist's remark about marble beds leads us to temper our acquies-

cence a little, we might yet consider that marble is known to have been imported into England from the Continent[75] and used in English churches and monasteries,[76] and that another material, calling itself 'marble', was quarried in England.[77] Indeed, a bed made of finely-figured stone which looks like marble is actually depicted in an eleventh-century Anglo-Saxon manuscript.[78] Without necessarily agreeing with every point that the homilists make, we can at least assent in general terms to the picture they draw of rich furnishings in the homes of the powerful.

Yet, when all has been said, it is doubtful if the splendours of the courts of kings and the homes of the wealthy could entirely match the riches of the churches and cathedrals. These latter had a capacity for attracting benefactions which made them unrivalled in their ability to accumulate art-objects, and an institutional continuity which made the disposal of these objects difficult.

The Anglo-Saxon church was a place not only for the worship of God but also for the veneration of His saints and martyrs. This is clearly expressed by Bede in his description of the achievements of Acca (who became bishop of Hexham in 709) which underlines the importance to the Anglo-Saxons of the relics of saints and martyrs: 'He enhanced the building with much decoration and with wonderful works. For he took care and does to this day, to acquire relics of the blessed apostles and martyrs of Christ from all parts, and to set up altars for their veneration in separate side-chapels especially made in the walls of the church.'[79] The Anglo-Saxons were avid collectors of relics – the mortal remains of saints, which might vary from a hair of their heads to their whole bodies, and which also extended to their personal possessions. Relics might be described as spiritual keepsakes of those who had been close to Christ though, in a deeper sense, they were venerated because they retained the original 'virtue' of the saint to cure the sick, to control the forces of nature and to deflect evil.[80] The lengths to which the more zealous collectors would go to secure relics is indicated by the account of King Athelstan's donation to the monastic church of Exeter about 932.[81] This speaks of him sending men 'to lands as distant as they could travel' who acquired on his behalf 'the greatest collection of relics gathered from every place far and wide'. There follows an inventory of the relics he gave, which included fragments of the Holy Cross, of objects associated with Christ, His Mother and His apostles, and with numerous martyrs, saints and confessors. They amount, in all, to about one hundred and fifty. This means that, if – as we are told – they represented a third of Athelstan's collection, then the whole must have numbered some four hundred and fifty. Set down a century after the event, the Exeter

document may, it is true, be exaggerating details, but Athelstan's passionate interest in relic-collecting was well known even to foreign dignitaries, and the statements must at least indicate what the Anglo-Saxons themselves considered plausible. Not only kings like Edgar,[82] but archbishops like Æthelnoth,[83] abbots like Benedict Biscop,[84] and missionaries like Boniface,[85] expected to accumulate relics on their travels, and we may presume that the three hundred relics, in reliquaries of gold and silver, that the Conqueror found in the treasury of the Anglo-Saxon kings and gave to Battle Abbey[86] did not exhaust the whole of the acquired collection.

Early reliquaries might be of wood, like the surviving coffin-reliquary of St Cuthbert[87] to which he was translated in 698, or the reliquary to which Chad was translated some time after his death at Lichfield in 672. Bede describes the latter as having an aperture in the side from which the devout could remove dust (later to be used for cures). It was also shaped like a small house[88] – perhaps under the influence of the tombs of patriarchs in the Holy Land which were said to be in the form of churches.[89]

Most reliquaries, however, were of precious metals. Bede says that, at Bamburgh, a silver reliquary preserved the right hand and arm of St Oswald,[90] which had been cut off by the pagans who had slain him in 642. In the tenth and eleventh centuries there are frequent references to reliquaries adorned with gold and silver, and those given by Bishop Alfwold (1045–58) to Sherborne[91] are a few of many examples. Often these costly containers had an aperture, covered with crystal, through which their venerated contents could be viewed, and the Abingdon chronicler draws special attention to the particularly large crystal on one of the three reliquaries that Athelward gave to his house in the reign of Cnut.[92] Naturally, the size of the reliquary was related to the size of the relic. Clearly, those made to accommodate a complete corpse – like the one provided for the body of St Edith[93] – must have been at least of human size but others could be quite tiny. One, confiscated from St Wilfrid by Queen Iurminburg, was small enough for her to wear 'as an ornament both in her chamber at home and when riding abroad in her chariot'.[94] Another (not so certainly Anglo-Saxon)[95] was worn by the corpse of Edward the Confessor and removed from his tomb in 1685.[96] It took the form of a hollow gold cross on a gold chain, and on the cross was a 'rich Enamell, having on one side the Picture of our Saviour Jesus Christ in his Passion wrought thereon, and an eye from above casting a kind of beams upon him: whilest on the reverse of the same Cross is Pictured a Benedictine Monk in his habit . . .'.[97]

Reliquaries acquired abroad (only, of course, because of their con-

tents) could (if decorated) transmit artistic influences over long dist-
ances. It is always, then, of interest to learn of such purchases. One was
bought by Ælfsige, who was abbot of Peterborough for most of the first
half of the eleventh century. When he was in France, he found that the
monks of St Florentin at Bonneval were in such financial straits that
they were prepared to sell even their own patron saint: 'So they sold
him, complete but for his head, together with his shrine . . . He [Abbot
Ælfsige] therefore paid five hundred pounds of silver and forthwith sent
the saint along with many other relics and ornaments in the charge of
his monks to England to his own monastery . . .'[98]

The ownership of relics was by no means confined to churches or to
the religious, though it is only when they are given to monasteries that
we actually hear of those in private hands. It is for this reason that we
learn of ladies in the tenth and eleventh centuries having reliquaries
made of precious metals and sometimes embellished with jewels, for
their secular owners later presented them to religious communities at
Abingdon,[99] Evesham,[100] Ramsey[101] and Rochester.[102] A late source
also purports that the ealdorman Æthelmær left a shrine to the New
Minster at Winchester some time between 975 and 1015.[103] With very
rare exceptions, such as the reliquary given by a wealthy widow to Ely
at the end of the tenth or beginning of the eleventh century which was
characterised as 'a stepped shrine',[104] these gifts from private persons
are described in the most general of terms. However, an Anglo-Saxon
bejewelled reliquary of gold and silver, which an English nobleman
presented to the house of Montecassino early in the eleventh century,
was described by its chronicler as being 'delicately and beautifully
decorated'[105] and as containing a fragment of the Holy Shroud which
could be viewed through crystal. We are also given some details of a
reliquary which was taken to Scotland in the latter part of the eleventh
century by St Margaret. Because of its association with a saint and
because of its miraculous properties, it attracted superlatives which can
here be shed. But the information that remains is still valuable. A palm
in length and made of gold, it was in the shape of a cross which could be
opened and closed to reveal a fragment of the true Cross, and it also had
a partly gilded ivory carving of the Redeemer.[106]

The churches of the wealthier monasteries had large numbers of such
reliquaries, though we are given few details about them. They tended to
be taken for granted by writers who contented themselves with giving
impressionistic pictures of their overall splendours. So, we are simply
told that, in the monastic church of Coventry (itself only founded in
1043), 'such was the display of gold and silver that the very walls of the
church seemed insufficient for the caskets of treasures [i.e. reliquaries],

filling with great wonder the eyes of the beholders'.[107] The fact that reliquaries were made of precious metals may have promoted their splendours, but it also magnified their risk. Alcuin tells us that when, in the eighth century, Offa adorned the last resting place of St Oswald with gold, silver and gems, he offered it as an example to later generations.[108] In fact, it was to bequeath a danger more than a pattern to the future for it was exactly treasures of this kind that attracted the Vikings to the churches and monasteries of Anglo-Saxon England. Reliquaries and shrines offered rich and easy booty to the Danish freebooters, and when the chronicler of Evesham said that the original shrine of the abbey's patron saint, 'elegantly adorned with precious tawny metal', had 'long since been stripped down by the Danes',[109] he was speaking for numerous other monasteries. The losses were appalling but in the course of time replacements were made, and costly reliquaries continued to be fashioned until the very end of the Anglo-Saxon period and, of course, beyond. In the eleventh century, for example, Earl Harold gave four gold and nine silver reliquaries to Waltham,[110] and the last Anglo-Saxon abbot of Peterborough presented his house with 'a great number of shrines of gold and silver'.[111] Unfortunately – as in other areas of the goldsmith's art – descriptions of these shrines and reliquaries do more to tease than to satisfy our historic curiosity. The remark of a Winchester chronicler that Æthelwold laid the remains of St Birinus to rest 'in a shrine beautifully fashioned in gold and silver',[112] is characteristic of the enthusiastic imprecision.

No doubt, some of the early gold and silver shrines had decorative designs on them which might compare with the handsome and animated patterning of animals and interlace on a small surviving reliquary of walrus ivory (Plate 52). This was at Ely before the latter's destruction by the Danes in 886 and it has a runic inscription asking the Virgin, or a virgin, to illuminate Ely. It may, therefore, have contained a relic of one of those early virgin saints, nurtured by Ely during its early decades as a double monastery, and lavishly commemorated in goldsmith's work in the later Anglo-Saxon centuries.[113]

The two most extensive descriptions of shrines indicate that some had narrative scenes featuring the victory of life over death. The first gives an account of the shrine which King Edgar commissioned for the remains of St Swithun at Winchester in the tenth century. The second describes the shrine which King Cnut provided for the body of St Edith at Wilton in the eleventh. The shrine of St Swithun was made of silver-gilt (the precious metals weighed three hundred pounds) and was also bejewelled.[114] It had engraved scenes of the Passion of Christ, His Resurrection, and His Ascension to the star-filled Heavens,[115] and

**52**  The Gandersheim casket of walrus ivory, formerly at Gandersheim and now in the
Herzog Anton-Ulrich Museum of Brunswick, second half of eighth century.

'many others' about which the writer withholds details because he claims that they 'would take too long to describe'.[116] We may suppose them to have continued with the same topic of eternal life since we find a similar overall theme on the shrine of St Edith. This portrayed the Massacre of the Innocents whose souls (as Goscelin reminds us) went straight to Heaven, the miracle of Christ restoring to life the dead daughter of Jairus, Christ's own Passion, and the angel at the sepulchre announcing to the Maries 'the triumph and joy of the Resurrection'.[117] We know that the engraved and cast figures on Mannig's great pre-Conquest shrine at Evesham did not depict the life or merits of the incumbent saint since the shrine was originally made for the relics of another,[118] and we may, therefore, presume that they also illustrated Scriptural subjects – perhaps, again, demonstrating the irrelevance of death to the Christian.

Other shrines commemorated their holy contents more personally. The shrine for St Aldhelm, which was made at Malmesbury between 839 and 858 and was lost to the Danes, had the miracles of the saint presented in relief work.[119] The various detachable figures on the later shrine of St Ivo at Ramsey were probably there to symbolise the purity of this enigmatic – perhaps even spurious – saint. They included silver figures of the Virgin, the Evangelists and the apostles, together with a portrayal of Christ treading underfoot the asp and the basilisk,[120] which latter subject traditionally represented the defeat of temptation – here, no doubt, the temptation of the flesh. We further know that a gold and silver reliquary presented by King Edgar to Glastonbury had ivory figures 'becomingly interposed' on it,[121] but we have no other information from which to deduce their identities.

Shrines might identify the giver and (more rarely) the recipient. At Abingdon 'a finely decorated reliquary of silver and gold' containing the remains of the Spanish martyr Vincent was inscribed with the names of the royal donors and of the abbot.[122] At Glastonbury a reliquary of St Oswald had the lines: 'A humble Bishop, Brihtwold by name, devoutly offers to his Lord and Master and to Mother Mary a humble gift from his heart, sending it to the ancient church of Glastonbury. May he obtain by this the sweet joys of everlasting life'.[123] At Coventry, a reliquary informed the onlooker that 'Archbishop Æthelnoth, returning from Rome, bought this arm of St Augustine at Pavia for one hundred talents of silver and one talent of gold'.[124] (There were apparently more venerable objects than silks to be bought in the capital of Lombardy.) And, after the Conquest, the religious at Waltham could still identify reliquaries, appropriated by the Normans, by the names of the original donors on them.[125] It was not only reli-

quaries that were so inscribed. At Malmesbury, for example, the organ and the stoup had statements saying that they had been given by Dunstan,[126] and the surviving stole and maniple of St Cuthbert are both embroidered with the name of the donor (Queen Ælfflæd) as well as that of the original recipient (Bishop Frithestan of Winchester).[127]

Some of the smaller reliquaries may have been fashioned to the shape of the relic within. At least, the statement (albeit a very late one) that the arm of St Cyriacus at Westminster was 'covered in a becoming fashion in gold and silver'[128] suggests a reliquary adapted to the shape of its contents. It may therefore have looked like the surviving eleventh-century German arm-reliquary of St Blase, which the countess Gertrud gave to Brunswick cathedral.[129] Relics might also be housed in objects which were not themselves primarily reliquaries. There were relics in the gold cross that King Edgar gave to Ely,[130] and in the great gold cross which Cnut presented to the New Minster at Winchester (Plate 47). Ely had a censer in which was incorporated an ingenious reliquary-cross made of crystal,[131] and the Christ-figure on one of its silver Crucifixes was hollowed out to take relics.[132] One Anglo-Saxon reliquary-Crucifix[133] has happily survived (Plate G) and its Christ-figure is a delightful example of Anglo-Saxon ivory-carving of the late tenth century. A cavity in the mount made provision for the relics, which a later, and now very incomplete, inscription tells us included a fragment of the true cross. The mount itself is of wood, gold-sheathed and decorated with cloisonné, filigree work and enamels. Unfortunately there is a division of opinion as to whether it is Anglo-Saxon or German, though comparable Anglo-Saxon works in gold and ivory did exist. Such was the Crucifix 'skilfully made of gold and ivory' that, in 934, King Athelstan gave to Chester-le-Street.[134]

Bede tells us that, at Hexham in the early eighth century, Acca was not only anxious to collect the relics of saints, but eager also to assemble together any accounts of their sufferings.[135] This reference by an Anglo-Saxon historian to the texts of books is an unusual one, since – as we have seen – the interest of writers in manuscripts was mostly focussed on their gold content. This gold was chiefly to be found in the bindings of Gospel-books, for, no less than the relic of a saint, the divine word of God invited precious metals and fine artistic treatment in its encasement.

Despite controversy over one cover,[136] none of these bindings in gold and silver seems to have survived. Yet there must have been very many of them, and an Old English riddle about a manuscript – presumably a Gospel-book – simply assumes that it will have a precious binding: 'a man afterwards covered me with protecting bonds, stretched hide over

me, adorned me with gold; I was therefore embellished with
goldsmith's fine handiwork clasped in wire . . .'.[137] These riddles reflect
the realities of the Anglo-Saxon world, as we can see from an entry in a
Gospel-book from Thorney Abbey which tells us that the original
binding was ornamented with gold-wire ornament.[138] Already, in the
seventh century, St Wilfrid had commissioned 'a casing of purest gold,
set with most precious gems' for a particularly fine Gospel-book which
he presented to Ripon,[139] and we know that the first binding of the
Lindisfarne Gospels was of gold and jewels.[140] In the early ninth
century Æthelwulf remarks that even in his own small cell sacred books
were bound 'with plates of bright, hammered-out gold',[141] and, later on,
there are numerous references to gifts of costly bindings. For example,
two Gospel-books presented by King Athelstan to the tomb of St
Cuthbert were adorned with gold and silver;[142] three of the Gospel-
books given by Earl Harold to Waltham were bound in gold, and five
others in silver-gilt;[143] the last pre-Conquest abbot of Peterborough
donated 'a great number of Gospel-books, bound in gold and silver', to
his house;[144] and the last Anglo-Saxon bishop of Rochester bequeathed
two Gospel-books, finely adorned with gold and silver, to Abingdon.[145]
The numbers of precious bindings in the wealthier Anglo-Saxon
churches must have been quite considerable. Malmesbury could strip
down twelve to help pay the levy enforced by William Rufus,[146] and,
after all the losses it had suffered at the Conquest, Ely could still
catalogue fourteen.[147] Some of these bindings were worked with artistic
themes which might also incorporate ivory figures.

St Wilfrid was celebrated during his own lifetime for his generosity,
and it is possible that the two Gospel-books bound in gold and silver
which were in the treasury of York Minster just before the Reformation
were correctly described by the Fabric Rolls as having been given by
him. One had representations in ivory of the Crucifixion with Mary and
John, and of the Holy Trinity with two angels. The other portrayed the
Crucifixion, and Christ in Majesty with Peter and Paul.[148] Unfortu-
nately, the source of information is so late that little reliance can be
placed on it and we cannot be sure that the bindings were even
Anglo-Saxon. However, there can be no such doubts about other
bindings described at Ely.[149] One was of gold and silver and was
enriched with precious stones. It had been given by King Edgar and
had, at the front, the figure of Christ in Majesty with apostles and
angels, and, at the back, depictions of virgins (no doubt the Anglo-
Saxon ones whose relics were preserved at Ely). Another, presented by
Abbot Ælfsige and studded with engraved gems, had portrayals of the
crucified Christ and other figures. Four other bindings had similar

representations, sometimes in ivory. These have all disappeared but, happily, one or two Anglo-Saxon ivory book-bindings have survived to give us some idea of what has been lost. They may also, perhaps, indicate the appearance of the gold and silver bindings that have been destroyed for it is probable that both ivory and gold bindings had certain thematic and stylistic features in common. Two late-tenth-century ivory covers on the same manuscript are here reproduced. One represents the so-called 'Traditio legis' in which Christ gives St Peter and St Paul their missions, represented by the key and the book, with the antique river god, Oceanus, reclining below (Plate 53). The other, which is very much rubbed, portrays the Madonna and Child with angels (Plate 55).

These manuscripts with artistically worked and costly covers were never intended to be shut away in libraries. They were display-objects to enhance the church along with its other embellishments. At Coventry they were fashioned along with the gold and silver Crucifixes and effigies,[150] and they were certainly associated by writers with other works of art in precious metals. At Abingdon, for example, those given by St Æthelwold were listed between the gold and silver Crucifixes and church vessels that he also presented:

> . . . the blessed Æthelwold enriched that house . . . with the most precious adornments. For, as we learn from the testimony of ancient books, he gave a golden chalice of great weight . . . He also gave three extremely beautiful Crucifixes of silver and pure gold . . . He also adorned the church with Gospel-Books made from pure silver and gold as well as with the most precious gems, with censers and cruets, cast basins and silver repoussé candelabras, and many other fine objects appropriate both for the monks' rites about the altar and for the comeliness of the church.[151]

The statement in this Abingdon account that the vessels for the Divine Office were amongst 'the most precious adornments' of the church is understandable for they, too, were often of precious metal, and this is true from the earliest Christian times onwards. In the first half of the seventh century, King Edwin had a gold chalice in his private chapel,[152] and King Oswald provided the churches that he built in Northumbria with precious vessels.[153] In an account of a church, written towards the end of the century, Aldhelm refers to a glittering gold chalice,[154] encrusted with gems, and there is a similar (perhaps too similar) description of a chalice and paten in Æthelwulf's later verse-history of a cell of Lindisfarne.[155] There must have been many such holy vessels in the seventh and later centuries, for, when Wighard was sent to Rome in 667 by the kings of Northumbria and Kent, he was able to take

**53** Ivory cover from the same book as **55** showing Christ in Majesty, flanked by two angels, handing the book to St Paul and the key to St Peter. The reclining figure below is Oceanus.

with him as presents for the pope 'a large number of gold and silver vessels'[156] (Anglo-Saxon vessels in precious metals feature quite conspicuously in later papal inventories). In the eighth century, the 'splendid ornaments of gold, silver and precious stones' that Bishop Acca presented to Hexham[157] must have been chiefly vessels for the Divine Service. To York Archbishop Wilfrid II gave 'silver vessels of shining beauty suitable for the services'[158] and Archbishop Albert presented a larger ewer 'made from a mass of gleaming gold'.[159] Scattered and exceptional in the earlier centuries, these references become more frequent in the late Anglo-Saxon period when the sources are so much fuller. We learn, for example, that one single donor gave Waltham 'gold vessels for feast days and silver ones for the eves of feast days, gold and silver candlesticks, censers, ewers and basins';[160] that another presented Ely with 'gold and silver vessels both large and small for the rites of the holy altar';[161] and yet another donated to Glastonbury four gold and two silver chalices, and a gold and silver censer of wonderful size.[162]

These church vessels attract from our writers the generosity of admiration and frugality of information that we have encountered elsewhere, and a characteristic statement is the one made by the Abingdon chronicle that Bishop Siweard gave a large gold and silver chalice of exquisite workmanship.[163] Such taciturnity seems particularly curious when we consider that the work of Anglo-Saxon goldsmiths and silversmiths had long been known in Italy for the Englishness of its decorative style as we particularly see from the papal records of the *Liber Pontificalis*. From this Roman source, we learn more about Anglo-Saxon vessels[164] than from all the English ones.

It tells us that Gregory III (731–41) gave to an oratory in St Peter's two gold, and five other, Anglo-Saxon dishes;[165] and that Leo III (795–816) had Anglo-Saxon silver dishes, which were decorated with gilded gryphons and weighed two pounds.[166] Gregory IV (827–44) owned Anglo-Saxon hanging-bowls,[167] some of which were gilded in uniform forms of craftsmanship. One was shaped like a cross and had varied workmanship of purest gold and the representation of a lion. Another must have had a family likeness to a hanging-bowl which was found in the River Witham near Lincoln in the nineteenth century, but which has since been lost and is now known to us only from wood blocks made of it (Plates 54a and 54b), and from coloured drawings and from notes.[168] These are sufficient to inform us that the bowl was quite small (six inches in diameter) and was of silver, with embossed scrolls, and with blue glass gems set in filigree. If Gregory IV's bowl had a pinecone standing in the middle, the Witham one had a free-standing

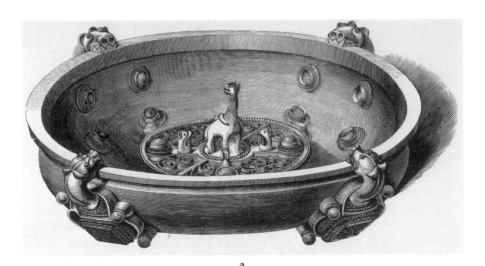

a

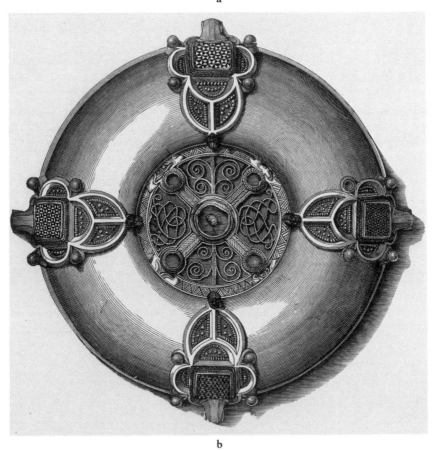

b

**54** (**a** and (**b**) Engravings of a ninth-century hanging-bowl, found in the River Witham near Lincoln, and since lost (Library of Society of Antiquaries).

animal. If the papal bowl had representations of four lions, four smaller lions and various serpents, the Witham bowl had four animal-headed studs inside, and the heads of four other animals forming hooks round the rim. Leo IV (847–55) had an Anglo-Saxon arm-ring.[169] His successor, Benedict III, received a number of gifts from King Æthelwulf (who stayed as a pilgrim in Rome from 855 to 856) and these included four silver-gilt bowls, also described as being Anglo-Saxon (*saxiscae*).[170] The next pontiff (Nicholas) witnessed the visit of a number of Anglo-Saxons, who presented a silver altar-frontal to the oratory of Gregory the Great.[171] He owned a gilded bowl of purest silver which was characterised as Anglo-Saxon.[172] The *Liber Pontificalis* peters out as a source of information on such artistic objects at the end of the ninth century but the Montecassino chronicle later picks up the thread. It refers to 'a large silver Anglo-Saxon chalice' that Montecassino had received in the earlier Middle Ages;[173] describes the 'wonderful' reliquary of English workmanship that had been sent from England about 1012[174] which has already been referred to; and speaks of two Anglo-Saxon chalices of silver which were bequeathed by the former abbot of Montecassino, Pope Victor III,[175] who died in 1087.

Specific references over a span of three and a half centuries to Anglo-Saxon objects suggest that there was a certain style of goldsmiths' work that the Italians recognised as peculiarly English. This could not have characterised a shape or form since the term was used of such dissimilar objects as an arm-ring, a reliquary, hanging-bowls and chalices. It must, therefore, have indicated a type or quality of decoration.

This might have been engraving. As we have seen in an earlier chapter,[176] the English goldsmiths had a reputation in northern Europe for their engraving in the eleventh century. Moreover, one of their greatest goldsmiths before the Conquest was an engraver,[177] and there were engravers amongst the goldsmiths who attracted a royal commission at Winchester.[178] Further to this, there is some emphasis on engraving amongst the sparse references to the techniques of goldsmiths' work over the Anglo-Saxon Christian centuries. We, therefore, read of an engraved chalice and paten,[179] of engraved altar-frontals,[180] and of engraved reliquaries,[181] a minor example of which could draw from a twelfth-century writer the enthusiastic praise that it was 'wonderfully engraved'.[182]

Against all this must be set the insuperable fact that the Anglo-Saxon objects in Rome included a number of Christian hanging-bowls, and that no such surviving hanging-bowl has engravings of any significance on it. Here the family likeness of Gregory IV's Anglo-Saxon

hanging-bowl to the lost bowl of Witham (Plates 54a and 54b) may be of help to us. The attraction of the Witham bowl clearly owed something to the lively animal in the centre and to the animated animal heads elsewhere, but much of it was centred on the delicate filigree ornamentation. This enlivened almost the whole of the base, both within and without, and the four escutcheons around. Anglo-Saxon arm-rings also had filigree work on them, and one of the Anglo-Saxon objects in Rome was an arm-ring. In fact, the Anglo-Saxon jewellery that survives demonstrates that there was a tradition of filigree work amongst Anglo-Saxon goldsmiths which continued from pagan times onwards; it is exemplified by the Kingston (Plate 3) and Abingdon brooches, the buckle and clasps from Taplow, the Alfred (Plate 4) and Minster Lovell jewels and the tenth-century Wudeman brooch.[183] It is clear from such survivals that Anglo-Saxon goldsmiths had a special grace and dexterity in working the pearled, granulated or beaded gold wire which they delicately shaped into animated patterns almost like exquisite gold embroidery. In this they had few rivals, and it may be that contemporary Italian references to Anglo-Saxon workmanship were recognising this fact as we can appreciate it still today. Whether this be so or not, any hints from Italian sources about the style of Anglo-Saxon goldsmiths' work can only be of value in the face of the taciturnity of English writers.

The silence of the English was not absolute, though details given of church vessels are quite exceptional. A chalice found in the coffin of St Cuthbert, who was interred in the seventh century, prompted a twelfth-century writer to observe that: 'its lower part was in the form of a lion of the purest gold, which wore on its back an onyx stone hollowed out by the ingenuity of the artist with the most beautiful workmanship, and so attached to the lion that it could be easily turned round with the hand although not detached from it'.[184] Aldhelm tells us of a seventh-century censer which was surrounded on all sides by small heads or small columns[185] (the Latin is ambiguous), and Æthelwulf remarks that a gold chalice and silver paten (given by Sigbald who died about 771) had engraved figures on it.[186] In the context of this chalice, we might remind ourselves of the existence of the almost contemporary Tassilo chalice (Plate H), already referred to, which can give us some idea of the Anglo-Saxon chalices of the period. Like Sigbald's chalice, this one is engraved. It has, round the bowl, engraved bust-figures of Christ and the evangelists, each in separate interlinked oval frames, filled with interlace. Each evangelist has his accompanying symbol and, in linked medallions round the foot, there are also bust-figures engraved and nielloed on a background of silver relieved with gold. The decoration

between the medallions consists of chip-carved palmettes and interlace, some of it with animals.

If the vessels of the church attracted costly materials and fine workmanship, the altar, and especially the high altar on which the sacrifice of the Mass was offered, was always the primary focus of splendour and artistic skill. Already in the seventh and eighth centuries, English altars were being adorned with gold, silver and precious stones. In the seventh century King Oswald 'clothed' the altars of the churches he had built with gold and precious stones.[187] At York, in the eighth century, Archbishop Wilfrid II 'covered the altar . . . with gold and silver',[188] Archbishop Albert embellished another with silver set with gems,[189] and covered yet another 'all over with silver, precious stones and gold'.[190] In the ninth century (as we have seen)[191] an Anglo-Saxon delegation presented a silver altar-frontal to St Peter's at Rome. The costly altars of the early period offered rich booty for the Danes but those of the tenth and eleventh centuries were not less splendid. In the wealthier churches they were adorned with precious metals, as at Winchester;[192] enhanced further with precious stones, as at Ramsey,[193] Peterborough[194] and Ely;[195] or furnished with a detachable frontal of gold or silver, as at Worcester[196] and Glastonbury.[197]

Some of these altars and their frontals had figural or decorative work. About these, writers were again more appreciative than communicative, veiling the details with wrappings of set, commendatory phrases, like that of the Evesham chronicler who simply tells us that the altar given by abbot Æthelwig was 'most beautifully fashioned in gold and silver'.[198] Nevertheless, further information is occasionally vouchsafed us. We learn, for example, that the gold and gemmed altar of a cell of Lindisfarne in the early ninth century had a silver altar-frontal on which was engraved a representation of the blessed in heaven[199] – a scene suggested by the Apocalypse, which had earlier inspired some of the panel paintings brought back by Benedict Biscop from Rome.[200] We discover that a tenth-century gold and silver frontal at Abingdon was engraved with representations of the twelve apostles,[201] and that these later appeared in a different technique at Waltham. There, the altar, of pure gold, had 'for the adornment of the church twelve cast figures of apostles to support the golden altar in front, and lions in the same workmanship to support it behind'.[202] On a gold, silver and bejewelled altar-frontal at Ely there was a Christ in Majesty in relief together with personifications of the sun and moon and representations of four angels in ivory.[203] It is true that this was made between 1076 and 1079 after the Anglo-Saxon period – no doubt to replace an earlier one stripped down at the Conquest – but it was probably made by Anglo-Saxon craftsmen

and can be reasonably brought within the Anglo-Saxon context.

Apart from their high altars, churches and cathedrals had other altars dedicated to various saints. In the eighth century, according to Alcuin, the Minster at York had as many as 'thirty altars decorated in various ways',[204] which latter phrase probably indicates embellishments in precious metal. Small portable altars also existed, and these might be enhanced with decorative and figured work. Such a one, reconstructed from fragments found in the coffin of St Cuthbert and dating from the seventh or eighth century though repaired in the ninth, originally had a representation of St Peter.[205] Another survives from the late tenth century in a complete, if somewhat worn, condition (Plate 14) and is now in the Cluny Museum in Paris.[206] It is just over ten inches high – about as tall as a modern book – and is, in effect, a slab of prophyry in a silver-gilt frame. The frame is engraved at the top and bottom with representations of the Crucifixion, of the Agnus Dei, and of the symbols of the Evangelists; and at the sides with figures of Mary and John, and of two archangels. The engraving of John shows the vivacity of the engraving at its best and (as we have seen) is similar to the zestful drawings of the period (Plate 15).

The Cross, the most potent symbol of the faith, understandably inspired some of the finest religious poetry of the Anglo-Saxons. In *Elene*, Cynewulf wrote of the discovery of the true Cross by the empress Helen and of how she ordered it 'to be overlaid with gold and gems, with the most costly precious stones . . .'.[207] Compared to this, the Latin verse of Æthelwulf is pedestrian but it reaches a new point of warmth when it describes a vision of a cross which 'shone with ruddy gold and splendid gems'.[208] It is, however, in one of the most famous of Old English religious poems, the *Dream of the Rood*, that we find a poet really inspired by this theme. Here the Cross is again pictured as being enriched with gold and jewels (line 16) and flashing with colours (line 22).

The visions of Anglo-Saxons often reflected the world in which they lived and these visions of the Cross were, no doubt, inspired by contemporary displays in their own great churches. Many Anglo-Saxon crosses were of precious metals. Some were also bejewelled and, already in the seventh century, Aldhelm refers to a cross made resplendent with gold, silver and jewels.[209] Elsewhere, there are frequent references to crosses, or Crucifixes, of precious metals. Alcuin, for example, speaks of Wilfrid II, in the eighth century, covering crosses at York with gold and silver,[210] and of Albert presenting a great cross made of gold and silver.[211] Later English chroniclers – like obituarists lauding the virtues of the departed – become most expansive about the splendours of such crosses when they have gone for ever. It is in this context that we learn

that King Cnut gave to the New Minster at Winchester 'a large and holy cross . . . most beautifully adorned with gold, silver, gems and precious stones',[212] and that, after the Conquest, Hereward and his men could seize no fewer than 'fifteen crosses, or Crucifixes, of both gold and silver' from Peterborough.[213] There are other indications that the wealthier foundations owned quite a number. Waltham received three gold and six silver crosses or Crucifixes from Earl Harold;[214] Glastonbury was given twenty-six gold and silver ones in 1045;[215] and, even after its terrible losses at the time of the Conquest, Ely could still muster twenty-seven.[216] In all this, it should be added, there are some uncertainties of translation since both the Old English and the Latin use the same word (*rod* and *crux*) for the cross and the Crucifix indiscriminately. The areas of ambiguity are really resolved only when there is mention of a figure.

Some precious Crucifixes came to monastic churches as gifts from secular patrons. It may not be a coincidence that three donors, who were hoping for the privilege of burial in monastic ground, each gave two gold Crucifixes to the monastic church concerned. The first was a king, Eadred, who left 'two gold Crucifixes with gold figures for the place where he chooses to rest',[217] which was in fact the Old Minster at Winchester. The second was an earl – Byrhtnoth – who gave two gold crosses, or Crucifixes, to Ely[218] where he had made arrangements to be buried. The third was a private lady called Ælfwaru, also anxious to be interred at Ely, who presented two Crucifixes 'marvellously wrought of gold, silver and jewels'.[219] Wulfwaru bequeathed two gold crosses, or Crucifixes, to St Peter's monastery at Bath[220] but it is not known whether she was also buried there.

Crosses, or Crucifixes, in precious metals were used for various purposes in churches – for example, in religious processions or in ancillary chapels. The largest of them were placed above the high altar or on a nearby beam, and, in view of their complete disappearance, emphasis needs to be given to the fact that some were of quite noble proportions. Indeed, there are indications that the wealthiest churches tried to match the Christ-figure on their biggest precious Crucifix to His human size. At Ely, for example, we are explicitly told that the Crucifix, given by Stigand, had a silver-plated figure of Christ which was life-size.[221] So too, presumably, were the accompanying figures of John and Mary for they were described as being 'of the same workmanship'.[222] Again, the Christ-figure set over the altar at Bury was said to have been the same size as Christ Himself. (It was inspired by a Crucifix at Lucca that abbot Leofstan, who died the year before the Conquest, had seen on his way to Rome. Its materials are not mentioned, but a Crucifix set

up in such a position in one of the wealthiest houses of Anglo-Saxon England would probably have been precious.)[223] There is evidence that other such figures, elsewhere, were large. Just before the Conquest, Leofric and Godiva gave to Evesham a Crucifix in gold and silver with accompanying figures of the Virgin and John. It was described as being 'of no ordinary size',[224] and, since Crucifixes four feet high were considered quite ordinary at Abingdon,[225] we might suppose that the figures were at least life-size, a view supported by the fact that Godiva could arrange for one of her own necklaces to be hung round the neck of the effigy of the Virgin.[226] The records of Anglo-Saxon treasures at Winchester are scanty, but a late account says that Cnut gave his crown to the monastic cathedral there and set it on (or over) the head of Christ on the Crucifix before the high altar.[227] The source is less reliable than earlier ones but, if correct, it suggests that the Christ-image was large enough to wear a human crown.

It may be profitless to speculate about details, but it would be equally unhistoric to ignore the general impressions that the sources convey, and these suggest that, when a writer was describing an Anglo-Saxon statue as *large,* he was thinking of something that was at least life-size. In this context, it is worth recording that, even in the early seventh century, King Edwin had a *large* gold Crucifix or cross (*crucem magnam auream*) which in Bede's day could be seen in the church at Canterbury:[228] that Eadred gave to the Old Minster at Winchester a *large* Crucifix of gold (*magna aurea crux*):[229] that Cnut presented two *large* statues (*duas magnas imagines*), finely adorned with gold and silver, to the New Minster to accompany a Crucifix there:[230] that Stigand not only gave to Winchester a *large* Crucifix (*magnam crucem*), with figures of Mary and John richly covered with gold and silver,[231] but also presented St Augustine's, Canterbury, with a *large* silver Crucifix (*magnam crucem*).[232] Two other dignitaries of the Anglo-Saxon church, who, like Stigand, survived the Conquest, presented *large* Crucifixes, or crosses, to their own churches: one was Æthelwig, abbot of Evesham, who gave one (*crucem magnam*):[233] the other was Leofric, Bishop of Exeter, who gave two, though these latter, described as 'decorated Crucifixes' (.*II. mycele gebonede roda*)[234] may have been simply gold-embellished. William of Poitiers gives an account of a number of extremely large Anglo-Saxon gold and gemmed Crucifixes or crosses sent to Normandy (*cruces aureas admodum grandes insigniter gemmatas*).[235] This was not long after the Conquest, when a Crucifix 'of wonderful workmanship in silver and gold'[236] that abbot Leofric had earlier set up over the high altar of Peterborough attracted the attention of Hereward and his men, whose attack on the house has been mentioned earlier. The monks resisted them but the

Anglo-Saxon Chronicle says that Hereward's force 'went into the church, climbed up to the Holy Rood and took the crown off our Lord's head – all of pure gold – and then took the foot-rest that was underneath His feet, which was all of red gold'.[237] A later but reliable source, which describes the Crucifix as *large* (*magnam crucem*),[238] comments on the fact that the marauders had attempted to remove the Christ-figure itself but had been frustrated – perhaps because of its size.

Unlike the Crucifixes so far described, one at Durham was made of non-precious metals. However, it was decked out in gold and silver and its ample scale is indicated by the fact that, when the Durham clergy were escaping with the cathedral treasures from the Normans who were harrying the North, they had to leave this Crucifix behind. Though probably the most costly of their artistic possessions, it was simply too large and cumbersome to carry.[239] The Waltham Crucifix also, though not made of precious metals was laden with them, and this must have been life-size since we are told that Tovi was able to affix his own sword to its side.[240] About the Crucifix with which Stigand enriched Bury we can be less specific. It included accompanying figures of the Virgin and St John and is simply described as having a great weight of gold and silver.[241]

These large-scale effigies in precious metals did not occur only in Crucifixes. We catch glimpses of them elsewhere and, though such intimations are rare, they are not to be ignored.

Unlike the miracle which prompts it, the first reference is a particularly convincing one. It occurs in an account of the work of the abbot/ goldsmith Spearhafoc at St Augustine's Canterbury. This tells of how he lost a valuable ring, which had been given by the Confessor's queen (no doubt to embellish effigies, for we have seen that Godiva had given her jewellery for the same purpose). In his distress, he prayed to St Letard, whose relics were conserved there. The ring was recovered and this was accounted a miracle. It is in this context that Goscelin says that '. . . he [Spearhafoc] fashioned statues of *enormous* size and beauty . . . of Letard and the venerable queen, Bertha, which he solemnly erected over his [Letard's] tomb'.[242] This casual reference suggests that large-scale effigies in precious metals might be placed over tombs or reliquaries, and, in this context, the statement that Cnut accompanied his gift to Winchester of a reliquary for St Birinus with a 'large effigy'[243] takes on a new significance.

The only other two references occur in the accounts of Ely's misfortunes at the hands of the Normans. One[244] records the loss of four gold and silver statues of virgins, which had been given by abbot Brihtnoth in the latter part of the tenth century, and which no doubt

**55** Much rubbed ivory book-cover of late tenth century representing the Madonna and Child, enthroned and adored by angels (Paris, Bibliothèque Nationale, cod. lat. 323).

represented the Anglo-Saxon 'virgins' buried there. All the indications are that they were large. To begin with, they must have been of a reasonable size if they were not to look ridiculous in the positions assigned to them – two on each side of the high altar. Then the description itself carries undertones of the spectacular in its statement that they occasioned great wonder to the people. And, finally, the technique by which they were made – not cast, but needing a wooden core to support the gold and silver sheathing[245] – would itself suggest something big.

The final reference[246] is a very positive one. It relates to the loss of a Madonna and Child which had been made for abbot Ælfsige (981 – c. 1019). We are told that the effigy of the Virgin was 'of gold, silver and gems, and *priceless because of its size*' and are further informed that she sat on a throne 'as long as a man'.[247] This emphasis on the size of the throne is of some interest because a contemporary Anglo-Saxon carving of the same scene in ivory (Plate 55) also represents an unusually large throne, for it is almost as long (i.e. wide) as it is high. If we suppose the proportions of the Ely statuary to have been at all similar to that of the ivory carving, and allow the length of a man to be about 5 feet 9 inches, then we must conclude that the Ely Virgin in gold and silver, though seated, would have been something like seven feet high.

Now we do not know of these large-scale figures from comprehensive surveys of Anglo-Saxon art. They are brought to our attention by chroniclers whose primary interests lay elsewhere: by writers for whom art was always incidental to their main narrative – an accidental setting for a miracle, a chance example of a church's losses. These allusions do not, then, comprehend the extent, they merely indicate the existence of large-scale effigies in precious metals amongst the Anglo-Saxons. When we reflect on this and bear in mind the use of gold and silver in so many other areas of secular or religious life – on the textile coverings of tombs and altars, on costumes and vestments, in jewellery, weapons, ships, domestic plate, household furnishings, reliquaries, book-bindings, church vessels and altars – then, without going as far as the Conqueror's biographer who likened England to the gold treasury of Arabia,[248] we can say that Anglo-Saxon England was a rich country and one which dedicated an appreciable part of its precious metals to its crafts. As we have seen, this very lavishness was to place the more costly crafts at continual risk for they were always exposed to the needs and greeds of various groups of predators. And amongst the most rapacious of these were the Normans.

# CHAPTER VIII

# ANGLO-SAXON ART AND THE NORMAN CONQUEST

The Norman Conquest shaped the whole future of England. This is most obvious in the political field, where the intruding Normans were determined to preserve themselves as a ruling caste over the English. It is also evident in the world of art, where the shock-waves of its original impact were felt for the remaining decades of the eleventh century. But, after this, the effects remained less sharply silhouetted in art than in politics; the consequences became more diffuse; there was a new Anglo-Norman synthesis; a settling down into different patterns. This brief survey of the effect of the Conquest on Anglo-Saxon art will, therefore, be confined to the period between the victory of William in 1066 and the death of his son, William Rufus, in 1100. It will be extended beyond this date only in order to demonstrate that initial attitudes of the Normans to Anglo-Saxon art did continue into the twelfth century.

The immediate effect of the Norman Conquest was the loss of art on a scale unparalleled since the days of the Danish predators. Unlike these earlier attackers, the Normans went to great lengths to legitimise their enterprise. Unlike the Vikings also, the Normans were, of course, conventional – indeed, in the invasion context, ostentatious – Christians (the fact that their invasion fleet carried the blessing of the papacy gave their calculated attempt at self-aggrandisement a particularly religious aura). Despite all this, what they impounded from the English was still a form of plunder whose ultimate sanction was the sword.

Large quantities of art treasures were shipped across the Channel to the Normans' homeland. It is true that much of it went to foreign churches, but this was only to despoil the churches of England in order to enrich those of the Continent: or, as the Waltham chronicler bitterly put it, to amputate the limbs of God's Son in one country in order to offer them to the same God in another.[1] Whether the purposes were pagan or pious, the losses were the same.

The Conqueror's biographer speaks with positive pride of the torrents of Anglo-Saxon art that were poured overseas for the benefit of Rome,

and of France, but especially of Normandy. Some of the immense quantity of treasures that William found in England

he generously bestowed on those who had helped in the war now concluded. Most of them, and these the most precious, he distributed amongst the needy monasteries of various provinces. He sent to the Roman church of St Peter more abundant wealth in gold and silver than would be believed if we told it, and sent into the possession of Pope Alexander artistic objects which Byzantium would hold very dear . . . In a thousand churches in France, Aquitaine, Burgundy and Auvergne and other regions, the memory of King William will be celebrated in perpetuity . . . Some received extremely large gold Crucifixes, remarkably adorned with jewels. Many were given pounds of gold, or vessels made of the same metal. Several received costly fabrics [*pallia*] or other precious gifts. What the least monastery enjoyed from amongst his largesse would splendidly adorn a metropolitan basilica . . .[2]

William of Poitiers went on to say that the art treasures sent to Caen alone would take too long to enumerate, let alone describe.[3] And as, from the English side,[4] we read of the incredible number of preciously bound Gospel-books, costly reliquaries, Crucifixes, chalices, censers, ewers, copes, chasubles and so on, seized from only one English house by William and his son Rufus for the benefit of a single Norman foundation, Caen, we can believe him. The English account has nothing of the blandness of the Norman. It is poignant and despairing. Secular, as well as religious, works of art were sent across the Channel. William was compared by his biographer to a Roman general and he did not deny himself his own form of Roman triumph. In Normandy he paraded the youth of the defeated country, with their long hair and comely features.[5] He also exhibited the secular crafts of the conquered Anglo-Saxons – their garments, heavily embroidered with gold,[6] and their vessels of gold and silver.[7]

In a situation of defeat the vocabulary will vary. But, whether one side referred to voluntary gifts, as did the Normans,[8] or the other to forcible spoliation, as did the English, or whether, in reality, there was a mixture of a few grudging gifts and much bare-faced extortion, the fact remains that art treasures which would normally have remained with their English owners were lost to them. Waltham was especially unfortunate and particularly penalised for having had Harold as a benefactor, but other religious houses suffered. From Abingdon, the Normans seized 'a wealth of gold and silver vestments, books and vessels of different kinds intended for the rites and honour of the church',[9] as well as all the valuables lodged for safekeeping in the monastery by local residents. From Durham, Bishop Odo thought nothing of purloining, along with other objects, a pastoral staff 'of

extraordinary material and workmanship, for it was made of sapphire'.[10] Anglo-Saxon works of art given by former kings were not immune, as the New Minster at Winchester discovered when the two large statues, embellished with gold and silver, and the noble cross, enhanced with gold and precious stones, which Cnut had presented were quickly seized.[11] At Glastonbury, twenty-six crosses or Crucifixes, an altar, a censer 'of wonderful size' and other objects of gold and silver were stripped down.[12] Reprisals taken against Ely, which had made a stand against William, were more understandable though, in artistic terms, no less catastrophic. In 1071, in order to raise money to buy off the Conqueror's displeasure, the monks had to sell off gold and silver Crucifixes, altars, reliquaries, book-covers, chalices, patens, bowls, stoups, and dishes, and, when more money was required, they had to break up other gold and silver objects, including large effigies in precious metals, and especially the great Madonna and Child and the statues of the four Virgins[13] that have already been described. The chronicler's statement that everything of gold and silver was sacrificed was an exaggeration as we see from his later pages. But this should not lead us to underestimate the scale of Ely's losses at the time of the Conquest. Nor was this the end of them. On the death of abbot Thurstan in 1076, the king sent to Ely 'and ordered all that was finest of the art treasures and of the various objects which he knew to be there to be carried off to his own treasury'.[14] These included a particularly splendid Anglo-Saxon vestment in gold cloth which was never seen again.[15]

There is occasional evidence of these same attitudes of despoliation within the monasteries themselves for they were now ruled by Norman abbots and Norman officials. At Abingdon Norman monks took gold and silver art treasures, believed to have been given by St Æthelwold,[16] and sent them to their own Norman mother house of Jumièges. They also sent the precious metals stripped from a gold timbrel said to have been made by the saint.[17] Later on, Norman sacristans at Peterborough transferred Anglo-Saxon treasures, which included a splendid chasuble, from thence to their own original Norman house.[18] Such actions from within the monasteries were no doubt unusual and symptomatic only of some currents of feeling, and we must set against them the occasional gifts by the early Norman abbots to their new abbeys;[19] and, particularly, the honourable fact that the very first Norman abbot of Ely refused to take office until precious objects and money and assets seized by the Conqueror on the death of the last Anglo-Saxon abbot were restored.[20]

More insidious and far-reaching than these confiscatory attitudes

were the colonial ones that the Conquest introduced. This was recog-
nised by the Anglo-Saxon, but pro-Norman, Eadmer, who expressed
indignation that Henry I passed over English ecclesiastics for prefer-
ment in their own country, making a virtue of the foreignness of
others.[21] It was commented on by the half-Norman William of
Malmesbury who in 1124–5 wrote that 'England is become the resi-
dence of foreigners and the property of strangers. At the present time,
there is no Englishman who is either earl, bishop or abbot. Strangers all,
they prey upon the riches and vitals of England'.[22] Thirty years later
(according to a chronicle itself written about 1175) the Normans in
England could still remind an English king of the Norman Conquest
'whereby we have all been enriched with great wealth' and could
counsel him to preserve the independence of an abbey built on English
soil 'against the machinations of the English'.[23] It is true that the
marriage of Henry I to a descendant of King Edgar meant that the
Norman royal family began to show a more favourable face to the Old
English line. It is also true that, under Henry II, Normans were taking
English brides so that later on, in the 1180s, the Dialogue of the
Exchequer could rightly speak of the intermixing by marriage of the two
'nations'.[24] Despite all this, it is still fair to say that, for the first century
after their occupation of England, the Normans were a colonial power
in England in the sense that they were a dominant caste ruling over a
defeated and alien nation.

This meant that they had colonial attitudes to the native art of the
past. They could appreciate its aesthetic quality but its monetary worth
mattered more and this is nowhere more clearly seen than in the way
William the Conqueror's son, Rufus, had art treasures melted down in
order to raise money to take the Duchy of Normandy in pawn from his
brother, Robert. He and his counsellors used every method of extortion
known to them and met every objection with a cold indifference.

The bishops and abbots [said William of Malmesbury] flocked to the court
complaining about this outrage, pointing out that they were not able to meet
such heavy taxation. . . . To which, the officials of the court, replying as usual
with angry expressions, said: 'Do you not have reliquaries made of gold and
silver, full of the bones of dead men?' No other reply did they deign to give their
petitioners. So, the latter, seeing the drift of the reply, stripped the reliquaries
of the saints, despoiled the Crucifixes, melted down the chalices, not for the
benefit of the poor but for the King's treasury. Almost everything which the
holy frugality of their ancestors had preserved was consumed by the avarice of
these extortioners.[25]

The levy, according to another contemporary, 'completely beggared

the whole kingdom' sparing 'no ecclesiastical ornaments, no sacred altar vessels, no reliquaries, no Gospel-books bound in gold and silver'.[26] To meet their contribution, the abbey of Malmesbury had to strip down eight shrines, eight Crucifixes and twelve bindings of gold and silver.[27]

One or two of the earliest Norman abbots were infected with the same colonial attitudes, and those at St Albans and Abingdon[28] did not conceal the fact that they considered the English to be boors and simpletons. Abbot Paul of the first abbey went so far as to destroy the tombs of his Anglo-Saxon predecessors.[29] An abbot of Malmesbury ejected the relics of the Anglo-Saxon saints at his house with a jeer.[30] As late as 1124 or 1125, the greatest and most cultured son of Malmesbury refused to record the names of Anglo-Saxon saints at Thorney because of their uncouth sound.[31] Given this undercurrent of feeling towards the abbots and saints of the Anglo-Saxon past, it is not surprising to find that some Norman abbots and bishops saw Anglo-Saxon art not in terms of historic pride or aesthetic esteem but of economic appraisal. It was a financial asset to be disposed of at will.

The monastery of Coventry had been built and artistically enriched by the pious munificence of Earl Leofric and the Countess Godiva not long before the Conquest. Soon after the Norman victory, it found itself dispossessed of treasures for the financial benefit of the second Norman bishop of Lichfield and Chester.[32] Generously endowed with art treasures by its last pre-Conquest abbot, the monastery of Peterborough was despoiled by its first Norman one simply in order that he might enrich the bishopric of Beauvais to which he had been appointed.[33] The first Norman abbot of Abingdon gave a large and beautiful Anglo-Saxon chalice as part of the purchase price for a village.[34] In order to raise money for an estate, a successor, in the first part of the twelfth century, broke up an Anglo-Saxon altar-panel of gold and silver with representations of the apostles, even though it was thought to have been made by St Æthelwold himself.[35] His immediate successor, Ingulf, went considerably further. He melted down a reliquary given by Cnut to pay for food during a famine,[36] but made much heavier sacrifices for more material purposes. To secure an estate, he stripped down twelve other reliquaries of gold and silver,[37] and, towards the end of his life, 'removed practically everything of gold and silver that was to be found in the church to settle his debts'.[38] When, in the twelfth century, Bishop Nigel of Ely needed to raise money in order to repair his own political fortunes, he stripped down, sold, or used as security, a quite astounding number of Ely's monastic treasures.[39] These numbered Crucifixes of gold and silver and splendid vestments from the Anglo-Saxon past, and

they included an alb with gold-embroidered apparels, given by St Æthelwold, and a chasuble, given by King Edgar, which was almost all of gold.[40] A gold and bejewelled textile covering, which had been presented by a pre-Conquest queen for the shrine of the patron saint of the monastery, was sold to the bishop of Lincoln, Alexander, who took it with him to Rome as a gift of particular splendour. It is a biting commentary on attitudes of the Anglo-Norman episcopacy of the day to Anglo-Saxon art that it was left to the pope to point out that such an artistic heirloom should never have left Ely in the first place and to order its return. Even on its way back, attempts were made to strip it of its precious material.[41]

It is not easy, of course, to separate out the attitudes that are here referred to as colonial from the philistinism that is present in every age and in every country, and which was present to a slight degree, at any rate, in Anglo-Saxon England.[42] But it is significant that when, in the first half of the twelfth century, the French (who had philistines of their own) were lovingly cherishing works of art associated with the great men of their own historic past (saints like Éloi and emperors like Charles the Bald),[43] the Normans were breaking up or melting down treasures connected with comparable great figures of England's own history (saints like Æthelwold and kings like Edgar and Cnut).[44] At Westminster, consideration was actually given to selling the royal regalia of its Anglo-Saxon patron and virtual founder of the monastery, Edward the Confessor, even after steps had been taken for his formal canonisation.[45] Amidst all this, we need to bear in mind the reverence that prevailed amongst many English monks for past saints and past kings. We would not know of the destruction of treasures associated with them had it not been for the feelings of outrage on the part of the writers. We should also remember that, once the twelfth century had been reached and the new order fully consolidated, there was a new anxiety amongst the Anglo-Norman prelates and abbots to enrich their churches and monasteries with fine works of art of every description, and these included shrines for local saints like Alban and Etheldreda.

It remains true, however, that the Conquest had intruded into England an alien and dominant class, whose own roots did not go back into the soil of England before 1066, but – like the almost horizontal tap-root of an apple tree – went sideways to Normandy. For them, the art of the country before Hastings did not represent heirlooms of history but the acquisitions of victory, to be displayed, sold, melted down, but not cherished. Those amongst them that were interested in art were more concerned with the art of the present than that of the past. They are in some ways typified by a twelfth-century bishop, uncharacteristic in

almost all else, Henry of Blois. Henry was a great patron of contemporary art, who commissioned contemporary paintings and metalwork, and who even admired classical Roman sculpture before the days of its popularity, and imported examples of it to England. Yet, he was so indifferent to the historic associations of Anglo-Saxon art that he simply removed one of the most important Anglo-Saxon heirlooms from his own cathedral,[46] and also tried to buy the chief embellishment of the most celebrated of all the Anglo-Saxon miracle-working Crucifixes to survive the Conquest – that of Waltham.[47]

In using the term 'colonialism', the emphasis so far has been on the imposition of a foreign caste on a people with alien traditions and values. Inherent in the expression, also, is the distinction between domination on the one hand and service on the other: a contrast between those who do not have to work and those who do. This latter feature is mirrored in the development of dress after the Conquest, though coincidentally so, for this same spirit of domination is inherent in feudalism itself and there is no difference between the styles in England and those found on the Continent.

After the Conquest, the Normans put forward a view of the Anglo-Saxons which characterised them as effete and decadent. 'Champions with combed, anointed hair, effeminate young men'[48] was their later description of Harold's army before Hastings. They had a particular fascinated aversion for the length of hair of their enemies, although this fashion was already in decline before the Conquest[49] and came to an end after it. Indeed, within less than thirty years the situation was reversed and it was the English, including those who were pro-Norman, who were criticising the Normans. 'They grow their hair long like girls', said Eadmer, alluding to some Normans of 1094 '. . . walking with delicate steps and mincing gait'.[50] Length of hair (as generations very far removed were to discover) has a peculiar capacity for triggering off emotive feelings, and there can be no doubt of the contempt that the Normans originally felt towards the Anglo-Saxons for allowing nature to take its course where the growth of their hair was concerned. Yet, in those areas where nature herself could be shaped and manipulated at great cost and ingenuity, it was the Normans who introduced foppish fashions into England.

Before the Conquest, as we have seen, the primary male attire almost everywhere was the simple tunic, sometimes accompanied by a cloak; and female dress consisted basically of head-dress and a long tunic – generous, it is true, in volume but simple in cut and sometimes caught in at the waist. Indications of rank, wealth and dignity were achieved not by the design of garments but by the costliness of their adornments.

The clothing of all classes was essentially practical, leaving the body and limbs free for either the toil of the field or the pleasures of the hunt. After the Conquest, however, there was a revolution in outlook, particularly when the Conqueror himself was dead. It was then that there developed, especially at the court of William Rufus, tortured and outlandish fashions that angered the monastic observers. 'They add excrescences like serpents to the tips of their toes and gaze with admiration at these scorpion-like shapes', said Ordericus Vitalis.[51] 'They longed to deck themselves in long, over-tight shirts and tunics', he also complained,[52] and he further attacked the extravagant sleeves, the unnecessary mantles and the lengthy trains of the men, which swept the ground and made them 'almost incapable of walking quickly or doing any kind of useful work'.[53] One can point to rudimentary elements of such styles at an earlier date,[54] but sartorial extravaganzas like these, flaunting the leisured status of their wearers, were entirely new. We can see them illustrated in later manuscripts,[55] and realise then that writers were not exaggerating. The purpose of these fashions was radically to reshape the human silhouette both by constricting the centre part and by extending the extremities. All this introduced into England a stylistic chasm in dress that divided the lower classes, whose tunic was adapted for labour, from the courtier whose garments actually inhibited work. It was a symbol of the fissure that separated the English classes from the Norman caste.

These new and bizarre fashions must have given much employment to shoe-makers, sempstresses and tailors at court, but, for some of the more traditional crafts (other than that of building), the Conquest was less of a blessing.

In terms of survival, the best documented of these crafts in the post-Conquest period is manuscript illumination. Manuscripts – and their illustrations – were produced chiefly by monks and they, like everyone else, saw great changes at the Conquest. The most important of these was the replacement of the Anglo-Saxon rulers of monasteries by Norman ones. At the death of the first archbishop of Canterbury from Normandy, there was no remaining Anglo-Saxon abbot of any important English monastery, and between 1066 and 1135 over sixty abbacies were filled from overseas. The Norman governance of the English monasteries was part of their general colonial policy which aimed to keep the native population under control. It did not pass without occasional incidents which indicate how strong were the underlying feelings on both sides. At St Augustine's, Canterbury, the first Norman abbot was accepted by the monks 'not without bitterness of soul',[56] and, when the second was presented, the whole community

expressed its resentment by quitting the monastery, and he had to be installed in an empty church. At the neighbouring house of Christ Church, Anglo-Saxon monks were refusing to accept the authority of the Norman prior as late as 1093.[57] At Glastonbury, a Norman abbot tried to settle a liturgical dispute with Norman weapons. His Norman troops killed and wounded Anglo-Saxon monks seeking refuge around the altar, and their arrows even pierced a Crucifix which one monk had picked up as a protection for himself.[58] Despite all this, the transition, on the whole, was a reasonably smooth one. The first precept of the monk was, after all, obedience, and, if this was colonialism within the monastery, it was often of a paternal kind. It was paternal because the first two rulers of the English church after the Conquest were men of exceptional sensibility and exceptional quality. Both were Italian by birth. The first, Lanfranc, was an understanding ecclesiastical states-man. The second, Anselm, was a humane and kindly saint.

The Normans who controlled the monasteries certainly had a regard for books. Many, indeed, might qualify for the epithet 'a lover of manuscripts', which was applied to Paul, the Norman abbot of St Albans.[59] Apart from service books and others, he left twenty-eight 'noble' volumes to his monastery,[60] and it was during his abbacy that a local knight set up a special endowment to finance scribes.[61] For his house of Evesham, the Norman abbot, Walter, 'had many books made'.[62] Geoffrey of Jumièges instituted a small library at Malmesbury.[63] William of St Carilef left almost fifty books to Durham[64] of which a number survive.[65] Yet, without detracting in any way from the well-known bibliophile interests of the Normans, all this will be put in perspective when we see that the Anglo-Saxon bishop of Exeter, Leofric, who died in 1072, gave fifty-eight manuscripts to his cathedral.[66] The Anglo-Saxons also had an interest in books but they did not usually choose to put it on record as did the Normans. We only know of Leofric's bequest because of a memorandum in one of his manuscripts. It is doubtful whether an Anglo-Saxon chronicler would have bothered to mention them. Whereas (as we have earlier seen) later Anglo-Saxon writers usually took notice of books only when they were costly works of art, Norman chroniclers tended to record all gifts of books, practically all of which, of course, were intended for use in the library.

As there were different attitudes to manuscripts on the part of the Anglo-Saxon and Norman chroniclers who mention them, so there were, too, by the Anglo-Saxon and Norman abbots who commissioned them. The Normans had little of the Anglo-Saxon interest in pictorial illustration. According to Eadmer, who was born a few years before the

Conquest and brought up from infancy at the monastery of Christ Church, Canterbury, the fire that burnt down the cathedral there in 1067 destroyed practically all the monastery's sacred and secular manuscripts.[67] It is certain that key documents which affected the very authority of the Archbishops of Canterbury were thought to have been lost in the flames,[68] and, in the next century, another fire destroyed books in the neighbouring monastery of St Augustine's.[69] Yet, illustrated manuscripts of the Anglo-Saxon period from Canterbury remain in reasonable numbers to this day. This would suggest that the collections on the eve of Hastings were particularly rich, and that earlier productions had been quite considerable. On the other hand, to judge by the same criterion, namely survivals, few illustrated manuscripts appeared at Canterbury in the thirty years after the Conquest. Those that did could not compare in wealth of illustration with the earlier ones which, if they were like the Benedictional of St Æthelwold[70] or the Sacramentary of Archbishop Robert,[71] had numerous pictures, and, if they were like the Harley Psalter,[72] or the Canterbury Hexateuch,[83] had literally hundreds of scenes. Though not large, many of these Anglo-Saxon paintings and drawings were on pages separate from the text and, if mounted and framed, would look choice enough in any art gallery hung with small pictures (say Rowlandsons) today. Such illustrations, independent of the text, were, however, discontinued by the Normans. The newcomers were interested not so much in the art of the book as in its written content. For the Anglo-Saxons, the paintings were so important that they might rival the text. For the Normans, it was the text that mattered and the art was therefore simply a garnish. They therefore subordinated the paintings to the written page and concentrated them inside the initials.[74] The illuminated initial had, of course, been known to the Anglo-Saxons, but it had always played a minor rôle in their repertory, and now it was the complete repertory itself.

Yet, although this complete absorption with the initial was not part of the Anglo-Saxon tradition, the actual stylistic ingredients of the Anglo-Norman initial were.[75] And the reason for this was that, both in their own duchy and in their newly-conquered kingdom, the Normans were themselves strongly influenced by Anglo-Saxon manuscript paintings. Anglo-Saxon illustrated manuscripts had certainly found their way to Normandy before the Conquest.[76] More had also arrived after it, for we may assume that the preciously bound manuscripts despatched from England by William and his son,[77] included some that were illustrated. There may even have been Anglo-Saxon artists in Normandy. William of Poitiers tells us that Anglo-Saxon ecclesiastics were taken to

Normandy in William's train after his Conquest[78] and we know that they included dignitaries like Stigand, archbishop of Canterbury, and Æthelnoth, abbot of Glastonbury. Apart from this, Ordericus Vitalis hints that Anglo-Saxon monks were given experience of Norman monasteries.[79] We further know of at least one Anglo-Saxon monk who was sent to Normandy for about two years as a disciplinary measure;[80] he is brought to attention only because of a special relationship with St Anselm and presumably there were others who remained unnoticed. If among these monks there were artists, then there would have been Anglo-Saxon monk-illustrators in Normandy after the Conquest just as there had been some in Flanders a few decades before.[81] This would account for the fact that a drawing in a Fécamp manuscript seems to be the work of an Anglo-Saxon[82] and explain why some Norman initials (especially those in the Carilef manuscripts) have an Anglo-Saxon 'feel'. Although influences from Germany and Flanders played their part, it was England that affected Norman illumination most. Hence, the Norman illumination, imposed in English monasteries between 1066 and 1100, was highly redolent of Anglo-Saxon work in terms both of figure style and of decoration.[83]

In terms of quality, there is, however, a change from Anglo-Saxon times. A new uncertainty is introduced, and illumination after the Conquest registers erratic fluctuations, varying from the almost jewelled quality of the New Minster Crucifixion[84] to the garish bathos of the Lincoln Bible initials.[85] A new localisation, or regionalisation, of styles also appears which means that one can now distinguish between the products of houses as closely linked as the two neighbouring monasteries at Canterbury.[86] This development of separate artistic schools was to continue throughout the twelfth century. Yet, before the Conquest, it would have been difficult to differentiate between the styles of any of the great reformed houses of southern and eastern England. Another departure from the past is the end of the splendour and éclat of the native manuscript art. Before Hastings, there had been sumptuous and preciously bound manuscripts which, like the Benedictional of St Æthelwold, had been rich with colour, lavish with gold and with full-page illustrations on the finest vellum. As far as we know, it was not until fifty years or more after William came to the throne that *manuscrits de luxe* of a comparable costliness were allowed to re-appear.[87]

This loss of resplendence is evident in wall-paintings too. The little information we have about Anglo-Saxon wall-paintings indicates that the finest were given the added splendour of gold.[88] But there is no suggestion that this continued after the Conquest. The wall-paintings commissioned by Lanfranc for Canterbury soon after the Conquest

were not so enriched.[89] Nor those provided by prior Ernulf (1093–1107).[90] Nor by Ernulf's successor either.[91] Nor was the painting with which a Norman abbot adorned the vault over the altar at St Albans between 1077 and 1093.[92] Clearly, Norman wall-paintings were less costly than some of the earlier Anglo-Saxon ones.

The Anglo-Saxons were probably more interested in hangings than in murals, and Leofric's donations to Exeter were characteristically Anglo-Saxon in the provision of these.[93] His other bequests, which included carpets, seat-covers and dorsals, indicate the more widespread interest of the Anglo-Saxons in textiles, and though there is no evidence that the early Normans in England shared this interest in fabrics, it is probable that needlework was the native skill which suffered least from their conquest of England.

Anglo-Saxons continued to give embroidered textiles to churches after the Conquest. For example, a wealthy citizen of Salisbury whose name, Edward, indicates that he was English, gave to the Norman foundation of Selby a linen altar-cloth embroidered, according to the twelfth-century chronicler, in 'wonderful workmanship' with representations of Christ in Majesty, the Four Evangelists, the Crucifixion and the twelve apostles.[94] This was probably during the reign of the Conqueror himself.[95] Then, Anglo-Saxon prelates who survived the Conquest followed their old traditions of bequeathing vestments. Leofric, for example (Anglo-Saxon by birth and blood despite his Lotharingian education), gave to Exeter five complete mass-vestments, two dalmatics, three copes, four maniples and three epistle-vestments.[96] Abbot Æthelwig willed an unspecified number of chasubles, copes and precious coverings to Evesham.[97] Siweard left to his former abbey of Abingdon the contents of his private chapel which included an alb, super-humeral, stole with fanon, and chasuble with apparel worked in gold.[98] We cannot of course know whether these vestments, bequeathed by Anglo-Saxons after 1066, were made before or after this critical date, but of far more significance than such Anglo-Saxon bequests was the patronage that the incoming Normans themselves gave to the English embroideresses.

The much-admired embroidery in gold of the Anglo-Saxon women was certainly allowed to continue. At court, as we have already seen,[99] one professional embroideress in gold, Leofgyth, remained to serve the Norman royal family as she had the Anglo-Saxon one. In her will, Matilda speaks of another Anglo-Saxon needlewoman at Winchester, who is making a chasuble for her, and she may be referring obliquely to a third when she mentions another vestment that is being made for her in England.[100] With our knowledge of the kind of vestment donated by

Matilda to other churches, we may assume that these vestments were gold-embroidered. Her will also mentions a cloak that is worked in gold. Given the admiration of the Normans for Anglo-Saxon embroidery, it seems probable that the patronage, documented at the royal court, had its parallels in the households of ecclesiastical princes. This is quite clear from the Bayeux Tapestry (Plate 32) which was made for Odo of Bayeux, and any vestments commissioned by the Normans were almost certainly made by the English too. In this context, we may observe that Abbot Paul of St Albans gave copes and albs to his own house,[101] and two sets of vestments for the private chapel of the knight Robert:[102] that Abbot Theodwin of Ely had a white cope made:[103] and that William of St Carilef left five copes, three chasubles and an embroidered stole and maniple to Durham.[104]

The most generous donor of such vestments after the Conquest was the Italian, Lanfranc. To Canterbury, he gave copes, chasubles, dalmatics and tunicles, all embellished with gold.[105] To Rochester he presented twenty-five silk copes, five other copes and a dalmatic, with gold embroidery.[106] The bishop there, Gundulf, added four other copes, one of which was enriched with gold.[107] Given the particularly close relationship between Canterbury and Rochester, these gifts of gold-embroidered vestments suggest that Anglo-Saxon needlework in gold continued at Canterbury, just as the Bayeux Tapestry indicates the continuance there of embroidery of a less exotic kind. In this context, we may note that three of Lanfranc's chasubles had the decoration of pearls[108] which Goscelin considered a characteristic of Anglo-Saxon vestments,[109] and that two were embellished with gold pearls: earlier Bede had mentioned the assorted colours of the pearls of England.[110] At Ely, also, there is record of gold-embroidered vestments. Abbot Godfrey gave two copes, two stoles with maniples, and one alb and amice with workmanship in gold, as well as three copes, two dalmatics, and a tunicle of a more ordinary kind.[111] It is true that all these gold-worked vestments appeared under somewhat exceptional circumstances. At Canterbury, the contents of the cathedral had been largely destroyed by the fire of 1067, which had gutted the Saxon structure and made it necessary for Lanfranc to build and furbish a new cathedral. At Rochester, the cathedral was being rebuilt, and a long-vanished monastery was being revived which, like that at Christ Church, Canterbury, was placed under the bishop as abbot. In effect, then, and with some marginal help from Gundulf for Rochester, Lanfranc was providing vestments for two re-foundations. At Ely, the position was different but not less unusual. Godfrey's Norman predecessor had stripped Anglo-Saxon vestments of their gold-

embroidery[112] and his own action may have been a form of restitution. But, whatever the reasons, there is evidence for the continuation of the celebrated Anglo-Saxon embroidery in gold. The fortunes of the professional Anglo-Saxon needlewomen were not eclipsed by the Conquest.

Those of the Anglo-Saxon goldsmiths were however, different.

Have you ever seen a goldsmith making an exquisite design from gold or silver plate just by hammering it? . . . In order to obtain the right shape from the metal, he now carefully applies pressure and hammers it with his tools, and then with well-judged relief work he raises it more gently into shape. In the same way, if you want your children to be well-behaved, you must, whilst bearing down on them with blows, offer them the relief and support of fatherly goodness and gentleness.[113]

St Anselm would hardly have used an analogy like this had he not actually seen a goldsmith at work, but there is little evidence that the Normans made use of the native goldsmiths of England. We certainly know of goldsmiths with Anglo-Saxon names who were associated with monasteries after the Conquest. One, named Wuluric, a secular, is referred to at Battle Abbey.[114] At Malmesbury, in 1084, the goldsmiths, Cytel and Ewart, were described as 'men of the abbot';[115] at some time before 1097, an Anglo-Saxon goldsmith, Hereward, was designated as being the *socius*, or colleague, of the sacristan there;[116] and, at Evesham, a professional Anglo-Saxon goldsmith became a monk under abbot Walter (1077–86).[118] All this does not, however, mean that such craftsmen were given much opportunity for artistic workmanship by the Normans.

There is occasional evidence that the Anglo-Saxons themselves continued in a minor way to patronise the goldsmith. Edward, the Anglo-Saxon citizen who had presented an altar-cloth to the new foundation of Selby, gave also a little gold reliquary, though the fact that – small as it was – it attracted such ecstatic praise in the twelfth century[118] may indicate how meagre were such donations of precious objects between 1066 and 1100. In an obscure centre, like Sherborne, where Anglo-Saxons, as priors, still exercised some sort of power, some goldsmiths' work did continue. Ælfric, who was *prepositus* there for an unknown period between 1078 and 1099,[119] had splendidly-ornamented reliquaries made in gold,[120] and this had the fulsome approval of his (Anglo-Saxon) brethren. But the real rulers of the church after the Conquest showed little interest in commissioning works in precious metals even though they might draw on the goldsmith for their metaphors.

It is significant that, though, according to late authorities, Lanfranc made presentations of a few works in precious metals to St Albans[121] and to Rochester,[122] there is little evidence of him making such gifts to his own cathedral of Canterbury, despite the losses it had suffered from the fire which gutted it. It is true that Gervase, writing a century later, claimed that he gave gold and silver objects amongst his *ornamenta*,[123] but an earlier chronicler, William of Malmesbury, who describes the same *ornamenta*, only mentions vestments and wall-paintings[124] amongst them. There were very few Norman donors of goldsmith's work before 1100, and it is a strange irony that they included two abbots who held the English in particular contempt. At Glastonbury, Thurstan, who was chiefly remembered for the slaughter of two Anglo-Saxon monks and the wounding of others, gave two censers and two candelabra.[125] At St Albans, Paul, who had referred to the English as barbarians, gave two precious book-bindings, reliquaries, a silver dish, two candelabra of silver gilt and three others of gold and silver.[126] The most important Norman donation of this period was an altar-frontal of gold and silver, representing Christ in Majesty and other figures, which was ordered for Ely by abbot Theodwin.[127] His successor, Godfrey, presented a gold chalice and two silver ones with patens.[128] Later, William of St Carilef gave to Durham a number of altar-vessels.[129]

In relation to the enormous losses of Anglo-Saxon objects in precious metals which were exported or melted down after the Conquest, the replacements by the Normans themselves were simply derisory. In the thirty-four years before Hastings, members of the Anglo-Saxon nobility like Harold, Leofric and Godiva had given superabundantly, flooding the churches of their choice with works in gold and silver. Kings like Cnut and Edward the Confessor had given royally, and lesser persons had given reliquaries and Crucifixes of precious metals. Amongst Church leaders, the generosity of an archbishop like Stigand was not exhausted by munificent presentations of large Crucifixes in precious metals to Bury, Canterbury, Ely and Winchester. A great, and art-loving, abbot like Leofric could so enrich his monastery of Peterborough that, in the words of the Anglo-Saxon Chronicle, 'it was called the Golden Borough'.[131] But his death coincided with the Conquest, after which time, says the same source, 'the Golden City became a wretched city'.[132]

In terms of goldsmiths' work, the whole country then became wretched. The emphasis by the new ruling class was on the removal of precious art treasures and not on the commissioning of them. We have seen something of the sheer volume of artistic objects in gold and silver that William I sent abroad,[133] yet his own gifts to Anglo-Saxon founda-

tions were meagre and grudging – to Rochester a reliquary, which probably came from the collection acquired with the royal Anglo-Saxon treasury,[134] and a silver-plated support for an altar,[135] and to Westminster precious workmanship for the tomb of Queen Edith[136] which was a purely political gesture since his own claims to England rested largely on her husband's alleged gift of the kingdom to him. In a scene of death-bed repentance for all the bloodshed he had caused, which was luridly reported by later Norman writers, he made lavish gifts to the poor of his realms and to their churches. The so-called Florence of Worcester later reported that, as a result of this, his son and heir in England, William II, distributed largesse to major churches and monasteries in the form of precious Crucifixes, altars, reliquaries, candelabra and Gospel-books.[137] This was, of course, only to give back to the English a part of what had been taken from them, but, before long – as we have already seen[138] – this, too, was to be recalled for the melting pots. Our information about the patronage of the Norman aristocracy in terms of precious objects is slight. We do not know what William de Warenne gave to his Cluniac foundation at Lewes in 1077, nor what was presented to lesser houses founded in the final decades of the eleventh century, other than Selby. But there is no evidence that any secular patron amongst the Normans commissioned goldsmith's work of any significance for church or monastery.

The new rulers of these churches and monasteries, the intruded Norman bishops and abbots, also spent little of their newly acquired wealth on objects in precious metals. Certainly nothing that could vie with the gifts of the Anglo-Saxons. In Anglo-Saxon terms, Bishop Leofric of Exeter was not especially munificent. He did not give on the scale of Harold or Godiva or Stigand, yet what he donated to his cathedral in 1072[139] could compare with the gifts of all the Norman bishops and abbots before 1100 throughout the country. And, if it is argued that the building programmes of the Normans prevented other forms of liberality, let it be said that one Anglo-Saxon abbot, who survived the Conquest by more than a decade, not only gave large and handsome objects in gold and silver but built a chapel and left money for the rebuilding of the monastic church as well.[140]

Of course, the Anglo-Saxons and the Normans had different conceptions of rebuilding and, when we have set on one side the fact that the colonial attitudes of the Normans to art treasures in gold and silver were those of the predator rather than of the benefactor, it remains a fact that the tastes of the Normans and the English were different. The interest of the Normans was in spaciousness: that of the Anglo-Saxons was in fine and costly objects. There is truth in the remark of William of

Malmesbury that the Normans lived frugally in large buildings and the
Anglo-Saxons extravagantly in small ones.[141]

The differences are seen from opposing points of view in the written
sources. On the one hand, an Anglo-Saxon annalist speaks warmly of
the fact that a pre-Conquest queen and bishop 'vied with each other in
making embellishments for the church of St Swithun from their
treasures'[142] and, on the other, a Norman chronicler censures the
Anglo-Saxons for collecting art-treasures.[143] On the one hand, an
Anglo-Saxon bishop after the Conquest wept that his church, built by a
past saint, should be destroyed simply for present grandeur,[144] and, on
the other, a Norman bishop was praised for his rebuilding of St Paul's
which was seen as 'proof of his magnanimity . . . So vast is the crypt, so
spacious the upper church that it seems able to hold any number of
people'.[145] Æthelwig, whose abbacy of Evesham spanned the Conquest,
remained faithful to his own Anglo-Saxon traditions when he adorned
his house with 'a great many embellishments – chasubles, copes, preci-
ous textiles, a large cross and an altar most beautifully worked in gold
and silver'.[146] His Norman successor, Walter, true to his, 'turned to new
fashions . . . he began to build a church and gradually destroyed the
ancient building which was then one of the most beautiful in England.
Remarkable as it is to relate, the ancient church could have been
contained in the crypt of the new one'.[147] According to the mediæval
commentators, the Bride in the Song of Solomon was a personification
of the Church of Christ. It is as if the Anglo-Saxon wished to shower his
Bride with jewels and the Norman to provide his with a spacious
dwelling.

The new fashions for large-scale building to which the Evesham
chronicle refers would probably have come to England from the Conti-
nent – indeed, from Normandy itself – whether the Normans had invaded
or not. Already, the Westminster Abbey of Edward the Confessor,
dedicated in 1065, had followed Norman models – indeed it is this that
William of Malmesbury saw as the precursor of all that followed.[148] It is
impossible for us to judge how far the vogue might have continued
under an Anglo-Saxon monarchy since all the major Anglo-Saxon
buildings were destroyed. But the pursuit of these fashions would not
have engaged amongst the Anglo-Saxons the ruthless single-
mindedness that it did amongst the Normans. Occasionally, when fire
destroyed the old cathedral, as at Canterbury, York, or London, or
when the transfer of bishoprics from rural areas to major towns like
Lincoln, Chichester and Chester necessitated new cathedrals, the
hands of the Normans were forced. But force would have been needed to
restrain, not to compel, hands so eager for construction. Once the

Norman abbots and Norman bishops felt themselves entrenched, their first concern was rebuilding. In the 1070s, cathedrals or major churches were begun at centres like Canterbury (both Christ Church and St Augustine's), Winchester, Lincoln, St Albans, Bury St Edmunds, Rochester, Worcester, Old Sarum and Battle; in the 1080s, at places like London, Ely, York, Gloucester and Tewkesbury; and, in the 1090s, in towns or cities like Chichester, Norwich, Durham and Chester. This was apart from the building, or rebuilding, of smaller churches and priories, like the priories of Blyth and Whitby.

All this meant initial destruction. The amount of demolition of minor churches that went on we do not know, though it was said that the reconstruction of a collegiate church at Twynham (Hants.) led Ranulf Flambard to destroy not only the original church but nine others adjacent to it.[149] Certainly some of the greater Anglo-Saxon buildings were pulled down, as at Winchester, Bury and Durham. And Goscelin, who was English only by adoption, could not restrain the remark that, after untold expense and fruitless labour, the pre-Conquest abbot of St Augustine's, Canterbury, Wulfric II, had left his work for others to destroy.[150]

This massive rebuilding meant losses in terms of any wall-paintings that there might have been in the demolished churches. It also meant the destruction of any sculptures which might have been part of their wall-fabric. Nor was the destroyed sculpture replaced by Anglo-Saxon craftsmen. It is true that a meagre and provincial strain of post-Conquest Anglo-Saxon sculpture still survives in backward areas like Newton in Cleveland (Yorks.) and Uppington (Salop),[151] but the major centres were dominated by Norman masons and those now referred to, like Hugo in Domesday Book[152] and Robert at St Albans,[153] have Norman names. In the wealthier and more progressive areas, Anglo-Saxon sculpture as a living craft was stifled. The Norman carving that replaced it before 1100 had a cetain vigour, but it was much cruder in quality than the best Anglo-Saxon sculpture and the treatment of the human form at Durham castle is quite childish. It seems to represent the work of enthusiastic but unsophisticated masons. Moreover, just as, in manuscript-painting, large narrative pictures were discontinued by the Normans and all art diverted to the decorative initial, so the large carvings of the Anglo-Saxons (almost to human scale in surviving examples at Bristol or Romsey) were abandoned, and sculptures were confined to the capitals.

The architecture to which these carvings were subordinated was, in art, the Normans' great achievement. 'Everywhere you could see churches in the villages, and monasteries in the town and cities rising up

in the new style of building' wrote one chronicler.[154] Never before, nor
since, has England seen such an efflorescence of building. It was great
in its scale. It was rapid in its proliferation. It was positive in its
evolution. Stylistically, it began by being dependent on Normandy
though nothing of this scope of rebuilding was ever seen there. Nor
could it have been, for the Normans who seized the wealth of England
were made vastly richer than the Normans in Normandy. Furthermore,
they had no compunction about the destruction of the historic churches
of a foreign land, which was a necessary prelude to their replacement by
larger ones. So, the Conquest gave them the money to build, the
indifference to demolish, and perhaps also the psychological need to
raise both spiritual and military citadels in the country they had
vanquished. The impetus of this Anglo-Norman architecture was such
that, within a generation, it had found its own creative force and was
making England one of the most architecturally progressive areas in
Europe. A particularly famous example of their work is Durham
cathedral which is still largely the Norman building begun in 1093.
Some may think that, from within, this famous structure has the
over-ponderous strength of a fortress rather than the quiet dignity of a
cathedral. But, in technical and engineering terms, it clearly shows the
heights to which Norman architects could rise. It is the earliest known
example of a building with ribbed vaulting throughout: it epitomises all
the technical ingenuity of the Norman, his boldness of conception, his
adroitness of skill.

Of course, other Norman buildings have disappeared as completely
as the Anglo-Saxon art that they exported or melted down or which, for
so many other reasons, has perished. Yet, despite this, history has been
kinder to them than to the race they conquered. The Normans excelled
in the art of architecture, and admirable examples of this can still be
seen in stone around us. But the supreme skills of the Anglo-Saxons
were in gold and gold-embroidery. And, though we have fine examples
of their goldsmiths' work from the period before *c*. 700, when paganism
and Christianity co-existed, we have none that the Anglo-Saxons
themselves would have considered impressive from the later and longer
Christian period. For a better understanding of this, we need to turn to
the written sources and seek enlightenment in terms of a new, a literary
perspective.

# ABBREVIATIONS FOR SOURCES
# MOST FREQUENTLY CITED

*Ælfric's Colloquy* – *Ælfrici abbatis colloquia ab Ælfrico Bata aucta*, in *Anecdota Oxoniensia*, ed. W. H. Stevenson (Oxford, 1929) VI, pp. 75–101.

Æthelwulf *De Abbatibus* – Æthelwulf *De Abbatibus*, ed. A. Campbell (Oxford, 1967).

Alcuin *De Pontificibus* – *Alcuini De Pontificibus et Sanctis ecclesiae Eboracensis carmen*. The verses quoted here come from the poem, as printed in J. Raine *The historians of the Church of York and its Archbishops*, vol. 1 (London, 1879). It is also published in *Monumenta Alcuiniana*, ed. W. Wattenbach, and in *Mon. Germ. Hist. Poetae Latini*, vol. 1, ed. E. Duemmler.

*Aldhelmi Opera*, ed. R. Ehwald – *Aldhelmi Opera*, ed. R. Ehwald in *Monumenta Germaniae Historica*: *Auctorum antiquissimorum*, tomus XV (Berlin, 1919).

*Anglo-Saxon Chronicle*, ed. Whitelock – *The Anglo-Saxon Chronicle*, ed. Dorothy Whitelock with David C. Douglas and Susie L. Tucker (London, 1961).

*A.S.P.R.* – *The Anglo-Saxon Poetic Records*, ed. G. P. Krapp and E. V. K. Dobbie (6 vols., New York, Columbia University Press, 1931–53).

Asser *Life of King Alfred* – *Asser's Life of King Alfred*, ed. W. H. Stevenson (Oxford, 1904).

Bede *Hist. Abb.* – *Historia Abbatum auctore Baeda* in *Venerabilis Baedae Opera Historica*, ed. Carolus Plummer (Oxford, 1896), I, pp. 364–87.

Bede *Hist. Eccles.*, ed. Plummer – *Historia Ecclesiastica gentis Anglorum*, pp. 5–363 of volume last cited.

Bede *Hist. Eccles.*, ed. Colgrave and Mynors – *Bede's Ecclesiastical History of the English People*, ed. Bertram Colgrave and R. A. B. Mynors (Oxford, 1969). This is the text actually cited in the notes.

Bede *Life of St Cuthbert* – *Two Lives of St Cuthbert*, ed. Bertram Colgrave (Cambridge, 1940), pp. 142 ff.

*Beowulf* – *Beowulf with the Finnesburg Fragment*, ed. C. L. Wrenn, revised W. F. Bolton (London, 1973).

Birch *Cartularium* – W. de G. Birch *Cartularium Saxonicum* (3 vols., London, 1885–93).

*Blickling Homilies* – *The Blickling Homilies of the Tenth Century*, ed. R. Morris (London, 1880, E.E.T.S. 73).

*Chronica ecclesiae Eboracensis* – *Chronica pontificum ecclesiae Eboracensis* in James Raine, *The Historians of the Church of York and its Archbishops*, vol. II (Rolls Series, London, 1886).

*Chronicon Abingdon* – *Chronicon monasterii de Abingdon*, ed. Joseph Stevenson (2 vols., Rolls Series, London, 1858).

*Chronicon Evesham* – *Chronicon Abbatiae de Evesham*, ed. William Dunn Macray (Rolls Series, London, 1863).

*Chronica Gervasii* – *Chronica Gervasii monachi Cantuariensis* in *The Historical Works of Gervase of Canterbury*, vol. 1, ed. William Stubbs (Rolls Series, London, 1879).

*Chronica Rogeri de Hoveden* – *Chronica magistri Rogeri de Hoveden*, ed. William Stubbs (4 vols., Rolls Series, London, 1868–71).

*Codex Vercellensis* – *The Poetry of the Codex Vercellensis*, ed. J. M. Kemble (2 vols., Ælfric Society, London, 1843–56).

*De abbatibus Abbendoniae* – Ed. Joseph Stevenson in *Chronicon monasterii de Abingdon* (see above), vol. 2, pp. 267–95.

*De inventione Sanctae Crucis* – *The Foundation of Waltham Abbey. The Tract 'De inventione Sanctae Crucis nostrae in Monte Acuto et de ductione ejusdem apud Waltham'*, ed. William Stubbs (Oxford and London, 1861).

*Dialogue of Salomon and Saturn* – *The Dialogue of Salomon and Saturn*, ed. John M. Kemble (Ælfric Society, London, 1848).

Eadmer *Historia Novorum* – *Eadmeri Historia Novorum in Anglia*, ed. Martin Rule (Rolls Series, London, 1884).

Eddius *Life of St Wilfrid* – *The Life of Bishop Wilfrid by Eddius Stephanus*, ed. Bertram Colgrave (Cambridge, 1927).

Felix *Life of St Guthlac* – *Felix's Life of Saint Guthlac*, ed. Bertram Colgrave (Cambridge, 1956).

*Finnsburgh Fragment* – See *Beowulf*

Florence of Worcester *Chronicon* – *Florentii Wigorniensis monachi Chronicon ex Chronicis*, ed. Benjamin Thorpe (2 vols., London, 1848–9).

*Gesta abbatum S. Albani* – *Gesta abbatum monasterii S. Albani*, ed. Henry T. Riley (3 vols., Rolls Series, London, 1867–9).

Goscelin *La Légende de Ste. Edith* – *La Légende de Ste. Édith en prose et verse par le moine Goscelin*, ed. André Wilmart in *Analecta Bollandiana*, vol. 56, pp. 4–101, 265–307 (Brussels, 1938).

Goscelin *Miracula S. Ivonis* – In *Chronicon abbatiae Ramesiensis*, ed. W. Dunn Macray (Rolls Series, London, 1886), pp. 59–75.

Guillaume de Poitiers *Histoire* – Guillaume de Poitiers, *Histoire de Guillaume le Conquérant*, ed. Raymonde Foreville (Paris, 1952).

*Historia Abbatum auctore anonymo* – *Historia Abbatum auctore Anonymo* in *Venerabilis Baedae Opera Historica*, ed. Carolus Plummer (Oxford, 1896), I, pp. 388–404.

*Historia Ramesiensis* – In *Chronicon abbatiae Ramesiensis*, ed. W. Dunn Macray (Rolls Series, London, 1886).

Knowles *Monastic Order* – Dom David Knowles *The Monastic Order in England* (Cambridge, 1950).

L-B – Otto Lehmann-Brockhaus *Lateinische Schriftquellen zur Kunst in England Wales und Schottland vom Jahre 901 bis zum Jahre 1307* (5 vols., Munich, 1955-60).

*Liber Eliensis* – Ed. E. O. Blake (Royal Historical Society, London, 1962).

*Liber monasterii de Hyde* – Ed. Edward Edwards (Rolls Series, London, 1866).

*Lib. Pont.* – *Liber Pontificalis*, ed. L. Duchesne (3 vols., Paris, 1884–1957).

*Liber Vitae*, ed. Birch – *Liber Vitae: Register and Martyrology of New Minster and Hyde Abbey*, ed. Walter de Gray Birch (London, 1892).

Matthew Paris *Chronica maiora* – *Chronica maiora Matthaei Parisiensis monachi S. Albani*, ed. H. R. Luard (7 vols., Rolls Series, London, 1872–83).

*Memorials of St. Edmund's Abbey* – Ed. Thomas Arnold (3 vols., Rolls Series, London, 1890–6).

*Mon. Germ. Hist. SS.* – *Monumenta Germaniae Historica, Scriptores in folio.*

Ordericus Vitalis *Historiae Ecclesiasticae Libri* – *Orderici Vitalis . . . Historiae Ecclesiasticae libri tredecim*, ed. Augustus le Prevost (5 vols., Paris, 1838–55).

Osbert De Clare *Vie de S. Édouard* – *La vie de S. Édouard le Confesseur par Osbert de Clare*, ed. Marc Bloch in *Analecta Bollandiana* tom. XLI, pp. 64–129.

*Pat. Lat.* – *Cursus Patrologiae accur. Migne, Series Latina*, vols. 1–217 (Paris, 1844–64).

*Reginaldi monachi Dunelmensis libellus* – *Reginaldi monachi Dunelmensis libellus de admirandis b. Cuthberti virtutibus*, ed. James Raine (Surtees Society, London, 1835).

*Registrum Roffense* – Ed. John Thorpe (London, 1769).

Robertson *Anglo-Saxon Charters* – *Anglo-Saxon Charters*, ed. A. J. Robertson (Cambridge, 1939).

Stubbs *Memorials* – *Memorials of Saint Dunstan*, ed. William Stubbs (Rolls Series, London, 1874).

*Symeonis monachi opera* – *Symeonis Dunelmensis monachi opera omnia*, ed. Thomas Arnold (2 vols., Rolls Series, London, 1882–5).

Talbot *Anglo-Saxon Missionaries* – *The Anglo-Saxon Missionaries in Germany*, ed. C. H. Talbot (London and New York, 1954).

Tangl *Briefe* – M. Tangl, *Die Briefe des Heiligen Bonifatius und Lullus* (Berlin, 1916), being volume 1 of *Monumenta Germaniae Historica: Epistolae selectae.*

*The Chronicle of Hugh Candidus* – Ed. W. T. Mellows (Oxford, 1949).

Thomas Rudborne *Historia Wintoniensis* – *Historia maior de fundatione et successione ecclesiae Wintoniensis* in H. Wharton, *Anglia Sacra*, Pars Prima (London, 1691), pp. 177–286.

Turgot *Vita S. Margaretae* – *Vita S. Margaretae reginae Scotiae, auctore . . . Turgoto monacho Dunelmensis* in *Symeonis Dunelmensis opera et collectanea*, vol. I, Appendix 3, pp. 234–54 (Surtees Society, vol. 51, Durham, 1868).

*V.C.H.* – *Victoria County History*

*Vita Ædwardi*, ed. Barlow – *Vita Ædwardi Regis qui apud Westmonasterium requiescit*, ed. Frank Barlow (London, 1962).

*Vita Wulfstani*, ed. Darlington – *The Vita Wulfstani of William of Malmesbury*, ed. Reginald R. Darlington (Royal Historical Society, vol. XL, London, 1928).

Whitelock *Wills* – *Anglo-Saxon Wills*, ed. Dorothy Whitelock (Cambridge, 1930).

Whitelock *The Will of Æthelgifu* – *The Will of Æthelgifu*, ed. Dorothy Whitelock, Neil Ker, Lord Rennel (Roxburghe Club, London, 1968).

William of Malmesbury *De antiquitate Glastoniensis* – *De antiquitate Glastoniensis ecclesiae* in *Pat. Lat.* CLXXIX, cols. 1683–1734.

William of Malmesbury *Gesta Pontificum* – *Willelmi Malmesbiriensis Monachi Gesta Pontificum Anglorum*, ed. N. E. S. A. Hamilton (Rolls Series, London, 1870).

William of Malmesbury *De Gestis Regum* – *Willelmi Malmesbiriensis Monachi De Gestis Regum Anglorum,* ed. William Stubbs (2 vols., Rolls Series, London, 1887).

Winterbottom *Three Lives* – *Three Lives of English Saints,* ed. Michael Winterbottom (Toronto, 1972).

# NOTES

## Chapter I *Art Survivals and Written Sources*

1 Bede *Hist. Eccles.*, ed. Plummer, p. 84; ed. Colgrave and Mynors, p. 140.
2 *Two Lives of St Cuthbert*, pp. 162–4.
3 Bede *Hist. Eccles.*, ed. Plummer, p. 116; ed. Colgrave and Mynors, p. 190.
4 See John Beckwith *Ivory Carvings in Early Medieval England* (London, 1972), p. 117 with bibliography.
5 This is the view of Dr R. I. Page who, in his own authoritative account of the Casket, says that 'it is likely that the story illustrated has been lost in the course of the years' (*An Introduction to English Runes* (London, 1973), p. 181).
6 See Frank Barlow *The English Church 1000–1066* (London, 1963) pp. 259–60 for the laws. For the denunciation of pagan practices under stress from the Danes, see Wulfstan's *Canons of Edgar*, ed. Roger Fowler (Oxford, 1972), p. 26, and *Homilies of Ælfric*, ed. John C. Pope (Oxford, 1968), vol. II, p. 513.
7 Felix's *Life of St Guthlac*, pp. 92–4, and editor's note, p. 183.
8 Now being definitively published for the British Museum by Rupert Bruce-Mitford: *The Sutton Hoo Ship-Burial*, vol. I (1975), vol. II (1978); in progress.
9 The Wilton cross; *ibid.*, I, p. 709.
10 Goscelin, speaking of Wilton: '. . . tot annis, tot tempestatibus, tot periculis incendii immota . . .' (*La Légende de Ste. Édith*, p. 87).
11 'Stabula ergo et officinas in curia circum circa, que cooperte erant arundine prius, novis tectis appositis, lateribus cooperiri iussit, procurante H[ugone] sacrista, ut sic omnis timor excluderetur et periculum ignis' (*Chronica Jocelini de Brakelonda de rebus gestis Samsonis abbatis monasterii S. Edmundi* ed. H. E. Butler (London, 1949), p. 96: L-B, 524).
12 *Anglo-Saxon Chronicle*, ed. Whitelock, p. 185.
13 *Ibid.*, pp. 187–8.
14 *Ibid.*, p. 190.
15 '. . . quicquid in auro, in argento, in diversis aliarum specierum ornamentis, in divinis ac saecularibus libris preciosius habebat, fere totum vorans lingua ignis absorbuit' (Eadmer *Vita B. Bregwini* in Henry Wharton *Anglia Sacra*, 2 vols. (London, 1691), II, p. 188).
16 '. . . Ornamenta quoque ecclesiae quamplurima et bona in cinerem redacta sunt' (*Chronica Gervasii*, I, p. 5: L-B, 801).
17 '. . . totum monasterium, praeter cameram . . . et praeter campanarium . . . consumpsit incendium . . . Reliquiarum confusio, thesauri, tam in auro et argento, quam in pannis, sericis, libris, et ceteris ecclesiae ornamentis, direpcio, eciam remotos, haec audientes, non inmerito posset ad lamenta

provocare' (*Historia de rebus gestis Glastoniensibus, auct. Adamo de Domerham* ed. Th. Hearne (Oxford, 1727), pp. 333–4: L-B, 1878).

18  In the words of his biographer and former pupil, Wulfstan the Cantor, '. . . tolli iussit ornamenta queque et argentea uasa perplurima de thesauris aecclesiae precepitque ea minutatim confringi et in pecunias redigi intimo cordis suspirio protestans se equanimiter ferre non posse muta metalla integra perdurare, hominem uero ad imaginem Dei creatum et precioso Christi sanguine redemptum mendicitate et inedia perire' (Winterbottom *Three Lives*, p. 50).

19  St Oswald not only gave the food from his table to the poor in the streets outside but had the silver dish containing it broken up and distributed amongst them (Bede *Hist. Eccles.*, ed. Plummer, p. 138; ed. Colgrave and Mynors, p. 230).

20  'Iste quoque [Leofricus], invalescente fame miserabili in omnibus partibus Angliae, thesaurum ad fabricam ecclesiae diu ante reservatum . . . et vasis aureis et argenteis, tam suae mensae quam ecclesiae deputatis, in pauperum expendit sustentationem . . . Erat enim dictus abbas piissimus, et super afflictos pia gestans viscera; et quia sponte sua vasa argentea, suae, videlicet, mensae deputata, in usus pauperum erogaverat, concessa fuerunt eidem, ad eosdem usus, etiam vasa ecclesiae consecrata postulanti. Dicebat enim fideles Christi, maxime pauperes, Dei esse ecclesiam et templum, et ipsum specialiter esse aedificandum et conservandum' (*Gesta abbatum S. Albani,* I, p. 29: L-B, 3794).

21  '. . . de consensu et pari voluntate fratrum suorum thecam Sancti Vincentii penitus eruderavit, et in usus pauperum largiter infudit' (*Chronicon Abingdon*, II, p. 214: L-B, 57).

22  'Feretrum quoque Beati Martyris Albani, quod ipse [Gaufridus, abbas 1119–46] operuerat auro et argento, et gemmis pretiosis, ut praedictum est, discooperuit, ut eisdem spoliis pretiosis miserias pauperum alleviaret, et thesauros ecclesiae, sumens exemplum a beato Levita, Laurentio, in usus pauperum distribuendo erogaret' (*Gesta abbatum S. Albani*, I, p. 96: L-B, 3841). The shrine was Romanesque though some of the ornaments for it had come down from Anglo-Saxon times (*ibid.*, p. 29).

23  'Confluebant enim undecunque pauperes et mendici, eo quod alibi nullum vel modicum invenirent solatium. Erat enim fames in terra. Hac igitur occasione distracta sunt et distributa egenis ornamenta quaedam ejusdem Cantuariensis ecclesiae, quae tempore pacis reservari solent ad gloriam, in necessitate vero ad utilitatem' (*Chronica Gervasii*, p. 143).

24  'crucem hujus ecclesiae pretiosiorem, et culmen feretri . . . instante werra et urgente fame . . . monachi . . . auro et argento et lapidibus spoliaverunt' (*Chronicon Evesham*, p. 99: L-B, 1627).

25  'Sed de vii istorum [feretrorum] fratres ecclesie postea tulerunt aurum et argentum, ingruente famis tempore, et hactenus non sunt reformata' (*Liber Eliensis*, p. 290).

26 'Sicuti factum est temporibus ATHELREDI, regis Anglorum, vastante et depopulante hanc patriam pagano rege Danorum, SWEIN nomine, cum maximum et fere importabile tributum tota Anglia reddere cogeretur. Ob hujus itaque tam gravis tributi exactionem, omnia fere ornamenta hujus ecclesie distracta sunt, tabule altaris, argento et auro parate, spoliate sunt textus exornati, calices confracti, cruces conflate . . .' (*Chartularium Wigorniensis Ecclesiae* of Hemming ed. T. Hearne, 2 vols. (Oxford, 1723), vol. I, pp. 248–9).

27 Bede *Hist. Eccles.*, ed. Plummer, p. 228; ed. Colgrave and Mynors, p. 368.

28 *Sermo ad Anglos*, ed. Dorothy Whitelock (who kindly pointed the passage out to me), p. 49.

29 Quoted *ibid.*, p. 49, note 31.

30 Quoted *idem*.

31 To Æthelred, King of Northumbria (letter 16, pp. 42–3 of *Mon. Germ. Hist. Epist. Karol. Aevi*, II).

32 *King Alfred's West-Saxon Version of Gregory's Pastoral Care* ed. Henry Sweet (London, 1871) (E.E.T.S. 45), p. 4.

33 *Anglo-Saxon Chronicle*, ed. Whitelock, p. 152.

34 *Ibid.*, p. 158.

35 *Gesta Abbatum S. Albani*, I, p. 12: L-B, 3783.

36 Birch *Cartularium*, No. 634. The translation is from *English Historical Documents*, ed. Dorothy Whitelock (London, 1955 and 1979) No. 58.

37 Florence of Worcester *Chronicon*, I, p. 213.

38 'Et . . . insani supradicti [gens Scotorum] . . . barbara feritate flammis aedificia sacrata [Augustaldensi] destruentes, res ecclesiasticas repertas rapientes . . . ad hoc tandem perfidiae signum proruperunt ut reliquias sanctorum thecis reconditas despecte in ignem dejicerent, laminas auri vel argenti ac gemmas detraherent, caput quoque imaginis sancti Andreae figuram solum conculcandum inde recedens remearet' (*Chronicon de Lanercost*, ed. J. Stevenson (Edinburgh, 1839), p. 175: L-B, 2119). This was in 1296. In 1297, the Scots returned and, having been told that the church treasure had already been taken to Scotland, they seized the altar-vessels (*Chronicon Walteri de Hemingburgh de gestis regum Angliae*, ed. H. C. Hamilton, vol. II (London, 1849), pp. 143–4: L-B, 2120).

39 *Anglo-Saxon Chronicle*, ed. Whitelock, p. 178.

40 'In eius tempore uenerunt latrunculi . . . aliqui de Alemannia, aliqui de Francia, alii de Flandria, et intrauerunt per scalas in ecclesiam per fenestram que erat super altare Philippi et Iacobi et furati sunt magnam crucem auream de XX marcis auri cum gemmis que erat super altare, et duos magnos calices cum patena, et candelabra Elfurici archiepiscopi [Eboracensis] omnia aurea . . . Et quamuis postea capti essent, nichil tamen de hiis que acceperant ad proficuum ecclesie peruenerunt, set omnia regi data sunt' (*The Chronicle of Hugh Candidus*, p. 87: L-B, 3463).

41 *Historia monasterii S. Augustini Cantuariensis auct. Thomas de Elmham* ed. Charles Hardwick (London, 1858), p. 101.

42  Quoted C. Eveleigh Woodruff and William Danks *Memorials of the Cathedral and Priory of Christ in Canterbury* (London, 1912), p. 82.

43  John Bale, Bishop of Ossory 1553–63. Quoted in R. W. Dixon *History of the Church in England* (Oxford, 1895–1902), vol. 2, p. 206.

44  Talbot *Anglo-Saxon Missionaries*, p. 57.

45  *Ibid.*, p. 58.

46  E.g. David M. Wilson *Anglo-Saxon Ornamental Metalwork 700–1100* (British Museum, London, 1964), Nos. 16, 57, 145, 146.

47  E.g. Wilson, 2, 14, 83.

48  E.g. Wilson, 64.

49  E.g. Wilson, 82.

50  E.g. Wilson, Nos. 41, 65: David A. Hinton *A Catalogue of the Anglo-Saxon Ornamental Metalwork in the Department of Antiquities Ashmolean Museum* (Oxford, 1974), No. 1.

51  Hinton, 30.

52  It remained in St Cuthbert's coffin even after the latter had been ransacked at the Reformation by persons looking for gold and silver objects.

53  See below, p. 267, note 201.

54  P. Hunter Blair *An Introduction to Anglo-Saxon England* (Cambridge, 1956), p. 172.

55  Robertson *Anglo-Saxon Charters*, p. 152 (editor's translation).

56  *Theophilus De Diversis Artibus* ed. C. R. Dodwell (London, 1961).

57  Otto Lehmann-Brockhaus *Lateinische Schriftquellen zur Kunst in England, Wales und Schottland vom Jahre 901 bis zum Jahre 1307*, 5 vols. (Munich, 1955–60).

58  *Henry V*, Prologue, l. 23.

59  He says that the churches of St Stephen and of the Holy Trinity at Caen 'usque hodie gaudent spoliis sic adquisitis . . .' (*De Inventione Sanctae Crucis*, p. 32).

60  As Malmesbury himself tells us (*De Gestis Regum*, I, p. 144).

61  See Darlington's edition, p. ix.

62  '. . . ut ex antiquorum librorum accepimus attestatione' (*Chronicon Abingdon*, I, p. 344).

63  'Sicut enim scripto invenimus autentico, manibus magistri ipsius Adelardi qui tunc praeerat ecclesiae exarato . . .'(*De inventione Sanctae Crucis* ed. Stubbs, p. 32). Stubbs (p. xxvii) comments on the reliability of the twelfth-century writer in terms of the verbal evidence he uses.

64  See the two articles by R. R. Darlington in *Eng. Hist. Review*, XLVIII (1933), pp. 1–22 and 177–98, and also Knowles *Monastic Order*, Appendix VIII.

65  See Professor Whitelock's Foreword to Dr Blake's edition of the *Liber Eliensis*, pp. x, xi.

66  Dr Talbot says that 'Many of his writings, which merely deck out in "elegant" Latin what had been written earlier in Anglo-Saxon, repeat the

stories and legends of his predecessors, but some of them appear to have been based on first hand knowledge, or at least, to have been taken down from eye-witnesses . . .' (*The Life of Saint Wulsin of Sherborne by Goscelin* in *Revue Bénédictine*, LXIX, 1959, p. 68). Professor Barlow remarks that 'He was usually given old saints' lives or historical accounts to refashion in style, but not in substance. He seems to have treated his material with respect, and to have understood it well' (*Vita Ædwardi*, p. 105).

67 See below, p. 183

68 Bede gives a full and careful account of his sources in the preface to his *Historia Ecclesiastica*. With regard to the events in the province of Northumbria, he says that he depended on the verbal testimony of countless witnesses – '. . . non uno quolibet auctore sed fideli innumerorum testium, qui haec scire uel meminisse poterant, adsertione cognoui . . .' (ed. Plummer, p. 7; ed. Colgrave and Mynors, p. 6).

69 Goscelin, for example, declared that the chronicler derived his knowledge not only from literary accounts but from 'the memory of old men, or tradition . . . repeated from generation to generation' in his *Vita S. Augustini* (*Pat. Lat.* LXXX, 89–90).

70 'The appeal to witnesses is in accordance with the Antonian tradition, followed also by Bede' (Bertram Colgrave on p. 175 of his edition of Felix's *Life of St Guthlac*).

71 C. E. Wright *The Cultivation of Saga in England* (Edinburgh and London, 1939), pp. 58–9.

72 Quoted *ibid.*, p. 39.

73 Michael Dolley *Anglo-Saxon Pennies* (London, 1964), p. 12.

74 *Historia Novorum*, p. 108.

75 Malmesbury *Gesta Pontificum*, p. 408.

76 Goscelin *Historia translationis S. Augustini, Pat. Lat.* CLV, 31. The anecdote concerns abbot Ælfstan of St Augustine's, Canterbury, and his meeting with the emperor, Henry II, in Rome.

77 *The earliest life of Gregory the Great by an anonymous Monk of Whitby* (writing between 704 and 714) ed. Bertram Colgrave (Lawrence, 1968), p. 76 (editor's translation).

78 'Haec tota [theca] exterius praemirabili caelatura desculpitur, quae adeo est minuti ac subtilissimi operis, ut plus stupori quam scientiae aut possibilitati sculptoris convenire credatur' (*Reginaldi libellus*, p. 90: L-B, 1392).

79 Leofric of Peterborough and Ælfwig of the New Minster were with Harold at Hastings though it is uncertain if Ælfwig was a combatant.

80 Frank Barlow *The English Church 1000–1066* (London, 1963), p. 87.

81 Queen Emma, for example, made a number of gifts to Ely. See below, pp. 141 and 145.

82 See below, p. 182, for the objects removed by Queen Edith from Abingdon. For a gift from Peterborough to Queen Emma, see below, p. 22.

83 Cap. LVII.

84 'And riht is thæt preosta gehwylc toeacan lare leornige handcræft georne' (Canon II in Junius 121 version of *Wulfstan's Canons of Edgar* ed. Roger Fowler, E.E.T.S. 266, Oxford, 1972, p. 5). This is enlarged on in one of his homilies (ed. Bethurum, p. 193) where he enjoins canons to practise eagerly monastic crafts both for their livelihood and for their soul – 'Ne beo æfre ænig canonic life thæt sundercræfta sumne ne cunne, ac began georne mynsterlice crætas and geearnian mid tham thæs the hig big beon and eac æt Gode sylfum ece mede'. I owe the latter reference to Professor Whitelock who also draws my attention to the fact that it derives from Amalarius. It is significant that the reference here to monastic crafts is Wulfstan's own.

85 *Theophilus De Diversis Artibus*, ed. C. R. Dodwell (London, 1961), p. xi.

86 '. . . thone drencehorn the ic ær æt tham hirede gebohte on ealdan mynstre' (Whitelock *Wills* p. 56).

87 See, for example, David M. Wilson 'A late Anglo-Saxon strap end', Appendix to Seventh Interim Report on Excavations at Winchester 1968 by Martin Biddle (*Antiquaries Journal*, vol. XLIX, part II, 1969, pp. 326–8).

88 The account is given in William of Malmesbury's *Vita Wulfstani* (ed. Darlington), pp. 5, 15 and 16. 'Is [Ervenius] libros scriptos, sacrametarium [sic] et psalterium, quorum principales literas auro effigiauerat, puero Wlstano delegandos curauit. Ille preciosorum apicum captus miraculo; dum pulcritudinem intentis oculis rimatur; et scientiam literarum internis haurit medullis. Uerum doctor . . . sacramentarium regi tunc temporis Cnutoni, psalterium Emme regine contribuit. Perculit puerilem animum facti dispendium; et ex imo pectore alta traxit suspiria. Meror inuitauit sompnum; et ecce consopito assistens uir uultus angelici tristiciam propulsat; librorum reformationem promittit. Nec minus pollicito set multo post euenit . . . rex Edwardus Aldredum episcopum Coloniam ad seniorem imperatorem Henricum direxit; quedam negotia quorum cognitionem causa non flagitat compositurum . . . Ei seu pro sui reuerentia, seu quia tanti regis legatus esset, multi multa; quidam sacramentarium et psalterium de quibus supra dixi, dedit in exenium. Ambos enim codices ut sue memorie apud illas gentes locaret graciam; Cnuto quondam miserat Coloniam. Aldredus ergo prophetie quondam Wlstano dicte ignarus; patriam cum renauigasset; libros pro merito uite illi soli competere, arbitratus restituit.'

89 The story is found in Ordericus Vitalis *Historiae Ecclesiasticae Libri*, vol. II, pp. 41–2. 'Tunc etiam magnum psalterium variis picturis decoratum dono matris suae Uticensibus contulit; quod usque hodie monachorum concio psalmodiis intenta frequenter ad laudem Dei revolvit. Hoc volumen Emma conjux Edelredi regis Anglorum Rodberto Rotomagensium archiepiscopo fratri suo praesentaverat, et Willermus ejusdem praesulis filius de camera patris sui familiariter sustulerat, dilectaeque suae conjugi Hadvisae omnimodis placere volens detulerat.'

90 'Et quotienscunque venit Rofam, portavit secum aliquid ornamentum de ornamentis Gode comitisse que apud Lamhethe invenit, viz. feretram partim de auro partim de argento, textus ewangeliorum argento et lapidibus preciosis ornatos, scampna ferrea plicancia et argentata, et pallia, sc. quatuor, et baculos cantoriales, et cruces argenteas, et candelabra de cupro deaurata' (*Registrum Roffense*, p. 119: L-B, 3760).

91 'Eadem quoque mulier [Turgunda] dedit filacterium unum habens pretium duodecim mancarum auri, et album cum casula et stola, et calicem unum cum una cortina' (*Historia Ramesiensis*, p. 199: L-B, 3589).

92 'Quaedam matrona, Lefgiva nomine, dedit . . . unam crucem optimam' (*Historia Ramesiensis*, p. 199: L-B, 3590).

93 'Ic geann Ælfsige bisceope thære gyldenan rode . . .' (Whitelock *Wills*, p. 58).

94 '. . . and ic yan into Xristes cheriche to Xristes weuede ane litlene Geldene Rode . . .' (*ibid.*, p. 84).

95 See below, p. 67.

96 'Istud est Testamentum Edredi Regis, quod est persolvendum. Imprimis ipse legat loco in quo sibi placet, post obitum suum, requiescere, duas cruces aureas cum imaginibus aureis; et duos enses, quorum capituli sunt aurei' (*Liber monasterii de Hyda*, p. 158: L-B, 5952).

97 '. . . thæt is thonne thæt ic geann thæder into thære halgan stowe anes beages is on syxtigum mancussum goldes. And anre blede is on thriddan healfon punde. And twegea gyldenra roda. And anes mæssereafes mid eallum tham the thærto gebyreth . . .' (Whitelock *Wills*, p. 62).

98 'Scheldwara . . . dedit calicem unum aureum . . . et unam miscam auream gemmis pretiosis ornatam . . .' (*Historia Ramesiensis*, p. 199: L-B, 3590).

99 'Dedit . . . casulam unam, et albam . . . et pulvinar unum de palleo, duas quoque pelves argenteas, duas cortinas . . . et sellam suam cum omni equestri apparatu . . .' (*Historia Ramesiensis*, vol. 2, pp. 84–5: L-B, 3564).

100 See below, p. 119.

101 See below, chapter II, note 6 and p. 25.

102 '. . . retentis tantummodo quibusdam gemmis pretiosis . . . et quibusdam nobilibus lapidibus insculptis, quos 'camaeos' vulgariter appellamus. Quorum magna pars ad feretrum decorandum, cum fabricaretur, est reservata' (*Gesta abbatum S. Albani*, I, p. 29: L-B, 3794).

## Chapter II *Anglo-Saxon Taste*

1 Talbot *Anglo-Saxon Missionaries*, p. 96: Tangl *Briefe*, pp. 74–5.

2 *Ibid.*, pp. 91–2: Tangl *Briefe*, p. 60.

3 Ed. A. M. Harmon, vol. I (London, 1913), pp. 181–3.

4 Lines 91–6.

5 'Eadem quoque mulier [Turgunda] dedit filacterium unum habens pretium duodecim mancarum auri . . .' (*Historia Ramesiensis*, p. 199: L-B, 3589).

6 '. . . hunc ergo gemmarum circulum collo imaginis Sanctae Mariae appendi jussit. Sed quam pretiosarum putas gemmarum? Profecto a gnaris centum marcis argenti estimantur' (William of Malmesbury *Gesta Pontificum*, p. 311: L-B, 1131).

7 '. . . altare pretii 20 marcarum . . .' (William of Malmesbury *De antiquitate Glastoniensis*, col. 1723: L-B, 1859).

8 '. . . thecam de argento et auro . . . fieri fecit . . . In qua etiam apices sculptae erant, quorum forma haec est:

> Rex Cnut hanc thecam, necnon Aelfgiva regina,
> Cudere jusserunt; bis centum necne decemque
> Coctos igne chrison mancosos atque viginti
> Necne duas libras argenti pondere magno.'

(*Chronicon Abingdon* I, p. 433: L-B, 20).

9 '. . . rex Osuiu . . . promisit se ei innumera et maiora quam credi potest ornamenta regia uel donaria in pretium pacis largiturum, dummodo ille domum rediret et prouincias regni eius usque ad internicionem uastare desineret' (ed. Plummer, p. 177; ed. Colgrave and Mynors, pp. 288–90).

10 'And hio becwith him hyre goldfagan treowenan cuppan thæt he ice his beah mid tham golde oththe hi mon æt him gehweorfe mid. XVI. mancussum reades goldes . . .' (Whitelock *Wills*, p. 12).

11 'Hoc opus adeo multo pretio parauerant manus uirgineae cum mistica fide, ut tam placeret sanctitate quam ditioso decore' (Goscelin *La Légende de Ste. Édith*, p. 79: L-B, 6448).

12 I, 726.

13 I, 640; III, 355.

14 X, 243; XI, 488–90 and 744; XII, 87 and 430, etc.

15 XI, 303–4; XI, 774.

16 IX, 163.

17 X, 134.

18 V, 132–3.

19 XI, 72.

20 See below, pp. 36–7, 179.

21 *Met.* V, 51.

22 See below, pp. 36–7 179.

23 '. . . incultae solitudinis volucres et vagabundi coenosae paludis pisces ad vocem ipsius veluti ad pastorem ocius natantes volantesque subvenirent; de manu enim illius victum prout uniuscuiusque natura indigebat, vesci solebant' (Felix *Life of St Guthlac*, p. 120; editor's translation).

24 Felix's *Life of St Guthlac*, p. 88 (editor's translation).

25 Derek Pearsall and Elizabeth Salter *Landscapes and Seasons of the Medieval World* (London, 1973), p. 42.

26 'Ic eom fægerre    frætwum goldes . . .' (l. 46 of Riddle on Nature in *A.S.P.R.*, III, p. 201).

27 *Christ*, l. 1150 (*A.S.P.R.*, III, p. 35). See also *ibid.*, l. 692 (*A.S.P.R.*, III, p. 22).

28 *The Order of The World*, l. 68 (*A.S.P.R.*, III, p. 165).

29 As in *The Phoenix*, ll. 91, 117, 209, 289 (*A.S.P.R.*, III, pp. 96, 97, 100, 102).

30 *Guthlac*, l. 1302 (*A.S.P.R.*, III, p. 86); *Andreas*, l. 50 (*A.S.P.R.*, II, p. 4).

31 'capillo . . . flavo, filis aureis pulchre intorto' (William of Malmesbury's description of Athelstan, drawing on a tenth-century poem, in his *De Gestis Regum*, I, p. 148).

32 *The Dream of the Rood*, II, ll. 4–8, 14–18 (*A.S.P.R.*, II, p. 61).

33 *The Phoenix*, lines 299–304 (*A.S.P.R.*, III, p. 102): Israel Gollancz's translation.

34 'Thonne wundria weras ofer eorthan / wlite ond wæstma' (ll. 331–2, *ibid.*, p. 103).

35 '. . . wlitig ond wynsum, wuldre gemearcad . . .' (l. 318, *idem*).

36 '. . . glisnath glæshluttur gimmum gelicust' (*A.S.P.R.*, VI, p. 28).

37 'Cum tenebris nostris illuxit splendida gemma' (William of Malmesbury, drawing on a tenth-century poem about King Athelstan, in *De Gestis Regum*, I, p. 145).

38 King Edgar 'cujus pulchritudo aurifluo metallo comparari poterat' (*Vita Oswaldi auct. anonymo* in James Raine *The historians of the church of York*, vol. I (London, 1879), p. 436).

39 'Hie asodene beod, / asundrod fram synnum, swa smæte gold . . .' (*Elene*, ll. 1308–9, *A.S.P.R.*, II, p. 102).

40 'He sealde his thone readan gim, thæt wæs his thæt halige blod' (*Blickling Homilies*, pp. 9–11).

41 'Gylden is se godes cwide, gimmum astæned . . .' (*Dialogue of Solomon and Saturn*, l. 63, *A.S.P.R.*, VI, p. 33).

42 Lines 32–7 of *The Ruin* (*A.S.P.R.*, III, p. 228), W. S. Mackie's translation.

43 Here, a description of Sodom (*A.S.P.R.*, I, p. 72, ll. 2405–6).

44 '. . . sed etiam auro argentoque domus tota resplenderet. Aut enim aurea vel argentea, aut deaurata sive deargentata fuerunt vasa . . .' (Turgot *Vita S. Margaretae*, p. 242: L-B, 6010).

45 'Wintoniae maxime munificentiae suae magnificentiam ostendit, ubi tanta intulit ut moles metallorum terreat advenarum animos, splendor gemmarum reverberet intuentium oculos' (William of Malmesbury *De Gestis Regum*, I, p. 220: L-B, 4699).

46 Lines 1020–1.

47 '. . . uexillum eius super tumbam auro et purpura conpositum adposuerunt . . .' (Bede, *Hist. Eccles.* III, 11, ed. Plummer, p. 148; ed. Colgrave and Mynors, p. 246).

48 'Vexillum illud . . . quod erat in hominis pugnantis figura, auro et lapidibus arte sumptuosa intextum' (William of Malmesbury *De Gestis Regum*, II, p. 302: L-B, 6627). See also Guillaume de Poitiers *Histoire*, p. 224: 'Memorabile quoque vexillum Heraldi, hominis armati imaginem intextam habens ex auro purissimo.'

49 Line 715.

50 'Venusto enim admodum opere a fundamentis constructam [ecclesiam],

laminis aereis, auro undique superducto, capita columpnarum et bases flexurasque arcuum ornare fecit [Haroldus] mira distinctione artificis . . .' (*De inventione Sanctae Crucis Walthamensis*, p. 17). There follows an account of the gold altar. Though the church fabric itself is purportedly being described, I adopt here the suggestion of Stubbs (note 67) that originally the ciborium was intended. I venture, however, to disagree with this great historian's interpretation of the decoration of the capitals for, in the context, I think that the 'mira distinctione artificis' must represent gold-work.

51  Lines 927, 1800.

52  '. . . qui etiam, si uita comes fieret, orientalem porticum eiusdem Uuintoniensis aecclesiae deauratis imbricibus adornare disposuit' (Wulf-stan's *Life of St Æthelwold* in Winterbottom *Three Lives*, p. 40).

53  Lines 994–6.

54  See below, p. 136–7.

55  'Godwinus autem regi pro sua amicitia dedit trierem fabrefactam, caput deauratum habentem, armamentis optimis instructam, decoris armis electisque LXXX militibus decoratam quorum unusquisque habebat duas in suis brachiis aureas armillas, sedecim uncias pendentes, loricam trilicem indutam, in capite cassidem ex parte deauratam, gladium deauratis capulis renibus accinctum, Danicam securim auro argentoque redimitam in sinistro humero pendentem, in manu sinistra clypeum, cujus umbo clavique erant deaurati, in dextra lanceam, quae lingua Anglorum ategar appellatur' (Florence of Worcester *Chronicon*, I, p. 195: L-B, 6653).

56  Apoc. XXI, 18 ff.

57  *The Phoenix*, ll. 602–3 (*A.S.P.R.*, III, p. 111).

58  Bede *Hist. Eccles.*, IV, 17, ed. Plummer, p. 246; ed. Colgrave and Mynors, p. 396.

59  *Aelfric's Lives of Saints*, ed. Walter W. Skeat (London, 1881) (E.E.T.S. 76), p. 173 (editor's translation).

60  '. . . ecce sanctus Bartholomaeus cum immenso caelestis lucis splendore . . . ab aethereis sedibus radiantis Olimpi . . . aureo fulgore amictus . . .' (Felix's *Life of St Guthlac*, p. 106).

61  '. . . radianti lumine uibrans, / uestibus aurigeris in toto corpore plena . . .' (ll. 360–1, ed. Campbell).

62  *Ibid.*, lines 767–8, 777–8, 723–5.

63  See below, chap. VII, *passim*.

64  *De Templo Salomonis* xix, *Pat. Lat.*, XCI, 790–1.

65  See C. R. Dodwell *Painting in Europe 800–1200* (London, 1971), pp. 21 ff.

66  *Two Lives of St Cuthbert*, p. 294.

67  Eddius *Life*, pp. 4, 6, 14, 18, 32, 34, 42, 46, 48, 76, 122.

68  *Ibid.*, p. 28.

69  *English Coronation Records*, ed. Leopold G. Wickham (London, 1901), p. 24.

70 In the Canterbury *Hexateuch* (British Library, Cotton MS. Claudius B IV), for example, the Israelites are presented as Anglo-Saxons. See below, pp. 70, 72, 141, 175.

71 In *Genesis* A, for example, the patriarchs are conceived of as Anglo-Saxon princes, attracting loyalty and dispensing treasure.

72 See below, chapter VI, note 87. This must have been an Anglo-Saxon vestment.

73 Exod. XXXIX, 23.

74 This seems the only explanation of the gold-plated hoop with small bells which St Æthelwold gave to Abingdon, and which was to be played to rouse the people to greater devotion: 'Praeterea fecit vir venerabilis Athelwoldus quandam rotam tintinnabulis plenam, quam auream nuncupant, propter laminas ipsius deauratas, quam in festivis diebus ad majoris excitationem devotionis reducendo volvi constituit' (*Chronicon Abingdon*, I, p. 345: L-B, 14).

75 Unfortunately nothing is known about Jewish settlements in England before the Conquest.

76 See David A. Hinton *A Catalogue of the Anglo-Saxon Ornamental Metalwork 700–1100 in the Department of Antiquities Ashmolean Museum* (Oxford, 1974), p. 46.

77 'Attendens etiam diligenter beatus Atheluuoldus illud propheticum, quo dicitur, 'Domine, dilexi decorem domus tuae', (ut de domo exteriori ad praesens intelligatur) quoad decentius potuit domum istam ornamentis ditavit pretiosissimis' (*Chronicon Abingdon*, I, p. 344: L-B, 14).

78 'Dilexit autem gloriam ac decorem domus Dei, quam diversis ornamentis insignire appetebat. Fecit namque . . .' (*Liber Eliensis*, II, 6, p. 79).

79 III Kings VI.

80 'Sicut enim Moyses tabernaculum seculare manu factum ad exemplar in monte monstratum a Deo . . . distinctis variis coloribus aedificavit, ita vero beatissimus Wilfrithus episcopus thalamum veri sponsi et sponsae . . . auro et argento purpuraque varia mirifice decoravit' (Eddius *Life*, p. 34).

81 'Hic Salomoniaci misteria candida templi / Prerutilant; . . . Hic Salomone magis, magis hic templo Salomonis / Uirgo sacrat' (Goscelin *La Légende de Ste. Édith*, pp. 89–90: L-B, 4616).

82     'Quid Tirias gazas numerosa classe relatas
        Trans maria?
    Aut Libani nemus aut abiegna thimaque ligna
        Que dat Ophir,
    Cantorum citharis, tectis gradibusque sacratis
        Grande decus? . . .
    Omnis odorifera uestitur regia cedro
        Gratifice . . .
    Aurea iuge decus putrescere nescia cedrus
        Tecta tegit'
(*idem*). Compare 3 Kings (I Regum) V, 10, VI. 9, 15, 18, 34.

83          'Prestant fructifere uisu mirabile palme
                    Parietibus.
            Et cherubin sculpta speciosaque stant anaglyfa
                    Arce domus'
     (*ibid*. p. 89). Compare 3 Kings (I Regum) VI, 29, 32.

84          'Trinaque cedrinis surgunt cenacula tectis
                    Cum cocleis'.
     (*idem*). See 3 Kings (I Regum) VI, 8.

85          'Non sat erat saxis muros candere politis
                    Mirifice'
     (*idem*). See 3 Kings (I Regum) VI, 36.

86          'Sed tanta quis opes et opus Salomonis et artes
                    Enumeret?
            Tot facies rerum, miracla tot ingeniorum
                    Auget honor.
            Nil erat in templo quod non splendesceret auro
                    Lucifero.
            Aurea tota domus micat, aurea multa supellex
                    Et uaria'
     (*idem*). See I Regum VI, 22: 'Nihilque erat in templo quod non auro
     tegeretur: sed et totum altare oraculi texit auro'.

87 '. . . inter sacerdotes Wiltonie qui precedebant arcam federis Domini,
     ministri dominici tabernaculi . . .' (*ibid*., p. 50: L-B, 4619).
88 'Pontificalia nempe Christi indumenta, ut soror Aaron et sacrorum Dei
     germana, tota arte deflorabat et honorificentia' (*ibid*., p. 69: L-B, 5158).
89 Exod. XXXIX, 3, 8.
90 'Hic purpura, punico, murice et Sidoniis conchiliis imbuta, coccusque bis
     tinctus auro intexitur' (Goscelin *op. cit.*, p. 69: L-B, 5158).
91 '. . . crisolitus, topazius, onix et berillus lapidumque genera preciosa auro
     innectuntur . . .' (*idem*). See Exod. XXXIX, 10–13.
92 'of tham leoma stod, / thæt he thone grundwong  ongitan meahte, /
     wræte giondwlitan' (ll. 2769–71: *A.S.P.R.*, IV, p. 85).
93 '. . . alia ex auro uariato lumine uibrant' (l. 778, ed. Campbell).
94 The *De Virginitate* from *Aldhelmi Opera*, ed. R. Ehwald, p. 237. I take the
     translation from Michael Lapidge and Michael Herren *Aldhelm: The Prose
     Works* (Cambridge, 1979), p. 66.
95 Nigel F. Barley 'Old English colour classification' (in *Anglo-Saxon
     England*, ed. P. Clemoes, III (Cambridge, 1974), pp. 21–5).
96 He refers to the 'polito lapide' at Ripon, and the 'mire politis lapidibus' at
     Hexham (ed. Colgrave, pp. 36 and 46).
97 '. . . et lilia flagrant . . .' (l. 702, ed. Campbell).
98 '. . . hire rotostan cyrtel . . .' (ed. Whitelock, p. 13).
99 Lines 305–8 (*A.S.P.R.*, III, p. 102); R. K. Gordon's translation.

100        'ut celum rutilat stellis fulgentibus omne
           sic tremulas uibrant subter testudine templi
           ordinaribus uariis funalia pendula flammas'
       (ll. 625–8, *De Abbatibus*, ed. Campbell).

101    Barley '*Old English colour classification* . . .', p. 24.

102    '. . . et parietes erexit, totos equinis coriis obduxit . . .' (Goscelin *La Légende de Ste. Édith*, p. 87: L-B, 4615).

103    He gave three. See Robertson *Anglo-Saxon Charters*, p. 226. The Pseudo-Ingulfian account for Croyland is, of course, highly dubious as a historical source and, for this reason, has been totally ignored in this book even though I suspect that one or two of the references to art (e.g. the use of Harold Harefoot's coronation cloak as a cope) represent fragments of truth in an otherwise uncertain narrative. The statement made there that bear-skins were still used at Croyland in front of various altars may, however, indicate how they were used at Exeter – '. . . ursinas pelles, quarum coram diversis altaribus quaedam usque ad nostra tempora perdurarunt' (*Historia Croylandis auct. Ingulfo abbate* in *Rerum Anglicarum Scriptorum Veterum*, I, ed. William Fulman and Thomas Gale (Oxford, 1684), p. 61).

104    See below, pp. 145–9.

105    Glastonbury, for example, had a reliquary of gold and ivory (see below, p. 200) and an altar-frontal of gold, silver and ivory (William of Malmesbury *De antiquitate Glastoniensis*, col. 1719). Chester-le-Street had a cross, or Crucifix, worked in gold and ivory (Birch *Cartularium*, No. 685), and ivory carvings were used on book-covers (see below, p. 202). A number of very fine Anglo-Saxon ivory carvings of course survive – see John Beckwith *Ivory Carvings in Early Medieval England* (London, 1972).

106    *Vita S. Augustini* (*Pat. Lat.*, LVIII), col. 52.

107    '. . . gignit et lapidem gagatem plurimum optimumque; est autem nigrogemmeus . . .' (*Hist. Eccles.* I, 1, ed. Plummer, p. 10; ed. Colgrave and Mynors, p. 16).

108    See below, p. 208.

109    See below, pp. 217–18.

110    William of Malmesbury *Gesta Pontificum*, p. 373.

111    'Petras vero nigras, quas vestra flagitabat reverentia vobis diregi, veniat missus, qui considerat, quales animus vester desideret. Et ubicumque inventi fuerint, dari et in vehendo adiuvari libenter mandabimus' (*Mon. Germ. Hist. Epistolae IV, Karol. Aevi*, vol. II, ed. Duemmler, p. 145).

112    When discovered, it is described as being as 'inestimabilis imago decoris crucifixi Salvatoris ex atro silice', and later it is remarked that 'se clavis nullo modo permisit infigi', though in the interim there is a story of a sharp point bringing forth blood (*De inventione Sanctae Crucis*, ed. Stubbs, pp. 5 and 12).

113    '. . . in quo et lapidem infigi praecepit, qui furua nocte obductis luminaribus, radios emittit, ut circumstantibus possit lumen subclarum ad notitiam discernendarum rerum praebere' (*ibid.*, p. 12).

114 'Feretrum etiam sancti Egwini ex argento, auro, et lapidibus pretiosis composuit, in quo erant tres lapides magnam partem ecclesiae de nocte illuminantes . . .' (*Chronicon Evesham*, p. 86: L-B, 1610).

115 '. . . crucem praemirifice unionibus et margaritis expolientibus radi:.:am . . .' (*Reginaldi libellus*, p. 218: L-B, 1367).

116 See below, pp. 45, 57, 181, 185.

117 *Ibid.*

118 'sunt et musculae, quibus inclusam saepe margaritam omnis quidem coloris optimam inueniunt, id est et rubicundi, et purpurei, et hyacinthini et prasini, sed maxime candidi' (*Hist. Eccles.* I, 1, ed. Plummer, p. 10; ed. Colgrave and Mynors, p. 14).

119 See below, pp. 145 ff.

120 17. 'nec alius feminis quam viris habitus, nisi quod feminae saepius lineis amictibus velantur eosque purpura variant . . .'.

121 See pp. 33, 148 and 180.

122 '. . . fucato ostro . . . amictu . . . incompto utatur . . .' (*Aldhelmi Opera*, ed. R. Ehwald, p. 480, in *Mon. Germ. Hist. Auct. Ant.* XV).

123 'Unde usque hodie in eodem monasterio exemplo eius obseruatur ne quis uarii aut preciosi coloris habeat indumentum . . .' (Bede *Life of St Cuthbert*, p. 212).

124 Talbot *Anglo-Saxon Missionaries*, pp. 133–4 (Tangl, 78).

125 'Nam cultus gemini sexus huiuscemodi constat . . . manicae sericis clavatae . . .' (*Aldhelmi Opera*, ed. R. Ehwald, p. 318).

126 '. . . deliciis et epulis ut purpuratus dives inundant . . .' (E. Duemmler *Epistolae Karolini Aevi* II, Berlin, 1905: *Mon. Germ. Hist. Epist.* IV, p. 44).

127 He says that St Edith carried stones in her purple sleeve – 'Ipsa lapides in purpurea – manica portare . . .' (*La Légende de Ste. Édith*, p. 87: L-B, 4615).

128 See below, p. 179, p. 256 note 9.

129 '. . . filie Tyri, quas intincta precioso muricis sanguine circumdare purpura consueuerat . . .' (text in *Vita Ædwardi* ed. Barlow, p. 74).

130 Cf. Ovid: 'induerat Tyrio bis tinctam murice pallam', *Fasti* II, 107; and Virgil: 'Tyrioque ardebat murice laena', *Aeneid* IV, 262.

131 See Gino Luzzatto *An Economic History of Italy* (London, 1961), p. 35; W. Heyd *Histoire du commerce du Levant* (Leipzig, 1923) I, p. 111.

132 *Vita Ædwardi*, ed. Barlow, pp. xxi–xxxii.

133 See the remark of Goscelin: 'regia et pontificalia insignia, intincto murice . . . flammantia' (*Pat. Lat.*, LXXX, col. 52) though he himself may be the author of the *Vita Ædwardi*.

134 'Sunt et cocleae satis superque abundantes, quibus tinctura coccinei coloris conficitur, cuius rubor pulcherrimus nullo umquam solis ardore, nulla ualet pluuiarum iniuria pallescere, sed quo vetustior eo solet esse uenustior' (*Hist. Eccles.*, I, 1, ed. Plummer, p. 10; ed. Colgrave and Mynors, p. 14).

135 See below, pp. 146, 149 and p. 328 note 112.

136 'Nam cultus gemini sexus huiscemodi constat . . . tonica coccinea . . .' (ed. Ehwald, p. 318).

137 '. . . chlamyde coccinea, gemmato baltheo, ense Saxonico cum vagina aurea' (William of Malmesbury *De Gestis Regum*, I, p. 145: L-B, 6648).

138 Reginald of Durham (*Libellus*, p. 171: L-B, 1424) comments on the redness of Anglo-Saxon bronze which was due, he says, to the amount of copper they used.

139 See the twelfth-century description of the ivory comb found in St Cuthbert's coffin: 'Quod prae vetustatis gratia rubicundo colore suffunditur, ac candentis ossis habitus, quod, natura ordinante tribuitur, ex senio longitudinis subfuso rubore permutatur' (*Reginaldi libellus*, p. 89: L-B, 1391).

140 See below, p. 148.

141 'Hunc lapidem preciosum . . . dedit . . . Aetheldredus, pater beati Aedwardi, rex Anglorum . . . Plures quoque colores habet, campum videlicet fuscum, limbum quoque ad instar iris habentem ex aereo et subrufo colore compositum. Imaginum vero pars aerei coloris est, pars quoque subrufi' (Matthew Paris *Chronica maiora*, VI, pp. 387–8: L-B, 3970).

142 Whitelock *Wills*, p. 22.

143 'And ic an Odgar there gewele massehakele . . . And ic an Gundwine ther other gewele massehakele that is ungerenad' (Whitelock *Wills*, p. 4).

144 Whitelock *The Will of Æthelgifu*, p. 12.

145 '.II. mycele Xp̄es bec gebonede . . .' (Robertson *Anglo-Saxon Charters*, p. 226).

146 '.VI. hornas .IIII. gerenode . . .' (*ibid.*, p. 72).

147 '. . . and Æthelwerdæ anæs gerænodæs drincæhornæs' (Whitelock *Wills*, p. 22).

148 '. . . and ic yan seinte Eadmunde tueyn yboned hornes . . .' (Whitelock *Wills*, pp. 84–6 and note to *yboned* on p. 199).

149 'sextene hornas gerinade and threa unrinade . . .' (Robertson *Anglo-Saxon Charters*, p. 250).

150 'His tantum ex poculis coenaculum ingens bibebat, aut cornibus bubalinis metallo decoratis eodem circa extremitates utrasque' (Guillaume de Poitiers *Histoire*, p. 262).

151 For which see T. D. Kendrick *Anglo-Saxon Art to A.D. 900* (London, 1938), p. 78.

152 Leofric, for example, left wall-hangings, carpets and seat-covers to Exeter. For other references, see below, pp. 129–41.

153 The episode is of such interest that it is worth quoting in full. 'Cum primum Poterne uel Caninge adolescentulus, te infantula, ueni ad episcopum, hospitium michi decretum est adeo desertum, spurcum, cenosum et fetidum, ut magis porcorum uolutabrum quam hominum videretur habitaculum. Indignabar tacitus, nec me eo succedere posse credebam. Repente omnis illuuies exstirpatur, parietes et laquearia sordentia purgantur, frondibus et iuncis uiridantibus herbisque flagrantibus gratificatur, parietes et superna cortinis et auleis, sedilia tapetiis

contexuntur, cunctisque solemniter paratis hospes inducor. Non illam putabam domum quam prius uideram. Tantum distabat a priore, quantum decor a turpitudine, decus a feditate, splendor ab horrore, ornatus ab squalore, thimiamata a fetore. Quod prius horrebam dilexi, quod fugiebam ultro incolui . . .' (*The Liber Confortatorius of Goscelin of Saint Bertin*, ed. C. H. Talbot, p. 102. It is published in *Studia Anselmiana* fasc. XXXVII, *Analecta Monastica*, 3rd Ser. (Rome, 1955), pp. 1–117).

154 '. . . tecta et pavimenta frondibus virerent . . .' (Goscelin *Miracula S. Ivonis*, p. lxii: L-B, 5612).

155 See below, p. 190.

156 The will of Wulfwaru refers to 'anes godes casteneres wel gerenodes' (Whitelock *Wills*, p. 64).

157 The will of Wynflæd refers to 'hyre twa treowenan gesplottude cuppan' (*ibid.*, p. 14).

158 '. . . vidit . . . colum sculptura variatam . . .' (*Mon. Germ. Hist. Epist.* III, *Merov. et Karol. Aevi*, I, p. 255. The reference occurs in a letter written by Wynfrid to Eadburg of Thanet about a vision of a monk in 716. Anglo-Saxon visions tended to reflect the real world.

159 See below, p. 193.

160 Lines 1616, 1667.

161 H. R. Ellis Davidson *The Sword in Anglo-Saxon England* (Oxford, 1962), p. 122.

162 *Ibid.*, p. 123.

163 '. . . ille . . . quandam stolam sibi diversis formularum scematibus ipse praepingeret . . .' (*Vita S. Dunstani auct. B.* in Stubbs *Memorials*, p. 21: L-B, 6444).

164 '. . . miracla [sic] tot ingeniorum . . .' (*La Légende de Ste. Édith*, p. 89: L-B, 4616).

165 '. . . oththe hwær com . . . seo orthonce glaunes . . .?' (*Blickling Homilies*, p. 99).

166 'Nunc ferri stimulus faciem proscindit amoenam / Flexibus et sulcos obliquat adinstar aratri' (*The Riddles of Aldhelm* ed. J. H. Pitman (New Haven, Conn., 1925), p. 18).

167 '. . . acerra eburnea in naviculae modum parata . . .' (*Chronicon Abingdon*, II, p. 41: L-B, 29).

168 A reliquary given by Æthelmær to Winchester was described as 'quoddam scrinium curiosum . . .' (*Liber monasterii de Hyda* ed. Edward Edwards, Rolls Series (London, 1866), pp. 256–7).

169 '. . . quisquis ut ignotis haec deambulat atria plantis,
    nesciat unde meat, quoue pedem referat,
    omni parte fores quia conspiciuntur apertae,
    nec patet ulla sibi semita certa uiae'
(lines 47–50 of Wulfstan the Cantor's *Narratio Metrica de Sancto Swithuno* in Alistair Campbell *Frithegodi Monachi Breuiloquium vitae Beati Wilfredi et Wulfstani Cantoris Narratio Metrica de Sancto Swithuno* (Zurich, 1950), p. 66).

170 'insuper occultas studuistis et addere criptas,
    quas sic Dedaleum struxerat ingenium,
    quisquis ut ignotus ueniens intrauerit illas,
    nesciat unde meat, quoque pedem referat. . . .
    introitus quarum stat clausus, et exitus harum,
    quas homo, qui ignorat, luce carere putat,
    nocte sub obscura quae stare uidentur et umbra,
    sed tamen occulti lumina solis habent,
    cuius in exortu cum spicula prima resultant,
    lucifer ingrediens spargit ubique iubar . . .'
    (*ibid.*, lines 123–6, 129–34, p. 69).

171 '. . . domum columnis variis et porticibus multis . . . et liniarum variis
    anfractibus viarum, aliquando sursum, aliquando deorsum per cocleas
    circumductam . . .' (Eddius *Life of Wilfrid*, p. 46).

172 Translated in Talbot *Anglo-Saxon Missionaries*, pp. 153–77.

173 *Ibid.*, p. 167.

174 *Liber Vitae*, ed. Birch, pp. 9–10 (see below, pp. 121–2).

175 'Duo vera pallia subtilissimi operis . . . tuae paternitati mittere
    curavimus' (Tangl *Briefe*, p. 251).

176 'Swylce he siomian geseah   segn eall-gylden / heah ofer horde,   hond-
    wundra mæst / gelocen leotho-cræftum' (ll. 2767–9).

177 *Anglo-Saxon Chronicle*, ed. Whitelock, p. 134.

178 '. . . enta geweorc . . .' (*A.S.P.R.*, III, p. 227).

179 '. . . tantorum vestigia aedificiorum admirarentur . . .' (*Gesta Abbatum S.
    Albani*, I, p. 26: L-B, 3792).

180 'neque enim ullam domum aliam citra Alpes montes talem aedificatam
    audivimus' (ed. Colgrave, p. 46).

181 '. . . turris mirae altitudinis . . .' (*Liber Vitae*, ed. Birch, p. 9).

182 '. . . a sapiente regina moderatius ceptum' (*Vitae Ædwardi*, ed. Barlow,
    p. 47).

183 'Parvis et abjectis domibus totos absumebant sumptus [Angli], Francis et
    Normannis absimiles, qui amplis et superbis aedificiis modicas expensas
    agunt' (William of Malmesbury *De Gestis Regum*, II, p. 305: L-B, 5630).

184 It occurs in his chapter on the building of the church at Ripon in his *Life of
    Wilfrid* (p. 34): 'Secundum prophetam *omnis gloria filiae regis ab intus*' (I
    Kings II. 30).

## Chapter III  *Artists and craftsmen*

1 *The Gifts of Men* in *A.S.P.R.*, III, pp. 137 ff.; and *The Fortunes of Men* in
  *A.S.P.R.*, III, pp. 154 ff.

2 '. . . Sumum wundorgiefe / thurh goldsmithe   gearwad weorthath'(ll.
  72–3 of *The Fortunes of Men* in *A.S.P.R.*, III, p. 156).

3  '. . . sum searo-cræftig / goldes and gimma    thonne him gumena weard / hateth him to mærthum    maththum renian' (ll. 58–60 of *The Gifts of Men* in *A.S.P.R.*, III, p. 139).

4  '. . . egregie viri in omni valent artificio' (Guillaume de Poitiers, *Histoire*, p. 258).

5  'Item vasa argentea sive aurea admirabantur, quorum de numero vel decore vere narrari possent incredibilia. His tantum ex poculis coenaculum ingens bibebat, aut cornibus bubalinis metallo decoratis eodem circa extremitates utrasque. Denique plurima hujuscemodi competentia regali munificentiae notabant . . .' (*ibid.*, p. 262).

6  'Voluptuosum est ea perspectare hospitibus maximis, et qui saepe nobilium ecclesiarum thesauros viderant. Transiret illac hospes Graecus aut Arabs, voluptate traheretur eadem' (*ibid.*, p. 256).

7  '. . . materia artificioque pretiosissima, quae ad seculi terminum honora permanere valeant' (*idem*).

8  'Anglicae nationis feminae multum acu et auri textura . . . valent' (*ibid.*, pp. 256–8).

9  '. . . aurificum ingenia inter praeclaros lapides aurea ecclesiae adornant monilia; ipsos etiam aequat aut superat aurea Anglicarum virginum textura, quae regia et pontificalia insignia, intincto murice coccoque bis tincto flammantia, splendidis unionibus et margaritis cum praecellentibus gemmis praetexto auro instellant, et pretiosa stemmata artificii mixtura amplius irradiant' (Goscelin *Vita S. Augustini*, *Pat. Lat.*, LXXX, cols. 51–2). His remarks about St Edith in *La Légende de Ste. Édith* (p. 69 and L-B, 5158) can also be extended to Anglo-Saxon embroideresses in general: 'Hic purpura, punico, murice et Sidoniis conchiliis imbuta, coccusque bis tinctus auro intexitur; crisolitus, topazius, onix et berillus lapidumque genera preciosa auro innectuntur; concharum preciosarum uniones, quos sola India ab ortú solis et sola Anglorum Britannia ab occasu producit, auro instellantur'.

10  See below, p. 217.

11  See below, chapter VII, note 174.

12  Abbot Desiderius (later pope Victor III) owned English goldsmiths' work (see below, p. 207) and the English goldsmith killed near Montecassino (see below, p. 61) was presumably in his employment.

13  According to his biographer, Thangmar (*Pat. Lat.*, CXL, 397), the artistic interest of St Bernward (himself a craftsman) extended to 'transmarinis et . . . Scotticis vasis'. Here (as H. P. Mitchell has pointed out in *Burlington Magazine* XLII, 1923, p. 72, note 45) *transmarinis* means Anglo-Saxon (*Saxonia transmarina*).

14  See below, pp. 216–17.

15  'Templa, quibus visis stupuisset pictor Achivus, / Auri fusor Arabs, Sculptores Scottus et Anglus' (Raoul de Caen *Gesta Tancredi Principis* in Muratori *Rerum Italicarum Scriptores*, vol. 5 (Mediolani, 1724), p. 310). *Sculptores* here means 'metal-engravers'. There is not the slightest

evidence that the Norman writers were interested in English stone carvings though they very much admired English goldsmiths' work.

16  *Ibid.*, p. 305.

17  See below, pp. 216–20.

18  'Obtulit [rex Henricus] pontifici [Hildeberto] maximum pondus auri et argenti, unde sepulcrum beati Juliani honorifice . . . fieri potuisset . . . Hildebertus prudenter respuens, dixit: Nos caremus in partibus nostris artificibus, qui tantum opus congrue noverint operari; ex hinc regiae congruit dispositioni tam diligens opera et impensa, in cujus regno et mirabiles refulgent artifices, et mirabilem operantur caelaturam' (*Gesta episcoporum Cenomanensium*, *Pat. Lat.*, CLXXI, col. 92).

19  See below, pp. 216–17.

20  V. Mortet *Recueil de Textes*, I (Paris, 1911), p. 75.

21  D. J. V. Fisher *The Anglo-Saxon Age* (London, 1973), p. 330.

22  'swa swa . . . ymbhogan ge-yceth monnes mod, swa ge-ycth se cræft his are' (*The Dialogue of Salomon and Saturn*, ed. John M. Kemble (London, 1848), p. 266).

23  In the poem on His Nativity: '. . . se cræftga cume   ond se cyning sylfa' (*A.S.P.R.*, III, p. 3).

24  'Uerum doctor [Ervenius] ad seculi spectans comodum; spe maioris premii sacramentarium regi tunc temporis Cnutoni, psalterium Emme regine contribuit' (*Vita Wulfstani*, ed. Darlington, p. 5). The innuendo that Earnwig was promoting his own worldly interests at Peterborough by presenting the manuscripts he had written and illuminated to court is probably an unworthy one (see p. 5, note 2). It was presumably in the Anglo-Saxon source from which William of Malmesbury drew his account.

25  She had donated a ring towards his goldsmith's work at Canterbury. See below, p. 213.

26  '. . . rex quendam monachum de ecclesia Sancti Eadmundi regis et martyris, aurificis arte peritissimum, nomine Spearhauoc, Abbendoniae abbatem constituit . . . Spearhauoc autem a rege civitati Lundonensi eodem . . . anno in episcopatum promotus, dum auri gemmarumque electarum pro corona imperiali cudenda, regis ejusdem assignatione receptam haberet copiam. Hinc et ex episcopii pecunia marsupiorum farsisset plurimum receptacula, clanculo Anglia secedens ultra non apparuit' (*Chronicon Abingdon*, I, pp. 462–3: L-B, 6301).

27  'Item idem Osmundus libros scribere, ligare et illuminare non fastidauit' (*Statutes and customs of the cathedral church . . . of Salisbury*, ed. C. Wordsworth and D. Macleane (London, 1915), p. 26: L-B, 5933).

28  See above, chapter I, note 84.

29  '. . . his giefe bryttath / sumum on cystum.   sumum on cræftum. / sumum . . . / theaw-fæstne gethoht' (from *The Gifts of Men*, ll. 105–9, *A.S.P.R.*, III, p. 140).

30  See Dr R. I. Page's contribution to David Wilson *Anglo-Saxon Ornamental*

*Metalwork 700–1100 in the British Museum* (British Museum, London, 1964), pp. 75, 83–6.

31 '[SA]LVS FACTORI / [PA]X POSSESSOR[I]' (Elizabeth Okasha *Hand-list of Anglo-Saxon non-Runic Inscriptions* (Cambridge, 1971), No. 20).

32 *Ibid.*, No. 66.

33 *Ibid.*, No. 109.

34 It is in Little Billing parish church, Northamptonshire (*ibid.*, No. 85).

35 It is in Stratfield Mortimer parish church, Berkshire, and the stone engraver's name was Toki (*ibid.*, No. 111).

36 'Hic etiam inter sacra litterarum studia, ut in omnibus esset idoneus, artem scribendi necnon citharizandi pariterque pingendi peritiam diligenter excoluit, atque ut ita dicam, omnium rerum utensilium vigil inspector effulsit' (*Vita S. Dunstani auct. B.*, p. 20 in Stubbs *Memorials:* L-B, 6444).

37 'Hic vir venerabilis valde et sacris litteris aliisque plurimis artibus fuerat imbutus, videlicet cantoris, scriptoris, pictoris, aurique fabrilis operis . . .' (*Chronicon Evesham*, p. 86: L-B, 1610).

38 See below, note 74 of this chapter.

39 '. . . Edeiha diligitur, que uersu et prosa celebris et eximia et opere et pictura altera erat Minerua' (transcription of Osbert of Clare from British Museum Add. MS. 36737, printed in *Vita Ædwardi* ed. Barlow, p. 14). The passage is not very clear but the reference to Minerva would suggest that the *opus* here is that of needlework and the *pictura* the embroidered depictions.

40 '. . . inter sacerdotes Wiltonie . . . pollebant duo, tam morum quam scientie philosophia uenerandi, quorum . . . Benna . . . picturae artificiosique operis commentor egregius claruit . . .' (Goscelin *La Légende de Ste. Édith*, p. 50: L-B, 4619).

41 'Insuper opus eximium atque preclarum, stolam videlicet et manipulum similis materie ex auro et lapidibus pretiosis propriis, ut fertur, manibus docta auritexture ingenio fecit . . . destinavit, que in signum utriusque venerationis apud ecclesiam Dunhelmi servantur, quibusdam petentibus pro magna adhuc ostenduntur dignitate et de nostris quidam sepius aspexerunt' (*Liber Eliensis*, I, 9, p. 24).

42 'Organa propriis manibus ipse fecit. Rotam etiam, quae aurea dicitur . . . ipse fecit . . . Fecit et sanctus Athelwoldus tabulam supra altare, in qua erat sculpta et xii apostoli . . . Fecit etiam tres cruces ex auro et argento . . .' (*De abbatibus Abbendoniae*, II, p. 278: L-B, 13).

43 'Fecit etiam duo campana propriis manibus . . .' (*idem*).

44 *Theophilus De Diversis Artibus*, ed. C. R. Dodwell (London, 1961), pp. 142–50.

45 *Ibid.*, pp. 150–8.

46 Winterbottom *Three Lives*, p. 39.

47 *Ibid.*, pp. 43, 55.

48 *Regula, Cap.* XLVIII.

49 'hond bith gelæred / wis and gewealden    swa bith wyrhtan ryht . . .' (*The Gifts of Men, lines 45–6, A.S.P.R.*, III, p. 138).

50 Bede *Hist. Abb.*, p. 372.

51 Bede *Hist. Eccles.*, IV, 3, ed. Plummer, p. 208; ed. Colgrave and Mynors, p. 338.

52 By Gregory the Great – see *ibid.*, I, 31.

53 *Cap.* LVII, Cardinal Gasquet's translation, slightly amended.

54 *Æthelwulf De Abbatibus*, ed. A. Campbell (Oxford, 1967).

55 *Ibid.*, p. 19: 'Vltan . . . presbiter . . . comptis qui potuit notis ornare libellos, tque apicum speciem uititim sic reddit amoenam hac arte, ut nullus possit e aequare modernus scriptor . . .'

56 *Ibid.*, p. 25: 'mirificis fratrem liceat memorare loquelis, ferrea qui domitans potuit formare metalla, diuersisque modis sapiens incude subactum malleus in ferrum peditat, stridente camino.'

57 'Noui autem ipse fratrem . . . positum in monasterio nobili, sed ipsum ignobiliter uiuentem. Corripiebatur quidem sedulo a fratribus ac maioribus loci, atque ad castigatiorem uitam conuerti ammonebatur. Et quamuis eos audire noluisset, tolerabatur tamen ab eis longanimiter ob necessitatem operum ipsius exteriorum; erat enim fabrili arte singularis' (*Hist. Eccles.*, V, 15, ed. Plummer, pp. 313–14; ed. Colgrave and Mynors, p. 502).

58 British Library Cotton MS. Nero D. IV fol. 259. A facsimile of the manuscript, with a volume of commentary has been published by T. D. Kendrick, T. J. Brown, R. L. S. Bruce-Mitford, H. Roosen-Runge, A. S. C. Ross, E. G. Stanley and A. E. Werner under the title *Evangeliorum Quattuor Codex Lindisfarnensis* (2 vols., London, 1956–60).

59 Fol. 259: here given in the reading (with expansion of abbreviations) of Dr E. G. Millar (*The Lindisfarne Gospels*, London, 1923, p. 3). 'Eadfrith biscop lindisfearnensis æcclesiæe he this boc avrát æt frvma gode and sancte cvthberhte and allvm thæm halgvm gimænelice tha the in eolonde sint. And Ethilvald lindisfearneolondinga biscob hit v́ta githryde and gibélde sva he velcuthę and billfrith se oncrę he gismiothade tha gihrino thathe v́tan ón sint and hit gihrinade mith golde and mith gimmvm ę́c mith svlfre ofergylded faconleas felı.'

60 'the lifigiende god gemyne thu eadfrith and æthilwald and billfrith and aldred peccatorem thas feowero mith gode ymbweson thas boc' (*ibid.*, p. 4).

61 At the conclusion to his preface to the *Historia Ecclesiastica*.

62 On fol. 153 of a Gospel-book of the second half of the eighth century – Rome, Vatican, Biblioteca Apostolica MS. Barberini Lat. 570 (J. J. Alexander *Insular Manuscripts* (London, 1978), p. 62).

63 'Cutbercht scripsit ista IIII evangelia. praecat nos omnia oramus pro anima tua [sic]' in the Cutbercht Gospel Book – Vienna, National-bibliothek Cod. 1224 fol. 4* v. (*ibid.*, p. 62).

64 See above, p. 9.

65 The obits in British Library Cotton MS. Titus D XXVII include Obitus Ætherici mo[nachi] picto[ris] and Obitus Wulfrici monachi pictoris. The lists of monks in the *Liber Vitae* include Wulfric Aurifex Leuita, Bryhtelm Aurifex, Byrnelm aurifex and Ælfnoth pictor et sacerdos (*Liber Vitae*, ed. Birch, pp. 270, 271, 25,31).

66 *Ibid.*, p. 162.

67 'Erat quippe tunc temporis [Aegelwini II, abbatis 1059–77] quidam prior hic, . . . Alfricus nomine, qui fecit dorsellos capituli' (*Chronicon Evesham*, p. 91: L-B, 1617).

68 'Crucem vero fecit argenteam, que crux Leonis prepositi nominatur, in qua forma corporis Christi ingenio artificis cavata sanctorum reliquias Vedasti et Amandi continebat, quam Nigellus episcopus tulit . . .' (*Liber Eliensis*, p. 124).

69 See above, notes 36 and 37 of this chapter.

70 Oxford, Bodleian MS. Auct. F. iv 32, fol. 1. The inscription at the top of the page, saying that its artist and scribe was Dunstan, is post-mediæval (R. W. Hunt 'St Dunstan's classbook from Glastonbury' in *Umbrae Codicum Occidentalium*, IV, 1961, p. xv).

71 'Praeterea manu aptus ad omnia, posse facere picturam, litteras formare, scalpello imprimere, ex auro, argento, aere et ferro, quicquid liberet operari' (in Stubbs *Memorials* p. 79: L-B, 5160).

72 *Ibid.*, p. 84: L-B, 5161.

73 *Ibid.*, pp. 136 ff: L-B, 649.

74 '. . . Uox cignea, canor angelicus, mellita facundia, generosum et ad omnia capax ingenium, legendi intellectuosa flagrantia; manus pingendi, scriptitandi, dictitandi tam decentes, quam artificiose; digiti aurifices, gemmarii, citharedi, citharizantes . . .' (*La Légende de Ste. Édith*, pp. 68–9: L-B, 5158).

75 'Egregium artificem novimus abbatem Abbendoniae picturae, sculpturae et aurificii probatissimum, Speraver nomine' (Goscelin *Historia translationis S. Augustini, Pat. Lat.*, CLV, col. 46: L-B, 642).

76 '. . . plurimis artibus fuerat imbutus, videlicet cantoris, scriptoris, pictoris, aurique fabrilis operis scientia pollens . . .' (*Chronicon Evesham*, p. 86: L-B, 1610).

77 '. . . missalem librum atque Psalterium magnum propria manu descripsit ac laudabiliter depinxit . . .' (*ibid.*, p. 87: L-B, 1610).

78 See above, p. 22.

79 '. . . in scribendo et quidlibet coloribus effingendo peritum . . .' (*Vita Wulfstani*, ed. Darlington, p. 5).

80 See above, chapter I, note 88.

81 See the conclusions of Professor T. J. Brown and Dr R. L. S. Bruce-Mitford in vol. 2 of *Evangeliorum Quattuor Codex Lindisfarnensis* by T. D. Kendrick and others (London, 1960), p. 5.

82 The picture of St Matthew with symbols of the other evangelists on fol. 5v. of the Trier Gospels (Domschatz cod. 61), probably from Echternach, is

signed 'Thomas scribsit'. He is also one of the scribes and signs his name elsewhere (ff. 11, 125v.). See Carl Nordenfalk *Celtic and Anglo-Saxon Painting* (London, 1977), plate 31, and J. J. Alexander *Insular Manuscripts* (London, 1978), No. 26 with full bibliography.

83 '... pingere ... uerba ...' (Æthelwulf *De Abbatibus*, ed. Campbell, l. 250).

84 Rome, Vatican, Biblioteca Apostolica MS. Reg. lat. 12. It was made at Canterbury for Bury St Edmunds in the second quarter of the eleventh century.

85 Like much of the iconography, this is clearly inspired by that of the Utrecht Psalter where the psalmist is seen, not writing, but meditating on a book.

86 'Eligitur itaque abbas Hwætberchtus qui a primis pueritiae temporibus eodem in monasterio non solum regularis obseruantia disciplinae institutus, sed et scribendi, cantandi, legendi ac docendi fuerat non parua exercitatus industria' (Bede *Hist. Abb.* 18, p. 383).

87 Tangl *Briefe*, p. 251.

88 See Plummer's edition, p. xx.

89 Talbot *Anglo-Saxon Missionaries*, p. 84 (Tangl, 27).

90 *Ibid.*, p. 91 (Tangl, 35).

91 See above, p. 24.

92 Dr C. H. Talbot (*op. cit.*, p. xiii) writes: 'If we are to judge by some of his [St Boniface's] letters and by the names which appear in the fly-leaves and margins of manuscripts we must conclude that the production of books, on which he largely depended for personal study and for the training of others, was their [the nuns'] particular province.'

93 Talbot *op. cit.*, p. xii.

94 *Ibid.*, p. 215.

95 *Ibid.*, p. 223.

96 *Ibid.*, p. 214.

97 *Aldhelmi Opera* ed. R. Eiwald, p. 232 (*Mon. Germ. Hist. Auct. Ant.* XV).

98 *Ibid.*, p. 236 and 244 (translated by Michael Lapidge and Michael Herren in *Aldhelm: The Prose Works* (Cambridge, 1979), pp. 65, 71, 72).

99 'uirgines quoque Deo dicatae, contemta reuerentia suae professionis, quotiescumque uacant, texendis subtilioribus indumentis operam dant, quibus aut se ipsas ad uicem sponsarum in periculo sui status adornent, aut externorum sibi uirorum amicitiam conparent' (*Hist. Eccles.* IV, 23, ed. Plummer, p. 265; ed. Colgrave and Mynors, pp. 424–6).

100 A. W. Haddan and W. Stubbs *Councils and Ecclesiastical Documents relating to Great Britain and Ireland*, vol. 3 (Oxford, 1871), p. 382.

101 *Ibid.*, p. 369.

102 Talbot *Anglo-Saxon Missionaries*, pp. 84 and 91 (Tangl, 27 and 35).

103 'Inter quae fecerat ibi ex bisso candidissimo albam ... praestantissimam auro, gemmis, margaritis ac perulis Angligenis a summo contextam ... circa pedes aureas apostolorum ymagines Dominum circumstantes, Dominum medium assidentem, se uice suplicis Mariae affusam,

dominica uestigia exosculantem' (Goscelin *La Légende de Ste Édith*, p. 79: L-B, 6448).

104  See above, p. 45.

105  'Dedit . . . multa alia ornamenta, cum voluminibus pretiosis, quorum unum est missale, in quo canitur Missa Matutinalis. Unde in principio Missae, pingitur ejus imago ad pedes Majestatis . . .' (*Gesta Abbatum S. Albani*, I, p. 70: L-B, 3819).

106  '. . . hic tunc apud sanctum Augustinum invitatus ab abbate Elstano operabatur . . . Ejus [Letardi] quippe et venerabilis reginae Bertae . . . imagines enormi magnitudine ac decore effigiavit, ac super ipsius tumulum solemniter erexit' (Goscelin *Historia translationis s. Augustini*, in *Pat. Lat.*, CLV, col. 46: L-B, 642).

107  'Apud Cantuariam vero atque ecclesiam Coventreiam sicuti in multis aliis locis plurima opera tunc temporis valde laudabilia operatus est' (*Chronicon Evesham*, p. 86: L-B, 1610).

108  'From Britain an exceedingly large number of holy men came to his aid, among them readers, writers and learned men trained in the other arts. Of these a considerable number put themselves under his rule and guidance, and by their help the population in many places was recalled from the errors and profane rites of their heathen gods' (Talbot *Anglo-Saxon Missionaries*, p. 47).

109  In British Library Harley MS. 2506, Orléans, Bib. Mun. MS. 175 and Paris, Bib. Nat. lat. 6401. See Francis Wormald *English Drawings of the Tenth and Eleventh Centuries* (London, 1952), pp. 70, 73–4, plates 13 and 14, and 'The "Winchester School" ', pp. 311–12 in *England before the Conquest*, ed. P. Clemoes and K. Hughes (Cambridge, 1971).

110  See C. R. Dodwell *Painting in Europe 800–1200* (London, 1971), pp. 79–80.

111  See C. R. Dodwell *The Canterbury School of Illumination* (Cambridge, 1954), p. 9 and see below, pp. 225–6.

112  Cited by Philip Grierson in 'The relations between England and Flanders before the Norman Conquest', *T. R. Hist. Soc.* 1941, p. 94 from *Miracula S. Bavonis*, i. 9 (*Mon. Germ. Hist. SS.*, XV, p. 594).

113  See Günther Haseloff *Der Tassilo-Kelch* (Munich, 1951).

114  See below, pp. 208–9.

115  The question of whether the craftsman was Anglo-Saxon, and of where he came from, is discussed in Haseloff, *op. cit.*, pp. 64 ff. and p. 75.

116  'reminiscor una nocte . . . fulmen percussisse. Alia quoque vice cum Anglo quodam aurifice duos alios longe distantes uno ictu ad portam maiorem occidisse, et quod est mirabilius puerulum quendam praedicto Anglo innitentem nil nocuisse . . .' (*Chronicon Mon. Casinensis auctore Leone*, p. 712, in *Mon. Germ. Hist. SS.*, VII).

117  See below, pp. 205–8.

118  'Enimvero quum homo erat itinerarius lateque terrarum et urbium gnarus . . .' (*Ekkehardi IV Casus S. Galli* cap. iii, in *Mon. Germ. Hist. SS.*, II, p. 97).

119 V. Mortet *Recueil de Textes*, I (Paris, 1911), pp. 36–7.

120 R. E. Swartwout *The Monastic Craftsman* (Cambridge, 1932), pp. 55–6.

121 *Dialogus de Vita Ottonis auct. Herbordo*, III, 36 (in *Mon. Germ. Hist. SS.*, XX).

122 Mortet *op. cit.*, p. 235.

123 ed. Panofsky, pp. 72–4.

124 Lines 74–6.

125 Bede *Hist. Abb.*, 5, p. 368.

126 'Benedictus mare transiens architectos a Torhthelmo abbate, dudum sibi in amicitiis iuncto, quorum magisterio et opere basilicam de lapide faceret, petiit, acceptosque de Gallia Brittanniam perduxit' (*Historia Abbatum auctore Anonymo*, 7, ed. Plummer, p. 390).

127 'Sed et architectos sibi mitti petiit, qui iuxta morem Romanorum ecclesiam de lapide in gente ipsius facerent . . . Cuius religiosis uotis ac precibus fauens reuerentissimus abba Ceolfrid misit architectos, quos petebatur . . .' (Bede *Hist. Eccles.*, V, 21, ed. Plummer, p. 333; ed. Colgrave and Mynors, pp. 532–4).

128 Dom Paul Meyvaert's translation.

129 '. . . misit legatarios Galliam, qui uitri factores, artifices uidelicet Brittaniis eatenus incogniti, ad cancellandas aecclesiae porticumque et caenaculorum eius fenestras adducerent. Factumque est, uenerunt; nec solum opus postulatum compleuerunt, sed et Anglorum ex eo gentem huiusmodi artificium nosse ac discere fecerunt' (Bede *Hist. Abb.*, 5, p. 368).

130 Eddius wrote: '. . . per fenestras introitum auium et imbrium uitro prohibuit, per quod tamen intro lumen radiabat' (ed. Colgrave, p. 34).

131 It was commenced by King Edwin but completed by King Oswald who was killed in 642 (Bede *Hist. Eccles.*, II, 14, 20).

132 Ed. Colgrave, p. 34.

133 'Haec domus interius resplendet luce serena, / Quam sol per uitreas illustret forte fenestras / Limpida quadrato diffundens lumina templo' (*Carmina Ecclesiastica* III, 66–8, ed. Ehwald, pp. 17–18).

134 'haec est illa domus . . . / quam sol per uitreas illustrans candidus oras / limpida prenitido diffundit lumina templo' (ed. A Campbell, ll. 620–2).

135 Theophilus *De Diversis Artibus*, ed. C. R. Dodwell (London, 1961), p. 3.

136 See below, chapter VII, note 156.

137 'cuncta quae ad altaris et aecclesiae ministerium competebant, uasa sancta, uel uestimenta, quia domi inuenire non potuit, de transmarinis regionibus aduectare religiosus emptor curabat' (*Hist. Abb.*, 5, p. 368).

138 'Si aliquis homo in tua sit parrochia, qui uitrea uasa bene possit facere, cum tempus adrideat, mihi mittere digneris. Aut si fortasse ultra fines est in potestate cuiusdam alterius sine tua parrochia, rogo, ut fraternitas tua illi suadeat, ut ad nos usque perueniat quia eiusdem artis ignari et inopes sumus' (Tangl *Briefe*, p. 251).

139 See the excavation reports of Professor Rosemary Cramp in 'Decorated window-glass and millefiori from Monkwearmouth', *The Antiquaries Jour-*

*nal*, vol. L. (II) 1970, pp. 327–35, and in 'Window glass from the monastic site of Jarrow', *Journal of Glass Studies*, vol. XVII, 1975, pp. 88–96.

140 '. . . quod ordinem cantandi psallendi atque in aecclesia ministrandi iuxta morem Romanae institutionis suo monasterio contradidit, postulato uidelicet atque accepto ab Agathone papa archicantore aecclesiae beati apostoli Petri et abbate monasterii beati Martini Iohanne, quem sui futurum magistrum monasterii Brittannias, Romanum Anglis adduceret. Qui illo perueniens, non solum uiua uoce quae Romae didicit aecclesiastica discentibus tradidit . . .' (Bede *Hist. Abb.*, 6, p. 369).

141 'primusque, excepto Iacobo, . . . cantandi magister Nordanhymbrorum ecclesiis Aeddi cognomento Stephanus fuit, inuitatus de Cantia a reuerentissimo uiro Uilfrido . . .' (Bede *Hist. Eccles.*, IV, 2, ed. Plummer, p. 205; ed. Colgrave and Mynors, p. 334).

142 '. . . cum cantoribus Aedde et Eonan et caementariis omnisque paene artis institoribus regionem suam rediens . . .' (Eddius *Life*, ed. Colgrave, p. 30).

143 Bede *Hist. Eccles.*, V, 20, ed. Plummer, p. 331; ed. Colgrave and Mynors, p. 530.

144 '. . . sed in illa solum ecclesia Deo seruiens, et ubicumque rogabatur, ad docenda ecclesiae carmina diuertens' (*ibid.*, p. 228; p. 368).

145 'Delectat me quoque citharistam habere, qui possit citharizare in cithara, quam nos appellamus rottae; quia citharum habeo et artificem non habeo' (Tangl *Briefe*, p. 251).

146 '. . . operatoribus, quos ex multis gentibus collectos et comparatos propemodum innumerabiles habebat, in omni terreno aedificio edoctos' (*Asser's Life of King Alfred* ed. William H. Stevenson (Oxford, 1904), p. 87).

147 A. J. Robertson *The Laws of the Kings of England from Edmund to Henry I* (Cambridge, 1912), p. 72 (8) and (10) and notes.

148 'Ad hoc incolere apud eos Germani solebant talium artium scientissimi. Inferunt et negociatores, qui longinquas regiones navibus adeunt, doctarum manuum opera' (ed. Foreville, p. 258). The phrase 'talium artium scientissimi' has been taken to mean that these Germans were skilled in metalwork (and there were certainly moneyers from the Continent in England) but the previous sentence has, in fact, referred only to embroidery and the very general skills of the men – 'in omni . . . artificio'.

149 '. . . inter sacerdotes Wiltonie . . . alter memoratur Benna Treuerensis canonicus de Sancti Paulini patrocinio, isque picturae artificiosique operis commentor egregius claruit, qui deinde conditam per uirginem [S. Editham] basilicam uaria celatura, ut usque hodie lucet, deflorauit' (Goscelin *La Légende de Ste. Édith*, p. 50: L-B, 4619; see below, pp. 92–3).

150 See, for example, Olaf von Feilitzen and Christopher Blunt 'Personal names on the coinage of Edgar', in *England before the Conquest*, ed. Peter Clemoes and Kathleen Hughes (Cambridge, 1971), p. 208.

151 'Supra ostium etiam chori pulpitum opere incomparabili, aere, auro

argentoque fabricari fecit, et ex utraque parte pulpiti arcus, et in medio supra pulpitum arcum eminentiorem crucem in summitate gestantem, similiter ex aere, auro, et argento, opere Theutonico fabrefactos erexit' (J. Raine *Historians of the Church of York*, II, p. 354: L-B, 326).

152 William Stubbs (*The Foundation of Waltham Abbey* (Oxford, 1861), p. ix) comments on this and points out that the chaplains of both king and queen were Lorrainers, that Herman, bishop of Sherborne, was a Fleming or Lorrainer, and Duduc, bishop of Wells, a Saxon.

153 *Winchester in the Early Middle Ages,* ed. Martin Biddle (Oxford, 1976), p. 464.

154 '. . . aurique fabrilis operis scientia pollens, super omnes alios fere hujus patriae magister optimus habebatur' (*Chronicon Evesham,* p. 86: L-B, 1610).

155 See above, p. 58.

156 'Ante septem fere annos ex hac luce suae transmigrationis, justissima Dei clementia . . . permisit eum incurrere gravissimam atque insanabilem corporis infirmitatem quam Greci 'paralysin' appellant . . .' (*Chronicon Evesham,* p. 87: L-B, 1610).

157 'Hic inter caetera quae multum extollenda operatus est, scrinium sancto Odulfo fieri decrevit, quod opus ut vidit in melius ire studuit sancto Ecgwino dedicare' (*ibid.,* p. 44: L-B, 1611). We are later told that it was of gold and silver and set with precious stones: 'Feretrum etiam sancti Egwini ex argento, auro, et lapidibus pretiosis composuit' (*ibid.,* p. 86).

158 'Nam quidam inter aurifices post abbatem magister aliorum, Godricus nomine . . .' (*idem*).

159 'Is quum, sicut hujusmodi opus exigit, saepius fundendo et tundendo ac cum scalpro incidendo labori insisteret, quadam die more solito sedens et cum scalpro parvas imaginulas diligentissime coaptans, subito casu tam graviter manum sinistram cum ferro quod tenebat vulneravit . . .' (*ibid.,* p. 44: L-B, 1611).

160 'Aderant tum quamplures artificosi, quorum omnium magister erat quidam, pater videlicet domini Clementis postmodum Eoveshamensis prioris' (*idem*).

161 'Idem artifex Godricus postea, tempore Walteri abbatis, monachus factus, plurimis annis vivens in bona conversatione sancto fine quievit in pace' (*ibid.,* pp. 86–7: L-B, 1610).

162 See above, note 160 of this chapter.

163 This was certainly before the onset of Mannig's paralysis in 1059, and probably about the time of the dedication of the newly rebuilt church in 1054.

164 *Chronicon Evesham,* p. 96.

165 See above, note 160 of this chapter.

166 'Godiova vero religiosa comitissa omnem thesaurum suum eidem ecclesiae contulit, et accersitis aurifabris quicquid in auro et argento habuit, ad construendum sacros textus et cruces ac imagines sanctorum,

aliaque mirifica ecclesiae ornamenta devote distribuit' (Ordericus Vitalis *Historiae Ecclesiasticae Libri,* II, p. 183: L-B, 1129).

167 'Ministerium autem monete Papie debet habere novem magistros nobiles et divites . . . qui debent custodire et precipere omnibus aliis monetariis cum magistro camere, ut numquam faciant peiores denarios, quam semper fecerunt . . .' (*Mon. Germ. Hist. SS.,* XXX (2), p. 1454).

168 M. le Chanoine Dehaisnes *Documents . . . concernant l'Histoire de l'Art dans le Flandre, L'Artois et le Hainaut,* I (Lille, 1886), pp. 64–5.

169 '. . . et iubet aurifices simul adfore quosque peritos, / ut patris dignum fabricent in honore sacellum' (Wulfstan's *Narratio Metrica de Sancto Swithuno,* ed. A Campbell in his *Frithegodi monachi breuiloquium . . .* (Zürich, 1950), Book II, ll. 7–8, p. 141).

170 *Ibid.,* lines 9–11, p. 141.

171 *Winchester in the Early Middle Ages,* ed. Martin Biddle (Oxford, 1976), p. 466.

172 Wulfstan *op. cit.,* ll. 28–31, p. 141.

173 '. . . iugi cecitate oculorum quibus aurum concupierant sunt puniti, et de tenebrosis mentibus in exteriores tenebras missi. Cum cupidinea luce metalli perdiderunt lucem mundi et pro iniquo lucro mendicitati ignominiose sunt subiecti, ut tanti sacrilegii crimina loqueretur puplica pena' (Goscelin *La Légende de Ste. Édith,* p. 280: L-B, 4628).

174 When Ceolfrith died in 716, there were more than six hundred monks in his joint monastery of Monkwearmouth/Jarrow (*Historia Abbatum auctore Anonymo,* 33, ed. Plummer, p. 400).

175 See R. W. Southern *Saint Anselm and his Biographer* (Cambridge, 1963), p. 242.

176 Knowles *op. cit.,* p. 425.

177 *Ibid.,* p. 440.

178 Robertson *Anglo-Saxon Charters,* LXI and p. 369.

179 *Domesday Book,* I, 58b.

180 *Translatio et miracula S. Swithuni . . . auct. Lantfredo,* ed. E. P. Sauvage, in *Analecta Bollandiana,* IV, p. 378: L-B, 4680.

181 Goscelin *Vita S. Vulfhildae,* ed. Mario Esposito in *Analecta Bollandiana,* vol. 32 (Bruxelles, 1913), p. 20: L-B, 5163.

182 '. . . praepositurae super operarios administratione suscepta . . .' (*Historia Ramesiensis,* p. 89: L-B, 3566).

183 Wulfstan's life of Æthelwold refers to both *artifices* and *operarii* (p. 42 in *Three Lives* ed. Winterbottom).

184 *Ibid.,* p. 37 (Ælfric's *Life*) and p. 53 (Wulfstan's *Life*).

185 *Ibid.,* pp. 22 and 43.

186 Eddius *Life,* p. 47.

187 '. . . sanctus pontifex noster, a spiritu Dei doctus, opera facere excogitavit . . .' (*ibid.,* p. 46).

188 'Interea tamen rex . . . aurifices et artifices suos omnes . . . quoque docere, et aedificia supra omnem antecessorum suorum consuetudinem venerabiliora et pretiosiora . . . facere' (ed. Stevenson, p. 59).

189  Winterbottom *Three Lives*, pp. 20 and 41.
190  'Venit ergo rex quadam die ad monasterium, ut edificiorum structuram per se ipsum ordinaret; mensusque est omnia fundamenta monasterii propria manu, quemadmodum muros erigere decreuerat' (Wulfstan's *Life*, *ibid.*, p. 41).
191  '. . . hic regio opere lapideum monasterium inchoat, feruentiusque instans operarios maturat' (*Vita Ædwardi* ed. Barlow, p. 47).
192  See above, p. 48.
193  William of Malmesbury, see *Vita Ædwardi* ed. Barlow, p. xxxi.
194  *Ibid.*, pp. xvii and xxxi.
195  '. . . amiciretur vestibus auro intextis quas regina sumptuosissime elaboraverat . . .' (William of Malmesbury *De Gestis Regum*, I, p. 271: L-B, 6551).
196  '. . . filia eius prefata Æthelswitha . . . viri consortium aspernatur, illic iugiter professa est permanere. Cui tradita est Coveneia, locus monasterio vicinus, ubi aurifrixorie et texturis secretius cum puellulis vacabat, que de proprio sumptu albam casulam suis manibus ipsa talis ingenii peritissima fecit' (*Liber Eliensis*, II, 88, p. 158). An inventory, made towards the middle of the twelfth century records 'i candida infula bene brusdata, quam Ædelswitha domina fecit' (*ibid.*, p. 293) and a precious dalmatic given by her (*ibid.*, p. 294).
197  '. . . Quapropter nobilis quaedam matrona Aethelwynn nuncupata quodam momentulo vocavit eum familiari precatu ad se, quatenus ille ad divinum cultum quandam stolam sibi diversis formularum scematibus ipse praepingeret, quam postea posset auro gemmisque variando pompare' (*Vita s. Dunstani auct. B.* in Stubbs *Memorials*, pp. 20–1: L-B, 6444).
198  *Middlemarch*, chapter 3.
199  See below, p. 75, for needlewomen who were slaves.
200  *Domesday Book*, I, 149; and see *V. C. H. Bucks.*, I, p. 258.
201  For a fragment in the Basilica Ambrosiana, see the contribution by G. M. Crowfoot to *The Relics of Saint Cuthbert*, ed. Battiscombe, pp. 392–6. For the other four examples, see pp. 185–6 below.
202  'fæmne æt hyre bordan geriseth' (*A.S.P.R.*, III, p. 159).
203  Ed. W. H. Stevenson, p. 92.
204  F. L. Attenborough *The Laws of the Earliest English Kings* (Cambridge, 1922), p. 4 (item 7).
205  F. Liebermann *Die Gesetze der Angelsachsen*, 3 vols. (Halle, 1903–16), III, p. 2.
206  Attenborough *op. cit.*, p. 34.
207  63. *Ibid.*, p. 57.
208  19 (3). *Ibid.*, p. 75.
209  Line 1 ff. In fact, about one third of the poem relates to Wayland and his activities.
210  Line 455 claims that Beowulf's own battle-coat was forged by Wayland.

211  An excursus in *Christ* on God's gifts to man includes a reference to the smith who can make a tempered sword and weapon (ll. 679–80: *A.S.P.R.*, III, p. 22). Lines 62–6 of *The Gifts of Men* (*ibid.*, p. 139) expand on this.
212  Lines 1451–3.
213  Line 406.
214  Lines 1681, 1694–8.
215  '. . . ensem Constantini magni, in quo litteris aureis nomen antiqui possessoris legebatur; . . . lanceam Caroli magni . . .' (William of Malmesbury *De Gestis Regum*, I, p. 150). The sword had a relic in the hilt and the lance was also said to have been that used by the centurion at the Crucifixion.
216  'Ic geann Eadmunde minon brether thæs swurdes the Offa cyng ahte' (Whitelock *Wills*, p. 58).
217  '. . . spata I cum auro purissimo ligata . . .' (*Lib. Pont.*, II, p. 148.
218  '. . . duo scuta optima bocelata et duas optimas lanceas et duas optimas spatas operatas et probatas . . .' (*Institvta Regalia . . . Camerae Regvm Longobardorum . . .*, ed. A. Hofmeister in *Mon. Germ. Hist. SS.*, XXX, 2, p. 1452). For further comment on the compounding of import taxes by the Anglo-Saxons, see below, p. 149.
219  Attenborough *op. cit.*, p. 74 (19.3).
220  *Ibid.*, p. 136 (15).
221  'Ælfnothe minon swurdhwitan thæs sceardan malswurdes' (*ibid.*, p. 60).
222  '. . . thæs swurdes mid tham sylfrenan hiltan the Wulfric worhte . . .' (*ibid.*, p. 56).
223  'And thone gyldenan fetels. And thæne beh the Wulfric worhte . . .' (*idem*).
224  H. R. Ellis Davidson *The Sword in Anglo-Saxon England* (Oxford, 1962), pp. 43 and 52.
225  See above, this chapter, note 188.
226  *The Laws of Hywel Dda*, ed. Melville Richards (Liverpool, 1954), pp. 41–2.
227  British Library Add. MS. 40,000 fol. 4r: 'Ælfric and Wulfwine Eadgife goldsmithes geafen to brotherrædenne twegen orn weghenes goldes that is on this ilce boc her for uten gewired'. I owe the reference to A. J. Robertson (*Anglo-Saxon Charters*, p. 476).
228  I, 74b: 'Leuiede fecit et fecit aurifrisium regis et reginae'.
229  See above, this chapter, note 142.
230  F. E. Harmer *Anglo-Saxon Writs* (Manchester, 1952), p. 292.
231  'SVMARLETHAN HVSCARL ME FECIT' as read by Haigh in 1857 and partly supported by rubbings in the British Museum, though now illegible (Elisabeth Okasha *Hand-list*, No. 98 with bibliography).
232  *The Crawford Collection of Early Charters and Documents* ed. A. S. Napier and W. H. Stevenson (Oxford, 1895), p. 23.
233  P. H. Sawyer *Anglo-Saxon Charters* (London, 1968), Nos. 1344 and 1365. The leases were to revert to the church at Worcester.
234  See above, this chapter, note 188.

235 Eddius *Life of St Wilfrid*, p. 28.

236 Whitelock *Wills*, pp. 10–12.

237 Whitelock *The Will of Æthelgifu*, p. 13.

238 *Idem.*

239 Birch *Cartularium*, 1254.

240 The account is in *Liber Eliensis*, II, 105, pp. 183–4.

241 With the reservation that 'the term *mynetere* itself may well refer both to the gentleman, who farmed the office, and to the craftsman working in the mint', H. R. Loyn says that the signatures of goldsmiths responsible for mints show that they had names 'much more often than not of a type characteristic of the thegnly class, dithematic such as Wulfbold, Wulfhere, Leofric, and the like, rather than monothematic' (*Anglo-Saxon England and the Norman Conquest*, p. 125).

242 Grimbald: see *Domesday Book* I, 74.

243 ed. Melville Richards, p. 120.

244 *Ibid.*, pp. 41–2.

245 'Gif thu bearn hæbbe, lær tha cræftas thæt hi mægen be tham libban' (*Dialogue of Salomon and Saturn*, ed. John M. Kemble, p. 260, No. 20).

246 'Leorna hwæthwæge cræftas; theah the thine sæltha forlæton, ne forlæt thu thinne cræft' (*ibid.*, p. 264, No. 57).

247 'Ærest fram Leofan hagan west andlang cypstræte o hit cym to flæsc-mangere stræte; andlang flæscmangara stræte et it cym to scyldwyrhtana stræte; andlang scyldwyrhtana stræte east eft æt hit cym to Leofan hagan' (J. M. Kemble *Codex Diplomaticus Aevi Saxonici*, VI (London, 1848), p. 135; Sawyer, No. 889).

248 Frank Barlow *et al. Winchester in the Early Middle Ages*, ed. Martin Biddle (Oxford, 1976), p. 235.

249 *Ibid.*, p. 234.

250 *Idem.*

251 'And .IX. hagan on Wintancestre on Tænnere stret . . .' (Kemble, III, 1845, No. 673, p. 252; Sawyer, No. 874).

252 G. F. Jensen 'The name Coppergate', in *Interim* (Bulletin of the York Archaeological Trust), vol. 6, No. 2, pp. 7–8.

253 E. Ekwall *Street-Names of the City of London* (Oxford, 1954), pp. 49–50, 79, 116.

254 All the information in this paragraph has been kindly given me by Dr Alexander R. Rumble.

255 A. J. Robertson *Charters*, No. 60; *The Place-Names of the West Riding of Yorkshire*, ed. A. H. Smith, p. 281 (*English Place-Name Society* V, Cambridge, 1928).

256 *The Place-Names of the West Riding of Yorkshire*, ed. A. H. Smith, Part IV, p. 108 (*English Place-Name Society* XXXIII, Cambridge, 1961). *The Place-Names of Wiltshire*, ed. J. E. B. Gover, A. Mawer, F. M. Stenton, p. 244 (*English Place-Name Society* XVI, Cambridge, 1939).

257 'ful oft he gehyrdeth  ond gehyrsteth wel / brytencyninges beorn,  ond

he him brad syleth / lond to leane' (ll. 74–6, *A.S.P.R.*, III, p. 156).

258  'ob studium quam mihi auri argentique fabrica sollicite deservit atque decorat' (Birch *Cartularium*, 879).

259  Robertson *Anglo-Saxon Charters*, p. 145.

260  'Erat . . . quidam vir, Godwinus nomine . . . qui . . . dedit Deo et sanctae Mariae et sancto Benedicto Ramesiae totam terram de Hecham, quae sui juris erat, praeter trium tantum hominum tenuram, Aethelwaldi, scilicet, dapiferi sui, Lefrici aurifabri, et Wlfgari' (*Historia Ramesiensis*, p. 83: L-B, 5157).

261  His name was Theodoric. See *Domesday Book*, I, 36b, 63, 160b.

262  His name was Otto. See *Domesday Book*, I, 3b and 190: *Domesday Book*, II, 97b, 106b and 286b.

263  Robertson *Anglo-Saxon Charters*, p. 80, where we learn that Wulfnoth the painter (*Wulnothe metere*) with his own son acting as one of his sureties, sold Oxney '25 acres by measure, and outside the island 60 pieces of land which amount to 30 acres . . .'

264  Sawyer *Anglo-Saxon Charters*, No. 853.

265  F. E. Harmer *Anglo-Saxon Writs* (Manchester, 1952), pp. 353–4.

266  I, 74b.

267  See below, p. 233.

268  Or, at least, those with German names like Theodoric and Otto (see this chapter, notes 261 and 262).

269  See above, p. 65.

270  Olaf von Feilitzen and Christopher Blunt 'Personal names on the coinage of Edgar', in *England before the Conquest*, ed. P. Clemoes and K. Hughes (Cambridge, 1971), pp. 208–9.

271  See this chapter, note 228.

272  His name was Theodoric: *Domesday Book*, I, 36b.

273  *Domesday Book*, I, 63b.

274  *V.C.H. Berkshire*, III, p. 367.

275  I, 41 and 182.

276  I, 187, 187b, 202, 298; and II, 279b.

277  I, 79b, 90, 110b, 152b, etc. etc.

278  'ingeniator': I, 365b. He was perhaps involved in making engines of war.

279  *Winchester in the Early Middle Ages* ed. Martin Biddle (Winchester Studies I, Oxford, 1976), p. 57 No. 166.

280  *Ibid.*, p. 49 No. 94.

281  *Ibid.*, p. 68 No. 294.

282  *Ibid.*, p. 48 No. 91 – 'Elfegus tornator'.

283  *Ibid.*, p. 72 No. 27; p. 80 No. 120; p. 81 No. 133; p. 97 Nos. 379 and 382.

284  On the deterioration of this term, see Nikolaus Pevsner 'The term *Architect* in the Middle Ages' in *Speculum* XVII, 1942, especially pp. 551–5.

285  The work-force that Benedict Biscop brought from Gaul to build the church at Monkwearmouth was described by the earliest authority (one of Biscop's own monks) in the anonymous *Historia Abbatum* as *architecti*,

and they were both to direct and to carry out the work on the church: 'quorum magisterio et opere basilicam de lapide faceret' (ed. Plummer, p. 390). Bede, who knew this source and was himself educated under Biscop, referred to the same men simply as stone-masons: *cementarii*, but, when a very similar work-force went to build a church in Scotland, he also uses the term *architecti* (*Hist. Abb.* p. 368, and *Hist. Eccles.*, ed. Plummer, p. 333). This same word *architecti* becomes *master-craftsmen in stone-work* – 'sumne heahcræftigan stangeworces' – when Bede's *Ecclesiastical History* is translated into Old English, as Plummer points out (II, p. 331).

286  See reference to Wigberhtus above, p. 47.

287  *Vita Balderici ep. Leodiensis* (*Mon. Germ. Hist. SS.*, IV, p. 730).

288  *Ibid.*, p. 630.

289  The Italian artist, Nivardus, was working on wall-paintings at St Benoît-sur-Loire. See Victor Mortet *Recueil de Textes*, I (Paris, 1911), pp. 37–8.

290  Goscelin (*La Légende de Ste. Édith*, p. 50) sees him primarily as a priest: 'inter sacerdotes Wiltonie . . . memoratur Benna Treverensis canonicus de Sancti Paulini patrocinio'. A later poem describes him as St Edith's teacher (C. Horstmann *S. Editha sive Chronicon Vilodunense* (Heilbronn, 1883), l. 1381).

291  See last note.

292  E. A. Freeman *The History of the Norman Conquest in England*, vol. I (Oxford, 1867), p. 634. The fact that Trier gave Wilton a fragment of the relic of the nail of the Holy Cross which was collected by Benna (Wilmart, p. 73; Horstmann, ll. 1377–1407) no doubt reflects Egbert's English interests.

293  See below, pp. 92–3.

294  See above, p. 55.

295  See below, p. 92.

296  See C. R. Dodwell *Painting in Europe 800–1200* (London, 1971), plate 9.

297  Thangmar *Vita Bernwardi Episcopi* in *Mon. Germ. Hist. SS.*, IV, *Cap.* 1, p. 758 (see also *Cap.* 6).

298  At one time a supervisor of the royal mint of Denmark, Anketil features prominently in the *Gesta abbatum S. Albani* (I, pp. 83–7) as an 'aurifaber incomparabilis' and as the monk who made the shrine for the translation of the abbey's patron saint in 1129. For him are also claimed the more important pictures of the St Albans Psalter (see Professor Pächt in *The St Albans Psalter* by Otto Pächt, C. R. Dodwell, Francis Wormald (London, 1960), pp. 172 ff.).

299  Hugo, sacrist of Bury *c.* 1130–40, cast the bronze doors there and 'incomparabiliter fecit depingi' a great Bible by his own hand. The latter is identified as the magnificent Bury Bible in Corpus Christi College, Cambridge (*Gesta sacristarum monasterii S. Edmundi*, pp. 289–90, in *Memorials of St Edmund's Abbey*, II).

300  It is already apparent in the 'Dunstan' drawing of the mid tenth century (see plate 8) and continues on until the eve of the Conquest when it appears in a somewhat heavy form in the St John of the Winchester

Crucifixion scene: British Library Arundel MS. 60, fol. 10, 12 v. (Wormald *English Drawings*, plate 33).

301 '. . . prius arte clari, deinde infames scelere' (*La Légende de Ste. Édith*, p. 280: L-B, 4628).

302 See above, p. 52.

303 See above, p. 74.

304 See H. R. Lyon 'Boroughs and mints A.D. 900–1066', and R. H. M. Dolley and D. M. Metcalf 'The reform of the English coinage under Eadgar', both in *Anglo-Saxon Coins, Studies presented to F. M. Stenton* ed. R. H. M. Dolley (London, 1961), pp. 125 and 147.

## Chapter IV *Painting and carving*

1 '. . . ueniebant crucem pro uexillo ferentes argenteam, et imaginem Domini Saluatoris in tabula depictam . . .' (Bede *Hist. Eccles.*, I, 25, ed. Plummer, pp. 45–6; ed. Colgrave and Mynors, p. 74).

2 J. M. C. Toynbee *Art in Roman Britain* (London, 1962), pp. 195–6.

3 St Gregory, epistle 13 in *Pat. Lat.*, LXXVII, col. 1128: 'Nam quod legentibus scriptura, hoc idiotis praestat pictura cernentibus, quia in ipsa etiam ignorantes vident quid sequi debeant, in ipsa legunt qui litteras nesciunt. Unde et praecipue gentibus pro lectione pictura est.'

4 '. . . picturas imaginum sanctarum quas ad ornandam aecclesiam beati Petri apostoli, quam construxerat, detulit; imaginem uidelicet beatae Dei genetricis semperque uirginis Mariae, simul et duodecim apostolorum, quibus mediam eiusdem aecclesiae testudinem, ducto a pariete ad parietem tabulato praecingeret; imagines euangelicae historiae quibus australem aecclesiae parietem decoraret; imagines uisionum apocalipsis beati Iohannis, quibus septentrionalem aeque parietem ornaret . . .' (*Hist. Abb.*, 6, p. 369). This was from his fifth visit to Rome. From his next visit '. . . dominicae historiae picturas quibus totam beatae Dei genetricis, quam in monasterio maiore fecerat, aecclesiam in gyro coronaret, adtulit' (*ibid.*, 9, p. 373).

5 This is the generally accepted interpretation of the Latin even though scholars as distinguished as Adolph Goldschmidt and Ernst Kitzinger have considered other possibilities such as their being illuminated manuscripts as small-scale prototypes. Dom Paul Meyvaert deals definitively with the subject in his article 'Bede and the church paintings at Wearmouth/Jarrow', in *Anglo-Saxon England* 8, ed. Peter Clemoes (Cambridge, 1979) pp. 63–77. Since questions of the problem of transport have been raised, one might perhaps point to the fact that slabs, or blocks, of marble were being transported from Italy and northern Europe to England during the Anglo-Saxon period. See above, chapter II, notes 110–12.

6 *Ibid.*, p. 72.

7 '. . . quatinus intrantes aecclesiam omnes etiam litterarum ignari, qua-quauersum intenderent, uel semper amabilem Christi sanctorumque eius, quamuis in imagine, contemplarentur aspectum; uel dominicae incarnationis gratiam uigilantiore mente recolerent; uel extremi discri-men examinis, quasi coram oculis habentes, districtius se ipsi examinare meminissent' (*Hist. Abb.*, 6, pp. 369–70).

8 '. . . imagines quoque ad ornandum monasterium aecclesiamque beati Pauli apostoli de concordia ueteris et noui Testamenti summa ratione conpositas exibuit; uerbi gratia, Isaac ligna, quibus immolaretur portantem, et Dominum crucem in qua pateretur aeque portantem, proxima super inuicem regione, pictura coniunxit. Item serpenti in heremo a Moyse exaltato, Filium hominis in cruce exaltatum conparauit' (*ibid.*, 9, p. 373).

9 I Corinthinians X,6.

10 I Peter III,20–1.

11 Julius von Schlosser *Quellenbuch zur Kunstgeschichte des Abendländischen Mittelalters* (Wien, 1896), I.

12 *Ibid.*, VI.

13 H. M. Taylor and J. Taylor *Anglo-Saxon Architecture*, I (Cambridge, 1965), p. 440.

14 Paul Meyvaert *op. cit.*, p. 74.

15 *Idem.*

16 This would still form a *tabulatum* as Dom Paul Meyvaert suggests the single row of pictures was (*idem*). His own view seems to me to be a reasonable one, but, in an area where there is too much speculation amongst art-historians, I am trying to distinguish between historic fact and reasonable theory.

17 Francis Wormald *The Miniatures in the Gospels of St Augustine* (Cambridge, 1954), plate I.

18 *Ibid.*, plate II.

19 The Valenciennes illustrations are most conveniently consulted in J. J. G. Alexander *Insular Manuscripts* (London, 1978), ills. 302–309 where (pp. 82–3) a full bibliography is given.

20 See P. K. Klein *Trierer Apocalypse Vollstandige Faksimile – Ausgabe Kommentarband* (*Codices Selecti*, XLVIII, 1975), pp. 52 ff., 104 ff.

21 In the framework of folio 3, as Carl Nordenfalk has already pointed out (*Celtic and Anglo-Saxon Painting* (London, 1977), p. 87).

22 C. R. Dodwell *Painting in Europe 800–1200* (London, 1971), pp. 24, 40–1.

23 A tomb at Jouarre, traditionally associated with the seventh-century bishop, Agilbert, has a carved figure of the enthroned Christ flanked by figures holding both arms aloft in the *orans* gesture of prayer, and it has been argued that this simpler and earlier scene represents the Last Judgment (Jean Hubert *et al. Europe in the Dark Ages* (London, 1969), pp. 72–4).

24 By Dom Paul Meyvaert (see note 5 of this chapter).

25 '. . . pincturas sanctarum historiarum quae non ad ornamentum solummodo ecclesiae uerum et ad instructionem intuentium proponerentur aduexit uidelicet ut qui litterarum lectionem non possent opera domini et saluatoris nostri per ipsarum contuitum discerent imaginum' (*Hom.*, I, 13, ed. D. Hurst, *Corpus Christianorum, Series Latina* 122 (Turnholt, 1955), p. 93).

26 Dom Paul Meyvaert (*op. cit.*, p. 68) suggests that Nothelm had recently brought news from Rome of an iconoclastic movement beginning in the East.

27 Apart from one small adjustment, I take the translation from Dom Paul Meyvaert (*op. cit.*, p. 69). 'Si enim licebat serpentem exaltari aeneum in ligno quem aspicientes filii Israhel uiuerent, cur non licet exaltationem domini saluatoris in cruce qua mortem uicit ad memoriam fidelibus depingendo reduci uel etiam alia eius miracula et sanationes quibus de eodem mortis auctore mirabilitus triumphavit cum horum aspectus multum saepe compunctionis soleat praestare contuentibus et eis quoque qui litteras ignorant quasi uiuam dominicae historiae pandere lectionem? . . . Si licuit duodecim boues aeneos facere . . . quid prohibet duodecim apostolos pingere quomodo euntes docerent omnes gentes . . . et ita dixerim prae oculis omnium designare scriptura? Si eidem legi contrarium non fuit . . . sculpturas histriatas . . . fieri, quomodo legi contrarium putabatur si historias sanctorum ac martyrum Christi sculpamus siue pingamus in tabulis . . .' (ed. D. Hurst *Corpus Christianorum, Series Latina*, 119a (Turnholt, 1969), pp. 212–13).

28 'Quibus uerbis aperte declaratur quod illae similitudines fieri prohibentur ab hominibus quae in uenerationem deorum alienorum facere solent impii quaeque ad colendum atque adorandum gentilitas errabunda repperit. Ceterum similiter haec fieri nulla ut reor legis diuinae littera uetuit, alioquin et dominus temptantibus se Pharisaeis de tributo Caesari reddendo in quo nomen et imaginem Caesaris expressam esse dicebant nequaquam ita responderet, 'Reddite quae sunt Caesaris Caesari et quae sunt Dei Deo', sed potius eorum corrigeret errorem dicens, Non licet uobis in percussura auri uestri imaginem facere Caesaris quia talem sculpturam lex diuina prohibet. Esset namque locus ut ostenso sibi numismate census hoc diceret, si in eo Caesaris imago causa idolatriae et non ad indicium magis regiae potestatis esset deformata' (*ibid.*, p. 213).

29 ed. Hubertus Bastgen in *Mon. Germ. Hist. Legum Sectio III Concilia Tomi II Supplementum.*

30 Bastgen's view that the author was Alcuin is no longer generally accepted. Dr Ann Freeman has suggested Jonas of Orleans but the subject is still controversial.

31 For example, his *De schematis et tropis*, and his *In S. Joannis Evangelium Expositio.*

32 *Op. cit.*, p. 70.

33 *Ibid.*, pp. 90, 139.

34  *Ibid.*, p. vii.

35  Richard Gem and Pamela Tudor-Craig 'A "Winchester School" wall-painting at Nether Wallop, Hampshire' in *Anglo-Saxon England* vol. 9, pp. 115–36.

36  Peter Clemoes 'Cynewulf's image of the Ascension', in *England before the Conquest*, ed. P. Clemoes and K. Hughes (Cambridge, 1971), p. 304.

37  'Excavations at Winchester 1966: fifth interim report' by M. Biddle in *The Antiquaries Journal*, XLVII, Part II, 1967, p. 277.

38  Ailred of Rievaulx said 'picturis et caelaturis multiphariam decoravit' (J. Raine *The Priory of Hexham* . . ., I, p. 175: L-B, 2111). Richard of Hexham elaborated further and spoke of the walls, capitals and arch of sanctuary being adorned with sculptured figures and pictures (Twysden, *Historiae Anglicanae Scriptores decem* (London, 1652), col. 290). Though made in good faith, such statements, almost five hundred years after the event, have little weight as historical evidence.

39  See above, p. 169.

40  'Editha . . . totam uero basilicam, tam solaria quam parietes omnicolore pictura per manum artificiosi Benne decoravit passionis dominice monumenta, ut in corde depinxerat, imaginata exposuit' (Goscelin *La Légende de Ste. Edith*, p. 87: L-B, 4615).

41  *Idem.*

42  *S. Editha sive Chronicon Vilodunense* ed. C. Horstmann (Heilbronn, 1883).

43  *Ibid.*, p. vi.

44  Lines 1780–3.

45  '. . . totamque ecclesiam . . . superius opere pictoris, quod caelum vocant, auro multiformiter intermixto mirabili arte constravit' (*Chronica ecclesiae Eboracensis*, pp. 353–4: L-B, 326).

46  '. . . picturis caelaturisque infra et extra ubique locorum delectabile visu subornatis . . .' (*Chronicon Abingdon*, I, p. 474: L-B, 107).

47  'Trium tantum horum abbatum nomina rerum praeteritarum recordatrix manifestat pictura, quae sunt Worgret, Lademund, Bregored' (William of Malmesbury *De antiquitate Glastoniensis*, col. 1701: L-B, 1874).

48  'Hujus [Stiwardi] mores a nomine non discedisse picturae testantur, semper cum in omni imagine sua cum flagello vel scopa repraesentantes' (*ibid.*, col. 1712: L-B, 1875).

49  'ex figuratis imaginibus Dunstano visus est simillimus . . .' (Stubbs *Memorials*, p. 143).

50  One pre-Conquest drawing of St Dunstan in a Canterbury manuscript was copied into another later manuscript (see Dodwell *Canterbury School*, p. 5, plates 3a and 3b). Gervase (*Chronica*, p. 13) refers to an image of St Dunstan on the beam of the cathedral in the twelfth century but it is not likely that this was pre-Conquest.

51  Bede *Hist. Eccles.*, ed. Plummer, I, 29, p. 63; ed. Colgrave and Mynors, p. 104.

52  See above, p. 11.

53  '. . . bibliothecam utriusque monasterii, quam Benedictus abbas magna caepit instantia, ipse non minori geminauit industria; ita ut tres pandectes nouae translationis, ad unum uetustae translationis quem de Roma adtulerat, ipse super adiungeret; quorum unum senex Romam rediens secum inter alia pro munere sumpsit, duos utrique monasterio reliquit' (Bede *Hist. Abb.* 15, pp. 379–80). Also *Hist. Abb. auct. anonymo* 20, p. 395.

54  R. L. S. Bruce-Mitford *The Art of the Codex Amiatinus* (Jarrow Lecture 1967), p. 2.

55  T. Arnold *Memorials of St Edmunds Abbey* (London, 1890–6), p. 290.

56  'dato quoque Cosmographiorum codice mirandi operis, quem Romae Benedictus emerat, terram octo familiarum iuxta fluuium Fresca ab Aldfrido rege . . . in possessionem monasterii beati Pauli apostoli comparauit' (Bede *Hist. Abb.*, 15, p. 380). Aldfrith died before the completion of the exchange but his successor accepted the manuscript in part exchange for a much larger area of land.

57  See above, p. 32.

58  'Bibliothecam quam de Roma nobilissimam copiosissimamque aduexerat . . .' (*Hist. Abb.* 11, p. 375).

59  See below, chapter VII, note 155.

60  *De Pontificibus*, ll. 1535 ff.

61  'Inter caetera magnifica munera quae ibidem dempsit, dedit gloriosum pandecten, id est bibliothecam egregiam . . .' (*Vita Oswaldi*, in J. Raine *The historians of the church of York . . .*, vol. I (London, 1879), p. 463: L-B, 6406).

62  *Anglo-Saxon Charters* ed. A. J. Robertson (Cambridge, 1939), p. 72.

63  Whitelock *Wills*, p. 4.

64  No. 10 of *The Crawford Collection of Early Charters and Documents* ed. A. S. Napier and W. H. Stevenson (Oxford, 1895).

65  Whitelock *Wills*, p. 14.

66  Corpus Christi College MS. 286, published by Francis Wormald in *The Miniatures in the Gospels of St Augustine* (Cambridge, 1954).

67  E. A. Lowe *Codices Latini Antiquiores* II (Oxford, 1935), No. 126.

68  '. . . innumerabilem librorum omnis generis copiam adportauit' (Bede *Hist. Abb.*, p. 369).

69  'En vehebant volumina / Numerosa . . .' (*Aethilwaldi carmen*, ll. 107–8, in *Aldhelmi Opera*, ed. R. Ehwald, p. 531).

70  The information is in the ninth-century Paris manuscript, Bib. Nat. cod. lat. 12, 949 which was published by Traube in 1902 in *Neues Archiv der Gesellschaft für Ältere Deutsche Geschichtskunde* XXVII, pp. 277–8 (where, owing to a slip, it is referred to as Bib. Nat. cod. lat. 12, 940) and republished in 1920 in his *Vorlesungen und Abhandlungen*, III, pp. 239 ff. The relevant part is as follows: 'Quod ita ab antiquis intellectum testatur etiam pictura eiusdem libri, quem reverentissimus ac doctissimus vir Chuduini, orientalium Anglorum antistes, veniens a Roma, secum

Britanniam detulit, in quo videlicet libro omnes paene ipsius apostoli passiones sive labores per loca oportuna erant depicta. Ubi hic locus ita depictus est, quasi denudatus iaceret apostolus laceratus lacrimisque perfusus, super asstaret ei tortor quadrifidum habens flagellum in manu, sed unam e fidibus in manu sua retentam, tres vero reliquas solum ad feriendum habens exertas'.

71  See W. Koehler in Paul Clemen *Belgische Kunstdenkmaler* (Munich, 1923), I, pp. 7–11.

72  Bruce-Mitford *The Art of the Codex Amiatinus*, pp. 11 ff.

73  *Gesta Pontificum*, pp. 376–8.

74  *Symeonis monachi opera*, I, pp. 63–4.

75  'Habuerat librum Evangeliorum, gemmis et auro perornatum, in quo quatuor Evangelistarum imagines pictura auro admixta decorabat, set et capitalis quaeque littera auro tota rutilabat' (Turgot *Vita S. Margaretae*, p. 250).

76  See above, chapter I, note 88.

77  'Illud quoque mihi memorandum est quod ante hos septem annos rex Anglorum duci Aquitaniae regalia munera misit, simulque codicem litteris aureis scriptum, in quo nomina sanctorum distincta cum imaginibus continebantur . . .' (*Acta Concilii Lemovicensis*, II by Jordanus Lemovicensis episcopus, in *Pat. Lat.*, CXLII, col. 1369).

78  'Hic dedit . . . librum orationum auro pictum' (William of Malmesbury *De antiquitate Glastoniensis*, col. 1722: L-B, 1854).

79  'dedit etiam collectaneum auro illuminatum' (*ibid.*, col. 1723: L-B, 1859).

80  'Hic Eadgar rex privilegium quoddam totum aureis litteris scriptum in novum contulit monasterium' (*Annales Wintonienses . . .*, p. 69, in F. Liebermann *Ungedruckte Anglo-Normannische Geschichtsquellen* (Strassburg, 1879): L-B, 6405).

81  Wulfstan in his *Life of St Æthelwold* speaks of 'priuilegiis, diuina simul et regia auctoritate conscriptis, quae laminis aureis sigillata inibi usque hodie conseruantur' (Winterbottom *Three Lives*, p. 46). I owe the reference to Professor Whitelock.

82  When, according to Asser, King Alfred was a boy, his mother promised a book of Saxon poems to whichever son of hers learned it most quickly. Alfred was the successful one, since he had been 'pulchritudine principalis litterae illius libri illectus' (*Asser's Life of King Alfred* ed. W. H. Stevenson (Oxford, 1904), p. 20).

83  See above, chapter I, note 88.

84  *Aethilwaldi Carmen de transmarini itineris peregrinatione* (R. Ehwald *Aldhelmi Opera*, pp. 528–33).

85      '. . . addunt . . .
            Toracidas, tuentibus
            Retorquentes luminibus
            Imagines auriferis
            Christi matris capitibus'
        (ll. 172–6).

86  Ehwald says of *toracidae*: 'hae sunt imagines Sanctae Mariae pectore tenus (Byzantinorum more) pictae' and he quotes from Aldhelm and Adamnan (p. 532, note). W. Levison sees them as bust-pictures: '*Thoracic(u)la* ist von *thorax* "Brustbild" abgeleitet wie *crucicula* von *crux*. Das seltene Wort ist wohl durch die *Actus Silvestri* bei Iren und Angelsachsen bekannt geworden, von denen es Adamnan, Aldhelm and Aethilwald verwenden' (*Konstantinische Schenkung und Silvester Legende*, p. 196, in *Miscellanea Francesco Ehrle* II = *Studi e Testi* XXXVIII, Rome, 1924).

87  See below, note 90 of this chapter, where Aldhelm's reference to the 'pulcherrima membrorum liniamentia' certainly suggests something more than a bust-picture.

88  R. Garrucci *Storia dell' arte cristiana* III (Prato, 1876) tav. 178, figs. 6–12.

89  Ed. C. R. Dodwell, p. 46. Gilded tesserae for mosaics are being described.

90  '. . . quemammodum solent nobilium artifices imaginum et regalium personarum pictores deauratis petalis toracidas ornare et pulcherrima membrorum liniamenta fabrefactis cultibus decorare . . .' (*De Virginitate*, pp. 321–2 in *Aldhelmi Opera*, ed. R. Ehwald).

91  John Beckwith *Ivory Carvings in Early Medieval England* (London, 1972).

92  '. . . parva quaedam munuscula . . .id est capsam unam ad officium quidem sacerdotale ex ossibus fabricatam . . .' (Tangl *Briefe*, p. 253).

93  See below, p. 41.

94  See below, pp. 202–3.

95  See below, p. 201.

96  See below, p. 200.

97  *Gesta abbatum S. Albani*, I, p. 29: L-B, 3794.

98  *Ibid.* pp. 83–4: L-B, 3835; *Chronica maiora Matthaei Parisiensis monachi S. Albani* ed. H. R. Luard, vol. VI (London, 1882), p. 387: L-B, 3970.

99  Martin Henig *Corpus of Roman Engraved Gemstones from British Sites* (*British Archaeological Reports* 1974, part i, p. 198 and fig. opposite p. 198).

100  Peter Hunter Blair *The World of Bede* (London, 1970), p. 102.

101  This is admirably surveyed in Michael Swanton *The Dream of the Rood* (Manchester, 1970), p. 42 ff.

102  Cited F. M. Stenton *Anglo-Saxon England* (Oxford, 1975), p. 150.

103  Talbot *Anglo-Saxon Missionaries*, pp. 154–5.

104  This is in the context of a miracle at St Guthlac's birth in which a shining hand reached out from the skies as far as the arms of a cross in front of the house where he was being born: '. . . ad patibulum cuiusdam crucis ante ostium domus qua sancta puerpera futurae indolis infantulum enixa est, porrecta videbatur' (Felix's *Life of St Guthlac*, p. 74).

105  Talbot, pp. 109–110.

106  There is some evidence that this was occasionally done – for example, at Yeavering and possibly also at Lullingstone and Stone-by-Faversham – see Martin Biddle in *England before the Conquest*, ed. Clemoes and Hughes, p. 405.

107  Bede *Hist. Eccles.*, ed. Plummer, p. 65; ed. Colgrave and Mynors, pp. 106–8.

108 'Qui vero infra tres cruces lapideas, mirifice sculptas, et, ad introitum Beverlaci tunc ab eodem rege erectas, hanc pacem violaverit . . .' (*Alia miracula S. Johannis episcopi* in James Raine *The Historians of the Church of York*, I, Rolls Series (London, 1879), p. 298: L-B, 323).

109 The account is in William of Malmesbury *De Gestis Pontificum*, pp. 383–4, and it concludes: 'Manent omnes cruces, nec ulla earum vetustatis sensit injuriam; vocanturque biscepstane, id est lapides episcopi; quarum unam in claustro monachorum in promptu est videre'.

110 'ad crucis excelsae, princeps quam condidit ipse, / adponunt signum sacrate membra quieti' (Æthelwulf *De Abbatibus*, ed. Campbell, ll. 538–9).

111 'Fecerat iste de lapide crucem artifici opere expoliri, et in sui [Cuthberti] memoriam suum in eo nomen exarari' (*Symeonis monachi opera*, I, p. 39: L-B, 1393). The cross was later damaged by the Vikings and then repaired.

112 'Duaeque cruces lapideae mirabili celatura decoratae positae sunt, una ad caput, alia ad pedes ejus . . .' (*Symeonis monachi opera*, II, p. 33: L-B, 2096).

113 See T. D. Kendrick *Anglo-Saxon Art* (London, 1938), p. 134 note 2.

114 'arcus et columnas super sanctorum corpora Romana elegantia sollemniter aedificatos abstulit . . . de ipsis vero columnis et arcubus monasterii sui claustrum exornavit' (Goscelin *Historia translationis S. Augustini, Pat. Lat.*, CLV, col. 30: L-B, 638).

115 'Jacet [Wulstanus] inter duas piramides, arcu lapideo pulchre supervoluto' (William of Malmesbury *Gesta Pontificum*, p. 288: L-B, 4865).

116 '. . . conspexit virum . . . in cacumine stantem praescriptae pyramidis . . .' (*Translatio . . . S. Swithuni auct. Lantfredo monacho*, p. 392, in *Analecta Bollandiana*, IV: L-B, 4683).

117 '. . . ubi columnae marmoreae . . . super lapidem pyramidis fundabantur inferiorem . . .' (*Alia miracula S. Johannis episcopi*, in J. Raine *The Historians of the Church of York*, I, pp. 342–3: L-B, 342).

118 'Ipse namque sanctissimus pater ante ipsos gradus in magna profunditate terrae jacebat humatus, tumba super eum in modum pyramidis grandi sublimique constructa . . .' (J. Raine *The Historians of the Church of York*, vol. I, p. xlvi: L-B, 658).

119 See below, note 137 of this chapter.

120 *Idem.*

121 One of them, at least, is in its original socket and the present church was built on the site of the Anglo-Saxon one.

122 J. G. Lockhart *Life of Sir Walter Scott*, vol. 10, p. 107 (London and Edinburgh, 1839). The reference here to the 'gigantic' effigy reflects the legend that the two stone shafts marked a giant's grave.

123 'In the church-yard of Penrith, on the north side thereof, stand two pyramidal stones, near four yards in height, at five yards distance from each other' (J. Nicolson and R. Burn *The History and Antiquities of the*

*Counties of Westmorland and Cumberland*, 2 vols., (London, 1977), vol. 2, p. 410).

124  '. . . ad lapideam staurum . . . in cacumine . . . praescriptae pyramidis . . .' (*op. cit.*, pp. 391–2: L-B, 4683).

125  See J. M. C. Toynbee *Death and Burial in the Roman World* (London, 1971), pp. 127–8 and plate 33.

126  G. Rushforth *Magister Gregorius De Mirabilibus Urbis Romae*, p. 56 (in *The Journal of Roman Studies* IX, 1919).

127  *Idem.*

128  *Idem.*

129  See this chapter, note 125.

130  Rushforth *op cit.*, p. 18.

131  'Sunt autem piramides sepulcra potentum' (*ibid.*, p. 56).

132  *Idem.*

133  In chapter V of his *Hydriotaphia: Urne-Burial.*

134  'Praetermitto etiam de Kenwino in una piramide locato' (*De antiquit. Glast.*, col. 1700: L-B, 1872, spelling as in original manuscript. .

135  R. I. Page 'The Bewcastle Cross', in *Nottingham Mediæval Studies*, ed. Lewis Thorpe, IV (1960), p. 57.

136  *Ibid.*, pp. 56–7.

137  'Illud quod clam pene omnibus piramidibus est libenter predicarem, si veritatem exculpere possem, quid ille piramides sibi velint, que aliquantis pedibus ab ecclesia vetusta posite cimiterium monachorum pretexunt. Procerior sane et propinquior ecclesie habet quinque tabulatus, et altitudinem xxvi pedum. Hec pre nimia vetustate, etsi ruinam minetur, habet tamen antiquitatis nonnulla spectacula que plane possunt legi, licet non plene possint intelligi. In superiori vero tabulatu est imago pontificalis scemate facta. In secundo ymago regiam pretendens pompam et litterae: her, sexi et blisyer. In tertio nihilominus nomina: Wemcrest, bantomp, winethegn. In quarto: hate, wulfred, et eanfled. In quinto qui et inferior est imago et hec scriptura: logthor, weslicas et bregden, swelpes, hwingendes, bern. Altera vero pyramis habet xviii pedes et quatuor tabulatus, in quibus hec leguntur: Hedde episcopus, et bregored et beoruuard . . .' (*Pat. Lat.*, CLXXIX, col. 1700, corrected from Cambridge, Trinity College MS. R 5 33 (724) fol. 7, col. 2).

138  See Osbern's *Vita S. Dunstani* in Stubbs *Memorials*, p. 113 (L-B, 4677).

139  William of Malmesbury in his *De antiquitate Glastoniensis* (col. 1698) has a section on speaking Crucifixes at Glastonbury which includes 'alia crux antiquissima, quae olim in refectorio stare consuevit' which was said to have been the one that addressed King Edgar.

140  See his *Vita et miracula Dunstani* (pp. 342–3 of Stubbs *Memorials* and L-B, 4678).

141  The inflated account of the *Vita Haroldi regis* (p. 71; L-B, 4478) tried to account for the fact that the head was bowed by saying that the effigy had inclined its head to Harold.

142 '. . . inestimabilis imago decoris crucifixi Salvatoris ex atro silice, sic manuum extensione et omnium corporis liniamentorum compositione miro fabrili et inaudito opere composita, ut Ipsius Summi Artificis manibus perpendas operatam . . .' (*De inventione Sanctae Crucis Walthamensis*, p. 5: L-B, 3160).

143 'Multiplici igitur opere fabrili gemmarum, auri, et argenti praemunierat se gloriosus heros ille Tovi, quo redimire posset Corpus Crucifixi . . .' (*ibid.*, p. 10: L-B, 4469).

144 '. . . ensem quo primo fuerat accinctus miles factus, circumcinxit imagini, amodo militaturus Illi, et applicato eo super crucem ligneam laminis argenteis fecit involvi, quia se clavis nullo modo permisit infigi' (*ibid.*, p. 12: L-B, 4470).

145 'Uxor autem ejus, Glitha nomine, . . . circumdedit coronam ex auro obrizo, et lapidibus pretiosissimis obstructam . . . Circulum quoque insignem ex auro purissimo quali tunc temporis utebantur nobilissimae matronae, circumcinxit ejus femori, mirifico ornatu constructum, et ex eodem auro subpedaneum ex monilibus et armillis suis compactum . . .' (*ibid.*, p. 12).

146 '. . . comes . . . cum uxore nobili non destitit, toto tempore vitae suae eam auro et argento, ornamentis quoque pretiosis indesinenter ornare' (*ibid.*, p. 13).

147 '. . . imaginem crucifixi . . . imaginem quoque sanctae Dei genitricis Mariae, et Johannis Evangelistae, ipsa [Judith] et ejus conjux [Tosti] fieri jusserunt, et auro argentoque vestierunt . . .' (*Symeonis monachi opera*, I, p. 95: L-B, 1355).

148 '. . . mirifici operis crux . . .' (*ibid.*, p. 245: L-B, 1354).

149 The twelfth-century writer places the translation of the cross in the reign of Cnut but Stubbs (*ibid.*, p. xxviii and p. 13, note) thinks it to be a little later.

150 H. R. Ellis Davidson *Gods and Myths of Northern Europe* (London, 1973), p. 81.

151 *King Olaf Trygvesson's Saga*, LXXVI; and *Saint Olaf's Saga*, CXVIII, CXIX (*Heimskringla* by Snorri Sturluson, transl. Samuel Laing, revised J. Simpson, 2 vols. (London, 1964), II, p. 242; I, p. 63; II, pp. 240, 241, 242).

152 The reference in both the Latin *Life* and the Saga is not to Thor himself but to an idol similar to his. The former says that the son of Gudbrand 'retulit effectum esse in speciem Thoris, mallum manu gestare, statura ingenti . . . intus concavum . . . non deesse auri argentive ornatum . . .'. The Saga's account is that Gudbrand's son 'replied that he bore the likeness of Thor; had a hammer in his hand; was of great size, but hollow within . . . Neither gold nor silver are wanting about him . . .' The first quotation is from *Cap.* 107 of the *Historia de Olavo Sancto (Scripta Historica Islandorum*, IV (Copenhagen, 1833), p. 230); the second is from the *Heimskringla ed. cit.*, II, p. 240.

153  *Heimskringla, ed. cit.*, II, p. 242.

154  C. Marstrander 'Thór en Irlande', *Revue Celtique* XXXVI, 1915–16, pp. 241–53) (p. 243).

155  I am indebted to Professor David Greene of the Dublin Institute for Advanced Studies for his kindness in giving me his expert view on the subject. He tells me that there are no references in Irish texts to the embellishment of statues of Thor.

156  'cruces sculpte parietibusque ecclesie atque porticorum picte sunt' (Ælfrici abbatis Colloquia in *Early Scholastic Colloquies* ed. W. H. Stevenson (Oxford, 1929), p. 100).

157  '. . . in uestibus albis / inclita, sed uario comptim permixta colore, / a dextris uirgo . . .' (ed. Campbell, ll. 202–4).

158  '. . . torhte gefrætwed' (l. 715, *A.S.P.R.*, II, p. 23).

159  M. R. James *The Apocryphal New Testament* (Oxford, 1950), pp. 454–5.

160  Rosemary Cramp *Early Northumbrian Sculpture* (Jarrow Lecture, 1965), p. 3.

161  Elizabeth Okasha 'An Anglo-Saxon inscription . . .', in *Mediæval Archaeology* XI, 1967, p. 249.

162  I owe this information to the kindness of Mr W. J. Rodwell.

163  *Liber Vitae*, ed. Birch, pp. 9–10.

164  'AETHELGARVS . . . ipsius elegantis fabricae [turris] summam . . . biternis segmentorum caelaturis solerter discriminauit: . . . MARIAE suisque uirginibus, primae caelaturae porticum honorifice exornatum . . . dedicauit . . . Secundam denique segmentorum caelaturam SANCTAE TRINITATIS indiuiduae unitatis honore sanctificans: tertiamque uexillo sanctae crucis exornans: Necne quartam omnium sanctorum patrociniis replens: quintamque sub nomine archangeli MICHAELIS omniumque caelestium uirtutum constituens: extremam quatuor euangelistis iure consecrauit . . .' (Birch, p. 10).

165  R. N. Quirk 'Winchester New Minster and its tenth-century tower', *Journal of the British Archaeological Association*, 3rd Series, vol. XXIV, 1961, pp. 16–48.

166  'sed et sculpturae et imagines angelicae cum Dominica majestate super tumbam magnifici Augustini mirifice formatae . . .' (*Historia translationis S. Augustini*, col. 16 in *Pat. Lat.*, CLV: L-B, 700).

167  See J. Bolten *Die Imago Clipeata* (Paderborn, 1937), for an (unillustrated) survey, and, since then, R. Winkes *Clipeata Imago* (1969).

168  J. M. C. Toynbee *Art in Britain under the Romans* (Oxford, 1964), p. 131, fig. 1.

169  'Mox uero ut dedicata est, intro inlatum et in porticu illius aquilonali decenter sepultum est' (*Hist. Eccles.*, ed. Plummer, p. 86; ed. Colgrave and Mynors, pp. 142–4).

170  See H. M. Taylor and Joan Taylor *Anglo-Saxon Architecture* (3 vols. (Cambridge, 1965–78) I, pp. 134–7).

171  *Hist. Eccles.*, ed. Plummer, p. 86; ed. Colgrave and Mynors, p. 144.

172  *Ibid.*, pp. 366–8; pp. 227–8.

173  *Ibid.*, p. 245; p. 394.

174  Toynbee *op. cit.*, p. 210.

175  *Ibid.*, p. 211.

176  Emile Espérandieu *Recueil général des bas-reliefs de la Gaule romaine*, vols. 1–15 (Paris, 1907–66), 1, 59; 2, 1057; 5, 3791; 8, 6486.

177  Though the bust-figure is female.

178  The engraving itself is reversed and this has been corrected by reversing the photograph of it for plate 29c.

179  Jean Adhémar *Influences antiques dans l'art du Moyen Age Français* (London, 1939), p. 78.

180  *Hist. Eccles.*, I, 33.

181  See note 169 of this chapter.

182  'Substrati vero pavimenti, cui beatissima gleba incubuit, lateres puniceos, nitidos . . .' (*Pat. Lat.* CLV, col. 27: L-B, 711).

183  See note 166 of this chapter.

184  IV, 1–3; (Revelation, IV, 1–3).

185  F. van der Meer *Maiestas Domini* (Rome and Paris, 1938), pp. 236–7, 208, 292.

186  Myrtilla Avery *The Exultet Rolls of South Italy*, II (Princeton, London, Oxford, 1936), plate CXII.

187  F. van der Meer *Maiestas Domini*, pp. 255–6, 269, 368, 374.

188  'ad haec videres in altera frontium scrinii quasi maiestatem Dei super aspidem et basiliscum ambulantem . . .' (*Ex miraculis S. Foillani, auct. Hillino*, c. 18, in Otto Lehmann- Brockhaus *Schriftquellen zur Kunstgeschichte des 11. und 12. Jahrhunderts für Deutschland, Lothringen und Italien* (Berlin, 1938), vol. 2, No. 2549.

## Chapter V  *Textiles*

1  'Nunc qui Roma veniunt idem allegant, ut qui Haugustaldensem fabricam vident ambitionem Romanam se imaginari jurent' (Malmesbury *Gesta Pontificum*, p. 255: L-B, 2106).

2  '. . . qui (cementarii) lapideam sibi aecclesiam iuxta Romanorum quem semper amabat morem facerent . . .' (Bede *Hist. Abb.*, p. 368).

3  See above, pp. 84–5.

4  From his third visit to Rome from England 'conpleuit librosque omnis diuinae eruditionis non paucos'; from his fourth visit 'innumerabilem librorum omnis generis copiam adportauit'; from his fifth visit 'magna . . . copia uoluminum sacrorum . . . ditatus'; and, before his death, he gave instructions concerning 'Bibliothecam quam de Roma nobilissimam copiosissimamque aduexerat' (Bede *Hist. Abb.*, pp. 367, 369, 373, 375).

5  See above, p. 64.

6  According to Bede, Biscop was unable to obtain vessels and vestments at

home so he bought them abroad. They may have been included in the *ornamenta* he brought from Rome on his fifth visit (*Hist. Abb.*, 5, pp. 368, 369).

7  See below, p. 288, note 100.

8  *Lib. Pont.*, I, pp. 499 ff.

9  *Lib. Pont.*, II, p. 148: 'saraca de olovero cum chrisoclavo I . . . vela maiora de fundato II'.

10  Alcuin *De Pontificibus*, ll. 278–9: 'Serica parietibus tendens velamina sacris; / Auri blateolis pulchre distincta . . .'.

11  *Ibid.*, l. 1267: 'Serica suspendens peregrinis vela figuris'.

12  'Ego Ethelstanus rex do sancto Cuthberto . . . septem pallia, et tres cortinas, et tria tapetia . . .' (*Symeonis monachi opera*, I, p. 211: L-B, 2445).

13  *Vita Oswaldi auct. anonymo*, in *The Historians of the Church of York*, ed. J. Raine, vol. I, p. 446: L-B, 3554.

14  '. . . videlicet indumenta plurimum ornata, pannos sericos et cortinam valde pretiosam et nobilem, qua nulla pretiosior circumquaque estimari aut inveniri potuit – paratura enim ipsius auro intecta tota apparuit . . .' (*Liber Eliensis*, II, 138, p. 222). Though the description relates to the seizing of these textiles by Winchester monks in 1093, the textiles themselves must be pre-Conquest. (They are not included in the inventory of post-Conquest acquisitions.)

15  'Hec sunt que invenit Eudo dapifer et Willelmus de Belfou et Angerus in ecclesia sancte Ætheldrethe (*c.* 1081) . . .ii pendentia cum auro . . . xliii pallia pendentia . . . iiii tapeta . . . xxx cortinas' (*ibid.*, II, 114, pp. 196–7).

16  'Hic [Siricus] dedit vii pallia Glastoniae cum albis leonibus, de quibus vetus ecclesia in anniversario eius tota ornatur' (William of Malmesbury *De antiquitate Glastoniensis*, col. 1722: L-B, 1848).

17  See this chapter, note 11.

18  *Lib. Pont.*, II, pp. 76, 79, 82, 145.

19  *Ibid.*, p. 75.

20  *Ibid.*, pp. 55, 107, 108.

21  *Ibid.*, pp. 75, 76, 79, 109, 154.

22  *Ibid.*, pp. 75, 76, 109.

23  J. P. Migne *Patrologiae cursus completus, Series graeca*, 40, cols. 165–8.

24  *Lib. Pont.*, II, p. 32.

25  *Ibid.*, pp. 14, 55, 61, 71, 77, 80.

26  *Ibid.*, pp. 61, 76.

27  *Ibid.*, p. 129.

28  *Ibid.*, pp. 2, 10, 32.

29  *Ibid.*, pp. 10, 25, 32, 76, 77, 80, 95, 109, 119.

30  *Ibid.*, p. 93.

31  *Ibid.*, pp. 55, 130.

32  *Ibid.*, p. 77.

33  *Lib. Pont.*, I, p. 500.

34  *Lib. Pont.*, II, p. 32.

35  *Ibid.*, pp. 14, 76.

36  E.g. *ibid.*, p. 111 (SS. Martin and Agatha).

37  See below, pp. 132–3.

38  See above, p. 185.

39  See below, p. 185.

40  See above, p. 38.

41  'Vir in hac vicinia locuples et fidelis, Godricus vocabulo, quum affines et amicos sollenni ascivisset convivio, quum parietes pictis aulaeis candescerent . . . fulcra tapetis, mensae epulis . . .' (Goscelin *Miracula S. Ivonis*, p. lxii: L-B, 5612).

42  'And ic geann Wulfmære minum suna anes heallwahriftes . . . Ælfwine minum othrum suna ic geann anes heallreafes, and anes burreafes . . .' (Whitelock *Wills*, p. 64).

43  'and selle man loefsige iii wahrift swylce thær thonne bet sint . . .' (Whitelock *The Will of Æthelgifu*, p. 13).

44  '. . . and that betste wahrift . . .' (*ibid.*, p. 7).

45  '. . . milites regis, qui post velum extensum per transversum domus absconditi fuerant, subito prosilientes loricati in Wiheal comitem cum suis XL viris principalibus qui secum intraverant obtruncaverunt' (*Symeonis monachi Opera*, I, p. 218).

46  'ast alii rutilo condunt uexilla metallo, / que ueneranda pii promunt miracula Christi, / qui crucis in ligno mundum de morte redemit' (*De Abbatibus*, ll. 633–5). For *vexillum* as a hanging, see Albert Blaise's *Lexicon*.

47  Lines 738 and 767.

48  *Ibid.*, p. xxiii.

49  *Idem.* The editor deduces a date between 704/5 and 716.

50  'Gold-fag scinon / web æfter wagum wundor-siona fela / secga gehwylcum    thara the on swylc starath' (ll. 994–6).

51  Rupert Bruce-Mitford *The Sutton Hoo Ship-Burial*, I, pp. 716, 717: II, pp. 150, 158, 165, 205, 279.

52  *Ibid.*, I, p. 716. See also Dr Bruce-Mitford's remark in 'Sutton Hoo and the Background of "Beowulf" ' (in his *Aspects of Anglo-Saxon Archaeology* (London, 1974), p. 259): 'When we have a single long poem that deals with royal and secular society in the pre-Viking age and a single royal grave (as we suppose) of the pre-Viking period, we must be careful not to force the obvious relevance of the one to the other into a dual reflection of the same milieu. But it may well seem that at Sutton Hoo that is just what it is.'

53  See P. Rahtz 'Buildings and rural settlements' in *The Archaeology of Anglo-Saxon England*, ed. D. M. Wilson (London, 1976), and Rupert Bruce-Mitford *Aspects of Anglo-Saxon Archaeology*, p. 94.

54  'Uxor quippe eius [Brithnothi] . . . cortinam gestis viri sui intextam atque depictam in memoriam probitatis eius huic ecclesie donavit' (*Liber Eliensis*, II, 63, p. 136).

55  An excellent account of the warrior and his last battle is to be found in

E. V. Gordon's introduction to his edition of *The Battle of Maldon* (London, 1937). A new edition of the poem by Dr Donald Scragg is at the press (*The Battle of Maldon*, Manchester 1981). Though Dr Scragg says that the account in the *Liber Eliensis* 'in part conflicts with more contemporary evidence', he also agrees that 'the chronicler makes clear his dependence on earlier written records. One of these seems to have been the Anglo-Saxon Chronicle version used by Florence of Worcester . . . ' (p. 11).

56  In J. Raine *Historians of the Church of York* . . . , I, pp. 445 and 455 ff.

57  There are times in warfare when it is more important to take a chance on a victory raising general morale than to weigh too finely the balance of forces, and the Anglo-Saxons must have been quite demoralised at this time by the Viking raids. One point of view expressed has been that there was nothing to stop these Vikings simply sailing away to plunder elsewhere and that to entice them to fight on the mainland in the hope at least of inflicting some damage on them could well have been a sound tactical judgment. A sceptical view of the historic authenticity of the poem is presented by Dr N. F. Blake in 'The genesis of the *Battle of Maldon*' in *Anglo-Saxon England*, ed. P. Clemoes, vol. 7. He considers that the poem was not written until *c.* 1030 and was 'a literary creation based entirely on the *Vita Oswaldi* and imagination'.

58  Lines 312–13, translation by Michael Alexander.

59  The chronicler says that the gift was made 'eo tempore quo vir idem suus interfectus est et humatus . . .' (*Liber Eliensis*, p. 136).

60  See last note.

61  See this chapter, note 97.

62  See Professor Whitelock's Foreword to Professor Blake's edition, p. ix: 'The *Liber Eliensis* is unique among post-Conquest monastic histories in the extensive use it makes in Book II of vernacular documents'. The first part, she points out, derives from an earlier *Libellus* and the second (which includes our chapter) largely from vernacular documents in the archives of the house.

63  *Ibid.*, p. x.

64  'The information in ch. 63 about the gifts of Ælfflæd could come from this document [her will], with the addition from local knowledge that she gave a tapestry depicting the deeds of her husband' (*idem*).

65  Whitelock *Wills*, p. 62. The gift here to Bath abbey was of 'a set of bed-clothing with tapestry and curtain'.

66  Whitelock *The Will of Æthelgifu*, p. 7. Æthelgifu leaves her 'best wall-hanging' to St Albans, together with two silver cups and other objects.

67  'et torquem auream . . .' (*Liber Eliensis*, p. 136).

68  *Ibid.*, p. 134.

69  'De venerabili duce Brithnotho . . . ' (*ibid.*, p. 133).

70  *Idem.*

71        'Nobilis appensum    preciatur purpura uelum,
          quo patrum series    depicta docet uarias res,

bellaque nobilium    turbata per equora regum.
Antemne grauidus    stipes roburque uolatus
sustinet, extensis    auro rutilantibus alis'
(*Vita Ædwardi*, ed. Barlow, p. 14).

72  Martin Biddle 'Excavations at Winchester 1965: fourth interim report', Appendix, in *The Antiquaries Journal* XLVI (II), 1966, pp. 329–32. From this all the following information derives.

73  In particular, there is no evidence that the Normans had the skill in integrating various scenes in a continuing narrative that is so well exemplified here and demonstrated in earlier Anglo-Saxon manuscript illustrations.

74  See above, p. 78 and below, pp. 227–8.

75  See C. R. Dodwell 'The Bayeux Tapestry and the French secular epic', in *The Burlington Magazine* No. 764, vol. CVIII, Nov. 1966, pp. 549–60 (p. 549).

76  *Idem.*

77  The view, first expressed by David Douglas in 'The "Song of Roland" and the Norman Conquest of England' (in *French Studies* XIV, 2, April 1960, especially p. 103) has gained more and more currency.

78  See especially ll. 207–33 of the poem which is published in *Les Oeuvres poétiques de Baudri de Bourgueil*, ed. P. Abrahams (Paris, 1926), pp. 197 ff.

79  See this chapter, note 41.

80  See above, chapter II, note 153.

81  Wynflæd left three, and Wulfgyth left one to Christ-Church; Æthelgifu left one to St Albans, another to Wulfwynn and two to Leofsige (Whitelock *Wills*, pp. 12 and 84; *The Will of Æthelgifu*, pp. 6 and 12).

82  Wulfwaru left 'the best dorsal that I have' to St Peter's, Bath, and Wulfgyth left a dorsal to St Augustine's (Whitelock *Wills*, pp. 62 and 84).

83  Wulfwaru left a table-cover (*ibid.*, p. 64).

84  Wynflæd refers in her will to her 'best bed-curtain and a linen covering and all the bed-clothing which goes with it'. Wulfwaru leaves to St Peter's, Bath, 'a set of bed-clothing with tapestry and curtain . . .' (*ibid.*, pp. 14 and 62).

85  *Lib. Pont.*, I, p. 500.

86  Aldhelm, describing the church of the princess, Bugga, 'Aurea contortis flavescunt pallia filis, / Quae sunt altaris sacri velamina pulchra . . .' (ll. 70–1 of *Carmina ecclesiastica* III in *Aldhelmi Opera*, ed. R. Ehwald, p. 18).

87  '. . . altare . . . purpuraque auro texta induentes . . .' (Eddius *Life of Wilfrid*, ed. Colgrave, p. 36).

88  '. . . et quomodo altaria purpura et serico induta decoravit [Acca], quis ad explanandum sufficere potest?' (*ibid.*, p. 46).

89  'And. II. gegylde weofodsceatas' (Robertson *Anglo-Saxon Charters*, p. 72).

90  *Symeonis monachi opera*, I, p. 211: L-B, 2445).

91  Robertson *Anglo-Saxon Charters*, p. 226.

92  '. . . et desuper bissus sanguineo fulgore in longitudinem altaris et ad

cornua eius attingens usque ad terram cum aurifriso, latitudinem habens pedis, spectaculum decoris magni pretii administrat' (*idem*).

93  'Fecit etiam indumenta altaris, magnam pallam viridi coloris insignem cum laminis aureis, ut in faciem altaris per diem sollemnem celsius appareret . . .' (*Liber Eliensis*, p. 149).

94  'Quorum [Danorum] unus . . . pretiosum pallium quo tumba virginis Etheldridae operiebatur surripuit' (Malmesbury *Gesta Pontificum*, p. 323: L-B, 1523).

95  '. . . super sepulchrum pallium misit versicoloribus figuris pavonum . . .' (William of Malmesbury *De Gestis Regum*, I, p. 224: L-B, 1855).

96  'pallium auro textum, et alia IX' (Malmesbury *De antiquitate Glastoniensis*, col. 1723: L-B, 1859). He was a bishop of Salisbury who died in 1045.

97  'Insignem quoque purpuram, aurifriso undique cinctam, fecit [Emma] et per partes auro et gemmis pretiosis mirifico opere velud tabulatis adornavit illicque optulit . . . atque ceteris sanctis nostris pannum sericum unicuique . . . auro et gemmis intextum, optulit . . .' (*Liber Eliensis*, II, 79, p. 149). Again, III, 50, p. 294: 'Sunt ibi vii pallea cum aurifrig'; i de purpura circumquaque aurifriso et lapidibus optime parata quam Ymma regina dedit sancte Ætheldrethe, que etiam unicuique de sanctis nostris fecit pallam atque singulis altaribus in decorem ecclesie purpuream largita est'.

98  'Nam cultus gemini sexus hiuscemodi constat . . . manicae sericis clavatae' (ed. Ehwald, p. 318).

99  'Purpuram et sericum, pretiosas gemmas, argentum et aurum . . .' (*Ælfrici abbatis Colloquia*, p. 88, in *Early Scholastic Colloquies*, ed. W. H. Stevenson (Oxford, 1929)).

100  'Adtulit inter alia, et pallia duo oloserica incomparandi operis, quibus postea ab Aldfrido rege eiusque consiliariis . . . terram trium familiarum ad austrum Uuiri fluminis, iuxta ostium conparauit' (Bede *Hist. Abb.*, 9, p. 373).

101  See F. M. Stenton *Anglo-Saxon England* (Oxford, 1975), p. 279.

102  See below, chapter VI, note 55.

103  See below, chapter VI, note 62.

104  R. S. Lopez 'Silk industry in the Byzantine Empire' *Speculum*, XX, 1 (Jan. 1945), p. 14.

105  'purpureum uer' (9th Eclogue, 40).

106  'purpureis . . . oloribus' (*Od.* IV, 1. 10).

107  *Julius Caesar* III, i, 158.

108  'The morrow next appear'd with purple hayre . . .' (*Faerie Queene* V, x, 16). I owe the reference to Dr Arthur Johnston's article on ' "The Purple Year" in Pope and Gray', *The Review of English Studies* N. S. XIV (1963), pp. 389–93.

109  See below, chapter VI, note 71.

110  'Casulam quoque ex purpura optime . . . et aliam candidam similiter ex purpura: capamque uiridem ex purpura . . . dedit [Leofricus, abb. 1057–

66]' (*The Chronicle of Hugh Candidus*, ed. W. T. Mellows, p. 66: L-B, 3454).

111   'Lanfrancus archiepiscopus, inter cetera bona que fecit ecclesie nostre . . . duas casulas, unam rubeam et alteram nigram de purpura, et tunicam epistolariam nigram de purpura, stolam et phanum de nigra purpura . . . dedit' (*Registrum Roffense*, p. 120: L-B, 3713).

112   'Sicut enim Moyses tabernaculum seculare manu factum ad exemplar in monte monstratum a Deo . . . distinctis variis coloribus aedificavit, . . . vero beatissimus Wilfrithus episcopus thalamum veri sponsi et sponsae . . . auro et argento purpuraque varia mirifice decoravit' (ed. Colgrave, p. 34).

113   Though some certainly were purple. See below, p. 149.

114   *De Architectura*, VII, xiii.

115   J. André *Étude sur les Termes de Couleur dans la Langue Latine* (Paris, 1949), pp. 95–7. See also p. 102: 'On s'étonnera peut-être que les Romains n'aient éprouvé aucune gêne à donner à *purpureus* des sens aussi divers que "rouge" et "violet", y compris toutes les nuances intermédiaires et les tons de clair et de foncé qui peuvent aller du noir au lilas presque rose.'

116   *Ibid.*, p. 99.

117   *Idem.*

118   *Ibid.*, p. 100.

119   *Ibid.*, pp. 100–1.

120   *Idem.*

121   *Ibid.*, p. 98: '. . . le glissement de sens de l'adjectif avec perte de la couleur au profit de l'éclat à quoi semblent se référer Porphyrion, *Ad Hor.*, *Od.* IV, l. 10 et Servius, *Ad Aen.* I, 591, en interprétant *purpureus* par nitidus et pulcher'.

122   '. . . scinende swa swa purpura . . .' (*Ælfric's Lives of Saints*, vol. II, ed. Walter W. Skeat, E.E.T.S. 114 (London, 1890), p. 270).

123   These two points of information come from Francisque-Michel who cites from Du Cange a gloss on Isidore: 'Purpuram facere. Bombycinatores, purpuram facientes' (see under *Bombycinare*) and then points out that in a tenth-century *Life* of St Adalbert of Prague (*Acta Sanctorum* saec. V, p. 851), the writer interchanges the words *sericum* and *purpura* as synonyms (*Recherches sur le Commerce, la Fabrication et l'Usage des Etoffes de Soie*, 2 vols. (Paris, 1852–4), II, pp. 16–17).

124   'Capa . . . est de panno serico purpurae . . .' (*Descriptio . . . thesaurariae S. Pauli London*, ed. W. Sparrow Simpson in *Archaeologia*, L, 1887, p. 479: L-B, 2741).

125   See this chapter, note 88.

126   See this chapter, note 99.

127   '. . . Tunica de dyaspero marmoreo spisso quasi purpura . . .' (*Descriptio . . . thesaurariae ecclesiae S. Pauli . . .*, ed. W. Sparrow Simpson in *Archaeologia*, L, 1887, p. 485: L-B, 2744).

128   See above, chapter II, note 47.

129   See below, chapter VI, note 55.

130 See above, p. 137.

131 *Reginaldi . . . libellus*, p. 84: L-B, 1387. The translations from the *Libellus* are those of Pace, as quoted in *Relics of St Cuthbert*, ed. Battiscombe, here p. 107.

132 '. . . et inuolutum nouo amictu . . .' (Bede *Life of St Cuthbert*, p. 294).

133 *Reginaldi . . . libellus*, p. 87; Battiscombe, p. 110.

134 *Idem*.

135 *Idem*.

136 *Idem*.

137 See below, chapter VI, note 55.

138 Some of Wilfrid's *purpurae* at Ripon seem possibly to have been used for dressing the walls. See this chapter, note 112.

139 See this chapter, note 87.

140 See this chapter, note 97.

141 See above, p. 146.

142 Eddius (ed. Colgrave, p. 120) says that, in Rome, Wilfrid bought 'indumenta purpureaque et serica' for his churches; his epitaph at Ripon (quoted by Bede *Hist. Eccles.*, V, 19, ed. Plummer, p. 330; ed. Colgrave and Mynors, p. 528) speaks of how he adorned the church which he '. . . auro ac Tyrio deuotus vestiit ostro'.

143 *Epist. Karol. aevi*, 2 (Berlin, 1895), p. 145. The letter is dated after 18 April 796.

144 See R. S. Lopez and I. W. Raymond *Medieval Trade in the Mediterranean World* (New York and London, 1968), p. 56.

145 See *Institvta Regalia . . . Camere Regvm Lomgbardorvm . . .*, ed. A. Hofmeister in *Mon. Germ. Hist. SS.*, XXX, 2, p. 1452.

146 A. J. Robertson *The Laws of the Kings of England . . .* (Cambridge, 1912), p. 146 (5).

147 'Tunc inter se graecizantes . . . multa loqui coeperunt . . .' (Eddius *Life*, ed. Colgrave, p. 112).

148 This was done by Zacharias (741–52), himself a Greek: see *Lib. Pont.*, I, p. 435 and Duchesne's note on p. 439.

149 *Lib. Pont.*, II, pp. 30, 55, 57, 58.

150 Eddius *Life*, p. 66.

151 Described in detail from Stubbs' *Memorials*, pp. 391–2, in Frank Barlow *The English Church 1000–1066* (London, 1963), p. 293.

152 See this chapter, note 100.

153 See this chapter, note 142.

154 William of Malmesbury *Gesta Pontificum*, p. 364.

155 'Haec autem vestis . . . hactenus apud nos habetur . . . Est autem fili delicatissimi, quod chonchiliorum sucis ebrium rapuerit colorem coccineum; habentque nigrae rotulae intra se effigiatas species pavonum' (*ibid.*, p. 365).

156 It is in *S. Geraldi comitis, Aureliaci fundatoris vita* (*Pat. Lat.*, CXXXIII, col. 658) on which see F. L. Ganshof 'Note sur un passage de la vie de Saint

Géraud d'Aurillac', pp. 295–307 of N. Iorga *Mélanges* (Paris, 1933).

157 *Monachus Sangallensis Gesta Karoli Magni*, p. 760 (in *Mon. Germ. Hist. SS.*, II).

158 See E. Sabbe 'L'Importation des tissus orientaux en Europe Occidentale au haut moyen âge', *Revue Belge de Philologie et d'Histoire*, XIV (1935), p. 814, note 2.

159 Gino Luzzatto *An Economic History of Italy* (London, 1961), pp. 35, 60.

160 Robert S. Lopez 'Mohammed and Charlemagne: a revision', *Speculum*, XVIII (1943), pp. 35 ff.

161 '. . . sicut a multis videntibus eam audivimus, cotidie mendicans, in Pavia miserabiliter moreretur' (W. H. Stevenson *Asser's Life of King Alfred*, p. 14). The account is of the wretched end of Offa's daughter, Eadburh. Its interest in our context is the numbers of Anglo-Saxons who witnessed it in Pavia.

162 Whitelock *Wills*, p. 4 (editor's translation).

163 See below, pp. 186 ff.

164 See R. Freyhan 'The place of the stole and maniples in Anglo-Saxon Art of the Tenth Century', *The Relics of Saint Cuthbert*, ed. C. F. Battiscombe (Oxford, 1956), pp. 409–32, especially pp. 409–23.

165 *Ibid.*, p. 422.

166 See above, p. 151.

167 See above, p. 145.

168 See above, p. 130.

169 *Hist. Eccles.*, V, 7, ed. Plummer, p. 294; ed. Colgrave and Mynors, p. 472.

170 Talbot *Anglo-Saxon Missionaries*, p. 133 (Tangl, 78).

171 F. Barlow *The English Church 1000–1066* (London, 1963), p. 291.

172 *Lib. Pont.*, II, p. 148.

173 '. . . non solum Anglis genere qui plusquam octoginta numero in eius fuerant comitatu . . . in lacrimas luctusque solutis' (Bede *Hist. Abb.*, 21, p. 385).

174 *Aethilwaldi carmen de transmarini itineris peregrinatione* (in *Aldhelmi opera*, ed. R. Ehwald (Berlin, 1919), pp. 528–33), ll. 149–84.

175 *The Hodoeporicon of St. Willibald* in Talbot *Anglo-Saxon Missionaries*, p. 162.

176 W. Heyd *Historie du Commerce du Levant au Moyen-Âge* (Leipzig, 1923), p. 91, note 1.

177 Denis Meehan *Adamnan's 'De Locis Sanctis'* (Dublin, 1958), p. 40, editor's translation.

178 Of the emperor, Leo VI (889–912) – cited in Meyer Reinhold *History of Purple as a status symbol in Antiquity* (Collection Latomus 116, Brussels, 1970). There is an earlier reference to these stripes, but restricted to those attending the circus games, under Tiberius II (578–82). The varying history of what could or could not be exported (including the ways in which the rules might be circumvented) is treated in full by R. S. Lopez in his 'Silk industry in the Byzantine Empire' (*Speculum* XX (1) (Jan. 1945), pp. 1–42).

179  See above, p. 36.

180  'Vestimenta . . . , qualia Anglisaxones habere solent, hornata institis latioribus vario colore contextis' (*Pauli Historia Langobardorum*, ed. G. Waitz in *Scriptores Rerum Germanicorum in Usum Scholarum ex Mon. Germ. Hist. Separatim Editi*, vol. XLVIII, p. 155.

181  *Winchester in the Early Middle Ages*, ed. M. Biddle (Oxford, 1976), p. 478, with bibliography in note 5.

182  The account is in Eadmer (see next note) and is, of course, undated though the miracle (also recorded by Osbern, see Stubbs *Memorials*, p. 160) certainly took place after 988 since it was in response to a prayer to St Dunstan. It occurred when Æthelwine fell in with an imperial army in Lombardy. There were many incursions of imperial expeditionary forces into Italy in the decades after Dunstan's death. However, the tone of Eadmer's narrative suggests a time not long before the Normans took over. Its remark that the monks then lived more like earls than monks is very similar to the description earlier given of Canterbury at the time that Lanfranc became archbishop (pp. 237–8) and, indeed, Eadmer refers the reader back to this earlier account. Given the long minority and unhappy fortunes in Italy of Henry IV, it seems reasonably certain that Æthelwine's journey took place during the rule of the emperor Henry III who made two incursions into Italy, in 1046 and 1055, and it is probable that the monk's own return to Canterbury coincided with the latter expedition in 1055.

183  '. . . quidam ipsius ecclesiae [S. Salvatoris Cantuariensis] monachus, nomine Ægelwinus, cupiens ire Jerusalem, accepta licentia ab archiepiscopo et fratribus profectus est . . . prosperrimo itinere pervenit ad sepulcrum Domini, et inde rediens per Constantinopolim, emit ibi quod beato Dunstano deferret pallium unum pretiosum valde et pulchrum. Qui ubi, pertransita Apulia et Roma . . . ac patri Dunstano pallium quod promiserat obtulit' (*Miracula S. Dunstani auct. Eadmero* in Stubbs *Memorials*, pp. 245–6.

184  Quoted by Plummer, *Hist. Eccles.*, vol. II, p. 63.

185  R. S. Lopez 'Le Problème des relations Anglo-Byzantines du septième au dixième siècle' (*Byzantion*, XVIII), p. 148.

186  Bede *Hist. Eccles.*, IV, 1, ed. Plummer, pp. 203–4; ed. Colgrave and Mynors, p. 332.

187  *Ibid.*, IV, 1, p. 202; p. 328.

188  *Ibid.*, V, 20, p. 331; p. 530.

189  *Ibid.*, V, 23, p. 348; p. 556.

190  The lists of monks in the *Liber Vitae* of New Minster (ed. Birch, p. 33) includes the name of 'Andreas Grecus'.

191  William of Malmesbury records how a Greek monk, called Constantine, came to the abbey of Malmesbury and stayed there until his death (*Gesta Pontificum*, pp. 415–16).

192  ed. Blake, p. 73.

193  R. S. Lopez 'Relations Anglo-Byzantines', p. 145.

194  *Ibid.*, p. 156, note.

195  *Ibid.*, p. 156.

196  E. Sabbe 'L'Importation des tissus orientaux en Europe Occidentale au haut moyen âge', *Revue Belge de Philologie et d'Histoire*, XIV (1935), pp. 1264–5.

197  H. R. Loyn *Anglo-Saxon England and the Norman Conquest* (London, 1962, p. 90).

198  Philip Grierson 'The relations between England and Flanders . . .', *Trans. Royal Hist. Soc.* series 4, vol. 23 (1941) (p. 105).

199  *Ibid.*

200  Talbot *Anglo-Saxon Missionaries*, p. 118.

201  He divided his treasure into three parts. The second part he gave to the heads of Ripon and Hexham 'ut cum muneribus regum et episcoporum amicitiam perpetrare potuerint' (Eddius *Life*, p. 136).

202  See above, p. 244, note 88.

203  William of Malmesbury *De Gestis Regum*, pp. 149–51: L-B, 5943.

204  '. . . mihi eodem die tradidit . . . et sericum pallium valde pretiosum . . .' (ed. W. H. Stevenson, p. 68).

205  'Praeterea benedictionem protectoris uestri beati Petri apostolorum principis uobis direximus, id est camisia cum ornatura in auro una et lena Anciriana una . . .' (Bede *Hist. Eccles.*, II, 10, ed. Plummer, p. 104; ed. Colgrave and Mynors, p. 170).

206  'Vestrae quoque dilectioni . . . dirigere studuimus . . . duo pallia sirica.' (*Mon. Germ. Hist. Epist. IV, Karol. Aevi*, vol. II, ed. Duemmler, p. 146).

207  '. . . aliquam benedictionem de dalmaticis nostris vel palleis ad singulas sedes episcopales regni vestri vel Aedilredi . . . direximus' (*idem*).

208  These are referred to in a letter of Cuthbert from Wearmouth/Jarrow in 764 to Lull: 'Duo vero pallia subtilissimi operis, unum albi, alter tincti coloris . . . tuae paternitati mittere curavimus' (Tangl, *Briefe*, p. 251).

209  'Parva vero munuscula dilectioni tuae direxi, hoc est pallam olosericam optimi generis . . .' (*Ibid.*, p. 263).

210  'misi dilectioni vestrae unam pallam storacen et unum vestitum . . .' (*Alcuini . . . epistolae*, ed. E. Duemmler, *Mon. Germ. Hist. Epist.* IV, p. 413). These *pallia stauracia* occur fairly often in the papal inventories in the *Liber Pontificalis* (ed. Duchesne, I, pp. 499, 500; II, pp. 2, 9, 10, etc.) as well as in accounts of gifts in northern Europe.

211  Asser's *Life*, ed. Stevenson, p. 77.

212  '. . . multa donaria a regia largitate suscepti . . . cum multis sericis ornamentis et annulis cum lapidibus pretiosis' (*Chronica maiora Matthaei Parisiensis*, ed. H. R. Luard, vol. I (London, 1872), p. 467: L-B, 5960).

213  '. . . maxime autem ab imperatore donis variis, et muneribus pretiosis honoratus sum, tam in vasis aureis et argenteis, quam in palliis et vestibus valde pretiosis' (Florence of Worcester *Chronicon*, I, p. 186: L-B, 5973).

214  'Nam quattuor evangelia de auro purissimo in membranis depurpuratis,

coloratis, pro animae suae remedio scribere iussit: necnon et bibliothecam librorum eorum, omnem de auro purissimo et gemmis pretiosissimis fabrefactam, compaginare inclusores gemmarum praecepit' (Eddius *Life*, p. 36).

215  See above, p. 9.

216  Carl Nordenfalk 'A note on the Stockholm "Codex Aureus" ' in *Nordisk Tidskrift för Bok- och Biblioteksväsen*, vol. 38 (1951), pp. 145–55; also his *Celtic and Anglo-Saxon Painting* (London, 1977), p. 96.

217  *Idem*, and W. Levison *England and the Continent in the Eighth Century* (Oxford, 1973), p. 145. Lull refers to a copy borrowed from Worcester by Archbishop Cuthbert of Canterbury (740–60). Levison adds other interesting points about the knowledge of Porfyrius in eighth-century England.

218  'Ego Ethelstanus rex do Sancto Cuthberto . . . duas patenas, alteram auro paratam, alteram Graeco opere fabrefactam . . .' (*Symeonis monachi opera*, I, p. 211: L-B, 2445).

219  Recorded in its *Liber Vitae*, ed. Birch, p. 161, where there is a list of relics in the 'grecysscan scrine' that the queen (i.e. Cnut's queen) gave to New Minster.

220  'Transtulit enim, ut legitur, idem rex [Wilhelmus I] de Waltham in Normanniam . . . tres urceos magnos ex Graeco opere, argenteos atque deauratos . . .' (*Vita Haroldi regis* in J. A. Giles *Original lives of Anglo-Saxons* . . . , pp. 50–1: L-B, 4484). The source is unreliable but it claims to be quoting from earlier writings which we know existed and there seems little point in giving misinformation on a detail like this.

221  See below, p. 217.

222  Felix *Life of St Guthlac*, pp. 158, 164.

223  *The Auto-Biography of Symon Patrick, Bishop of Ely*, ed. J. H. Parker (Oxford, 1839), p. 5. I am indebted to Mr Donald King for drawing my attention to this, and other sources.

224  Charles Taylour *A True and Perfect Narrative of the Strange and Unexpected finding the Crucifix and Gold-Chain of That Pious Prince, St Edward the King and Confessor* (London, 1688), p. 10.

225  See below, p. 196.

226  In his edition of *The Auto-Biography of Symon Patrick* (p. 193) Parker says 'In the original manuscript a small piece of stuff answering this description was pinned to the paper, evidently as a specimen of the shroud'.

227  Sigrid Müller-Christensen *Das Grab des Papstes Clemens II im Dom zu Bamberg* (München, 1960), p. 68.

228  '. . . conspexerunt virum iacentem in vestitu deaurato . . .' (*Speculum historiale de gestis regum Angliae, auct. Ricardo de Cirencestria*, ed. John E. B. Mayor, vol. 2 (London, 1869), p. 324: L-B, 2598).

229  'corpus . . . in panno serico pretioso involventes, in cista lignea ad hoc praeparata incluserunt, omnia quae cum eo inventa fuerant intus relinquentes, excepto anulo aureo quem in digito regis inventum abbas propter devotionem retinuit . . .' (as note 228 above).

230 *The History of Westminster Abbey by John Flete*, ed. J. Armitage Robinson (Cambridge, 1909) pp. 71–2. Flete was a monk at Westminster from 1420 to 1465 and his history seems to have been written shortly after 1443.

231 The most detailed is that given by Thomas Wykes: see H. R. Luard *Annales Monastici*, vol. 4 (London, 1869), pp. 226–7: L-B, 2891.

232 *La Vie de S. Edouard le Confesseur par Osbert de Clare*, ed. M. Bloch in *Analecta Bollandiana*, XLI, 1923, pp. 5–131 (pp. 121–3).

233 'Qua de causa triumphator Anglorum Willelmus super sanctum regem Eadwurdum ex auro et argento capse fabricam condidit . . .' (*La Vie de S. Edouard*, p. 120). See, further, chapter VIII, note 136 below.

234 It improbably claims that Lanfranc tried to depose Bishop Wulfstan who insisted on giving his crozier to the Confessor since this king had invested him with it. Placed on the tomb, the crozier was immediately embedded in its stone and could not be removed. Matthew Paris set this incident in 1075 (*Chronica maiora*, II, p. 40). Professor Frank Barlow associates it with the events of 1070–1 (*Vita Ædwardi*, p. 118). The appearance of Gundulf, who only became Bishop of Rochester in 1077, indicates the false historic context of what everyone concedes is a ridiculous story.

235 Frank Barlow *Edward the Confessor* (London, 1970), pp. 263–4.

236 In a letter to Alexander III, Cardinals Henry and Otto report fully on this exhibit. It is printed in Barlow *Edward the Confessor*, pp. 311–12.

237 See this chapter, note 22.

238 A notorious fact amongst historians, and see also *Vita Ædwardi*, ed. Barlow, 123.

239 'Itaque retento pallio quo sanctissima ejus membra fuerant involuta, aliud aeque pretiosum apponunt . . .' (*Vita S. Edwardi Regis et Confessoris auctore Beato Aelredo* in *Pat. Lat.*, CXCV, col. 783: L-B, 2547).

240 In a letter of 764, Abbot Cuthbert of Wearmouth/Jarrow thanks Lull for having sent an 'olosericam ad reliquias beatę memoriae Baeda . . .' (Tangl *Briefe*, p. 250).

241 'Ipse vero [Edmundus] manu propria . . . duo pallia Graeca supra sanctum corpus [S. Cuthberti] posuit' (*Symeonis monachi opera*, I, p. 212: L-B, 5947).

242 'Ac fulcrum de nobilioris serici pallio, quod illi substratum fuerat . . . quasi recentius contextum nitidius relucebat' (*Reginaldi libellus*, pp. 84–5: L-B, 1388: and *Relics*, ed. Battiscombe, p. 108, Pace's translation).

243 For a full account of it, see J. F. Flanagan 'The "Nature goddess" silk', in *The Relics of St Cuthbert*, ed. Battiscombe, pp. 505–13.

244 *Reginaldi . . . Libellus*, p. 89.

245 See above, p. 288, note 100.

246 *Reginaldi . . . Libellus*, p. 89: *Relics*, ed. Battiscombe, p. 110 (Pace's translation).

247 Carl Nordenfalk *Celtic and Anglo-Saxon Painting* (London, 1977), p. 95 and plate 32.

### Chapter VI  *Costume and vestments*

1  P. V. Glob *The Bog People* (London, 1969), p. 18.
2  See above, p. 36.
3  British Library Harley MS. 603.
4  British Library Cotton MS. Claudius B IV. A facsimile has been published by C. R. Dodwell and Peter Clemoes: *The Old English Illustrated Hexateuch* (*Early English Manuscripts in Facsimile*, XVIII, Copenhagen, 1974).
5  See C. R. Dodwell 'La Miniature Anglo-Saxonne: un reportage sur la société contemporaine', *Les dossiers de l'archéologie*, No. 14, (Jan–Fév. 1976), pp. 56–63.
6  Gale R. Owen *Anglo-Saxon Costume: a study of secular civilian clothing and jewellery fashions* (thesis submitted to University of Newcastle upon Tyne, 1976) vol. 1, pp. 339 ff. I am deeply indebted to Dr Owen for lending me her exemplary thesis which is in the process of being published and from which I draw freely.
7  *Ibid.*, p. 340.
8  Glob *The Bog People*, p. 129.
9  Owen *Anglo-Saxon Costume*, I, pp. 367 ff.
10  *Ibid.*, p. 361.
11  *Ibid.*, p. 369.
12  See below, p. 175.
13  '. . . crines conposuit, caput linteo cooperuit et . . . reuersa est' (*Hist. Eccles.*, III, 9, ed. Plummer, p. 146; ed. Colgrave and Mynors, p. 244).
14  See above, chapter II, note 6.
15  'De qua ferunt quia, ex quo monasterium petiit, nunquam lineis, sed solum laneis uestimentis uti uoluerit' (*Hist. Eccles.*, IV, 17, ed. Plummer, p. 244; ed. Colgrave and Mynors, p. 392).
16  Felix's *Life of St Guthlac*, p. 94.
17  Owen *Anglo-Saxon Costume*, I, pp. 393–4.
18  *Idem.*
19  *Idem.*
20  *Germania* 17: 'Tegumen omnibus sagum fibula aut, si desit, spina consertum'.
21  *Idem*: 'locupletissimi veste distinguntur, non fluitante, sicut Sarmatae ac Parthi, sed stricta et singulos artus exprimente'.
22  Talbot *Anglo-Saxon Missionaries*, p. 128 (Tangl *Briefe*, 76).
23  Talbot, p. 143 (Tangl, 105).
24  The letter was sent to Offa in 796: 'Sed sicut vos de longitudine petrarum desiderium vestrum intimastis, ita et nostri de prolixitate sagorum deposcunt: ut tales iubeatis fieri, quales antiquis temporibus ad nos venire solebant' (*Epist. Karol. Aevi*, II, p. 145).

25 Or so they are represented in illustrated manuscripts, like the Tiberius Psalter and the Canterbury Hexateuch. I take the point from the admirable thesis by Dr Jennifer Harris, submitted to the University of Manchester, 1977: *The Development of Romanesque-Byzantine elements in French and English dress 1050–1180*, p. 25.

26 See, for example, P. E. Schramm and F. Mütherich *Denkmale der deutschen Könige und Kaiser* (Munich, 1962), plates 51 and 79.

27 It was sent by Cuthbert, abbot of Wearmouth/Jarrow to Lull, the Anglo-Saxon Bishop of Mainz, in 764. See Tangl *Briefe*, p. 251.

28 Wynflæd bequeathes 'hyre twilibrocenan cyrtel' (see Whitelock *Wills*, p. 14, and note on p. 113). This Professor Whitelock translates as 'her double badger-skin(?) gown'. Dr Gale Owen discusses the adjective at length and accepts that it may well refer to a badger-skin, but also comments that it could alternatively mean 'twice-worn' or of 'broken twill' ('Wynflæd's wardrobe', in *Anglo-Saxon England* 8, ed. Peter Clemoes (Cambridge, 1979), pp. 206–11).

29 *Mon. Germ. Hist. SS., XXX*, 2, p. 1452.

30 *Ibid.*, p. 1453.

31 D. Jellema 'Frisian trade in the Dark Ages', *Speculum* 30 (1955), p. 31.

32 *Anglo-Saxon Chronicle*, ed. Whitelock, p. 156.

33 I, 262c.

34 *Laws of Hywel Dda*, ed. Melville Richards, p. 106.

35 'Itaque semper omnis ostentationis refugus; in cunctis diuiciis agninis tantum amitiebatur pellibus. Unde quadam uice, a Gaufrido Constantiensis episcopo benigne reprehensus . . . Cum enim interrogasset cur agninas pelles haberet, qui sabelinas uel castorinas uel uulpinas habere posset et deberet . . .' (*Vita Wulfstani*, ed. Darlington, p. 46).

36 '. . . quidam major domus Osgodclap cognomine . . . pedetenus decoratus mastrugarum decore, armillas quoque bajulans in brachiis ambobus superbe, Danico more deaurata securi in humero dependente . . .' (*Memorials of St Edmund's Abbey*, I, p. 54: L-B, 467).

37 Talbot *Anglo-Saxon Missionaries*, p. 65.

38 Robertson *Anglo-Saxon Charters*, p. 153.

39 E. Crowfoot and S. C. Hawkes 'Early Anglo-Saxon gold braids', *Medieval Archaeology*, II (1967), pp. 42–86.

40 Whitelock *The Will of Æthelgifu*, p. 13.

41 Whitelock *Wills*, p. 64.

42 *Ibid.*, pp. 26, 28.

43 '. . . mafortibus cedunt, quae vittarum nexibus assutae talotenus prolixius dependunt' (*Aldhelmi opera* ed. R. Ehwald, in *Mon. Germ. Hist. Auct. Ant.*, XV, p. 318).

44 'Regis autem regiorumque satellitum indumenta spectantes intexta atque crustata auro, quaeque antea viderant vilia aestimavere' (Guillaume de Poitiers *Histoire*, pp. 260–2). The Conqueror was parading his triumph in Normandy and the garments described were Anglo-Saxon.

45 'hwær beoth thonne his idlan gescyrplan? hwær beoth thonne tha glengeas & tha mycclan gegyrelan the he thone lichoman ær mid frætwode? . . . Nu thu miht her geseon moldan dæl & wyrmes lafe, thær thu ær gesawe godweb mid golde gefagod' (*Blickling Homilies*, pp. 111–13, editor's translation).

46 'Regalis dignitas et matronarum ambitus . . . aurotextas clamides, gemmatas trabeas . . . apponit . . .' (Goscelin *La Légende de Ste. Édith*, p. 44: L-B, 4618).

47 'In praecipuis festivitatibus, quamvis amiciretur vestibus auro intextis quas regina sumptuosissime elaboraverat . . .' (William of Malmesbury *De Gestis Regum*, I, p. 271: L-B, 6551).

48 'Obsecuta est illi tamquam filia regina egregia eumque a principio sue desponsionis diuersis in opere redimiuit ornamentis' (*Vita Ædwardi*, ed. Barlow, p. 15).

49 '. . . eoque totius Anglie duces confluxerant et pontifices sollempnitatem regiam uariis diuitiarum suarum delitiis in fimbriis aureis decorantes' (Osbert de Clare *Vie de S. Edouard*, p. 75: L-B, 6553).

50 Athelstan gave a royal cap woven of gold – 'unum regium pilleum auro textum' – to the shrine of St Cuthbert (*Symeonis monachi opera*, I, p. 211: L-B, 2445).

51 'Hanc quoque donationem cum . . . duabus laciniis pallii sui, pretioso opere auri et gemmarum contextis . . . ecclesie Elyensi investivit' (*Liber Eliensis*, II, 62, p. 135).

52 '. . . et plena domus discumbentium purpureis vel aureis cultibus exultaret . . .' (Goscelin *Miracula S. Ivonis* in *Chronicon abbatiae Rameseiensis* ed. W. Dunn Macray, Rolls Series (London, 1886), p. lxii: L-B, 5612).

53 Eddius *Life*, p. 48: '. . . innumerumque exercitum sodalium regalibus vestimentis et armis ornatum'.

54 The *Hodoeporicon* of St Willibald, set down by Huneberc, the Anglo-Saxon nun of Heidenheim, recounts how 'The citizens of the town, who are inquisitive people, used to come regularly to look at them, because they were young and handsome and clothed in beautiful garments' (Talbot *Anglo-Saxon Missionaries*, p. 162).

55 'Enim vero clamidem suam de insigni purpura admodum lorice auro undique contextam illuc contulit, de qua infula facta est et in ecclesia, velud recens, hactenus servatur' (*Liber Eliensis*, II, 50, p. 117).

56 '. . . vestem etiam regalem, in qua fuerat coronatus, pretiosissimam, contulit, ut altaris cederet ornamento' (William of Malmesbury *De antiquitate Glastoniensis*, col. 1719: L-B, 1843).

57 See below, pp. 227–8.

58 See below, chapter VIII, note 100.

59 'Pallium quoque suum regale mirifice auro et gemmis pretiosissimis insignitum . . . conferri praecepit . . .' (*Chronicon monasterii de Bello*, ed. J. S. Brewer (London, 1846), p. 37: L-B, 254).

60 See above, p. 45.

61 '. . . regina Emma . . . dedit ecclesiae Cantuariensi . . . duo pallia et duas cappas cum tassellis aureis . . .' (*Historical Works of Gervase of Canterbury*, ed. Stubbs, II, p. 56: L-B, 646).

62 'Contulit etiam beatus pontifex . . . cappe videlicet plures, sed una insignis operis, festis precipuis condigna officio precentoris, aurifriso in girum optimo, ut decet talem amictum, pretiose purpure circumtecta' (*Liber Eliensis*, II, 3, p. 75).

63 A thirteenth-century inventory at St Paul's in London records: 'Casula Godivae de Coventria est de quo panno nigro minutissime ginillato, cum gemellis purpureis et rubeis cum aurifrigio, fino interhumerali breudatur arbor auro . . .' (*Descriptio . . . thesaurariae ecclesiae S. Pauli London*, ed. W. Sparrow Simpson in *Archaeologia*, L (London, 1887), p. 482: L-B, 2743).

64 'Nempe dalmatica . . . subrufi coloris purpuram, satis hoc tempore incognitam, cunctis experientioris viris scientiae praebet . . . Cujus dalmatiae fines extremos limbus deauratus instar aurifraxii alicujus, undique perambiendo circumluit, qui prae auri copia, quae in ejus fabrili textura inseritur, non facile, et tunc quidem cum aliquo stridore, reflectitur . . . Qui ad mensuram palmae virilis latitudine distenditur; cuius operis industria satis artificiosa fuisse videtur. Simili modo, in utriusque manicae finibus postremis, de quibus prodeunt manus vel brachia gloriosi Pontificis. Circa collum vero ubi caput emittitur limbus aureus priore latior, opere et precio etiam incomparatior esse videtur. Qui permaximam humeri utriusque partem tam posteriorem quam anteriorem obtegit, eo quod ex alterutra regione palmi ac pene dimidii plenitudine latior sit' (*Reginaldi libellus*, pp. 87–8: L-B, 1390). The translation is that of Pace in *The Relics of Saint Cuthbert*, ed. C. F. Battiscombe (Oxford, 1956), p. 110.

65 'Hujus [Oswaldi] infula purpurea, auro et gemmis ornata, et prisca pulchritudine fulgida . . .' (*Chronica ecclesiae Eboracensis*, p. 341: L-B, 6450).

66 'Casulam quoque ex purpura optime de auro et preciosis gemmis ornatam . .' (*The Chronicle of Hugh Candidus*, p. 66: L-B, 3454).

67 'casula albi coloris de pallio aurifrixo singula perlucida . . .' (*Chronicon Abingdon*, I, p. 462: L-B, 23).

68 'Brithwoldus . . . misit . . . albam de serico pretiosissimam, cappas etiam de palliis decem auro et gemmis decenter ornatas, misit etiam superhumerale, stolam, manipulum, casulam . . .' (William of Malmesbury *De antiquitate Glastoniensis*, cols. 1722–3: L-B, 1859).

69 The gifts of Harold included: 'Vestimentorum etiam habundantiam . . . in cappis et casulis, dalmaticis et tunicis et ceteris, redimitis auro et margaritis . . .' (*De inventione Sanctae Crucis*, ed. Stubbs, p. 18).

70 They are itemised in *Liber Eliensis*, II, 114, pp. 196–7.

71 'Nam dederunt pro animarum suarum expiatione . . . et tunicam ex rubea purpura per girum et ab humeris aurifriso undique circumdatam . . .' (*ibid.*, p. 158).

72 '. . . vestemque insignem, quam bonorum executor Stigandus

cum albis leonibus . . .' (*ibid.*, col. 1722: L-B, 1848). Sigfrid, a former monk of Glastonbury and later Bishop in Norway, sent 'quatuor cappas, ii cum leonibus . . .' (*ibid.*, col. 1722: L-B, 1844).

101 See above, p. 130.

102 See above, p. 57.

103 '. . . unius aurum casulae, quae vocabatur "*Dominus dixit ad me*," appenderetur xxvi. marc. auri in deauratione' (*De inventione Sanctae Crucis*, ed. Stubbs, p. 18: L-B, 4473). There is a second reference to it further on (p. 32): 'ipsam etiam casulam auro textam quae vocata est "*Dominus dixit ad me*," quam supra memoravimus . . .'.

104 Cf. *Liber de benefactoribus monasterii S. Albani*, in *Johannis de Trokelowe et Henrici de Blaneforde . . . Chronica et Annales*, ed. H. T. Riley, Rolls Series (London, 1866), p. 433: L-B, 3923 – 'Decoravit etiam ecclesiam duabus capis pretiosissimis; quarum una vocatur 'Vinea' hiis diebus, altera 'Paradisus', eo quod in ea ejectio Adae de Paradiso nobiliter opere plumario figuratur'.

105 '. . . et arte plumaria omne textrinum opus diversis imaginum thoracibus perornent . . .' (ed. R. Ehwald, p. 244). This is part of an extended metaphor in his treatise *De Virginitate* addressed to the nuns of Barking. Aldhelm at least assumes that the nuns knew about such things.

106 See M. Calberg 'Tissus et broderies attribués aux saintes Harlinde et Relinde', *Bulletin de la Société Royale d'Archéologie de Bruxelles* (Oct. 1951), pp. 1 ff.

107 *The Relics of St Cuthbert*, ed. Battiscombe, p. 84, quoting from *The Rites of Durham* probably by an eye-witness.

108 *Idem* (quoting from Reginald of Durham).

109 *Ibid.*, p. 79, quoting from the *Rites*.

110 The identifications are made by Christopher Hohler in his contribution on the iconography of the textiles (*ibid.*, pp. 396–408). The essay by Dr R. Freyham on the place of these textiles in Anglo-Saxon art (*ibid.*, pp. 409–432) is also indispensable.

111 '. . . Næs na mid golde ne mid godwebbenum hræglum . . .' (ed. R. Morris, p. 95).

112 See below, chapter VIII, note 18.

## Chapter VII    *Jewellery, silver and gold*

1 'Ista collum lunulis et lacertos dextralibus ornari ac gemmiferis digitorum anulis comi concupiscit . . .' (ed. Ehwald, p. 246).

2 *Medieval Handbooks of Penance*, ed. John T. McNeill and Helena M. Gamer (New York, 1965), p. 387.

3 'Theah we us scrydæn mid tham rædeste golde and mid tham hwiteste seolfre, and we mid tham fegereste gymstanes all uten embihangene beon,

theah the mon sceal ece ende abidæn' (*Twelfth Century Homilies* ed. Belfour, p. 130).

4 Whitelock *Wills*, p. 20.

5 *Ibid.*, pp. 26, 28.

6 See above, pp. 135–6.

7 'Mulier quaedam divitiis pluribus abundans, Scheldwara nomine, dedit . . . unam miscam auream gemmis pretiosis ornatam . . .' (*Historia Ramesiensis*, p. 199: L-B, 3590).

8 See above, p. 119.

9 See above, chapter II, note 6.

10 See above, pp. 174–5.

11 'Gold geriseth   on guman sweorde, / sellic sigesceorp   sinc on cwene' (*Exeter Book*, II, p. 40, ll. 125–6.

12 E.g. *Beowulf*, ll. 1157, 1194–6, 1750, 1881, 1969, 2018, 2172, 2812, 3014, 3163; *Christ*, l. 995; *The Gifts of Men*, ll. 58–60; *Widsith*, ll. 3–4, 73–4; *The Fortunes of Men*, ll. 74–5; and *Soul and Body*, II, l. 54 (*A.S.P.R.*, IV, pp. 36, 37, 54, 58, 60, 62, 67, 87, 93, 97; III, pp. 30, 139, 149, 151, 156, 176).

13 According to Roger of Wendover, King Edgar gave rings with precious stones to King Kenneth of Scotland (*Chronica*, p. 416).

14 Lines 1881–2.

15 See above, chapter II, note 55.

16 '. . . tunc erant Angli . . . armillis aureis brachia onerati . . .' (William of Malmesbury *De Gestis Regum*, II, p. 305: L-B, 6554).

17 Whitelock *Wills*, pp. 34 and 26.

18 *Ibid.*, p. 38.

19 'earm-beaga fela, / searwum gesæled' (ll. 2763–4).

20 '. . . and thæne beh the Wulfric worhte . . .' (Whitelock *Wills*, p. 56).

21 Lines 3015–16.

22 See this chapter, note 11.

23 See *Exeter Book*, Riddle 20 (*A.S.P.R.*, III, pp. 190–1).

24 *English Historical Documents*, ed. Whitelock, p. 433.

25 '. . . and a goldwreken spere . . .' (Whitelock *Wills*, p. 74).

26 '. . . and an handsex. and thæræ lecge is hundeahtati mancussa goldæs' (*ibid.*, p. 22).

27 '. . . ænne beah. on hundeahtotigan mancysan goldes. and an handsecs on ealswa miclan . . .' (*ibid.*, p. 26).

28 '. . . that suerd that Eadmund king me selde on hundtuelftian mancusas goldes. and four pund silueres on tham fetelse . . .' (*ibid.*, p. 6).

29 The ones left by Brihtric must have been if they were worth three pounds (*ibid.*, p. 28).

30 The Ætheling Athelstan leaves a silver-coated trumpet in his will (Whitelock *Wills*, p. 58).

31 According to William of Malmesbury, King Edgar gave to Malmesbury 'lituum proprium ebore decentissime formatum, auroque decoratum . . .' (*De Gestis Regum*, I, p. 168: L-B, 1842).

32 *Edward the Confessor,* ed. Barlow, p. 58; *Anglo-Saxon Chronicle,* ed. Whitelock, p. 136.

33 'Aureus e puppi  leo prominet; çquora prore / celse pennato  perterret corpore draco / aureus, et linguis  flammam uomit ore trisulcis' (*Vita Ædwardi,* ed. Barlow, pp. 13–14). This account, written 1065–6, is a curtailment of an earlier description: see *ibid.,* p. xxxviii.

34 'Haroldus quidam, rex Noricorum, misit ei [Ethelstano] navem, rostra aurea et velum purpureum habentem . . .' (William of Malmesbury, *De Gestis Regum,* I, p. 149: L-B, 5942).

35 'Godwinus autem regi [Hardecanuto] pro sua amicitia dedit trierem fabrefactam, caput deauratum habentem . . .' (Florence of Worcester *Chronicon,* I. p. 195: L-B, 6653).

36 Snorri Sturluson *Heimskringla* ed. Samuel Laing and Jacqueline Simpson (London, 1964), vol. 2, p. 305.

37 *Ibid.,* p. 326.

38 *Encomium Emmae Reginae,* ed. Alistair Campbell (London, 1949, Camden Soc. 3rd Series, vol. LXXII), pp. 19–21 (editor's translation).

39 A suggestion already made by the editors of the will – No. 10 of *The Crawford Collection,* ed. A. S. Napier and W. H. Stevenson, see p. 23.

40 Talbot *Anglo-Saxon Missionaries,* p. 143.

41 *Liber Eliensis,* p. 82: L-B, 405.

42 'Ego Ethelstanus rex do sancto Cuthberto . . . tria cornua, auro et argento fabrefacta . . .' (*Symeonis monachi opera,* I, p. 211: L-B, 2445).

43 '. . . cornua argento et auro vermiculata varietate redimita . . .' (*Vita Oswaldi auct. anonymo* in James Raine *The Historians of the Church of York,* Rolls Series, vol. I (London, 1879), p. 465: L-B, 3573).

44 '. . . cum cornu aureo mero pleno ad potum invitans . . .' (*Speculum historiale . . . auct. Ricardo de Cirencestria* ed. J. E. B. Mayor, Rolls Series, vol. II (London 1869), p. 172: L-B, 5974).

45 In British Library Cotton MS. Tib. C VI there is a representation of a decorated gold drinking horn (fol. 18v) and in British Library Cotton MS. Tib. B V a picture of a decorated drinking horn embellished with gold (fol. 10v).

46 'Eala beorht bune . . .' (l. 94, *A.S.P.R.,* III, p. 136).

47 'Ego Athelgiva comitissa do et concedo ecclesiae Ramesensi . . . et duos ciphos argenteos de xii marcis . . .' (*Historia Ramesiensis,* p. 58: L-B, 3562).

48 'Dedit . . . duas quoque pelves argenteas . . .' (*ibid.,* pp. 84–5: L-B, 3564).

49 Whitelock *The Will of Æthelgifu,* pp. 7 and 13.

50 Whitelock *Wills,* p. 12. (They have been borrowed and are to be returned to Eadwold.)

51 *Ibid.,* p. 64.

52 See the Exeter Book riddle-poem No. 14 (*A.S.P.R.,* III, p. 187).

53 *Ibid.,* p. 186, No. 11.

54 'Veruntamen cyphum quemdam desiderabilem, tam artificio quam materia admirabilem, adquisivit, et Beato Albano obtulit, ad Corpus

Dominicum reponendum' (*Gesta Abbatum S. Albani*, I, p. 20: L-B, 3785).

55  *Met.* II, 5: 'Materiam superabat opus'.

56  'Item vasa argentea sive aurea admirabantur, quorum de numero vel decore vere narrari possent incredibilia' (Guillaume de Poitiers *Histoire*, p. 262, speaking of Anglo-Saxon treasures utilised, or paraded, in Normandy).

57  Whitelock *Wills*, pp. 10–11, 14–15.

58  'Ego Ethelstanus rex do sancto Cuthberto . . . duo candelabra argentea, auro parata . . .' (*Symeonis monachi opera*, I, p. 211; L-B, 2445).

59  'Rex Cnutus dedit Wintoniensi ecclesiae . . . candelabrum argenteum cum sex brachiis . . .' (*Annales monasterii de Wintonia*, p. 16, in H. R. Luard *Annales monastici*, II (Rolls Series, London, 1865): L-B, 4702.

60  'Et quotienscunque venit Rofam, portavit secum aliquid ornamentum de ornamentis Gode comitisse que apud Lamhethe invenit, viz . . . scampna ferrea plicancia et argentata . . . et candelabra de cupro deaurata' (*Registrum Roffense*, ed. John Thorpe (London, 1769), p. 119: L-B, 3760). It seems from the context, where there is reference to a shrine and Gospel Book accompanying these gifts, that they came from the private chapel of the countess.

61  Amongst the treasures said to have been taken from Waltham by William the Conqueror were 'sellas femineas ex multo auro fabricatas' (*Vita Haroldi regis* in J. A. Giles *Original Lives of Anglo-Saxons* (London, 1854), p. 51: L-B, 4484).

62  Gold chairs are represented in British Library Cotton MS. Claud. B IV (fols. 62, 68v), and a gold footstool in British Library Cotton MS. Tib. C VI fol. 10. In British Library Cotton MS. Tib. BV there is a representation of an extremely opulent couch supported at each end by almost life-size figures of animals (fol. 4v). Both in British Library Cotton MS. Claud. B IV (fols. 27v, 55 and 69v) and in the Bayeux Tapestry there are representations of ornately carved or cast furniture. In the tapestry, the bed and seat of Edward the Confessor are decorated with animal heads which may be of precious metal, though equally they may be carved.

63  See above, p. 193, for the praise of them when they were actually removed to that Duchy.

64  'Maximi numero genere, artificio thesauri compositi fuerant, aut custodiendi ad vanum gaudium avaritiae, aut luxu Anglico turpiter consumendi' (*Histoire*, p. 224).

65  '& hwær com seo frætwodnes heora husa & seo gesomnung thara deorwyrthra gimma, oththe thæt unmæte gestreon goldes & seolfres . . .' (*Blickling Homilies*, p. 99).

66  '. . . and theah tha mihtige men and tha ricostæn haten heom ræste wurcean of marmanstane and of goldfretewum, and heom haten mid gymmum and mid seolfrene ruwum the bed al wreon, and mid the deorewurtheste godewebbe al uton ymbhon . . .' (*Twelfth-Century Homilies in MS. Bodley 343*, ed. A. O. Belfour, E.E.T.S. 137 (London, 1909), p. 130,

translation by Belfour, p. 131). The Homilies are pre-Conquest.

67 'Theah the tha mihtegestan and tha ricestan hatan him reste gewyrcan of marmanstane and mid goldfrætwum and mid gimcynnum eal astæned and mid seolfrenum ruwum and godwebbe eall oferwrigen and mid deorwyrthum wyrtgemengnessum eal gestreded and mid goldleafum gestrewed ymbutan . . .' (Arthur Napier *Wulfstan. Sammlung der ihm zugeschriebenen Homilien* (Berlin, 1883), p. 263).

68 *Synonyma*, II, 90 (*Pat. Lat.*, LXXXIII, 865). I owe this knowledge to the kindness of Dr Donald Scragg who also draws my attention to the article by J. E. Cross ' "Ubi sunt" passages in Old English sources and relationships', Lund, Vetenskaps-Societeten *Årsbok*, 1956, pp. 25–44.

69 Bed-hangings are represented in the Bayeux Tapestry and in a manuscript of the first half of the eleventh century – British Library Cotton MS. Claudius B IV fols. 27v and 55. Couch and chair covers appear in the latter manuscript, fols 11, 11v, 12 etc., and in British Library Cotton MS. Tib. B V fol. 4v.

70 See above, p. 286 note 65, p. 287 note 84.

71 See above, p. 130.

72 Judith X. 19, refers simply to a canopy of purple and gold.

73 Lines 42–3.

74 I am grateful to Dr C. Joy Watkin for drawing my attention to the literary importance of the curtain which she will develop in her forthcoming edition of the poem. This does not, of course, invalidate my own point.

75 See above, p. 35.

76 A portable altar of porphyry has survived from the Anglo-Saxon period, for which see below, p. 210. Apart from more general statements, there is a record of marble slabs at Bury (Robertson *Anglo-Saxon Charters*, p. 194), and of a marble inset in the altar at Waltham (*De inventione Sanctae Crucis Walthamensis*, p. 18).

77 Purbeck 'marble' – a stone which took a good polish – was quarried as early as the first century A.D. in Dorset, and Petworth 'marble' was quarried in Sussex. At the Reformation, Dr Caius pointed out that the tomb of St Etheldreda, which – following Bede – the Anglo-Saxons always said was of marble, was in fact of stone: 'Idem sepulchrum ex lapide communi fuit, non, ut Beda narrat ex albo marmore' (quoted C. W. Stubbs *Historical Memorials of Ely Cathedral* (London, 1897), p. 84).

78 British Library Cotton MS. Claud. B IV fol. 55.

79 '. . . aedificium multifario decore ac mirificis ampliauit operibus. Dedit namque operam, quod et hodie facit, ut adquisitis undecumque reliquiis beatorum apostolorum et martyrum Christi, in uenerationem illorum poneret altaria, distinctis porticibus in hoc ipsum intra muros eiusdem ecclesiae' (Bede *Hist. Eccles.*, V, 19, ed. Plummer, p. 331; ed. Colgrave and Mynors, p. 530).

80 For an admirable survey of the qualities attributed to relics, see Charles Thomas *The Early Christian Archaeology of North Britain* (Oxford, 1971), pp. 132 ff.

81  M. Förster *Zur Geschichte des Reliquienkultus in Altengland* (Munich, 1943), pp. 63–114. There is a translation in *Anglo-Saxon Prose* ed. M. Swanton (London, 1975), pp. 15–19.

82  '. . . multas insuper reliquias, quas per universas terras a se peragratas acquisivit, cum reliquiis duorum innocentium de Bethleem translatis Glastoniensi monasterio . . . commendavit' (Malmesbury *De antiquitate Glastoniensis*, col. 1719: L-B, 1843).

83  See below, p. 200.

84  Bede *Hist. Abb.*, 4 and 6, pp. 367 and 369.

85  Talbot *Anglo-Saxon Missionaries*, pp. 48 and 49.

86  Feeling death to be near, William ordered that Battle Abbey should be given 'trecenta numero philacteria decenter auro argentoque fabrifacta, quarum plura catenis aureis vel argenteis appendebantur, innumerabilium sanctorum reliquias continentia . . . quae inter alia multiformia ex praedecessorum suorum regum cum regno adquisitione obtinuerat, et quae in regio hactenus reposita thesaurario conservabantur . . .' (*Chronicon monasterii de Bello* ed. J. S. Brewer, p. 37: L-B, 254).

87  See the article by Professor Kitzinger in *Relics of St Cuthbert*, ed. Battiscombe, pp. 202–304.

88  *Hist. Eccles.*, IV, 3, ed. Plummer, p. 212; ed. Colgrave and Mynors, p. 346.

89  *Ibid.*, V, 17, p. 319; p. 512. This Dr Colgrave points out. For a discussion of European parallels, see Thomas *op. cit.*, pp. 163 ff.

90  'Denique in urbe regia, quae a regina quondam uocabulo Bebba cognominatur, loculo inclusae argenteo in ecclesia sancti Petri seruantur ac digno a cunctis honore uenerantur' (*Hist. Eccles.*, III, 6, ed. Plummer, p. 138; ed. Colgrave and Mynors, p. 230).

91  'Fecit idem pontifex plurima ornamenta ecclesie in scriniis et crucibus auro argentoque paratis' (C. H. Talbot 'The Life of Saint Wulsin of Sherborne by Goscelin', *Revue Bénédictine*, LXIX (1959), p. 83).

92  'Illis diebus vir praepotens nomine Atheluuardus ad novissimum vitae terminum veniens . . . scrinia iii, cum uno grandi cristallo, huic coenobio largitus est' (*Chronicon Abingdon*, I, p. 442: L-B, 21).

93  See below, pp. 198–200.

94  'Regina vero eius olim suprafata chrismarium hominis Dei sanctis reliquiis repletum – quod me enarrantem horruit – de se absolutum, aut in thalamo suo manens aut in curru pergens, iuxta se pependit' (Eddius *Life*, p. 70 and see editor's note on *chrismarium*, p.173).

95  For the uncertainties of the history of the contents of the tomb, see above, pp. 162–5.

96  See *A True and Perfect Narrative of the Strange and Unexpected finding the Crucifix and Gold-Chain of That Pious Prince, St Edward the King and Confessor* (London, 1688) by Charles Taylour (a pen-name for Henry Keepe).

97  *Idem.*, p. 13. For the later history of the cross, see C. F. Tanner 'The Quest for the Cross of St Edward the Confessor', *The Journal of the British Archaeological Association* (1954), pp. 1–11.

98 '. . . cum ad monasterium sancti Florentini de Bona Valle uenisset, et distracta iam omnia iunenisset, et adhuc fames illos cruciaret, et nichil habentes quod amplius uenderent, preter ipsum sanctum Florentinum suum patronum et protectorem, ipsum cum suo feretro totum preter solum caput ipsius, illi uendiderunt . . . Datis itaque quingentis libris argenti continuo illum cum multis aliis reliquiis et ornamentis in Angliam per monachos suos ad proprium monasterium, scilicet ad Burch transmisit' (*The Chronicle of Hugh Candidus*, ed. W. T. Mellors, p. 49: L-B, 3450).

99 'Item, nobilis . . . matrona, nomine Eadfled . . . Abbendonensi ecclesiae largita est cum scrinio sanctarum reliquiarum et textu Evangeliorum argento et auro redimitis . . .' (*Chronicon Abingdon*, I, p. 429: L-B, 24).

100 'Misit [Algitha] . . . ad Mannium . . . abbatem monasterii sancti Ecgwini, quaerens licentiam habendi reliquias, et promittens se feretrum ex auro et argento adornatum ob honorem reliquiarum facturam . . . Quam sponsionem . . . implevit. . . postea Omnipotens . . . et . . . scrinium . . . usque inpraesentiarum in monasterio sancti Ecgwini servatur' (*Chronicon Evesham*, p. 46: L-B, 1612).

101 See above, p. 23.

102 See above, p. 23.

103 'Concedo . . . novo monasterio Wyntoniae . . . quoddam scrinium curiosum . . .' (*Liber monasterii de Hyda* ed. Edward Edwards, pp. 256–7: L-B, 4698).

104 'Dedit autem Deo [Elfwara] . . . scrinium cum reliquiis quod gradatum feretrum vocabant' (*Liber Eliensis*, II, 61, p. 133).

105 See this chapter, note 174.

106 'Est autem crux illa longitudinem habens palmae de auro purissimo mirabili opere fabricata, quae in modum thecae clauditur et aperitur. Cernitur in ea quaedam Dominicae crucis portio . . . Salvatoris nostri imaginem habens de ebore densissime sculptam, et aureis distinctionibus mirabiliter decoratam' (*Genealogia regum Anglorum* auct. *Aelredo, abbate Rievallensis abbatiae* in *Pat. Lat.*, CXCV, col. 715: L-B, 5838).

107 '. . . tanto auri et argenti spectaculo, ut ipsi parietes ecclesiae angusti viderentur thesaurorum receptaculis, miraculo porro magno visentium oculis' (William of Malmesbury *De Gestis Regum*, II, p. 388: L-B, 1132).

108 'Postea rex felix ornaverat Offa sepulchrum / Argento, gemmis, auro, multoque decore / Ut decus et specimen tumbae per saecla maneret' (*De Pontificibus*, ll. 388–90).

109 'Servabantur namque reliquiae ejusdem patris . . . in quodam scrinio quondam precioso fulvoque metallo bene adornato, sed jam pridem a Dacis circum circa expoliato' (*Chronicon Evesham*, p. 38: L-B, 1609).

110 'Quatuor etiam capsas aureas, ix argenteas . . .' (*De inventione Sanctae Crucis*, ed. Stubbs, p. 18).

111 '. . . plurima feretra et texta euuangeliorum . . . similiter omnia ex auro et argento fecit' (*The Chronicle of Hugh Candidus*, ed. W. T. Mellors, p. 66: L-B, 3454).

112 '. . . Athelwoldus transtulit beatum Birinum . . . et in scrinio de argento et auro decentissime compositum collocavit' (Thomas Rudbourne *Historia Wintoniensis*, p. 223: L-B, 4686).

113 See below, pp. 213–15.

114 'contulit [Eadgar] argenti, gemmae rutilantis, et auri,
ter centum libras aequa sub lance probatas,
et iubet aurifices simul adfore quosque peritos,
ut patris dignum fabricent in honore sacellum'
(*Frithegodi monachi breuiloquium vitae beati Wilfredi et Wulfstani cantoris narratio metrico de Sancto Swithuno*, ed. A. Campbell (Zurich, 1950), ll. 5–8).

115 '. . . qua passio Christi / sculpta beata nitet, simul et surrectio, necne / eius ad astriferos ueneranda ascensio caelos' (*ibid.*, ll. 12–14).

116 'plura inibique micant, quae nunc edicere longum est' (*ibid.*, l. 15).

117 'Sed in illo opere expressum est dominice passionis commercium, cuius angelus sedens ad sepulcrum nunciat mulieribus triumphale resurectionis gaudium. Tali ferculo propinatur autori suscitanda virgo, et tali in somno pacis gaudere creditur presidio, vigilante et clamante desuper inmortalitatis Domino: 'Non est mortua puella sed dormit' . . . Sanctorum quoque Innocentum adornatur cede, quasi tot rosis paradisi, quos virgo virgines in celo et sinu et gremio fovet uirginali' (Goscelin *La Légende de Ste. Édith*, pp. 280–1: L-B, 4628).

118 See above, p. 65.

119 'Fecit [Æthelwulf] etenim scrinium quo sancti confessoris ossa locaret, in anteriori parte ex solido argento jactis imaginibus. In posteriori vero levato metallo miracula figuravit' (William of Malmesbury *Gesta Pontificum*, p. 389).

120 According to the *Cartularium monasterii de Rameseia* (ed. W. H. Hart and P. A. Lyons, Rolls Series (London, 1886), vol. 2, p. 274: L-B, 3596), Abbot Walter, about 1143, removed from the shrine of St Ivo: 'Imaginem Sancti Salvatoris, 'super aspidem et basiliscum ambulabis', magnam et ponderosam . . . Imaginem Sanctae Mariae . . . Imagines Sanctae Johannis Evangelistae, Marci, Mathaei, Lucae, et duodecim Apostolorum, omnes argenteas'. The iconography of Christ on the asp and basilisk is little known in England between 1066 and 1150 but was especially popular before the Conquest – on stone carvings, like the Ruthwell and Bewcastle crosses; on ivory carvings like the Alcester Tau-Cross; in manuscripts like the Arenberg Gospels (Pierpont Morgan Library MS. 869), the Crowland Psalter (Bodleian MS. Douce 296), the Winchcombe Psalter (Cambridge, University Library MS. Ff. 1. 23), and the Bury Psalter (Vatican Library MS. Reg. lat. 12). We have no special knowledge of any great calamity befalling Ramsey as a result of Hastings which might lead to the original shrine being dismantled, or of any fresh occasion, such as a new translation of relics, which would lead to the fashioning of a new one, so the probability is that this one was pre-Conquest.

121 'Scrinium magnum argento et auro coopertum, cum imaginibus ex ebore decenter intersertis, continens reliquias sancti Vincentii, et caput sancti Appollinaris dedit . . .' (William of Malmesbury *De antiquitate Glastoniensis*, col. 1719: L-B, 1843).

122 See above, p. 25. The inscription goes on to say that the abbot, then, was Æthelwine.

123 '. . . in quo [scrinio Oswaldi] sunt hi versus:
   Exiguus praesul Brithwoldus onomate dictus,
   Archonti domino, nec non matrique Mariae,
   Confert exiguum devote pectore munus,
   Ecclesiae veteri transmittens Glastonicum,
   Dulcia perpetuae capiat quo gaudia vitae'
(William of Malmesbury *De antiquitate Glastoniensis*, col. 1723: L-B, 1859).

124 'Coventreiae habetur brachium Augustini magni, theca inclusum argentea, cernunturque in celatura hujusmodi litterae: "Hoc brachium sancti Augustini Egelnodus archiepiscopus rediens a Roma apud Papiam [Pavia] emit centum talentis argenti et talento auri" ' (William of Malmesbury *Gesta Pontificum*, p. 311: L-B, 1128).

125 '. . . quae [ecclesia Cadomi et ecclesia S. Trinitatis] scilicet usque hodie gaudent spoliis sic adquisitis, et inscripta habent nomina in ipsis capsis et textis principum qui ea contulerunt ecclesiae Walthamensi . . .' (*De inventione Sanctae Crucis* ed. Stubbs, p. 32).

126 '. . . organa . . . in quorum circuitu hoc distichon litteris aeneis affixit, "Organa do sancto praesul Dunstanus Adhelmo; Perdat hic aeternum qui vult hinc tollere regnum". De fulvo aere vas aquatile fusili opere, in quo scriptum erat cernere, "Idriolam hanc fundi Dunstan mandaverat archiPraesul ut in templo sancto serviert Aldhelmo." ' (The writer is William of Malmesbury: Stubbs *Memorials*, pp. 301–2: L-B, 3029).

127 See *The Relics of St Cuthbert*, ed. Battiscombe, p. 13.

128 '. . . bracchium sancti Ciriaci martyris . . . decenter auro et argento coopertum ecclesiae beati Petri Westmonasterii devote contulerat . . .' (Richard of Cirencester *Speculum historiale*, ed. J. E. B. Mayor, Rolls Series, vol. II (London, 1869), p. 185: L-B, 2496).

129 See Hanns Swarzenski *Monuments of Romanesque Art* (London, 1954), fig. 66.

130 '. . . cum aurea cruce mirifico opere polita reliquiisque referta quam gloriosus rex . . . super altare sancte Æthelthrede in Hely gratanter optulit' (*Liber Eliensis*, II, 4, p. 76).

131 'Et i turris argenti quadrate figure intus de fuste bene operata et deaurata, de iv marcis et v uncis; in summitate huius turris est quedam crux, duplicem figuram habens crucis, in qua de ligno Domini visibiliter incaptum et de sepulcro Domini et de sepulcro sancte Marie et de monte Calvarie et de presepe Domini et de nativitate Domini et de Gescemani, omnia hec dico sic inposita, quod videri possunt; crux vero ista iniecta igni ut ab antiquis didicimus exuri non potuit' (*Liber Eliensis*, III, 50, p.

292). Though the description is taken from an inventory of the mid twelfth century, this seems to be one of the censers already referred to in a late-eleventh-century list. The final sentence indicates that it must have been of some antiquity.

132 See above, chapter III, note 68.

133 Beckwith *op. cit.*., p. 122.

134 '. . . unam crucem auro et ebore artificiose paratam . . .' (*Symeonis monachi opera*, II, p. 211: L-B, 2445).

135 '. . . et historias passionis eorum, una cum ceteris ecclesiasticis uoluminibus, summa industria congregans, amplissimam ibi ac nobilissimam bibliothecam fecit . . .' (*Hist. Eccles.* V, 20, ed. Plummer, p. 331; ed. Colgrave and Mynors, p. 530).

136 Some scholars believe that the cover of an Anglo-Saxon Gospel-book in New York (Pierpont Morgan Library MS. 708) is Anglo-Saxon. I personally share the view of Professor F. Steenbock (*Die kirchliche Prachteinband im frühen Mittelalter* (Berlin, 1965), p. 170) that it comes from what he calls the north-east France/Belgium area. The manuscript was in the possession of Judith, daughter of count Baldwin IV of Flanders, and stylistically it seems to me to belong to her original homeland. Since views here are shaped by stylistic criteria, there will continue to be a division of opinion. Dr W. M. Hinkle's attempts to determine an Anglo-Saxon provenance on other grounds seem to me to be unconvincing. ('The gift of an Anglo-Saxon Gospel-Book to the Abbey of Saint-Remi, Reims', *Journal of the British Archaeological Association*, XXXIII, 1971, pp. 21–33.) Briefly, the argument is that a seventeenth-century inventory describes an Anglo-Saxon manuscript at Reims as having both a Crucifixion and a Christ in Majesty on its binding, and since this conjunction also appears on the Judith manuscript and is found on no other surviving one, then the latter binding is probably Anglo-Saxon. If the argument were acceptable, it would ignore the close stylistic relationships between Flanders and England in the eleventh century. But it generalises far too much from the very few surviving book-bindings. As the writer agrees, the two illustrations were very popular – they were such stock scenes in Europe that Theophilus had them stamped out with prepared dies. There is no reason, therefore, why they should not occasionally appear together. Indeed, they do – even on book-covers of an earlier period. One, now in Dôle (of the tenth century), originally had a Crucifixion with a Majesty above it, as in the Judith manuscript (though there was also an added scene of the three women at the tomb below), and a Flemish book-binding of *c.* 900 has a Crucifixion below and again a Majesty above (though here there is the Lamb of God in between) (A. Goldschmidt *Die Elfenbeinskulpturen aus der Zeit der Karolingischen und Sachsichen Kaiser*, I (Berlin, 1969), No. 30, 160a).

137                           'mec siththan wrah  
     hæleth hleobordum,    hyde bethenede,

gierede mec mid golde;    forthon me gliwedon
wrætlic weorc smitha    wire bifongen'
(*A.S.P.R.*, III, p. 193).

138 See above, p. 75.

139 See above, chapter V, note 214.

140 See above, p. 51.

141 'quidam precipiunt sacratos scribere libros, / . . . / atque hos conspicui preuelat ductilis auri / lamina, sic sancti comunt altaria templi' (ed. Campbell, ll. 636, 639–40).

142 'Ego Ethelstanus rex do sancto Cuthberto . . . duos Evangeliorum textus, auro et argento ornatos . . .' (*Symeonis monachi opera* I, p. 211: L-B, 2445).

143 '. . . textus aureos tres magnos, v argenteos deauratos . . .' (*De inventione Sanctae Crucis*, ed. Stubbs, p. 18).

144 See this chapter, note 111.

145 '. . . evangeliorum duo codices . . . decenter argenti et auri parati . . .' (*Chronicon Abingdon*, I, pp. 461–2: L-B, 23).

146 'Nam, cum Willelmus rex junior importabile tributum indixisset Angliae quo Normanniam a fratre Rotberto intendebat emere, Godefridus . . . thesauros ecclesiae . . . distraxit . . . Denique die uno xii textus Evangeliorum, viii cruces, viii scrinia argento et auro nudata et excrustata sunt' (William of Malmesbury *Gesta Pontificum*, p. 432).

147 'Hec sunt que invenit Eudo dapifer et Willemus de Balfou et Angerus in ecclesia sancte Æthelrethe [*c.* 1081] . . . xii textus et aptamina ii orum textuum . . .' (*Liber Eliensis* II, 114, p. 196). Reference to *textus* in such inventories indicates a preciously bound Gospel-Book.

148 'duo textus Sancti Wilfridi, ornati cum argento et auro, quorum unus continet imaginem crucifixi, Mariae et Johannis in inferiori parte, et imaginem Sanctae Trinitatis et duorum Angelorum in superiore parte, de ebore; et alius continet imaginem crucifixi in parte inferiore, et Salvatoris sive majestatis Ejus, cum Petro et Paulo in parte superiore' (*Fabric Rolls of York Minster*, p. 223).

149 Almost all of the seventeen book-covers included in the inventory which was made at Ely towards the middle of the twelfth century were probably Anglo-Saxon (there were fourteen recorded in the latter part of the eleventh century) but the following were indubitably pre-Conquest – 'Ibi i textus iiii Evangeliorum, quem rex Ædgarus dedit sancte Atheldrethe . . . Hic cum maiestate et iiii angelis et xii apostolis argenteis habet totum Evangeliorum, quem rex Ædgarus dedit sancte Æthelrethe . . . Hic cum maiestate et iiii angelis et xii apostolis argenteis habet totum campum aureum cum lapidibus pretiosis et esmaltis. Altera pars huius textus de argento cum ymaginibus virginum . . . Ibi tertius textus deargentatus in una parte et bene deauratus cum crucifixo et ymaginibus fusilibus cum lapidibus sculptis per totum, quem Ælsius abbas fecit . . . Ibi sextus textus superargentatus cum crucifixo et ymaginibus fusilibus deauratus, quem Alsinus abbas fecit. Ibi vii textus superargentatus cum crucifixo parvo et

cum ii angelis fusilibus bene deauratus, quem idem abbas fecit. . . Ibi xi textus superargentatus partim deauratus cum crucifixo et ymaginibus planis cum lista sculpta in giro, quem Ælsius abbas fecit . . . Ibi xiiii textus parvus superargentatus cum crucifixo et ymaginibus elevatis per totum deauratus de operibus Ælsini abbatis, quem episcopus perdidit apud Warham' (*Liber Eliensis*, III, 50, pp. 290–1).

150 See above, p. 66.

151 '. . . Beatus Atheluuoldus . . . domum istam ornamentis ditavit pretiosissimis. Dedit autem, ut ex antiquorum librorum accepimus attestatione, calicem unum aureum immensi ponderis . . . Dedit etiam tres cruces admodum decoras ex argento et auro puro . . . Ornavit etiam ecclesiam textis tam ex argento puro quam ex auro obrizo pariter et lapidibus pretiosissimis, thuribulis et phialis, pelvibus fusilibus et candelabris ex argento ductilibus, multisque bonis aliis, tam usibus monachorum circa altare competentibus, quam decentiae ecclesiasticae competentibus' (*Chronicon Abingdon*, I, p. 344: L-B, 14).

152 'Attulit quoque secum uasa pretiosa Eduini regis perplura, in quibus et crucem magnam auream, et calicem aureum consecratum ad ministerium altaris, quae hactenus in ecclesia Cantiae conseruata monstrantur' (Bede *Hist. Eccles.* II, 20, ed. Plummer, p. 126; ed. Colgrave and Mynors, p. 204).

153 Alcuin *De Pontificibus*, ll. 275–6: 'Extruit ecclesias, donisque exornat optimis, / Vasa ministeriis praestans pretiosa sacratis'.

154 'Aureus atque calix gemmis fulgescit opertus, / Ut caelum rutilat stellis ardentibus aptum' (*Carmina Ecclesiastica*, III, ll. 72–4 in *Mon. Germ. Hist. Auct. Ant.*, XV, p. 18). Aldhelm is describing Bugge's church.

155 'aureus ille calix gemmis splendescit opertus, / argentique nitens constat fabricatus maclis' (*De Abbatibus* ed. Campbell, ll. 449–50). The editor (p. xlvi) has already pointed out the influence of Aldhelm. The silver paten is more fully described in ll. 649–51, for which see below, p. 208.

156 '. . . missis pariter apostolico papae donariis et aureis atque argenteis uasis non paucis' (Bede *Hist. Eccles.*, IV, 1, ed. Plummer, p. 201; ed. Colgrave and Mynors, p. 328).

157 'Acca episcopus, quae magnalia ornamenta huius multiplicis domus de auro et argento lapidibusque pretiosis . . . quis ad explanandum sufficere potest?' (Eddius *Life*, p. 46).

158 '. . . rutilo qui vasa decore / Apta ministeriis argentea jure sacratis / Fecit . . .' (Alcuin *De Pontificibus*, ll. 1222–4).

159 'Jussit ut obrizo non parvi ponderis auro / Ampulla major fieret, qua vina sacerdos / Funderet in calicem, sollemnia sacra celebrans' (*Ibid.*, ll. 1503–5).

160 The gifts from Harold included 'altaris vasa necessaria, diebus praecipuis aurea, profestis argentea, sufficienti copiositate . . . candelabra aurea et argentea, turribula, urceos et pelves . . .' (*De inventione Sanctae Crucis*, ed. Stubbs, p. 18).

161 They came from Stigand – 'vasa maiora et minora de auro et argento in ministerium sacri altaris contulit . . .' (*Liber Eliensis*, p. 168).

162 In 1045, Brihtwold, bishop of Ramsbury, bequeathed to the house, amongst other things, 'calices duos, unum de xx marcis argenti et IV auri, alium minori pondere, sed pretio majori . . . Thuribulum mirae magnitudinis de auro et argento . . .' (Malmesbury *De antiquitate Glastoniensis*, col. 1723: L-B, 1859).

163 See below, chapter VIII, note 34.

164 It uses the adjective *saxiscus*. The Anglo-Saxons often referred to themselves as *Saxon* and the fact that *Anglo-Saxon* is here meant is indicated by the application of this term to metalwork before the conversion of the Continental Saxons, and also its use to describe the gifts made by an Anglo-Saxon king.

165 'gabatas aureas numero II et alias saxiscas numero V' (*Lib. Pont.*, I, p. 417).

166 *Lib. Pont.* II, p. 3; 'gabathas argenteas saxisca, habentem grifos deauratos, pens. lib. II'.

167 *Ibid.*, p. 79: 'gabatam saxiscam signochristam, habentem storiam in modum leonis incapillatam cum diversis operibus purissimis aureis, pendentem in catenulas IIII et uncinum I; item gabatam saxiscam, habentem in modum leones IIII, cum diversas istorias serpentorum et in medio stantem pineam et IIII leoncellos modicos exauratam, pendentem in catenulas tribus et uncinum I; item gabathas saxiscas, ex quibus habet singulis operibus exauratis pendentes in catenulis III et uncinos IIII, ex quibus habet I gemmis vitreis II, quod domnus item Gregorius quartus pontifex libenti obtulit animum'.

168 The drawings, found in a scrap-book belonging to the Society of Antiquaries, were published by T. D. Kendrick in *The Antiquaries Journal*, XXI (1941), pp. 161–2 and plates XXXIV, XXXV.

169 *Lib. Pont.*, II, p. 132: 'dextra saxisca'.

170 *Ibid.*, p. 148: 'rex Saxorum . . . optulit dona beato Petro apostolo . . . gabathe saxisce de argento exaurate IIII'. For the name of the Anglo-Saxon king see this chapter, note 173.

171 *Ibid.*, pp. 161–2: 'Huius igitur tempore [858–67] . . . quidam de Anglorum gente Romam venerunt, qui in oratorio beati Gregorii papae et confessoris Christi . . . unam tabulam argenteam posuerunt . . .'.

172 *Ibid.*, p. 153: 'Obtulit . . . gabatham saxiscam de argento purissimo I, deaurata, que pens. lib. II et unc. IIII'.

173 'Calicem argenteum Saxonicum maiorem cum patena sua, quem Theodericus Saxonum rex beato Benedicto olim transmiserat' (*Chronicon monast. Casinensis auct. Leone* in *Mon. Germ. Hist. SS.*, VII, pp. 656–7). The king cannot be identified but the Italians had difficulty with Anglo-Saxon names as we see in the reference to Æthelwulf in the *Liber Pontificalis* II, 'dont le nom', says Duchesne (p. 150, note 26) 'aura causé quelque embarras aux scribes romains'.

174 *Ibid.*, p. 649: 'a quodam nobili Anglo transmissus sit . . . loculus ille mirificus . . . argento et auro ac gemmis Anglico opere subtiliter ac pulcherrime decoratus'.

175 *Chron. mon. Cas. auct. Petro* (continuing the above), p. 753: 'Ista praeterea ornamenta idem papa Victor ad mortem suam in hoc monasterio dereliquit . . . Calices argentei Saxonici ii, et alii argentei vii'.

176 See above, pp. 45–6.

177 Spearhafoc was an engraver (see above, p. 55).

178 The goldsmiths who made St Swithun's shrine for King Edgar included engravers. See above, p. 198.

179 See below, p. 208.

180 At a cell of Lindisfarne, and at Abingdon. See below, p. 209.

181 See above, p. 198 and next note.

182 It was given during the Conqueror's reign to Selby which was founded soon after the Conquest. The donor, a private citizen named Edward, was clearly Anglo-Saxon, and the workmanship must have been Anglo-Saxon too. '. . . contulit ad pretiosi digiti [S. Germani] repositionem phylacterium quoddam aureum, rotundum, quantitate praecipuum, qualitate perspicuum, caelatura mirificum, opere pretiosum, quod usque hodie [*a.* 1174] in Monasterio Selebiensi conseruatum, omnes se contemplantes non minus in sui ipsius laudem, quam admirationem pro antiqui operis accendit dignitate' (*Historia Selebiensis monasterii*, Durham, 1891, p. 9, in *The Coucher Book of Selby*, ed. J. T. Fowler, vol. I: L-B, 4181).

183 Ronald Jessup *Anglo-Saxon Jewellery* (London, 1950), plates XXIV, XXV(1), XXXVIII(1), B, XX(2).

184 '. . . calicem . . . cuius inferior pars, figura leonis ex auro purissimo, gestat dorso lapidem onichinum arte pulcherrima cavatum, qui ex studio artificis ita inhaeret leoni, ut manu facile possit in gyrum verti, nec tamen auferri' (*Symeonis monachi opera*, I, p. 255: L-B, 1385). The translation is that of Raine, revised by Professor Sir Roger Mynors in *The Relics of St Cuthbert*, ed. Battiscombe, p. 103.

185 'Hic quoque turibulum capitellis undique cinctum' (*Carmina Ecclesiastica* III, l. 79 in *Mon. Germ. Hist. Auct. Ant.*, IV, p. 18). The reference is to Bugge's church and the description is later borrowed by Æthelwulf in his account of a vision where a similar censer, of gold and 'capitellis undique cinctum', is seen (ed. Campbell, ll. 760–1).

186 'aureus ille calix, tetigi quem carmine dudum, / ac lata argento pulchre fabricata patena / celatas faciem portendunt apte figuras' (ed. Campbell, ll. 649–51).

187 '. . . gemmis aras vestivit et auro' (*De Pontificibus*, l. 277).

188 '. . . et argenti laminis altare crucesque / Texerat auratis . . .' (*Ibid.*, ll. 1224–5).

189 'Ast altare aliud fecit, vestivit et illud / Argento puro, pretiosis atque lapillis' (*Ibid.*, ll. 1500–1).

190 'Namque ubi bellipotens sumpsit baptismatis undam / Edvin rex, praesul

grandem construxerat aram, / Texit et argento, gemmis simul undique et auro' (*Ibid.*, ll. 1489–91).

191   See above, p. 207.

192   Given by King Eadred to the Old Minster. See this chapter, note 229.

193   'Comes [Ailwinus] . . . tabulam ligneam in fronte eminentioris altaris fabrefieri praecepit, quam ad honorem Dei et Sancti Benedicti et ad decus ecclesiae amplis et solidis argenti laminis, cum varii tam coloris quam generis gemmis, insigniter perornavit' (*Historia Ramesiensis*, p. 90: L-B, 3566).

194   '. . . magnam tabulam . . . totam ex auro et argento et gemmis preciosis . . .' It was concealed by the monks in the tower from Hereward's force, but discovered and seized (*The Chronicle of Hugh Candidus*, p. 78–9: L-B, 3458).

195   The altar at Ely was enhanced by Æthelwold with gold and precious stones – 'Porro fuerat exornatum etiam sacrum altare palliis regalibus atque vasis, auro et pretiosis lapidibus decoratum' (*Liber Eliensis*, II, 3, p. 75).

196   See above, chapter I, note 26.

197   'Anno 1017, Brithwius abbas constitutus fecit tabulam ante altare, auro et argento et ebore polimitam . . .' (William of Malmesbury *De antiquitate Glastoniensis*, col. 1719: L-B, 1853).

198   See below, chapter VIII, note 140.

199   In his *De Abbatibus* (ed. Campbell), Æthelwulf states that Sigbald (died probably 771) gave an altar with beautiful pictures – 'prepulchris mensa tabellis'. This is in l. 436. In ll. 641–2 he says that it was of gold and was bejewelled: 'ast quidam domine mensam, que nobilis ortu, / gemmarum flammis et fuluo uestit in auro'. In the following three lines, he speaks of glittering panels of silver on it, fittingly displaying figures of the blessed in heaven, which were engraved by hand: 'argenti has nitide distingunt rite tabelle, / inpressas digitis poteris quis cernere formas, / sanctorum splendunt animae cum sedibus altis'. The 'inpressas digitis' suggests the finger pressed on the engraving tool. Compare the 'valvae duplices insculptae digitis magistri Hugonis' much later at Bury (*Memorials of St Edmund's Abbey*, II, ed. T. Arnold, p. 289: L-B, 495).

200   See above, p. 85.

201   'Fecit et sanctus Athelwoldus tabulam supra altare, in qua erat sculpta et xii apostoli, ex auro puro et argento . . .' (*De abbatibus Abbendoniae*, II, p. 278: L-B, 13).

202   '. . . xii etiam imagines apostolorum opere fusili, quae deportarent altare aureum anterius; leones etiam ejusdem operis, quae supportarent altare posterius; ipsum etiam altare ex auro mero compositum . . . in ecclesiae ornamentum construxit [Haroldus]' (*De inventione Sanctae Crucis*, ed. Stubbs, pp. 17–18).

203   '. . . fecit [Theodwinus] . . . tabulam ex auro et argento admirandi operis, in cuius medio thronus cum imagine Domini et per girum imagines, ex

argento penitus deaurate atque hinc inde zone lapidibus preciosis ex-ornate . . .' (*Liber Eliensis* II, 113, p. 196). Later (III, 50, pp. 289–90) further details are given and we learn not only of the number and types of precious stones but of 'ii curruum solis et lune' and that 'circa maiestatem sunt ymagines iiii or angelorum de ebore'.

204  *De Pontificibus*, l. 1513: 'Quae triginta tenet variis ornatibus aras'.

205  See the contribution by C. A. Ralegh Radford on the subject in *Relics of St Cuthbert* ed. Battiscombe, pp. 326–35.

206  See H. P. Mitchell *Flotsam of Later Anglo-Saxon Art*, *Burlington Magazine* XLII (1923), pp. 63 ff.

207  Lines 14–17.

208  'crux ueneranda nitens precelso stipite surget / uertice de mense nimium candente smaragdo. / aurea gemmis flammescit lammina fuluis' (ed. Campbell, ll. 723–5).

209  'Hic crucis ex auro splendescit lamina fulvo / Argentique simul gemmis ornata metalla' (*Carmina Ecclesiastica*, III, ll. 77–78, in his *Opera*, ed. Ehwald, p. 18).

210  '. . . et argenti laminis altare crucesque / Texerat auratis' (*De Pontificibus*, ll. 1224–5).

211  'Et sublime crucis vexillum erexit ad aram, / Et totum texit pretiosis valde metallis' (*Ibid.*, ll. 1496–7).

212  Referring to the fire at Hyde abbey in 1141, Florence of Worcester says: 'erat in hac ecclesia sancti Grimbaldi crux magna, crux sancta, jussu regis Canuti dudum fabricata, et ab eodem auro et argento, gemmis et lapidibus pretiosis decentissime adornata' (ed. B. Thorpe, II, p. 133: L-B, 4758). Rudborne claimed that a gold and bejewelled cross given by Cnut had been removed by William the Conqueror (see below, p. 218), so we must presume either that it was later returned, or that Rudborne's reference was to a Crucifix (it is mentioned in the context of two figures, presumably the Virgin and John) and that Florence was speaking of a separate cross. An illustration to the *Liber Vitae* of Hyde abbey (Plate 47) shows Cnut presenting a cross.

213  *Anglo-Saxon Chronicle*, ed. Whitelock, E version, p. 152.

214  Harold gave 'cruces tres aureas, vi argenteas . . .' (*De inventione Sanctae Crucis*, ed. Stubbs, p. 18).

215  'Anno 1045 obiit Brithwoldus . . . Hic misit . . . crucem ad processionem et alias XXV . . .' (William of Malmesbury *De antiquitate Glastoniensis*, cols. 1722–3: L-B, 1859).

216  'Haec sunt que invenit Eudo dapifer et Willelmus de Belfou et Angerus in ecclesia sancte Æthelrethe (*c.* 1081) . . . x et ix magnas cruces et viii parvas . . .' (*Liber Eliensis*, II, 114, p 196).

217  'Istud est Testamentum Edredi Regis, quod est persolvendum. Imprimis ipse legat loco in quo sibi placet, post obitum suum, requiescere, duas cruces aureas, cum imaginibus aureis . . .' (*Liber monasterii de Hyda*, p. 158: L-B, 5952).

218 'Hanc quoque donationem cum duabus crucibus aureis . . . ecclesie Elyensi investivit' (*Liber Eliensis*, p. 135).

219 'Insuper addidit . . . duas cruces operatas ex auro et argento et gemmis pretiosis . . . Corpus vero eius in Ely delatum reconditur et nomen illius super sanctum altare descriptum cum fratrum nominibus perpetuam in ecclesia memoriam habet' (*ibid.*, p. 133). She probably died in 1007 (see editor's note).

220 '. . . twegea gyldenra roda . . .' (Whitelock *Wills*, p. 62).

221 'Fecerat [Stigandus] quoque illic crucem magnam deargentatam desuper totam cum imagine domini nostri Iesu Christi ad magnitudinem forme illius . . .' (*Liber Eliensis*, II, 98, p. 168).

222 '. . . atque similis operis imagines iuxta sancte Dei genitricis Marie et sancti Iohannis evangeliste ex ere fabrefactas . . .' (*idem*). On p. 290, the figures of John and the Virgin are said to be of silver (*ibid.*, III, 50).

223 'Sancta uero crux, que ibidem erecta est, sancta est et antiqua, et antecessoribus nostris in magne sanctitatis ueneracione uenerata, et multa miracula ante ipsam perhibebant celebrata. Nam quidam ante monachos introductos in ecclesiam sancti Edmundi longum tempus ibidem hanc fuisse putant; alii quando Leofstanus abbas iuit Romam crucem sacram que ueneratur in ciuitate Lucana in itinere contemplasse, quam expressius habere formam et magnitudinem dominici corporis, prebeat et mensuram eius sumptam domum reuersus hanc ad modum eius et secundum ipsam fieri fecisse' (*Registrum Album monasterii S. Edmundi*, British Library Add. MS. 14,847, fol. 21r. I take both the reference and the quotation from Frank Barlow *The English Church 1000–1066* (London , 1963), p. 21.

224 '. . . [Leofricus et Godgiva] fecerunt constitui crucem non modicam et imaginem sanctae Dei Genitricis Mariae sanctique Johannis Evangelistae argento et auro honorabiliter fabricatas' (*Chronicon Evesham*, p. 84: L-B, 1613).

225 The *De abbatibus Abbendoniae*, p. 278 (L-B, 13) notes without comment that Æthelwold 'Fecit etiam tres cruces ex auro et argento longitudine iiii pedum . . .'.

226 See above, chapter II, note 6.

227 'Rex quoque deinceps Cnuto nunquam coronam portavit, sed coronam suam super caput imaginis Crucifixi, quae stat in fronte summi Altaris in Ecclesia Cathedrali Wyntoniae, componens . . .' (Thomas Rudborne *Historia Wintoniensis*, p. 233; L-B, 4700).

228 See this chapter, note 152.

229 'Eadredus qui erat ueteris cenobii in Uuintonia specialis amator atque defensor, ut testantur ea quae ipso iubente fabricata sunt ornamenta, magna scilicet aurea crux, altare aureum et cetera . . .' (Wulfstan, in Winterbottom *Three Lives*, p. 40).

230 Cnutus Rex dedit novo Monasterio Wyntoniae, quod Hyda nominatur . . . duas magnas imagines auro et argento bene ornatas' (Thomas Rudborne *Historia Wintoniensis*, p. 249: L-B, 4701).

231 '. . . magnam crucem cum duabus imaginibus, scilicet Mariae et Johannis, et illas cum trabe vestitas auro et argento copiose, dedit Wintoniae ecclesiae' (*Annales monasterii de Wintonia* in *Annales monastici* II, ed. H. R. Luard, Rolls Series (London, 1865), p. 25: L-B, 4709).

232 'Anno . . . 1064 Stigandus archiepiscopus inter caetera bona quae huic monasterio contulit, crucem magnam argento undique coopertam in navi ecclesiae super pulpitum erectam s. Augustino dedit' (*Chronica Guillielmi Thorne* in Roger Twysden *Historiae Anglicanae Scriptores decem* (London, 1652), col. 1785: L-B, 653).

233 See below, p. 330, note 140.

234 Robertson *Anglo-Saxon Charters*, p. 226.

235 See below, p. 217.

236 '. . . magnam crucem que super altare est mirabili opere de argento et auro fecit' (*The Chronicle of Hugh Candidus*, p. 66: L-B, 3454).

237 Version E, ed. Whitelock, p. 152.

238 '. . . set sicut erant armati intraverunt in ecclesiam et volebant auferre magnam crucem, set non potuerunt. Acceperunt tamen coronam auream de capite crucifixi, cum preciosis gemmis, et scabellum sub pedibus eius similiter ex auro puro et gemmis . . .' (*The Chronicle of Hugh Candidus*, p. 78: L-B, 3458).

239 'Hanc enim solam ex ornamentis post se in ecclesia reliquerant ob hoc videlicet quod difficile in fuga portari poterat . . .' (*Symeonis monachi opera* I, p. 101: L-B 1356). (They had also hoped that a focus of piety, such as this, would be spared though it was, in fact, stripped by thieves.)

240 See above, p. 119.

241 '. . . crux que erat super magnum altare, et Mariola et Iohannes, quas ymagines Stigandus archiepiscopus magno pondere auri et argenti ornaverat et sancto Aedmundo dederat' (*Chronica Jocelini de Brakelonda* . . . ed. H. E. Butler (London, 1949), p. 5).

242 'Ejus [Letardi] quippe et venerabilis reginae Bertae . . . imagines enormi magnitudine ac decore effigiavit, ac super ipsius tumulum solemniter erexit' (Goscelin *Historia translationis S. Augustini*, *Pat. Lat.*, CLV, col. 46: L-B, 642).

243 'Rex Cnutus dedit Wintoniensi ecclesiae . . . feretrum ad reliquias Sancti Birini, magnum imaginem . . .' (H. R. Luard *Annales monastici*, II, p. 16: L-B, 4702).

244 'Fecit [Brithnodus] namque beatarum virginum imagines easque auro et argento gemmisque pretiosissime texuit et iuxta altare maius duas a dextris et duas a sinistris statuit. Spectaculum populo multum prebebant in magnitudine glorie templi Domini . . .' (*Liber Eliensis*, II, 6, p. 79).

245 '. . . que in deditione magni regis Willelmi excrustate et . . . solum nuda ligna hactenus valent intueri' (*idem*).

246 '. . . ad honorem beatissime Dei genitricis . . . imago ipsius habens filium in gremio de auro et argento gemmisque insigniter operata inestimabilis pretii magnitudine . . .' (*ibid.*, II, 61, p. 132).

247 '. . . desuper tronum ad longitudinem hominis . . .' (*idem*).
248 'Ut enim horreum Cereris dicenda videtur frumenti copia, sic aerarium
    Arabiae auri copia' (Guillaume de Poitiers *Histoire*, p. 254).

### Chapter VIII    *Anglo-Saxon Art and the Norman Conquest*

1 'ecclesiam Cadomensem ex rapina ornare et spoliis Walthamensis
  ecclesiae . . . si de alieno et quasi ab uno altari districto aliud ornetur et
  quasi munus gratum et valde pretiosum alicui patri offerantur praecisa
  proprii membra filii' (*De inventione Sanctae Crucis*, p. 32).
2 '. . . Quorum [thesauri] partem ad ministros confecti belli magnifice
  erogavit, plurima ac pretiosissima egenis et monasteriis diversarum pro-
  vinciarum distribuit. Id munificentiae studium adjuvit non modicus
  census, quem undique civitates et locupletes quique obtulerant novitio
  domino. Romanae ecclesiae sancti Petri pecuniam in auro atque argento
  ampliorem quam dictu credibile sit; ornamenta quae Bizantium percara
  haberet, in manum Alexandri papae transmisit . . . Mille ecclesiis
  Franciae, Aquitaniae, Burgundiae, nec non Arverniae, aliarumque re-
  gionum perpetuo celebre erit Guillelmi regis memoriale . . . Aliae cruces
  aureas admodum grandes insigniter gemmatas, pleraeque libras auri vel
  ex eodem metallo vasa, nonnullae pallia vel pretiosum aliud quid ac-
  cepere. Splendide adornaret metropolitanam basilicam, quod minimum
  in his donis coenobiolum aliquod laetificavit' (Guillaume de Poitiers
  *Histoire*, pp. 224–6).
3 'Nullius unquam regis aut imperatoris largitatem in oblationibus
  majorem comperimus. Item quas ecclesias [in Normannia] non
  praesentia sua, muneribus visitavit iterum. Cadomensi basilicae . . . tum
  diversa donaria advexit, materia artificioque pretiosissima, quae ad sec-
  uli terminum honora permanere valeant. Singula descriptionibus aut
  nominibus designare spatiosum foret. Voluptuosum est ea perspectare
  hospitibus maximis, et qui saepe nobilium ecclesiarum thesauros vide-
  rant' (*ibid.*, p. 256).
4 The English sources are the *De Inventione Sanctae Crucis* (ed. Stubbs, pp.
  31–2), and the *Vita Haroldi Regis* (ed. J. A. Giles in *Original Lives of
  Anglo-Saxons* . . . , pp. 306–7). The first account is reliable; the second is
  not, though it probably incorporates authentic material in its description
  of losses of art treasures.
5 Guillaume de Poitiers *Histoire*, p. 260.
6 See above, chapter VI, note 44.
7 See above, p. 193.
8 See Guillaume de Poitiers (*Histoire*, p. 258), and Guy, Bishop of Amiens
  (*Carmen de Hastingae Proelio*, ll. 615–16).
9 '. . . auri argentique, vestium, librorum, vasorumque diversi generis
  copia, usibus ecclesiae honorique computata, multa indiscrete distracta

sunt. Nullius sacrorum liminum prospectus reverentia, nulla fratrum desolatorum compassio' (*Chronicon Abingdon*, I, p. 486: L-B, 25).

10 'Quaedam etiam ex ornamentis ecclesiae [Dunelmensis], inter quae et baculum pastoralem materia et arte mirandum, erat enim de saphiro factus, praefatus episcopus [Odo] abstulit' (*Symeonis monachi opera*, I, p. 118: L-B, 6005).

11 'Cnutus Rex dedit novo Monasterio Wyntoniae, quod Hyda nominatur ... crucem nobilissimam de auro cum lapidibus pretiosis, et multis sanctorum reliquiis decenter ornatam, et duas magnas imagines auro et argento bene ornatas. Quae omnia Wilhelmus Conquaestor vi abstulit' (Thomas Rudborne *Historia maior de fundatione et successione ecclesiae Wintoniensis*, in H. Wharton *Anglia Sacra*, Pars Prima (London, 1691), p. 249: L-B, 4701). But see also above, chapter VII, note 212.

12 '... Thuribulum mirae magnitudinis de auro et argento, altare pretii XX marcarum, crucem ad processionem, et alias XXV quas cum Aegelnotus abbas [1053–77] cum aliis ornamentis auro et argento nudasset, in duabus XXII marcas auri accepit' (William of Malmesbury *De antiquitate Glastoniensis ecclesiae* in *Pat. Lat.*, CLXXIX, col. 1723, and L-B, 1859). The writer, who was far from sentimental about the past in general terms for he could be quite scathing about the Anglo-Saxons, nevertheless saw the halcyon days of Glastonbury as having been before the Norman period which, in his view, brought to the abbey a period of decline (cf. *Gesta Pontificum*, pp. 196–7).

13 '... promittentes [monachi] ei [Wilhelmo] pretium pecunie, septingentarum scilicet marcharum argenti. Tunc quidem monachi pretiosa queque in ecclesia sumentes, cruces, altaria, scrinia, textus, calices, patenas, pelves, situlas, fistulas, cifos, scutellas aureas et argenteas, ut pretaxatum explerent pecunie numerum . . . Exinde monachi . . . pactum denuo ineuntes eum eo novum, trescentas prioribus septingentis adicere marcas, videlicet millenarium supplere pollicent, ut gratia eius cum loci libertate ac bonorum redintegratione potirentur. Ob hoc totum quod in ecclesia ex auro et argento residuum fuit, insuper imaginem sancte Marie cum puero suo sedentem in throno mirabiliter fabrefactam, quam Ælfsinus abbas fecerat de auro et argento, comminutum est. Similiter imagines sanctarum virginum multo ornatu auri et argenti spoliate sunt, ut pretium pecunie exsolvi queat. Sed nichilominus sperate quietis fiducia caruerunt' (*Liber Eliensis*, pp. 194–5).

14 'Rex igitur citius cognito predicti abbatis decessu ad Ely misit et, quicquid optimum in ornamentis et variis rebus ibi fuisse didiscerat, in thesaurum suum iusserat asportari' (*Liber Eliensis*, II, 113, pp. 195–6).

15 See above, p. 181.

16 The attribution was probably incorrect (see above, p. 49) but the point is that it was thought to have been made by the saint.

17 'Illo enim tempore erant in hac domo quidam monachi et sacristae de coenobio Gemeticensi, qui ornamenta quamplurima a beato Atheluuoldo

laboriose adquisita et huic domui collata tam aurea quam argentea, eruderato penitus argento a rota memorata, secum in Normanniam fraudulenter asportaverunt' (*Chronicon Abingdon*, I, p. 345 and L-B, 14). A similar account is given in *De abbatibus Abbendoniae*, II, pp. 278–9, and both writers claim that the 'golden wheel' with bells all round its circumference was made by St Æthelwold himself. The Abingdon statements that some of their treasures were being sent to Jumièges have been disputed (Knowles, p. 117, note 4). But they gain some confirmation from a surviving Jumièges manuscript at Rouen (Bibliothèque Municipale MS. 32) in which an inscription tells us that it came from Abingdon. The manuscript was actually written there by Normans. However, this is not the point. Its real attraction, as the inscription itself makes clear, was its binding of gold and silver, set with gems, and this could well have been Anglo-Saxon. It is exactly in the context of these losses that the Abingdon chronicler tells us that St Æthelwold gave Gospel Books with gold and silver bindings inset with gems – 'Ornavit etiam ecclesiam textis tam ex argento puro quam ex auro obrizo pariter et lapidibus pretiosissimis'. The inscription on folio 1v of the Rouen manuscript reads: 'Rainaldus ... abbas abbendonensis [1085–97] hunc sancti evangelii textum sic auro argentoque ac gemmis ornatum beatae dei genetrici ac semper virgini marie beatoque PETRO Gemmeticensis coenobii mittit'.

18 'Quodam eciam tempore duos monachos de ultra mare fecit [Thoroldus abbas] secretarios qui furati sunt casulam optimam Elurici archiepiscopi [Eboracensis], que quasi aurum refulgebat in domo domini quando uestiebatur. Hanc secum et multas alias res ultra mare portauerunt, et sunt in monasterio quod dicitur Preiels [i.e. Préaux]' (*The Chronicle of Hugh Candidus*, p. 85 and L-B, 3461).

19 See below, pp. 224, 228 and 230.

20 'Hic abbas . . . ad eam [abbatiam] revocavit totum quod in auro et argento et lapidibus ante illius promotionem rex inde abstulerat, nolens eam ullo modo suscipere, nisi rex que iusserat auferri iuberat referri. Restitutis itaque spoliis ecclesiasticis, Elyensem abbatiam multum pro-futurus . . .' (*Liber Eliensis*, II, 113, p. 196).

21 *Historia Novorum*, p. 224.

22 *Gesta Regum* I, p. 278.

23 *Chronicon Monasterii de Bello* ed. J. S. Brewer (London, 1846), p. 89. But see also Freeman's interesting Appendix on the fusion of the Norman and Anglo-Saxon races in his *History of the Norman Conquest* (Oxford, 1876), vol. V, pp. 825 ff.

24 Cited by R. H. C. Davis *The Normans and their Myth*, p. 124.

25 'Itaque importabilis pensionis edictum per totam Angliam cucurrit. Tunc episcopi et abbates frequentes curiam adeunt, super violentia querimoniam facientes, non se posse ad tantum vectigal sufficere . . . Quibus curiales turbido, ut solebant, vultu, "Non habetis", inquiunt, "scrinia auro et argento composita, ossibus mortuorum plena": nullo alio

responso obsecrantes dignitati. Ita illi, intelligentes quo responsio tenderet, capsas sanctorum nudaverunt, crucifixos despoliaverunt, calices conflarunt, non in usum pauperum, sed in fiscum regium; quicquid enim pene sancta servavit avorum parcitas illorum grassatorum absumsit aviditas' (William of Malmesbury *De Gestis Regum*, II, pp. 371–2: L-B, 6012).

26 'Eo tempore Robertus comes Normanniae in expeditionem Ierosolimitanam proficisci disponens fratri suo Willelmo regi Angliae Normanniam spatio trium annorum pecuniae gratis in dominium tradidit. Quae pecunia per Angliam partim data, partim exacta, totum regnum in immensum devastavit. Nihil ecclesiarum ornamentis in hac parte indulsit dominandi cupiditas, nihil sacris altarium vasis, nihil reliquiarum capsis nihil evangeliorum libris auro vel argento paratis' (Eadmer *Historia Novorum*, pp. 74–5: L-B, 6013).

27 See above, chapter VII, note 146.

28 'Dixit enim esse Anglicos rusticos' (*De Abbatibus Abbendoniae*, II, p. 284).

29 'Tumbas venerabilium antecessorum suorum Abbatum nobilium – quos rudes et idiotas consuevit appellare – delevit' (*Gesta abbatum S.Albani*, I, p. 62: L-B, 3813).

30 Abbot Warin, originally a monk from Lyre, who made an exception for St Aldhelm (William of Malmesbury *Gesta Pontificum*, p. 421).

31 William of Malmesbury *Gesta Pontificum*, pp. 327–8; cited by Frank Barlow *The English Church 1000–1066* (London, 1963), p. 26, where it is also pointed out that Malmesbury further suppressed the names of Anglo-Saxon witnesses to miracles in his *Vita Wulfstani* (p. 23), 'ne uocabulorum barbaries delicati lectoris sauciaret aures'.

32 The relevant passage follows on from an account of the gold and silver treasures adorning the walls of the church, which Leofric and Godiva had given, and the *Hoc* refers to these: 'Hoc Robertus, ejusdem episcopus provinciae . . . ex ipsis ecclesiae gazis surripiens unde datoris manum suppleret . . . unde aviditati Romanorum irreperet; pluresque ibi annos moratus nihil probitatis exhibuit. Adeo tecta ruinam minitantia nunquam periculo exemit, adeo sacras opes dilapidans peculatus crimen incurrit, repetundarum reus futurus episcopus si esset accusator paratus' (William of Malmesbury *De Gestis Regum*, II, pp. 388–9: L-B, 1132).

33 '. . . Turo abbas emit alio tempore episcopatum Beluacensium, et multa secum tulit ornamenta ecclesie, que pene omnia perdita erant' (*The Chronicle of Hugh Candidus*, p. 85: L-B, 3461).

34 'Leouinus quandam villam Niweham de suo patrimonio, trans flumen Tamisiae e regione monasterii Abbendoniae sitam ipsi abbati [Athelelmo], pretio accepto, distraxit. In qua distractione et calix praegrandis magnifici operis, argenti aurique, Siwardi pontificis et olim hujus loci abbatis, expensus est . . .' (*Chronicon Abingdon*, II, p. 9: L-B, 5993).

35 'Fecit et sanctus Athelwoldus tabulam supra altare, in qua erat sculpta et

xii apostoli, ex auro puro et argento, pretio ccc librarum. Hanc tabulam fregit abbas Vincentius et dedit regi Henrico . . . pro libertate fori Abbendoniae et pro libertate hundredi de Hornigmere . . .' (*De abbatibus Abbendoniae*, II, p. 278: L-B, 13). It was said that St Æthelwold himself had given King Edgar a gold cross or Crucifix in part exchange for land. The chapter of the *Liber Eliensis* (Book II, 4) in which this is stated is, however, suspect. The account says that the king gave it to Ely and perhaps this account was to establish an association with the saint.

36 See above, chapter I, note 21 and chapter II, note 8.

37 'Cujus [Ricardi de Sancta Helena] petitioni abbas maturius satisfaciens, xii thecas ex auro puro et argento coopertas iterum eruderavit, utilius dijudicans aurum et argentum pro redemptione militis et libertate ecclesiastica in fisco regio ad horam exaggerare, quam servitium ejusdem terrae penitus amittere . . .' (*Chronicon Abingdon*, II, p. 214: L-B, 58). Later on, Ingulf gathered together enough treasure to replace the gold and silver stripped from the reliquaries but this was appropriated by the king (*ibid.*, p. 215).

38 '. . . circa finem abbatis, quicquid paene auri et argenti in scriniis sanctorum, vel vasis, in ecclesia repertum est, pro reddendis debitis ipsius distractum' (*Chronicon Abingdon*, II, p. 210: L-B, 56).

39 For the extraordinary number of art-objects which Nigel took from Ely see *Liber Eliensis*, Book III, chaps. 78 and 89. The following comments refer to the Anglo-Saxon Crucifixes he removed. 'Crucem vero fecit argenteam [Leofwine], que crux Leonis prepositi nominatur, in qua forma corporis Christi ingenio artificis cavata sanctorum reliquias Vedasti et Amandi continebat, quam Nigellus episcopus tulit . . .' (*ibid.*, II, 54, p. 124). 'Dedit [Elfwara] autem Deo . . . duas cruces operatas ex auro et argento et gemmis pretiosis, quas Nigellus episcopus postea tulit atque contrivit' (*ibid.*, II, 61, p. 133). '. . . magna crux cum crucifixo de argento et ymagines similiter beate Marie et sancti Iohannis . . . quas Stigandus archiepiscopus fecit in magnificentiam templi Domini, sed has tulit episcopus Nigellus . . .' (*ibid.*, III, 50, p. 290). The large number of vestments removed included 'albam optime paratam pallio pulcherrime superaurato, quam sanctus Æthelwoldus dedit ecclesie' and 'casulam videlicet beate memorie regis Ædgari et cinctorium ipsius' (*ibid.*, III, 78 and 92, pp. 325 and 338).

40 I am presuming that this (see last note) was the chasuble described above, p. 181.

41 The story is told in *Liber Eliensis*, Book III, 122, pp. 371–2.

42 See above, pp. 7–8.

43 I am thinking, of course, of Suger and Saint Denis – see his *De Administratione,* ed. Panofsky, pp. 78, 60, 70.

44 See above, pp. 218, 220–1, and note 39 above.

45 See *Vita Ædwardi*, ed. Barlow, p. 116 and p. 129, note 2.

46 Eadred had given to Winchester a large gold Crucifix (see above, p. 212)

and this seems to be the one referred to by the archbishop of Canterbury in his letter to Henry: '. . . pro certo accepimus quod crucem vestram auream ab ecclesia vestra alienaveritis, quod satis improvide et citra omnem canonum censuram factum interpretamur . . .' (*Materials for the history of Thomas Becket*, V, ed. J. C. Robertson, Rolls Series (London, 1881), p. 255: L-B, 6040).

47 Henry tried to purchase for Winchester a highly prized precious stone which embellished the Waltham Crucifix: '. . . Hunc centum marcis emere, et Wintoniam transferre cupivit Henricus, episcopus illius ecclesiae, tunc quidem decanus noster, sed in veritate quae Deus est, nec illud nec minimam ornamentorum portionem, permisimus ab ecclesia transferri . . .' (*De inventione Sanctae Crucis Walthamensis*, p. 12).

48 'Est sibi milicies unctis depexa capillis, / Feminei iuuenes . . .' (*The Carmen de Hastingae Proelio of Guy, Bishop of Amiens*, ed. C. Morton and H. Muntz (Oxford, 1972), ll. 325–6). The editors suggest that these were 'the Housecarls . . . who groomed themselves carefully – especially their hair – before battle' (p. 23 note).

49 Harris, *English Dress* (thesis), I, pp. 29–30.

50 'Eo tempore curialis juventus ferme tota crines suos juvencularum more nutriebat, et quotidie . . . delicatis vestigiis, tenero incessu obambulare solita erat' (*Historia Novorum*, p. 48).

51 'Pedum articulis, ubi finis est corporis, colubrinarum similitudinem caudarum imponunt, quas velut scorpiones prae oculis suis prospiciunt' (*Historiae Ecclesiasticae Libri*, vol. III, p. 324).

52 '. . . prolixisque nimiumque strictis camisiis indui tunicisque gaudebant' (*idem*).

53 'Humum quoque pulverulentam interularum et palliorum superfluo surmate verrunt, longis latisque manicis ad omnia facienda manus operiunt, et his superfluitatibus onusti celeriter ambulare, vel aliquid utiliter operari vix possunt' (*ibid.*, pp. 324–5).

54 Harris, *English Dress* (thesis), I, p. 31.

55 *Ibid.*, chaps. 3 and 4 and illustrations.

56 Thorne's chronicle in Twysden's *Historiae Anglicanae Scriptores decem*, col. 1788.

57 R. W. Southern *Saint Anselm and his Biographer* (Cambridge, 1963), p. 253.

58 William of Malmesbury *De antiquitate Glastoniensis*, cols. 1730–31. According to this account, two monks were killed and fourteen wounded. The Anglo-Saxon Chronicle says that the number killed was three and the number wounded eighteen. The first source places this event in 1081 and the second in 1083.

59 The phrase 'amator scripturarum' is applied both to Abbot Paul and to the knight referred to in note 61 below (*Gesta abbatum S. Albani*, I, p. 57: L-B, 3809).

60 'Dedit [Paulus] igitur ecclesiae [S. Albani] viginti octo volumina notabilia, et octo Psalteria, Collectarium, Epistolarium, et librum in quo

continentur Evangelia legenda per annum'. Others included service books and books 'qui in armariolis habentur' (*ibid.*, p. 58: L-B, 3810).

61 *Ibid.*, pp. 57–8. The knight's name was Robert.

62 'Libros multos fecit' (*Chronicon Evesham*, p. 97: L-B, 1623).

63 'Libri conscripti nonnulli, vel potius bibliothecae primitiae libatae' (William of Malmesbury *Gesta Pontificum*, p. 431).

64 *Dunelmensis Ecclesiae Cathedralis Catalogi librorum* (Surtees Society VII, 1838), pp. 117–18.

65 Professor Sir Roger Mynors lists twenty-two books in his section on Carilef's manuscripts in *Durham Cathedral Manuscripts* (Oxford, 1939).

66 They are listed in Robertson *Anglo-Saxon Charters*, p. 228.

67 See above, p. 6.

68 Rightly or wrongly (and probably wrongly) Eadmer believed that documents from Rome establishing the primacy of Canterbury had been destroyed in the fire (See his *Vita S. Bregwini* in *Pat. Lat.*, CLIX, cols. 757–8). The so-called Lanfranc forgeries which derived from this belief have interested historians of the period from H. Boehmer onwards.

69 'Anno . . . 1168 . . . combusta fuit ista ecclesia [S. Augustini] pro maxima parte, in qua combustione multae codicellae antiquae perierunt' (*Chronica Guillielmi Thorne* in Twysden *Historiae Anglicanae Scriptores decem* (London, 1652), col. 1815: L-B, 748).

70 British Library, Add. MS. 49588.

71 Rouen, Bibliothèque Municipale, MS. Y 6.

72 British Library, MS. Harley 603.

73 British Library Cotton MS. Claudius B IV. A facsimile has been published by C. R. Dodwell and Peter Clemoes under the title *The Old English Illustrated Hexateuch (Early English Manuscripts in Facsimile*, vol. 18, Copenhagen, 1974).

74 I am referring here, of course, to the Normans in England. In Normandy itself there was some interest in full-page pictures (partly inspired by Anglo-Saxon illustrations) as we see especially in the Mont St Michel Sacramentary.

75 Dodwell *Canterbury School*, pp. 20 and 23 ff.

76 See, for example, the Anglo-Saxon Psalter described by Ordericus Vitalis above, p. 22. The Anglo-Saxon Sacramentary of Archbishop Robert (Rouen, Bib. Mun. MS. Y 6) was in Normandy before the Conquest and so, too, the Benedictional of Archbishop Robert (Rouen, Bib. Mun. MS. Y 7) whether it belonged to Robert, Archbishop of Rouen, or Robert of Jumièges.

77 See *Vita Ædwardi*, ed. Barlow, p. 116 and p. 129 note 2.

78 '. . . quam gloriose revectus est . . . habens in comitatu . . . magnos in transmarinis coenobiis abbates . . .' (*Histoire*, p. 252).

79 'Aliquanti abbates a rege noviter ordinati sunt, et complures coenobitae in monasteriis Gallicis competenter edocti sunt' (II, p. 208). I owe the reference to Knowles *Monastic Order*, p. 113.

80 He was Osbern who was sent by Lanfranc from Canterbury to Bec. See R. W. Southern *Saint Anselm and his Biographer* (Cambridge, 1963), p. 248.

81 See above, pp. 58–61.

82 See Dodwell *Canterbury School*, p. 9.

83 *Ibid.*, pp. 19 ff. and 26 ff.

84 British Library MS. Arundel 60 fol. 52v.

85 Now divided between Lincoln and Cambridge: Lincoln Cathedral MS. 1 and Trinity College MS. B 5 2.

86 Dodwell *Canterbury School*, p. 30.

87 Though, exceptionally (as we see below, p. 230), the gifts of Abbot Paul (1077–93) to St Albans included two Gospel-books with bindings of gold and silver, set with gems.

88 See above, pp. 92–3.

89 William of Malmesbury *Gesta Pontificum*, pp. 69–70: L-B, 663.

90 *Ibid.*, p. 138: L-B, 730.

91 *Inventories of Christchurch Canterbury* ed. J. Wickham Legg and W. H. St John Hope, p. 44: L-B, 721.

92 'Concamerationem quoque, quae est ultra majus altare, pictura venustavit [Paulus]' (*Gesta abbatum S. Albani*, I, p. 60: L-B, 3812).

93 See Robertson *Anglo-Saxon Charters*, p. 226. Apart from bear-skins and altar-covers, this list itemises amongst his gifts 2 carpets, 7 seat-covers, 3 dorsals, 2 wall-hangings, and 7 other coverings.

94 'Dedit [Edwardus] . . . ad altare operimentum linteum quoddam opere mirifico decoratum maiestatis Domini cum Euangelistis quator, sed et crucifici Domini necnon etiam duodecim Apostolorum continens imagines opere plumario supertextas' (*Historia Selebiensis monasterii*, in *The Coucher Book of Selby*, ed. J. T. Fowler, vol. I, p. 9: L-B, 4181).

95 *Idem.*

96 Robertson *Anglo-Saxon Charters*, p. 226.

97 See this chapter, note 140.

98 'Cunctum etiam suae capellae paratum, in qua continebantur . . . alba, super-humerale, stola cum fanone et casula albi coloris de pallio aurifrixo singula perlucida . . .' (*Chronicon Abingdon*, I, pp. 461–2: L-B, 23).

99 See above, p. 78.

100 'Ego Mathildis regina do Sancte Trinitati Cadomi casulam quam apud Wintoniam operatur uxor Aldereti et clamidem operatam ex auro que est in camera mea ad cappam faciendam . . . ac vestimentum quod operatur in Anglia . . .' (*Les actes de Guillaume le Conquérant et de la Reine Mathilde pour les abbayes caennaises*, ed. L. Musset, *Mémoires de la société des antiquaires de Normandie*, 37 (1967) No. 16, pp. 112–13).

101 '. . . absque . . . capis, albis et aliis variis ornamentis' (after an account of his gifts of books: *Gesta abbatum S. Albani*, I, p. 58: L-B, 3810).

102 'contulit praefato militi Roberto, ad capellam suam in curia de Hathfeld, duo paria vestimentorum . . .' (*ibid.*: L-B, 3809).

103 'cappam nivei candoris valde insignem parari fecit . . .' (*Liber Eliensis*, p. 196).

104 'Et de ejusdem Capella habuit Ecclesia [Dunelmensis] plurima ornamenta, videlicet v capas, quarum iii albae et ii nigrae; iii casulas, quarum ii albae et una nigra, cum stola et manipulo magnis, in fine tantum brudatis . . .' (*Wills and Inventories . . . of the Northern Counties* . . . , ed. J. Raine, vol. 1, Surtees Society, vol. 2, p. 1: L-B, 1372).

105 Legg and Hope *op. cit.*, pp. 51, 53, 57. And see above, pp. 183–5.

106 '. . . misit una die xxv capas de serico optime de aurifriso ornatas . . . et dalmaticam principalem de albo diaspre circumdatam aurifriso optimo . . . capas quinque optime de aurifriso ornatas . . .' (*Registrum Roffense*, p. 120: L-B, 3713).

107 Gundulfus, inter cetera bona fecit fieri casulam principalem undique de auro circundatam, et alias tres de purpura nigra . . .' (*idem*: L-B, 3714).

108 Legg and Hope *op cit.*, p. 51.

109 See above, p. 45.

110 See above, p. 36.

111 'Hoc est incrementum per testimonium ipsorum monachorum ex quo Godefridus suscepit abbatiam in custodiam . . . v cappas, ii cum aurifriso in antea et per girum, ii sine auro, i cum taisello; ii taisellos, ii stolas cum manipulis cum auro; ii dalmaticas; i tunicam; i albam cum amictu et cum aurifriso' (*Liber Eliensis*, p. 197).

112 An inventory, made after the death of Theodwin in 1075, speaks of a red chasuble 'de qua abbas Tedwinus sumpsit aurifrisum quod in antea erat' and another 'de qua sumpsit florem' (*idem*).

113 Eadmer's *Vita S. Anselmi*, p. 340 in Eadmer *Historia Novorum*.

114 *Chronicon monasterii de Bello*, ed. J. S. Brewer, p. 13: L-B, 252.

115 *Registrum Malmesburiensis*, ed. J. S. Brewer I, p. 328: L-B, 5167.

116 *Memorials of St Edmund's Abbey* I, p. 170: L-B, 5166.

117 See above, p. 66.

118 '. . . ei contulit ad pretiosi digiti [S. Germani] repositionem phylacterium quoddam aureum, rotundum, quantitate perspicuum caelatura mirificum, opere pretiosum, quod usque hodie in monasterio Selebiensi conservatum, omnes se contemplantes non minus in sui ipsius laudem, quam admirationem pro antiqui operis accendit dignitate' (*Historia Selebiensis monasterii*, in *The Coucher Book of Selby*, ed. J. T. Fowler, vol. 1, p. 9: L-B, 4181).

119 C. H. Talbot 'The Life of Saint Wulsin of Sherborne by Goscelin', in *Revue Bénédictine*, LXIX, 1959, p. 72.

120 '. . . preciose reliquie . . . a preposito uenerabili alfrico cum uotiuo fratrum desiderio et obsequio in scriniis singulis auro splendide paratis solempni honore sunt reposite . . .' (*ibid.*, p. 84).

121 'Insuper obtulit calicem aureum Sancto Albano de tribus marcis . . . et tria magna candelabra deargentata et duo argentea de triginta marcis' (*Liber de benefactoribus . . . S. Albani*, in *Johannis de Trokelowe et Henrici de Blaneforde . . . Chronica et Annales* . . . , ed. H. T. Riley, p. 441: L-B, 3805).

122 '. . . misit . . . duo candelabra meliora de argento deaurata, et duas cruces

de auro . . . Feretrum parvum cum pede suo argenteo . . . et tabulam argenteam ante majus altare . . . dedit . . . autem crucem que stat super feretrum S. Paulini, et thuribulum argenteum' (*Registrum Roffense*, p. 120: L-B, 3713).

123 'Jam vero ex habundanti est dicere, quantum ibi ornamentorum conges-serit, vel in palliis et sacratis vestibus . . . vel in diversicoloribus picturis . . .' (*Gesta Pontificum*, p. 69: L-B, 663).

124 '. . . et quamplurima de auro et argento et pannis sericis et in diversis rebus innumera fecit ornamenta' (W. Stubbs *The Historical Works of Gervase of Canterbury*, II (London, 1880), p. 368: L-B, 666).

125 '. . . duo thuribula, duo candelabra fecit' (William of Malmesbury *De antiquitate Glastoniensis*, col. 1729: L-B, 1862).

126 'Dedit . . . duos textus, auro et argento et gemmis ornatos . . . Pelvem quoque argenti dedit . . . Tria quoque candelabra, argento et auro cooperta . . . duo quoque praeterea candelabra argentea, operis mirifici, et eleganter deaurata . . .' (*Gesta abbatum S. Albani*, I, pp. 58–9: L-B, 3810, 3811).

127 '. . . tabulam ex auro et argento admirandi operis, in cuius medio thronus cum imagine Domini et per girum imagines, ex argento penitus deaurate atque hinc inde zone lapidibus preciosis exornate . . .' (*Liber Eliensis*, p. 196).

128 '. . . ii calices argenteos cum patenis et unum aureum cum patena . . .' (*ibid.*, p. 197).

129 On his return to England 'non pauca ex auro et argento sacra altaris vasa . . . ad ecclesiam praemittere curavit' (*Symeonis monachi opera*, I, p. 128: L-B, 1365).

130 See, for example, his gifts of large and small altar-vessels of gold and silver to Ely. These were apart from the magnificent vestments he gave there (*Liber Eliensis*, p. 168). The statement in Gervase (ed. Stubbs I, p. 363: L-B, 5999) that documents itemising concealed treasures were found in his belongings on his death carries a very unworthy innuendo. He was one of the most generous and open-handed of all Anglo-Saxon art-patrons.

131 Version E, ed. Whitelock, p. 127.

132 *Ibid.*, p. 142.

133 See above, p. 217.

134 See above, p. 196 and next note.

135 '. . . dedit . . . feretrum cum altari gestatorio deargentato . . .' (*Registrum Roffense*, ed. J. Thorpe (London, 1769), p. 120: L-B, 3709). William also gave his royal tunic, an ivory horn, a dorsal and a costly cover decorated with lions to what was virtually a re-foundation.

136 After speaking of him having the Dowager Queen buried at Westminster, William of Malmesbury says '. . . habet tumbam argenti aurique expensis operosam' (*De Gestis Regum*, I, p. 332: L-B, 2523). For a dubious account of him making a precious shrine for the Confessor, see above, p. 164. Perhaps it was confused with this account or, possibly, the gold and silver

on Queen Edith's tomb was later transferred to that of her husband.

137 'Dein Wintoniam rediens, thesauros sui patris, ut ipse iusserat, per Angliam divisit . . . cruces, altari, scrinia, textos, candelabra, situlas, fistulas, ac ornamenta varia gemmis, auro, argento, lapidibusque pretiosis redimita, per ecclesias digniores ac monasteria iussit dividi' (*Chronicon ex chronicis*, I, p. 21: L-B, 6008).

138 See above, p. 000.

139 Listed in Robertson *Anglo-Saxon Charters*, p. 226. It included one altar, three reliquaries, two large Crucifixes or crosses, two episcopal crosses, some silver neck-crosses, two large and preciously bound Gospel-books, two large candlesticks, six smaller ones, five silver chalices, one silver censer, and two bowls and eight basins which latter seem from the context to have been precious. The altar was thought by Förster to be a portable one (quoted *ibid.*, p. 476), but there is certainly evidence of large altars being presented by donors.

140 'Ornamenta quoque acquisivit [Agelwinus, abbas Eveshamensis] plurima, videlicet, casulas, cappas, pallia, crucem magnam, et quoddam altare auro et argento pulcherrime operatum, necnon etiam quandam capellam valde honestam in honore Sancti Nicholai construi . . . fecit' (*Chronicon Evesham*, p. 93: L-B, 1616); '. . . et quinque archas plenas argento ad novam ecclesiam construendam quam facere disposuerat, reliquit' (*ibid.*, p. 96: L-B, 1618).

141 See above, chapter II, note 183.

142 'Regina [Emma] et episcopus [Aelfwinus] certabant se invicem superare in ornamentis faciendis ecclesiae sancti Swithuni de thesauris suis. Sed ille superatus est; quia vel illa plus potuit, vel plus dilexit decorem domus Dei' (*Annales monasterii de Wintonia*, in H. R. Luard *Annales Monastici* II, p. 25: L-B, 4706).

143 'Maximi numero genere, artificio thesauri compositi fuerant, aut custodiendi ad vanum gaudium avaritiae, aut luxu Anglico turpiter consumendi' (Guillaume de Poitiers *Histoire*, p. 224).

144 *Vita Wulfstani*, p. 262: L-B, 4860.

145 'Tanta criptae laxitas, tanta superioris aedis capacitas, ut quamlibet confertae multitudini videatur posse sufficere' (William of Malmesbury *Gesta Pontificum*, p. 145: L-B, 2531).

146 See this chapter, note 140.

147 '. . . dominus Walterus Eoveshamensem abbatiam regendam suscepit. Is . . . novis rebus, ut fieri solet, animum tradidit. Ecclesiam namque recenti opere delectatus incepit, et antiquum opus quod tum temporis ex pulcherrimis in Anglia exstit, paulatim destruxit. Cerneres, mirum dictu! tam magnum antiquitatis opus in solam cryptam insimul congestum' (*Chronicon Evesham*, p. 55: L-B, 1620).

148 *De Gestis Regum*, p. 280: L-B, 2511.

149 A. W. Clapham *English Romanesque Architecture after the Conquest* (Oxford, 1964), p. 26, note 2.

150 'Opus autem suum [Vulfrici II], innumeris sumptibus et laboribus frustratis, ad destructionem aliis reliquit' (*Historia translationis S. Augustini, Pat. Lat.*, CLV, col. 33: L-B, 645).

151 G. Zarnecki *English Romanesque Sculpture 1066–1140* (London, 1951), plates 13 and 15.

152 I, 41 (Hants).

153 See the agreement made between Abbot Paul of St Albans (1077–93) and Robert the mason and his heirs in *Gesta abbatum S. Albani*, p. 63: L-B, 3814.

154 'videas ubique in villis ecclesias, in vicis et urbibus monasteria, novo aedificandi genere consurgere' (*De Gestis Regum*, II, p. 306: L-B, 5631).

# INDEX

This index incorporates biographical and other information not found in the text. Particular attention is drawn to the long entry on Iconography. References to Plates are given in **bold** type